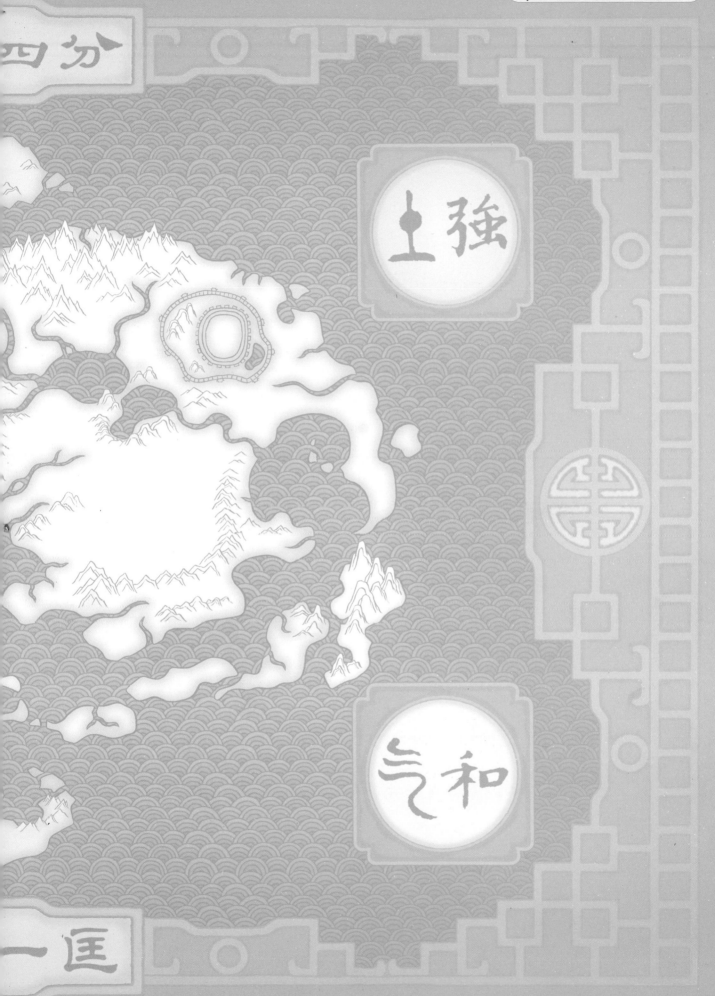

AVATAR

THE LAST AIRBENDER

Created by

BRYAN KONIETZKO

MICHAEL DANTE
DiMARTINO

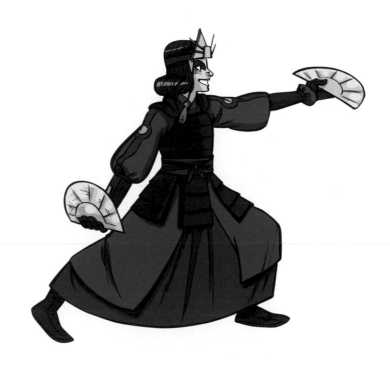

nickelodeon™

AVATAR

THE LAST AIRBENDER™

THE LOST ADVENTURES
TEAM AVATAR TALES

Cover by
CHAN CHAU

Featuring the work of
MAY CHAN | JOAQUIM DOS SANTOS | WES
DZIOBA | AARON EHASZ | AMY KIM GANTER |
ELSA GARAGARZA | SARA GOETTER | GURIHIRU
| JOSHUA HAMILTON | TIM HEDRICK | FAITH
ERIN HICKS | RYAN HILL | KIKU HUGHES | HYE
JUNG KIM | SARA KIPIN | RON KOERTGE | JENN
MANLEY LEE | COREY LEWIS | LITTLE CORVUS |
REAGAN LODGE | RAWLES LUMUMBA | JOHANE
MATTE | KATIE MATTILA | CARLA SPEED MCNEIL
| TOM MCWEENEY | JOHN O'BRYAN | CRIS
PETER | LARK PIEN | FRANK PITTARESE | BRIAN
RALPH | JUSTIN RIDGE | NATALIE RIESS | CLEM
ROBINS | DAVE ROMAN | DAVE SCHEIDT | SNO
CONE STUDIOS | ETHAN SPAULDING | RICHARD
STARKINGS AND COMICRAFT | J. TORRES | ALISON
WILGUS | GENE LUEN YANG | CONI YOVANINIZ

DARK HORSE BOOKS

MIKE RICHARDSON
Publisher

RACHEL ROBERTS
Collection Editor

JENNY BLENK
Collection Assistant Editor

SARAH TERRY
Collection Designer

SAMANTHA HUMMER
Digital Art Technician

TODD BALTHAZOR
Martial Arts Consultant and Model

Special thanks to LINDA LEE, JAMES SALERNO, *and* JOAN HILTY *at Nickelodeon, to* DAVE MARSHALL *at Dark Horse, and to* BRYAN KONIETZKO, MICHAEL DANTE DIMARTINO, *and* TIM HEDRICK.

57910864

eBOOK ISBN 978-1-50672-277-1 ISBN 978-1-50672-274-0 Nick.com DarkHorse.com First edition: November 2020

Published by **DARK HORSE BOOKS**, a division of Dark Horse Comics LLC, 10956 SE Main Street, Milwaukie, OR 97222

To find a comics shop in your area, visit comicshoplocator.com

This book collects *Avatar: The Last Airbender—The Lost Adventures & Team Avatar Tales*

BOOK ONE: WATER

BOOK TWO: EARTH

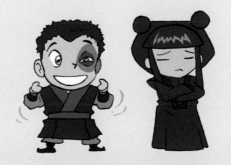

BOOK THREE: FIRE

BOOK FOUR: MORE STORIES

BOOK ONE
WATER

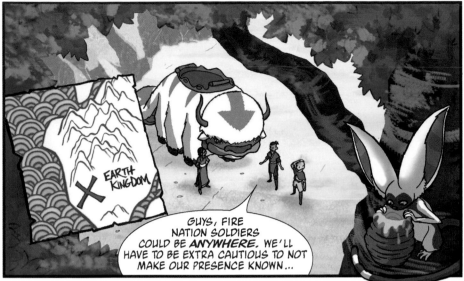

GUYS, FIRE NATION SOLDIERS COULD BE **ANYWHERE.** WE'LL HAVE TO BE EXTRA CAUTIOUS TO NOT MAKE OUR PRESENCE KNOWN...

EARTH KINGDOM

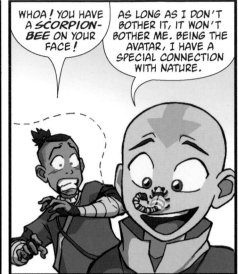

WHOA **!** YOU HAVE A **SCORPION-BEE** ON YOUR FACE **!**

AS LONG AS I DON'T BOTHER IT, IT WON'T BOTHER ME. BEING THE AVATAR, I HAVE A SPECIAL CONNECTION WITH NATURE.

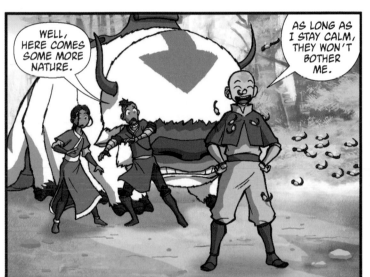

WELL, HERE COMES SOME MORE NATURE.

AS LONG AS I STAY CALM, THEY WON'T BOTHER ME.

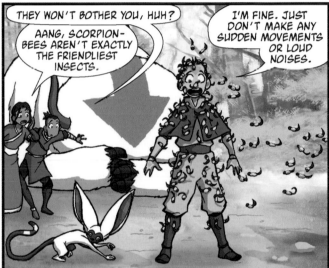

THEY WON'T BOTHER YOU, HUH?

AANG, SCORPION-BEES AREN'T EXACTLY THE FRIENDLIEST INSECTS.

I'M FINE. JUST DON'T MAKE ANY SUDDEN MOVEMENTS OR LOUD NOISES.

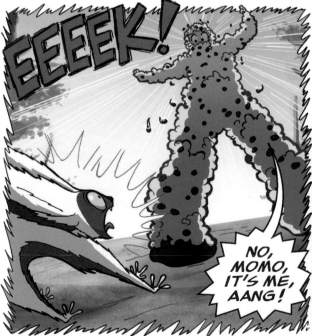

EEEEK **!**

NO, MOMO, IT'S ME, AANG **!**

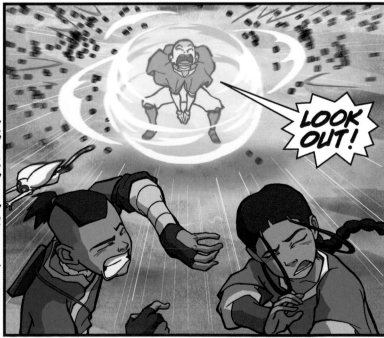

LOOK OUT **!**

Story by Joshua Hamilton and John O'Bryan, art by Justin Ridge, colors by Hye Jung Kim, and lettering by Clem Robins.

9

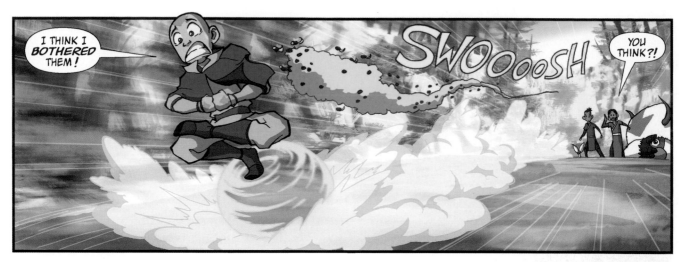

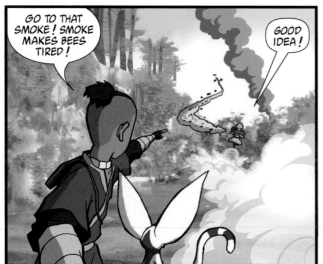

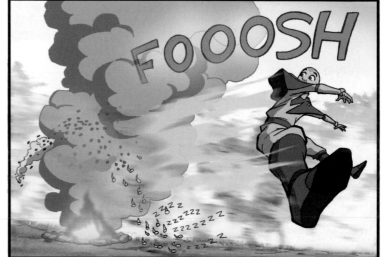

THE END

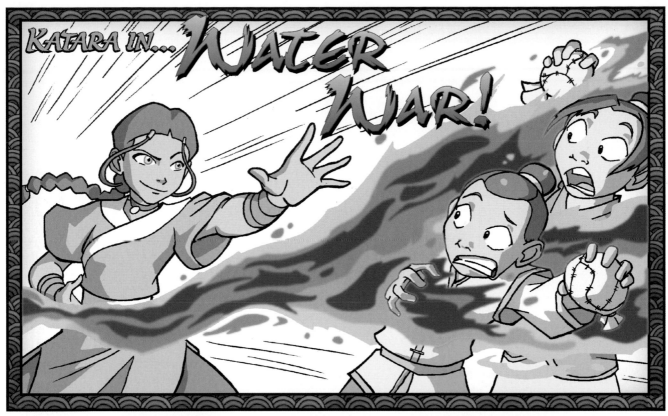

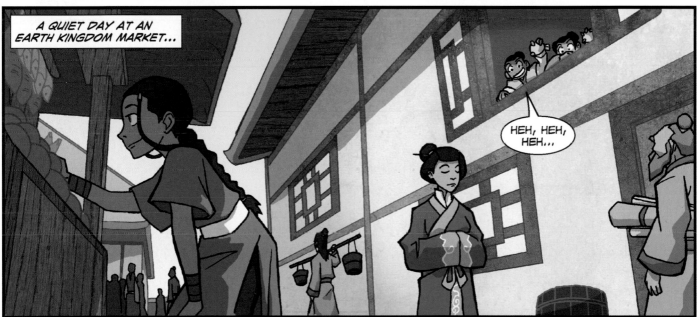

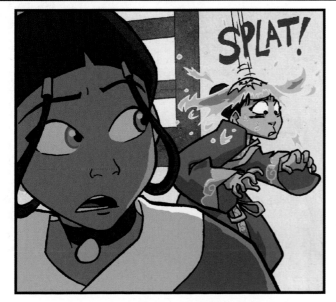

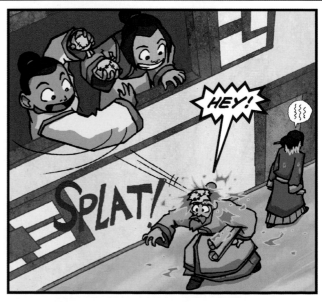

Story by Tim Hedrick, art by Justin Ridge, colors by Hye Jung Kim, and lettering by Comicraft.

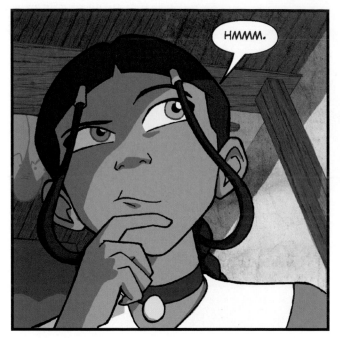

HMMM.

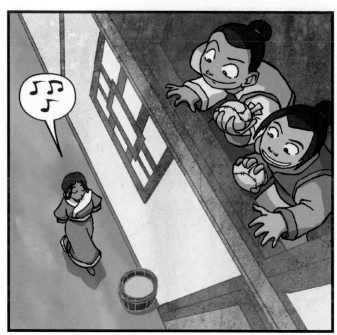

♪♪

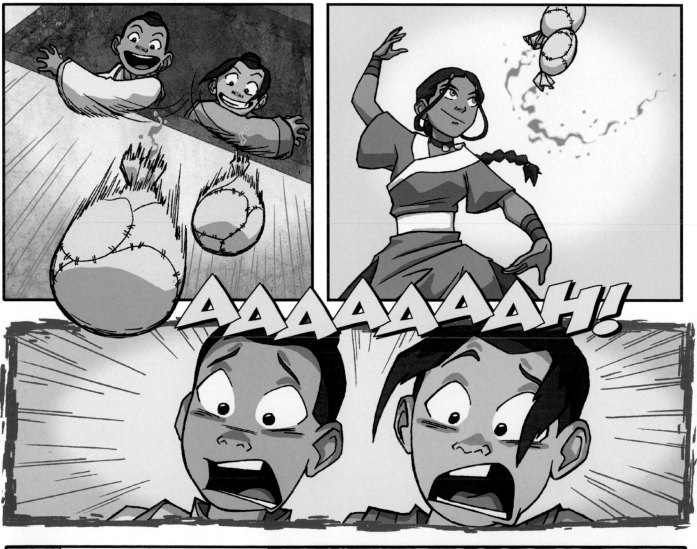

AAAAAAAH!

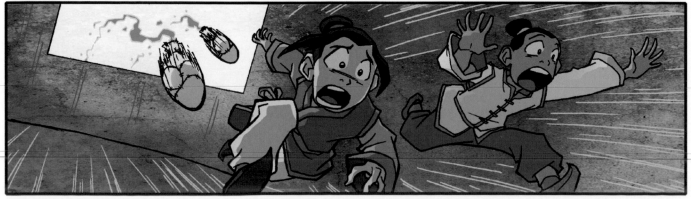

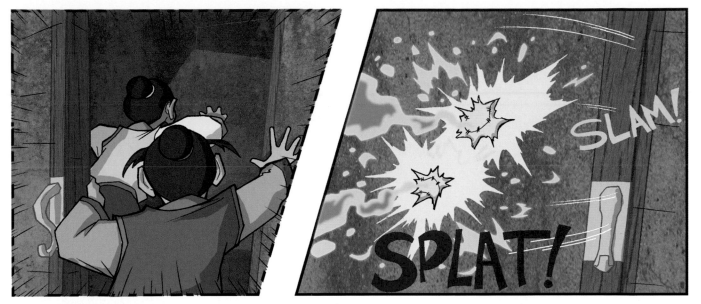

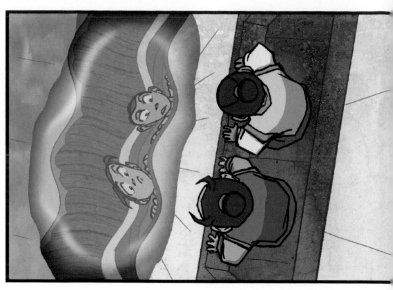
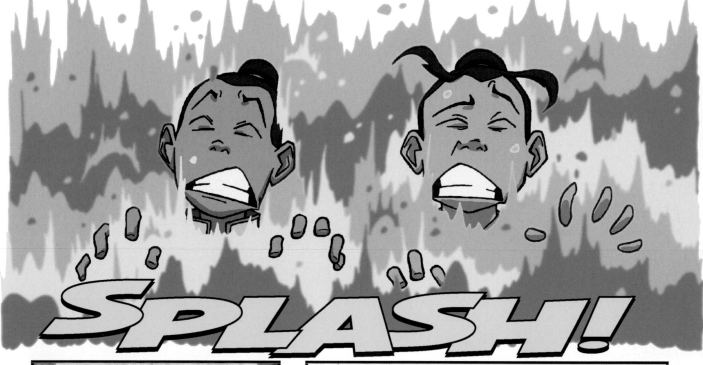

SPLASH!

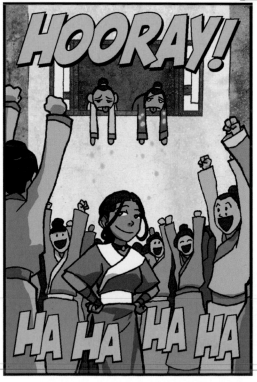

HOORAY!

HA HA HA HA

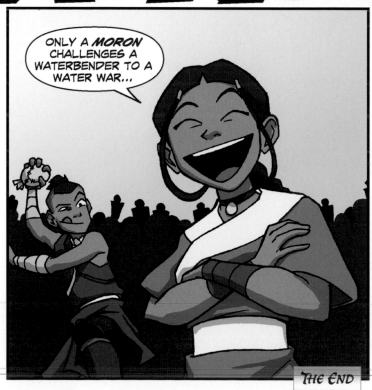

ONLY A *MORON* CHALLENGES A WATERBENDER TO A WATER WAR...

THE END

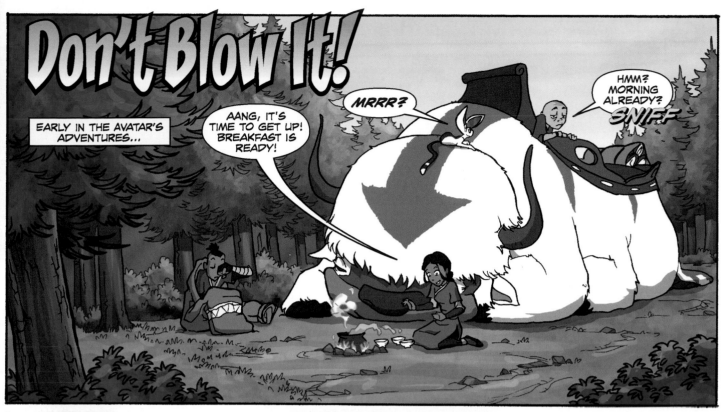

Don't Blow It!

EARLY IN THE AVATAR'S ADVENTURES...

AANG, IT'S TIME TO GET UP! BREAKFAST IS READY!

MRRR?

HMM? MORNING ALREADY? *SNIFF*

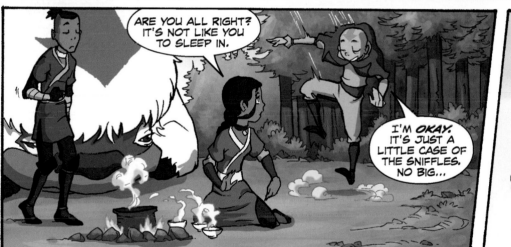

ARE YOU ALL RIGHT? IT'S NOT LIKE YOU TO SLEEP IN.

I'M *OKAY.* IT'S JUST A LITTLE CASE OF THE SNIFFLES. NO BIG...

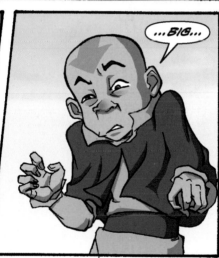

...*BIG*...

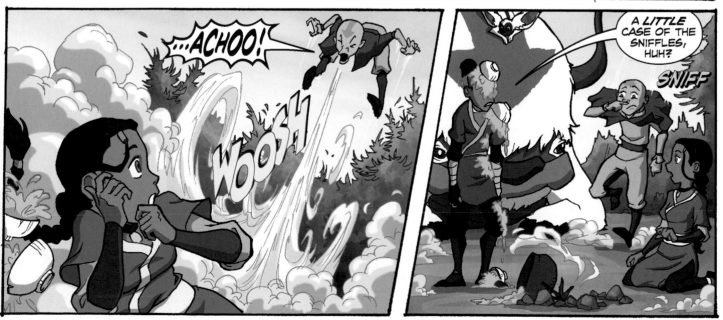

...ACHOO!

WOOSH

A LITTLE CASE OF THE SNIFFLES, HUH?

SNIFF

Story by Alison Wilgus, art by Elsa Garagarza, colors by Wes Dzioba, and lettering by Comicraft.

15

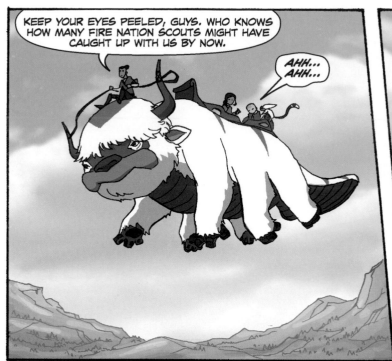

KEEP YOUR EYES PEELED, GUYS. WHO KNOWS HOW MANY FIRE NATION SCOUTS MIGHT HAVE CAUGHT UP WITH US BY NOW.

AHH... AHH...

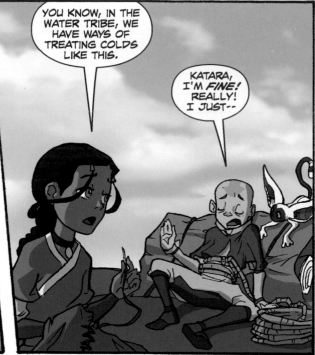

YOU KNOW, IN THE WATER TRIBE, WE HAVE WAYS OF TREATING COLDS LIKE THIS.

KATARA, I'M *FINE*! REALLY! I JUST--

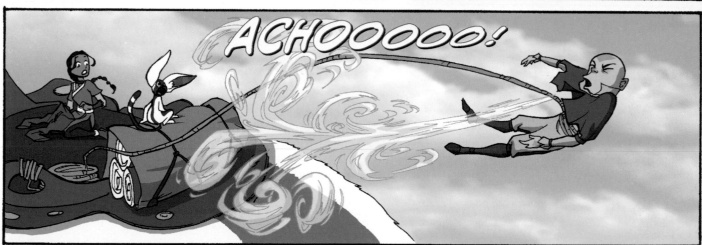

ACHOOOOOO!

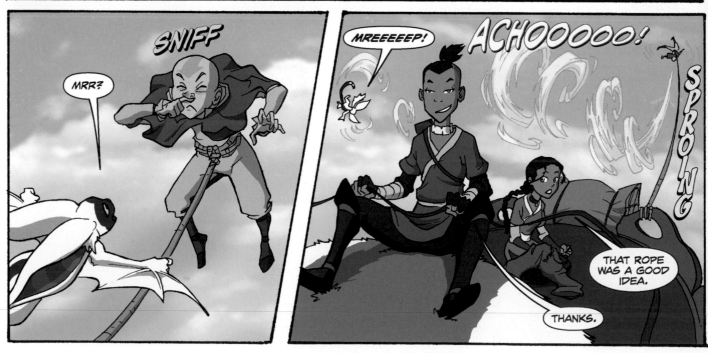

MRR?

SNIFF

MREEEEEP!

ACHOOOOO!

SPROING

THAT ROPE WAS A GOOD IDEA.

THANKS.

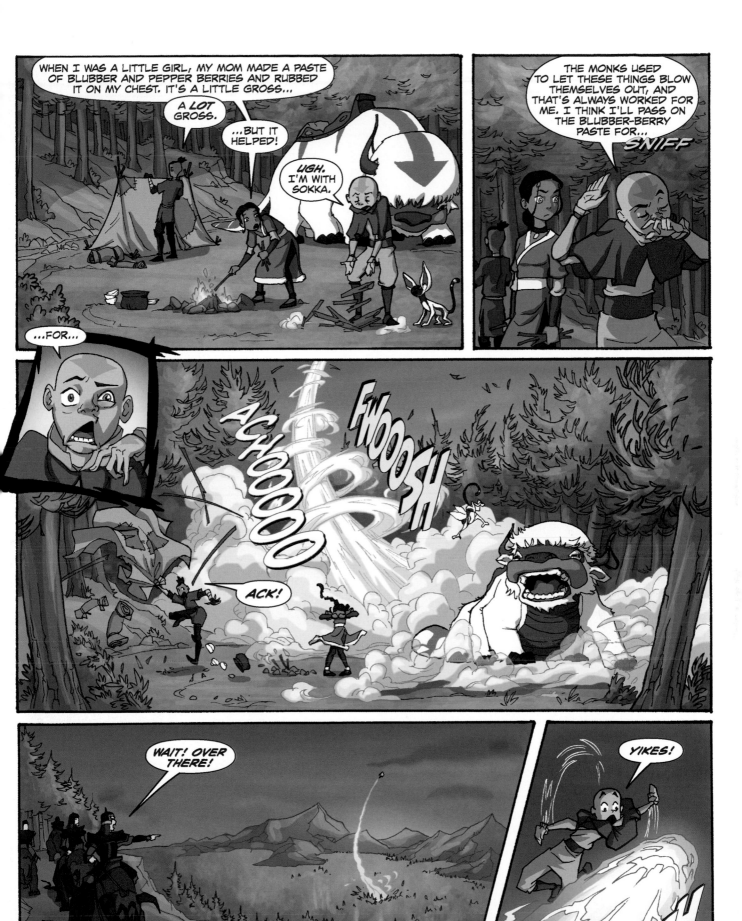

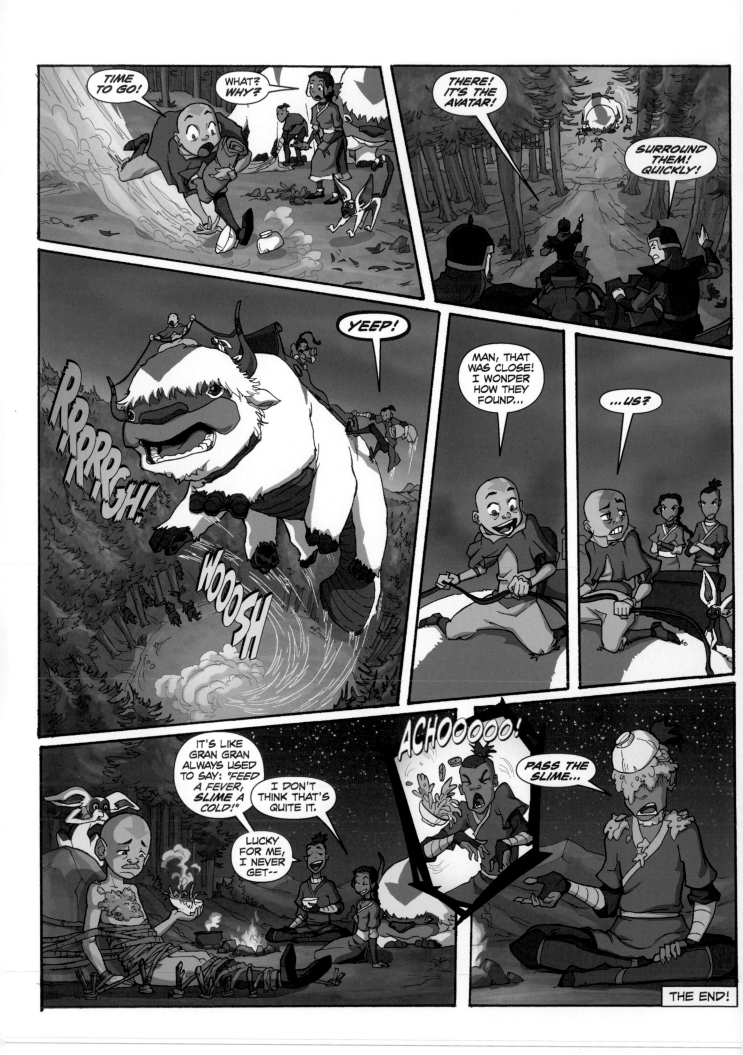

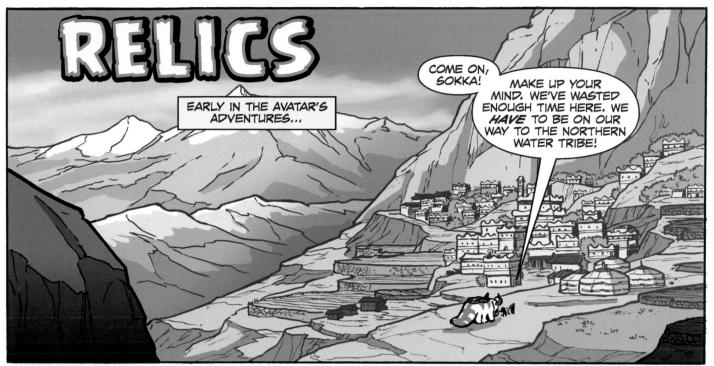

RELICS

EARLY IN THE AVATAR'S ADVENTURES...

COME ON, SOKKA!

MAKE UP YOUR MIND. WE'VE WASTED ENOUGH TIME HERE. WE *HAVE* TO BE ON OUR WAY TO THE NORTHERN WATER TRIBE!

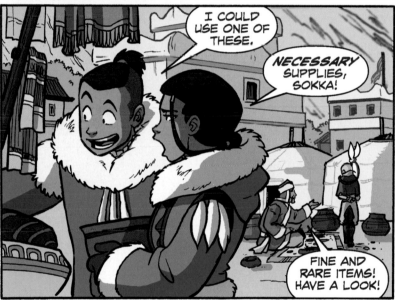

I COULD USE ONE OF THESE.

NECESSARY SUPPLIES, SOKKA!

FINE AND RARE ITEMS! HAVE A LOOK!

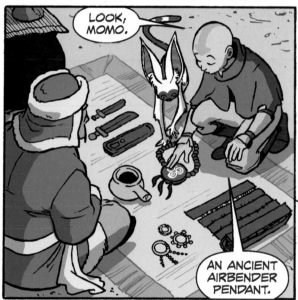

LOOK, MOMO.

AN ANCIENT AIRBENDER PENDANT.

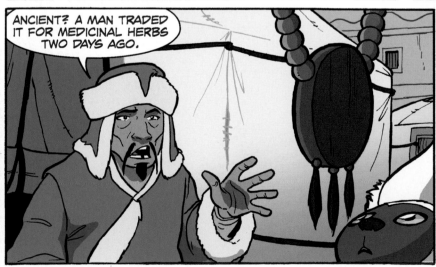

ANCIENT? A MAN TRADED IT FOR MEDICINAL HERBS TWO DAYS AGO.

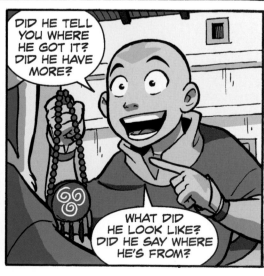

DID HE TELL YOU WHERE HE GOT IT? DID HE HAVE MORE?

WHAT DID HE LOOK LIKE? DID HE SAY WHERE HE'S FROM?

Story by Johane Matte and Joshua Hamilton, art by Johane Matte, colors by Hye Jung Kim, and lettering by Comicraft.

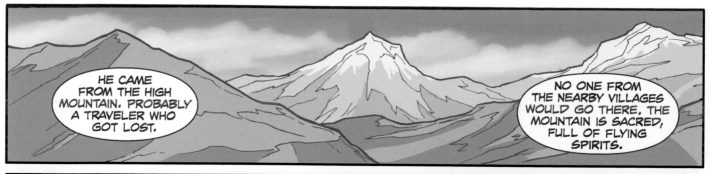

HE CAME FROM THE HIGH MOUNTAIN. PROBABLY A TRAVELER WHO GOT LOST.

NO ONE FROM THE NEARBY VILLAGES WOULD GO THERE. THE MOUNTAIN IS SACRED, FULL OF FLYING SPIRITS.

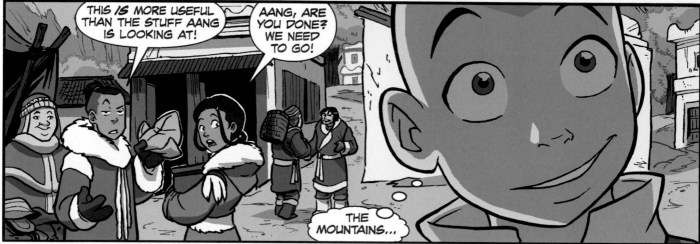

THIS *IS* MORE USEFUL THAN THE STUFF AANG IS LOOKING AT!

AANG, ARE YOU DONE? WE NEED TO GO!

THE MOUNTAINS...

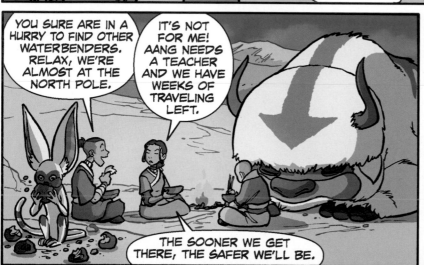

YOU SURE ARE IN A HURRY TO FIND OTHER WATERBENDERS. RELAX, WE'RE ALMOST AT THE NORTH POLE.

IT'S NOT FOR ME! AANG NEEDS A TEACHER AND WE HAVE WEEKS OF TRAVELING LEFT.

THE SOONER WE GET THERE, THE SAFER WE'LL BE.

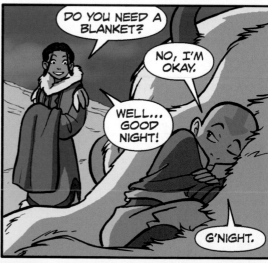

DO YOU NEED A BLANKET?

NO, I'M OKAY.

WELL... GOOD NIGHT!

G'NIGHT.

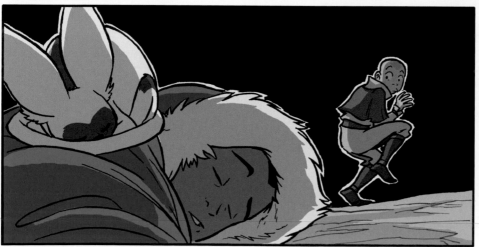

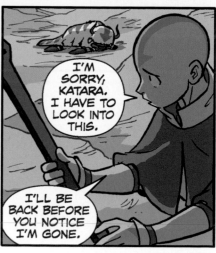

I'M SORRY, KATARA. I HAVE TO LOOK INTO THIS.

I'LL BE BACK BEFORE YOU NOTICE I'M GONE.

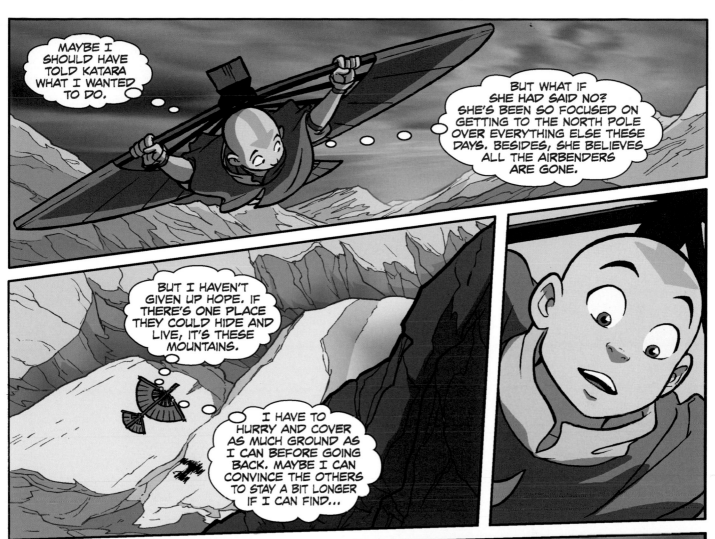

MAYBE I SHOULD HAVE TOLD KATARA WHAT I WANTED TO DO.

BUT WHAT IF SHE HAD SAID NO? SHE'S BEEN SO FOCUSED ON GETTING TO THE NORTH POLE OVER EVERYTHING ELSE THESE DAYS. BESIDES, SHE BELIEVES ALL THE AIRBENDERS ARE GONE.

BUT I HAVEN'T GIVEN UP HOPE. IF THERE'S ONE PLACE THEY COULD HIDE AND LIVE, IT'S THESE MOUNTAINS.

I HAVE TO HURRY AND COVER AS MUCH GROUND AS I CAN BEFORE GOING BACK. MAYBE I CAN CONVINCE THE OTHERS TO STAY A BIT LONGER IF I CAN FIND...

WHIISH

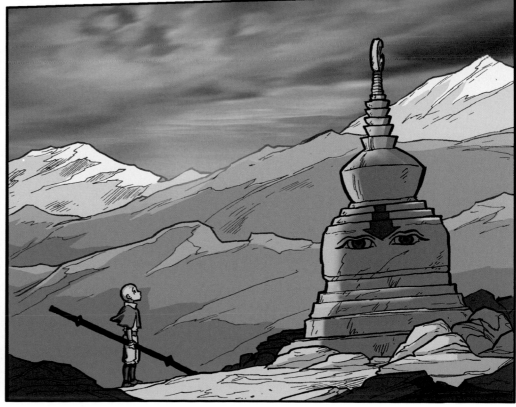

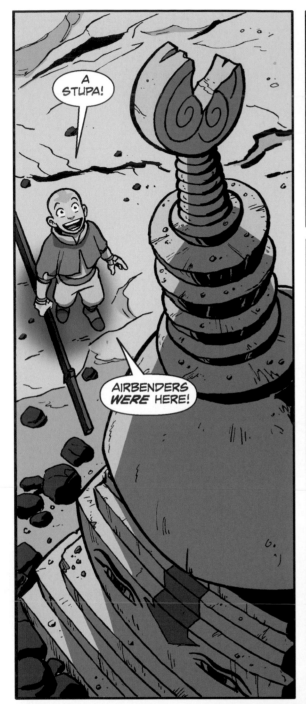

A STUPA!

AIRBENDERS *WERE* HERE!

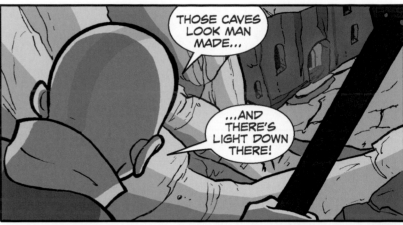

THOSE CAVES LOOK MAN MADE...

...AND THERE'S LIGHT DOWN THERE!

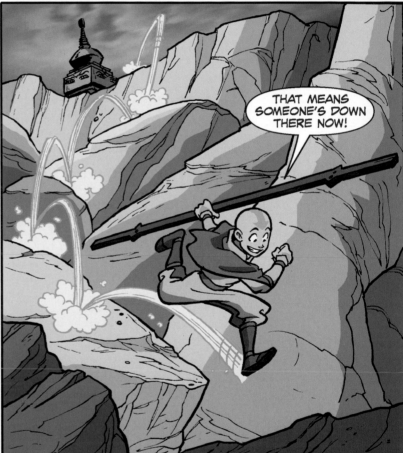

THAT MEANS SOMEONE'S DOWN THERE NOW!

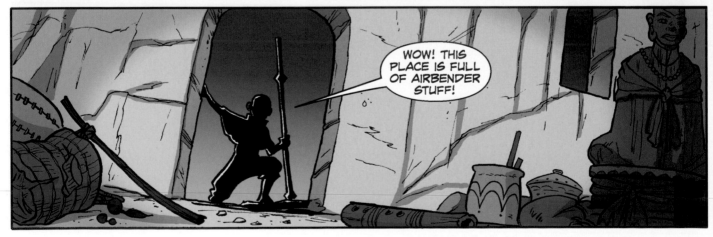

WOW! THIS PLACE IS FULL OF AIRBENDER STUFF!

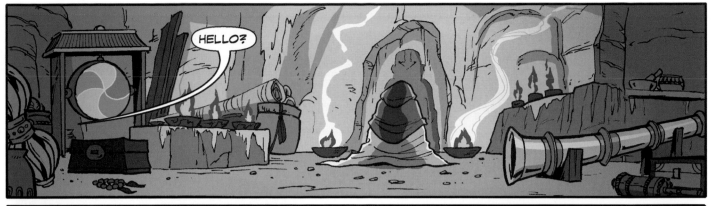

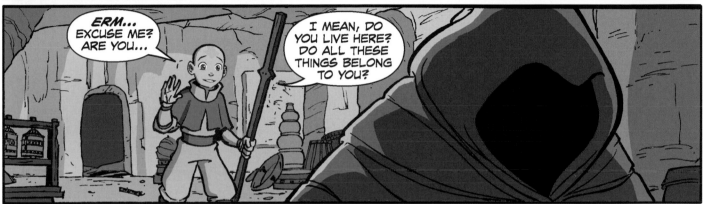

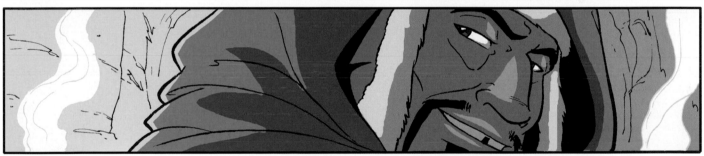

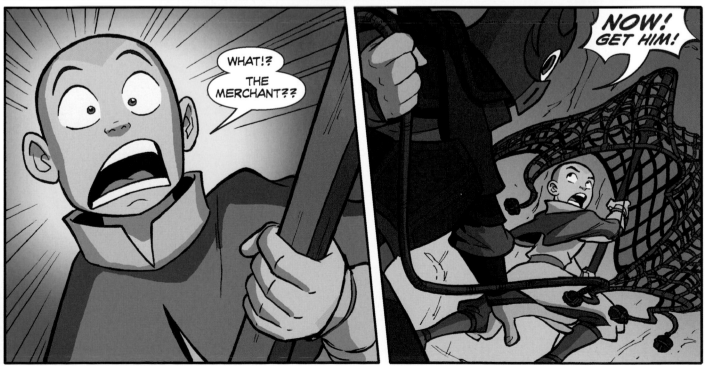

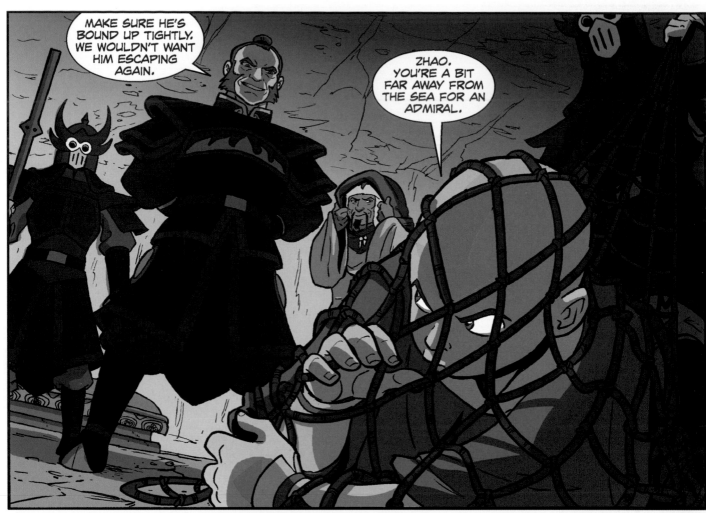

MAKE SURE HE'S BOUND UP TIGHTLY. WE WOULDN'T WANT HIM ESCAPING AGAIN.

ZHAO. YOU'RE A BIT FAR AWAY FROM THE SEA FOR AN ADMIRAL.

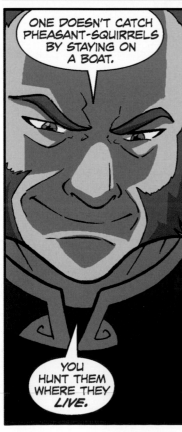

ONE DOESN'T CATCH PHEASANT-SQUIRRELS BY STAYING ON A BOAT.

YOU HUNT THEM WHERE THEY *LIVE*.

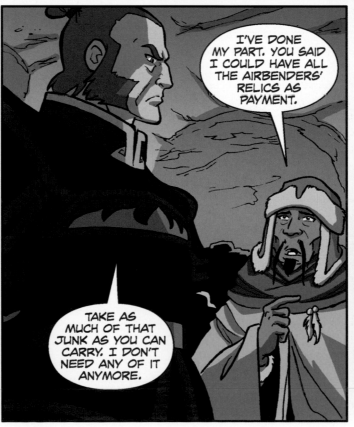

I'VE DONE MY PART. YOU SAID I COULD HAVE ALL THE AIRBENDERS' RELICS AS PAYMENT.

TAKE AS MUCH OF THAT JUNK AS YOU CAN CARRY. I DON'T NEED ANY OF IT ANYMORE.

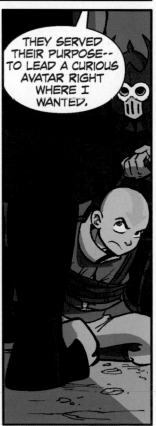

THEY SERVED THEIR PURPOSE-- TO LEAD A CURIOUS AVATAR RIGHT WHERE I WANTED.

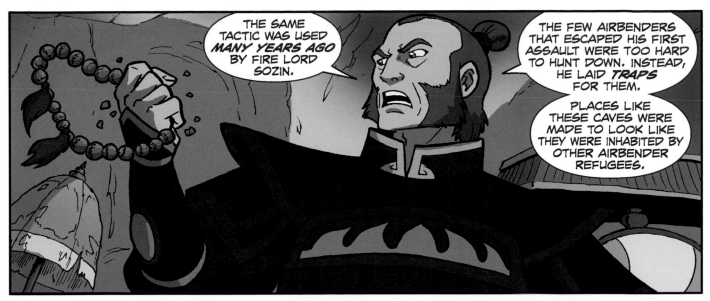

THE SAME TACTIC WAS USED *MANY YEARS AGO* BY FIRE LORD SOZIN.

THE FEW AIRBENDERS THAT ESCAPED HIS FIRST ASSAULT WERE TOO HARD TO HUNT DOWN. INSTEAD, HE LAID *TRAPS* FOR THEM.

PLACES LIKE THESE CAVES WERE MADE TO LOOK LIKE THEY WERE INHABITED BY OTHER AIRBENDER REFUGEES.

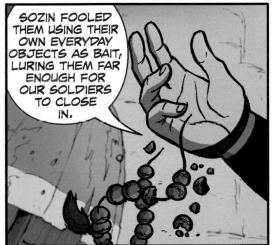

SOZIN FOOLED THEM USING THEIR OWN EVERYDAY OBJECTS AS BAIT, LURING THEM FAR ENOUGH FOR OUR SOLDIERS TO CLOSE IN.

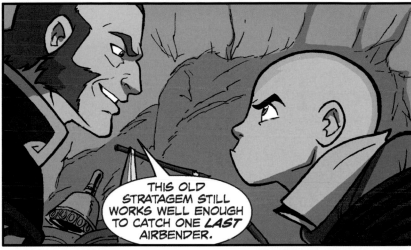

THIS OLD STRATAGEM STILL WORKS WELL ENOUGH TO CATCH ONE *LAST* AIRBENDER.

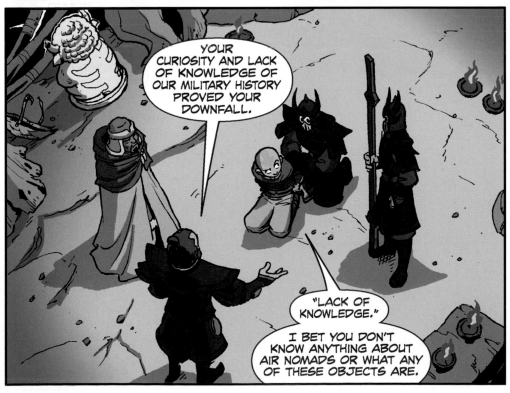

YOUR CURIOSITY AND LACK OF KNOWLEDGE OF OUR MILITARY HISTORY PROVED YOUR DOWNFALL.

"LACK OF KNOWLEDGE."

I BET YOU DON'T KNOW ANYTHING ABOUT AIR NOMADS OR WHAT ANY OF THESE OBJECTS ARE.

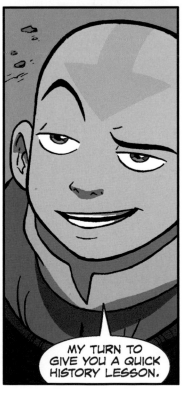

MY TURN TO GIVE YOU A QUICK HISTORY LESSON.

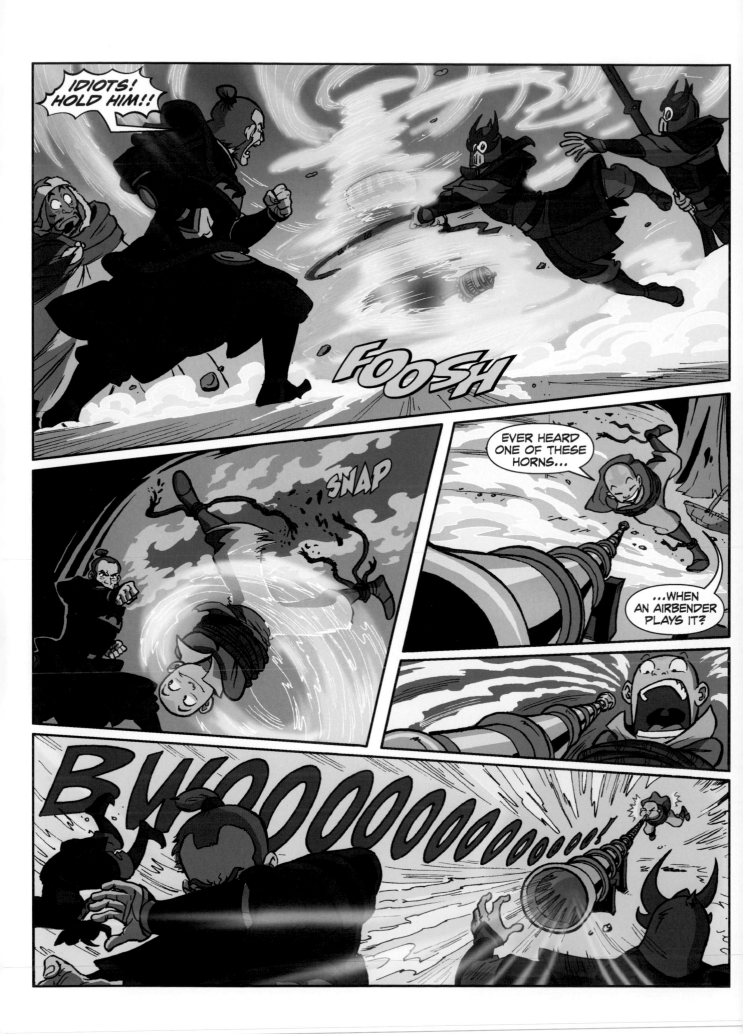

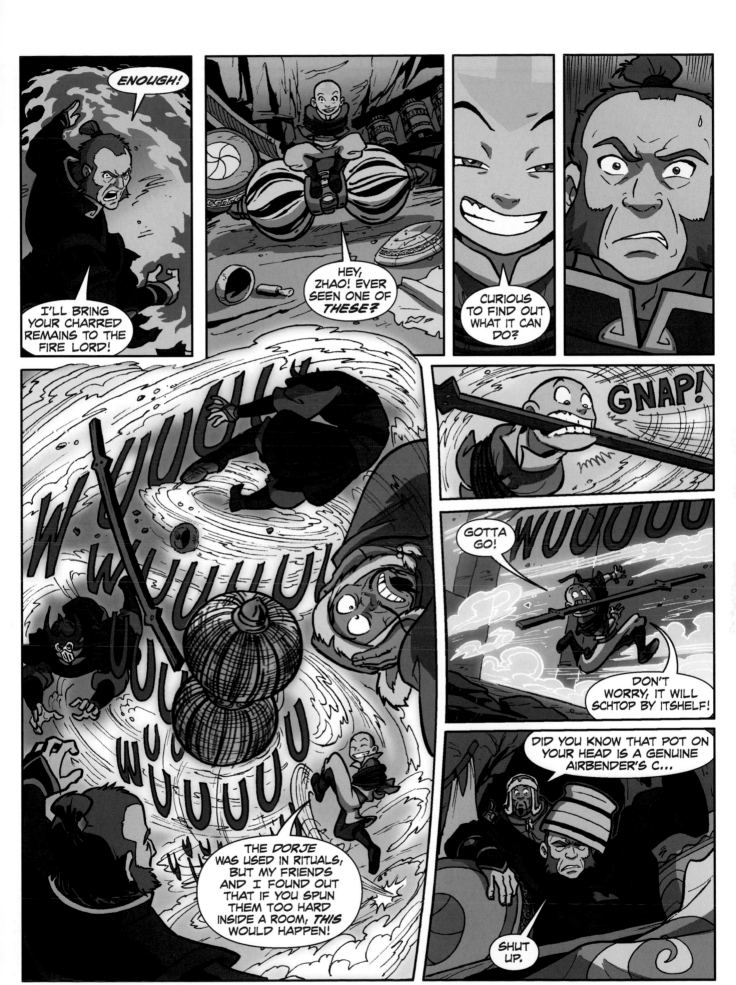

27

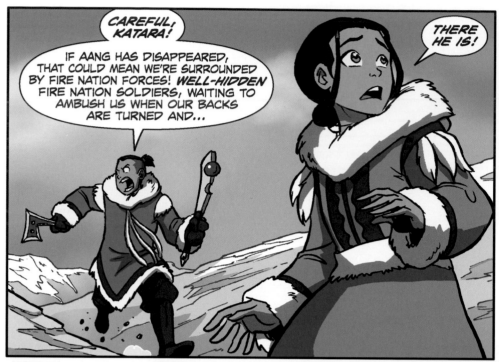

THE END

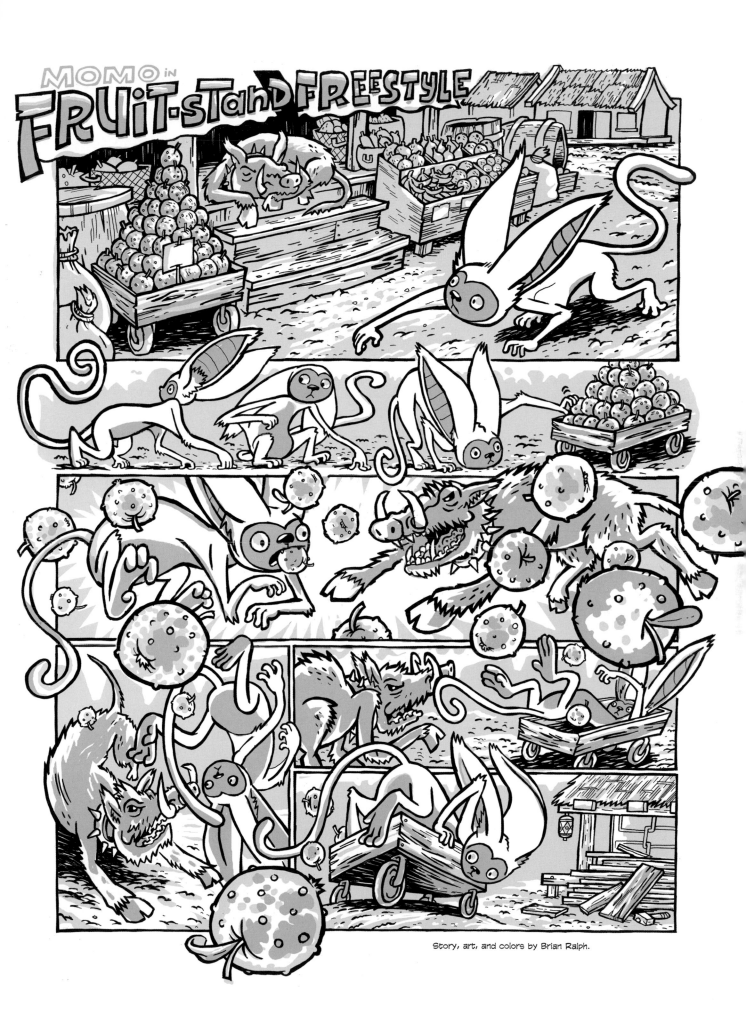

Story, art, and colors by Brian Ralph.

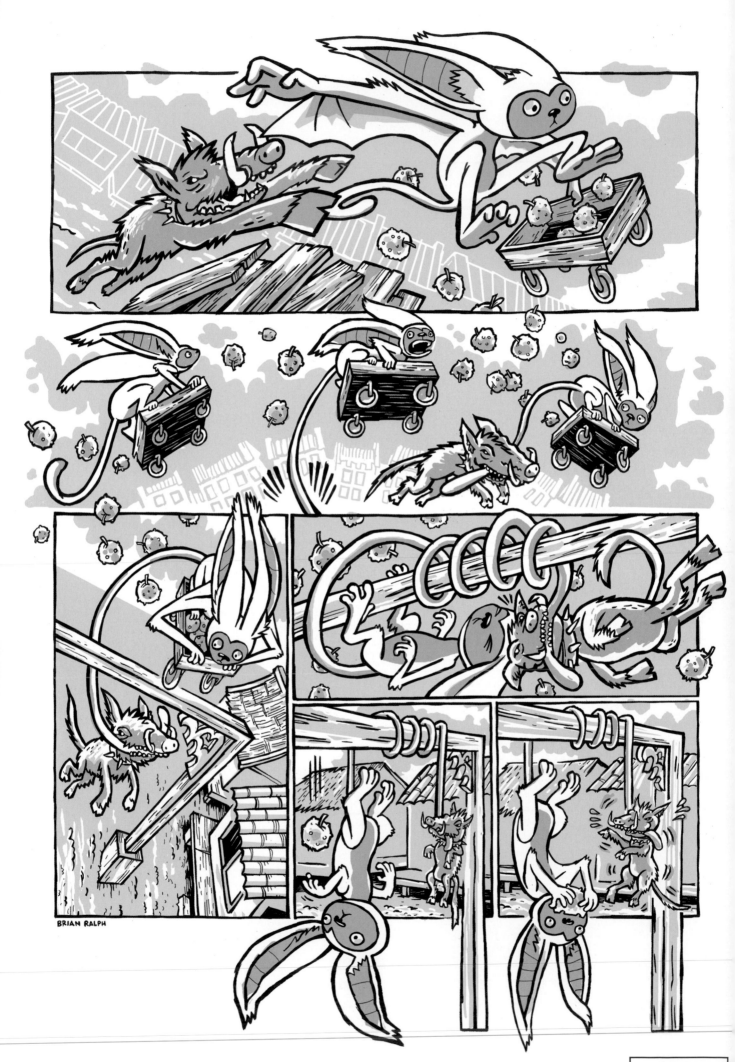

BRIAN RALPH

THE END

BOOK TWO
EARTH

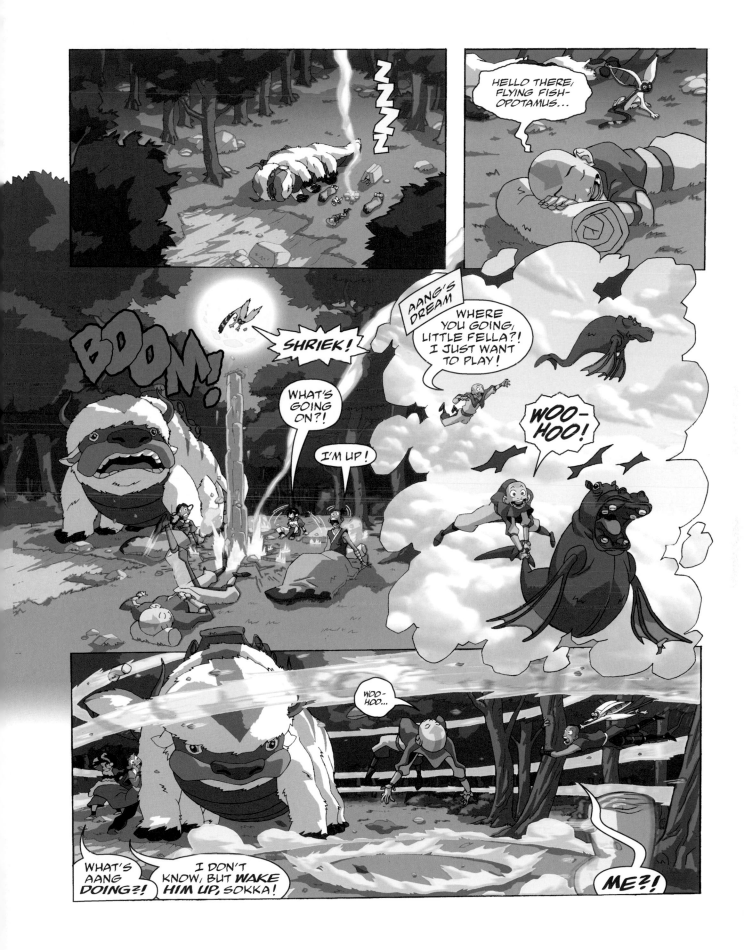

Story by Joshua Hamilton, art by Joaquim Dos Santos, colors by Hye Jung Kim, and lettering by Clem Robins.

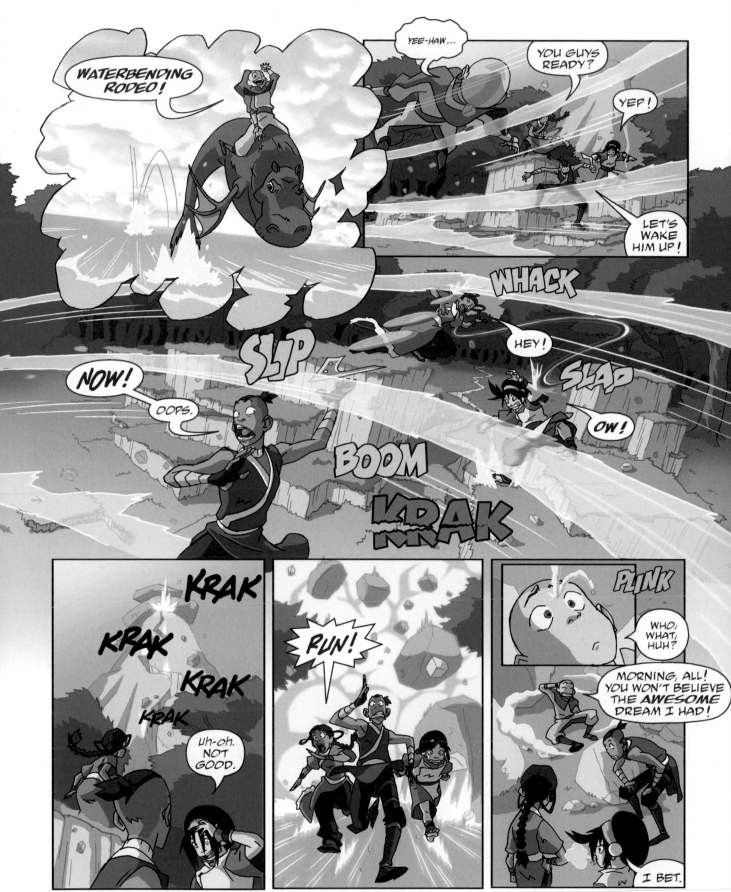

LESSONS

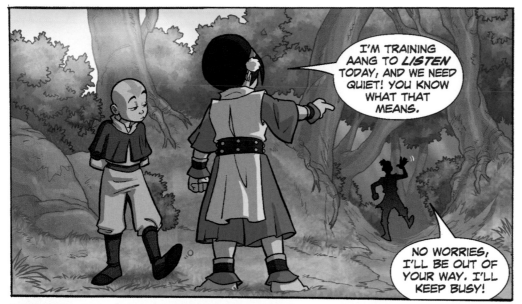

I'M TRAINING AANG TO *LISTEN* TODAY, AND WE NEED QUIET! YOU KNOW WHAT THAT MEANS.

NO WORRIES, I'LL BE OUT OF YOUR WAY. I'LL KEEP BUSY!

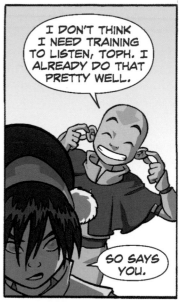

I DON'T THINK I NEED TRAINING TO LISTEN, TOPH. I ALREADY DO THAT PRETTY WELL.

SO SAYS YOU.

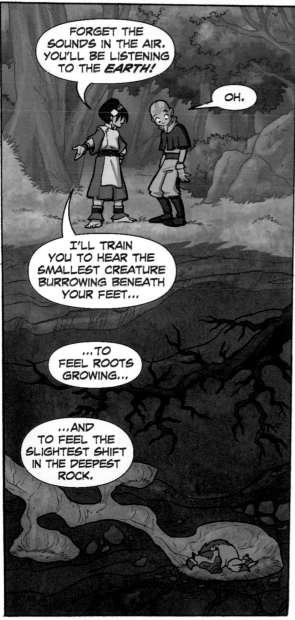

FORGET THE SOUNDS IN THE AIR. YOU'LL BE LISTENING TO THE *EARTH!*

OH.

I'LL TRAIN YOU TO HEAR THE SMALLEST CREATURE BURROWING BENEATH YOUR FEET...

...TO FEEL ROOTS GROWING...

...AND TO FEEL THE SLIGHTEST SHIFT IN THE DEEPEST ROCK.

KEEP BUSY, KEEP BUSY, ALL I CAN THINK ABOUT IS...

...FOOD?

MUNCH MUNCH

WHY, MOMO, THAT'S A MIGHTY FINE, BIG, JUICY FRUIT YOU GOT THERE. A REALLY *BIG* FRUIT...

MRR?

...TOO BIG FOR A *LITTLE* LEMUR!

Story and art by Johane Matte, colors by Wes Dzioba, and lettering by Comicraft.

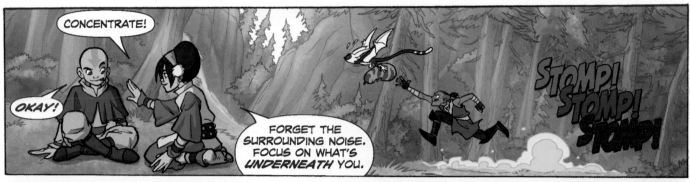

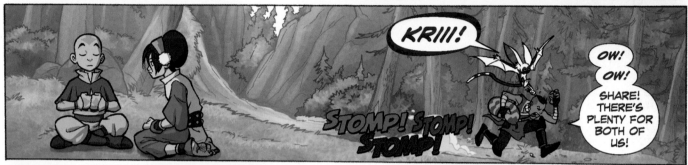

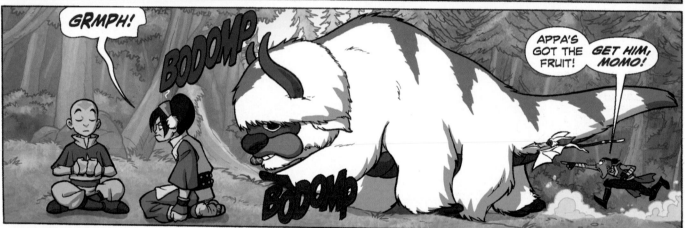

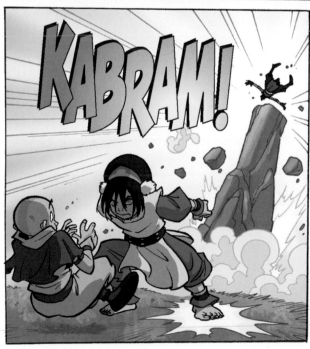

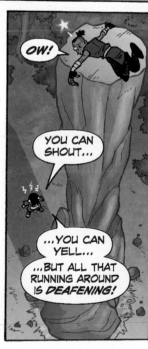

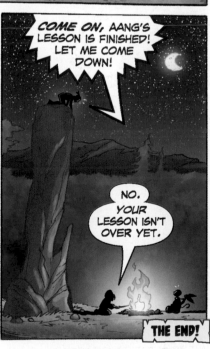

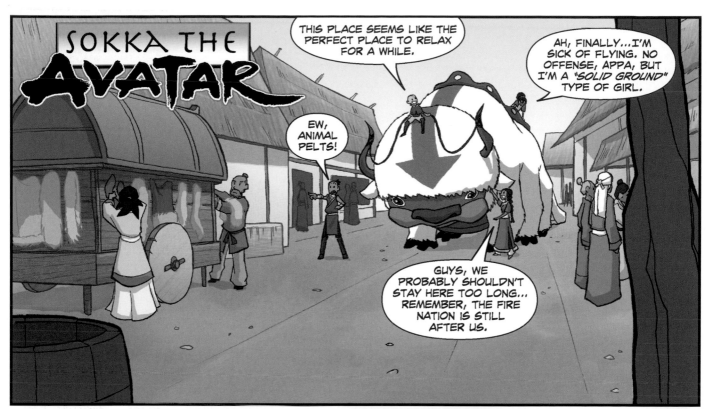

SOKKA THE AVATAR

THIS PLACE SEEMS LIKE THE PERFECT PLACE TO RELAX FOR A WHILE.

AH, FINALLY...I'M SICK OF FLYING. NO OFFENSE, APPA, BUT I'M A *SOLID GROUND* TYPE OF GIRL.

EW, ANIMAL PELTS!

GUYS, WE PROBABLY SHOULDN'T STAY HERE TOO LONG... REMEMBER, THE FIRE NATION IS STILL AFTER US.

≤SNIFF, SNIFF≥ ARE THOSE DEEP-FRIED PICKLED RADISHES I SMELL? MAYBE WE CAN STAY FOR A *LITTLE* WHILE...

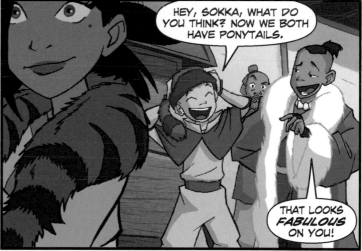

HEY, SOKKA, WHAT DO YOU THINK? NOW WE BOTH HAVE PONYTAILS.

THAT LOOKS *FABULOUS* ON YOU!

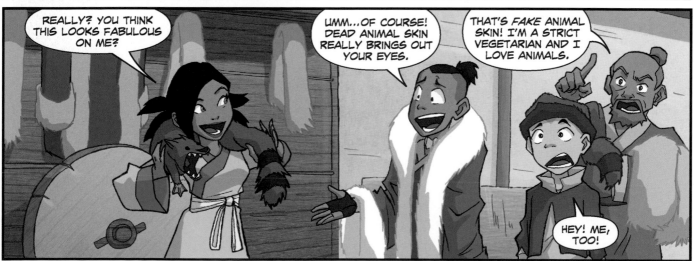

REALLY? YOU THINK THIS LOOKS FABULOUS ON ME?

UMM...OF COURSE! DEAD ANIMAL SKIN REALLY BRINGS OUT YOUR EYES.

THAT'S *FAKE* ANIMAL SKIN! I'M A STRICT VEGETARIAN AND I LOVE ANIMALS.

HEY! ME, TOO!

Story by Joshua Hamilton, art by Justin Ridge, colors by Sno Cone Studios, and lettering by Comicraft.

37

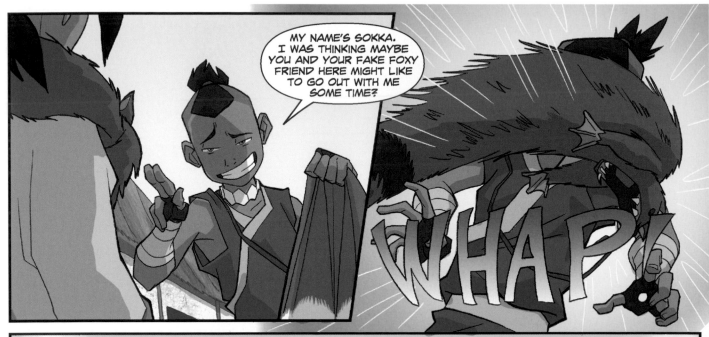

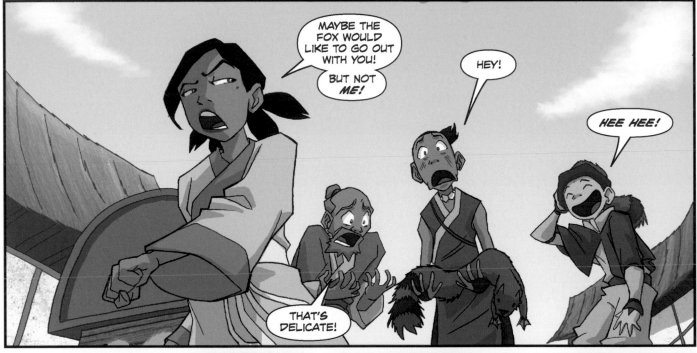

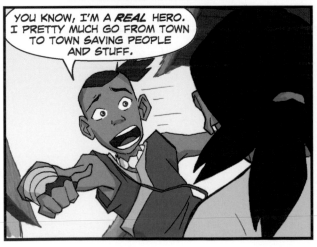

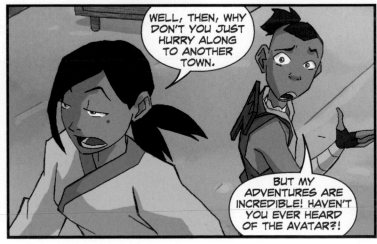

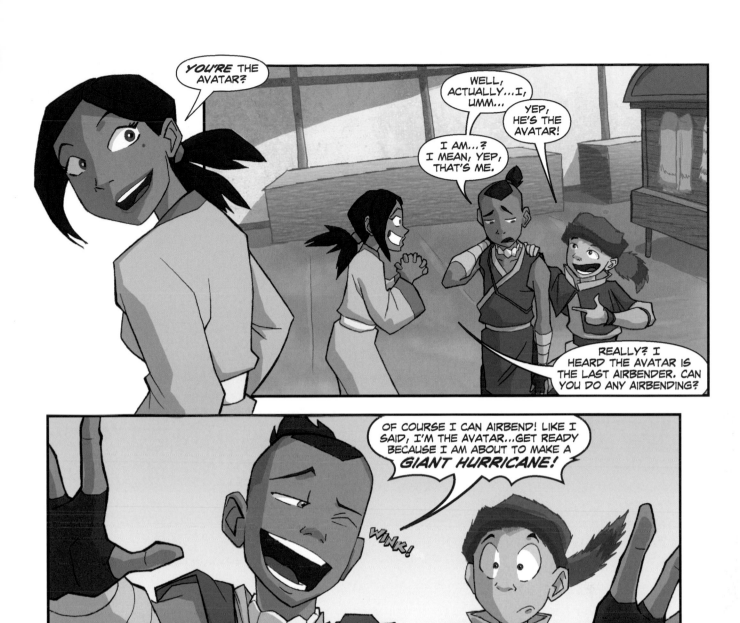

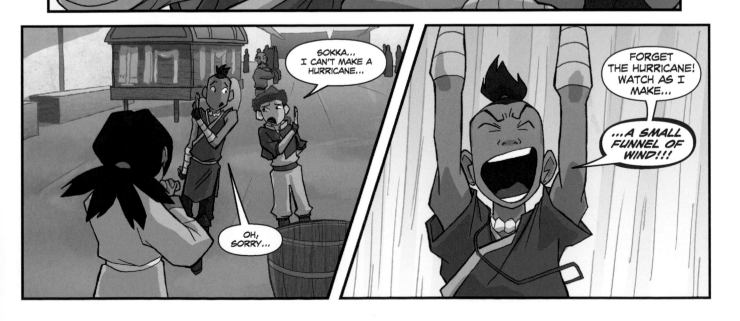

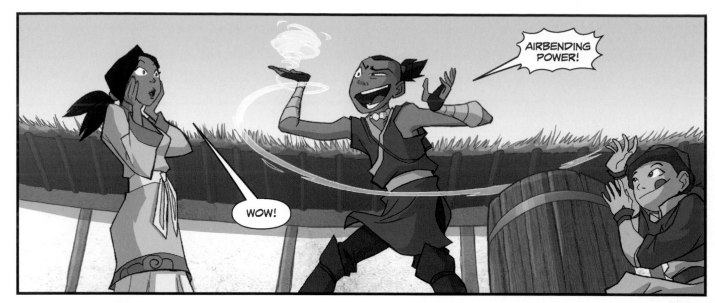

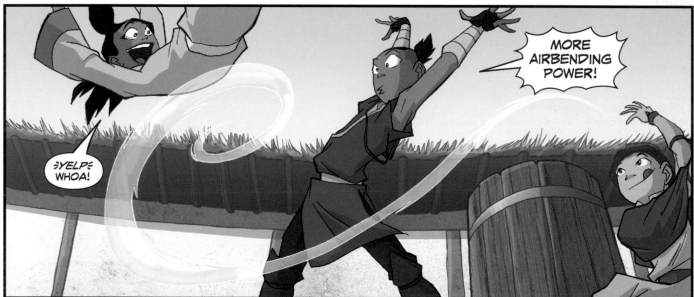

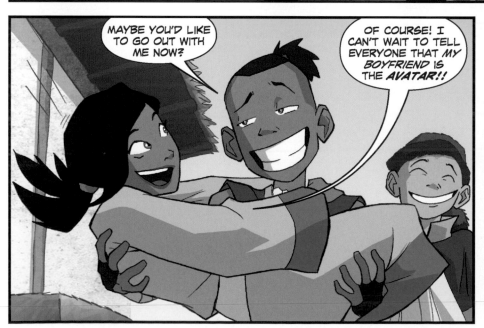

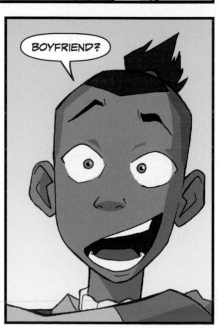

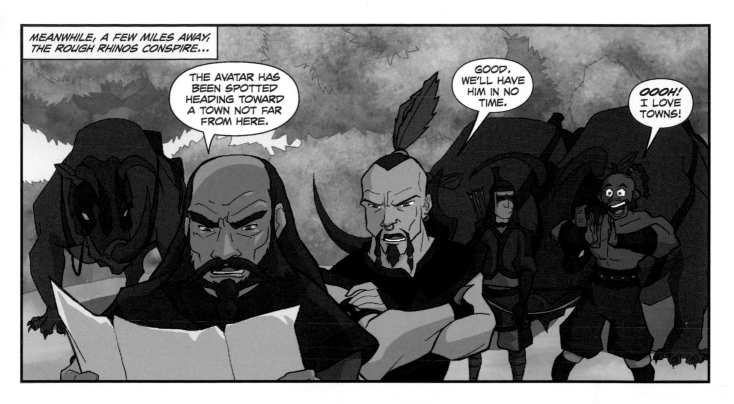

MEANWHILE, A FEW MILES AWAY, THE ROUGH RHINOS CONSPIRE...

THE AVATAR HAS BEEN SPOTTED HEADING TOWARD A TOWN NOT FAR FROM HERE.

GOOD. WE'LL HAVE HIM IN NO TIME.

OOOH! I LOVE TOWNS!

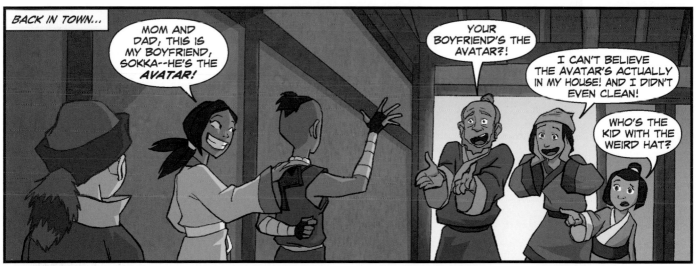

BACK IN TOWN...

MOM AND DAD, THIS IS MY BOYFRIEND, SOKKA--HE'S THE AVATAR!

YOUR BOYFRIEND'S THE AVATAR?!

I CAN'T BELIEVE THE AVATAR'S ACTUALLY IN MY HOUSE! AND I DIDN'T EVEN CLEAN!

WHO'S THE KID WITH THE WEIRD HAT?

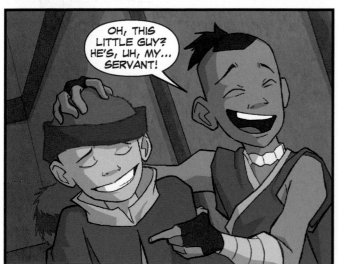

OH, THIS LITTLE GUY? HE'S, UH, MY... SERVANT!

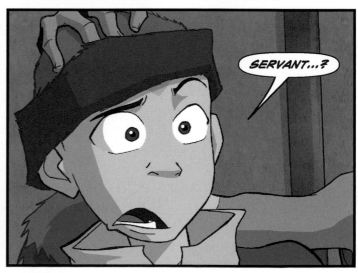

SERVANT...?

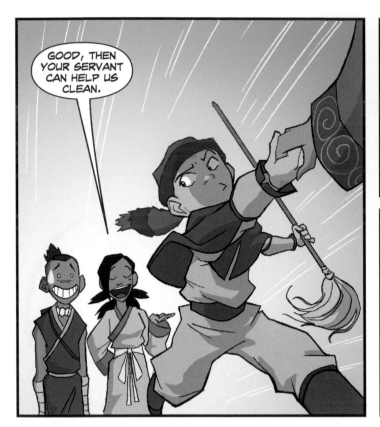

GOOD, THEN YOUR SERVANT CAN HELP US CLEAN.

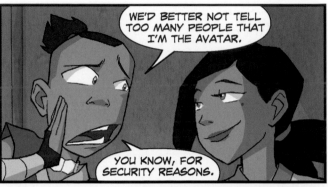

WE'D BETTER NOT TELL TOO MANY PEOPLE THAT I'M THE AVATAR.

YOU KNOW, FOR SECURITY REASONS.

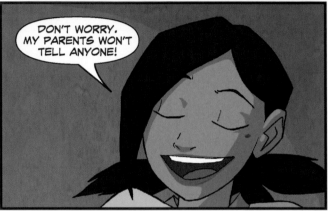

DON'T WORRY. MY PARENTS WON'T TELL ANYONE!

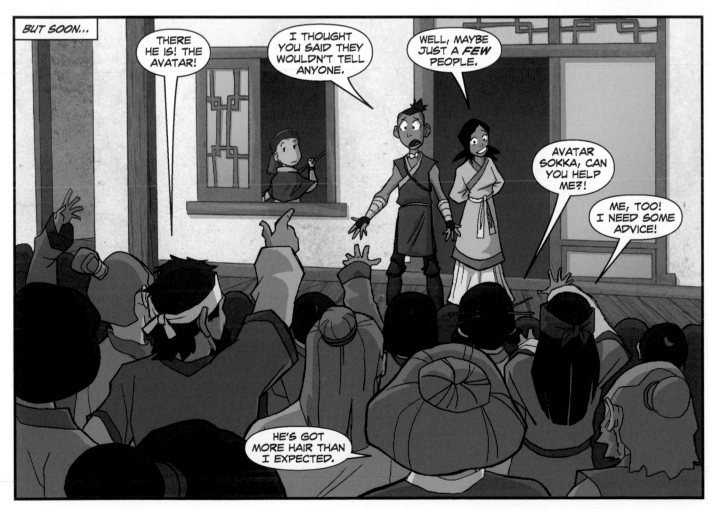

BUT SOON...

THERE HE IS! THE AVATAR!

I THOUGHT YOU SAID THEY WOULDN'T TELL ANYONE.

WELL, MAYBE JUST A *FEW* PEOPLE.

AVATAR SOKKA, CAN YOU HELP ME?!

ME, TOO! I NEED SOME ADVICE!

HE'S GOT MORE HAIR THAN I EXPECTED.

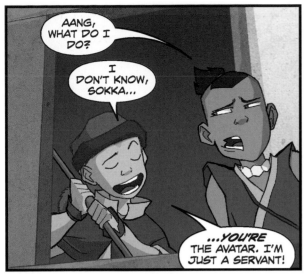

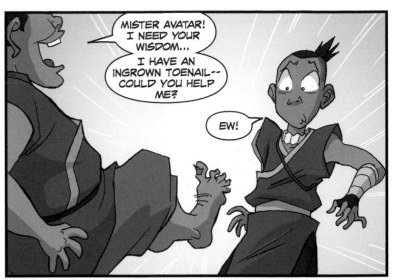

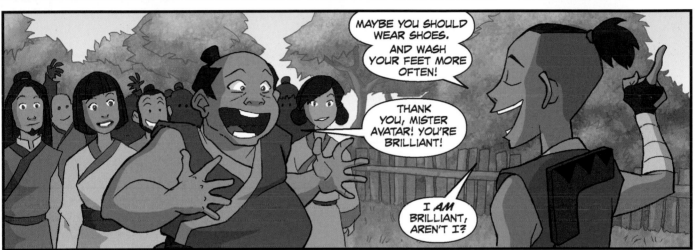

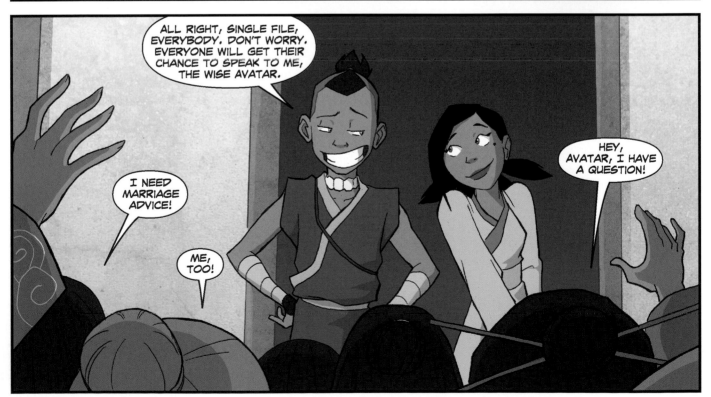

43

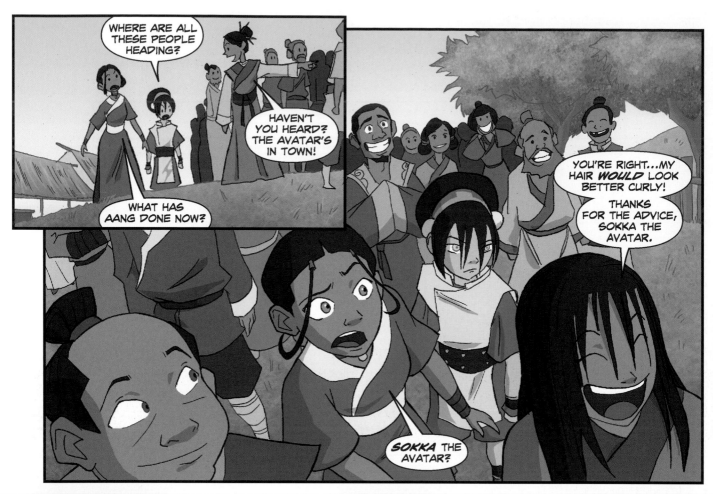

WHERE ARE ALL THESE PEOPLE HEADING?

HAVEN'T YOU HEARD? THE AVATAR'S IN TOWN!

WHAT HAS AANG DONE NOW?

YOU'RE RIGHT...MY HAIR *WOULD* LOOK BETTER CURLY!

THANKS FOR THE ADVICE, SOKKA THE AVATAR.

SOKKA THE AVATAR?

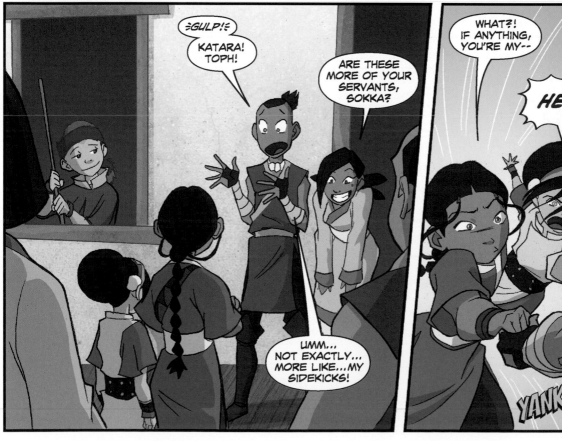

≥GULP!≤

KATARA! TOPH!

ARE THESE MORE OF YOUR SERVANTS, SOKKA?

UMM... NOT EXACTLY... MORE LIKE...MY SIDEKICKS!

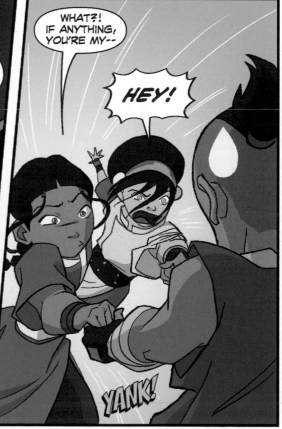

WHAT?! IF ANYTHING, YOU'RE MY--

HEY!

YANK!

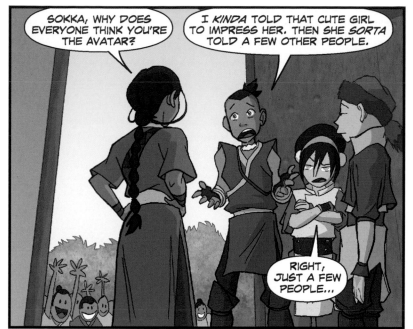

SOKKA, WHY DOES EVERYONE THINK YOU'RE THE AVATAR?

I *KINDA* TOLD THAT CUTE GIRL TO IMPRESS HER. THEN SHE *SORTA* TOLD A FEW OTHER PEOPLE.

RIGHT, JUST A FEW PEOPLE...

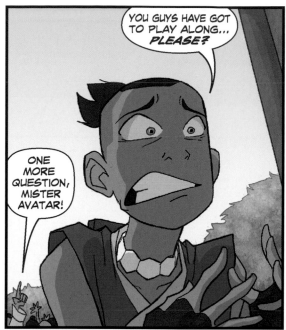

YOU GUYS HAVE GOT TO PLAY ALONG... *PLEASE?*

ONE MORE QUESTION, MISTER AVATAR!

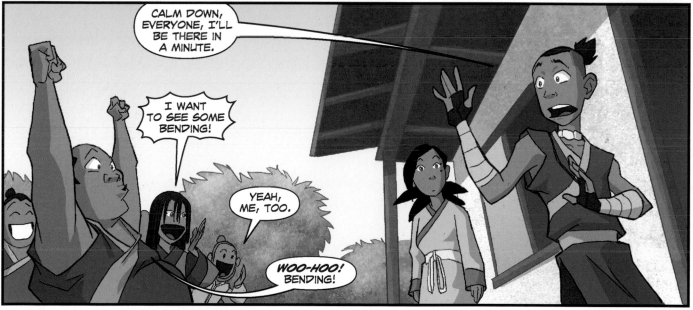

CALM DOWN, EVERYONE, I'LL BE THERE IN A MINUTE.

I WANT TO SEE SOME BENDING!

YEAH, ME, TOO.

WOO-HOO! BENDING!

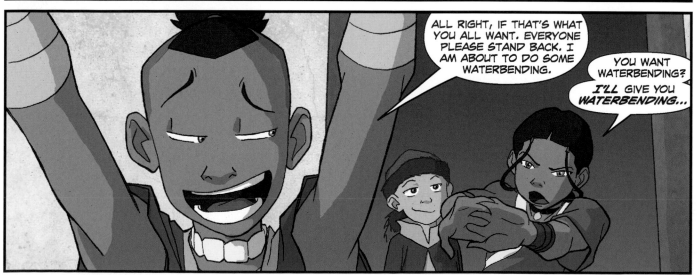

ALL RIGHT, IF THAT'S WHAT YOU ALL WANT. EVERYONE PLEASE STAND BACK. I AM ABOUT TO DO SOME WATERBENDING.

YOU WANT WATERBENDING? *I'LL* GIVE YOU *WATERBENDING...*

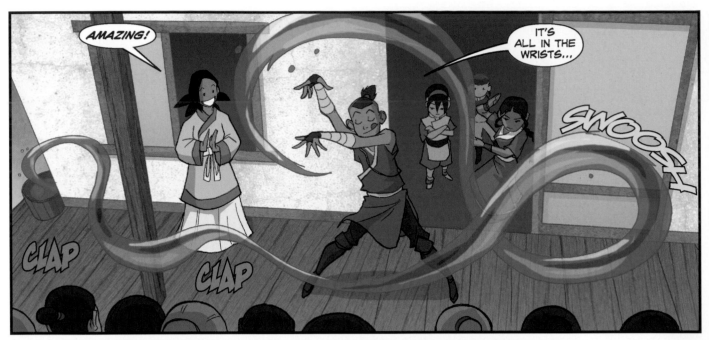

AMAZING!

IT'S ALL IN THE WRISTS...

SNOOSH

CLAP

CLAP

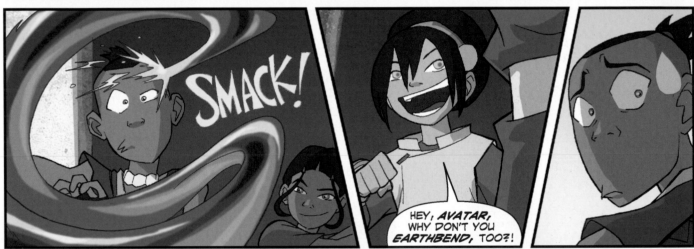

SMACK!

HEY, *AVATAR*, WHY DON'T YOU *EARTHBEND*, TOO?!

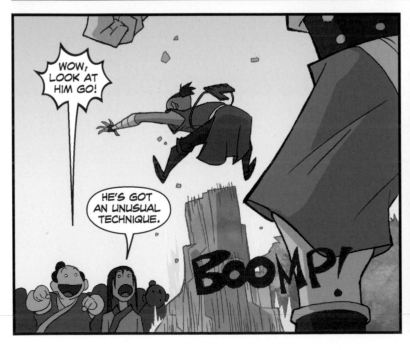

WOW, LOOK AT HIM GO!

HE'S GOT AN UNUSUAL TECHNIQUE.

BOOMP!

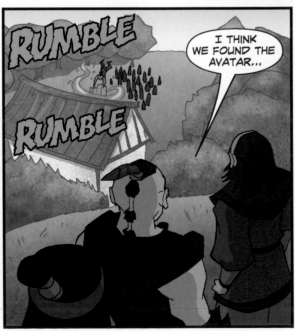

RUMBLE

RUMBLE

I THINK WE FOUND THE AVATAR...

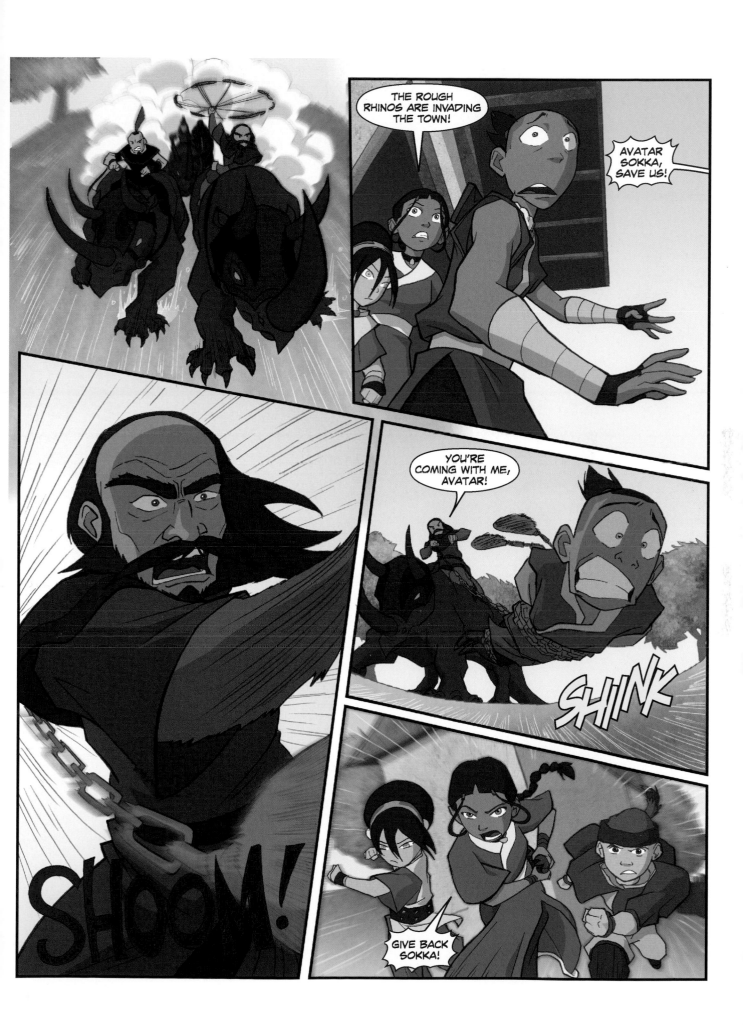

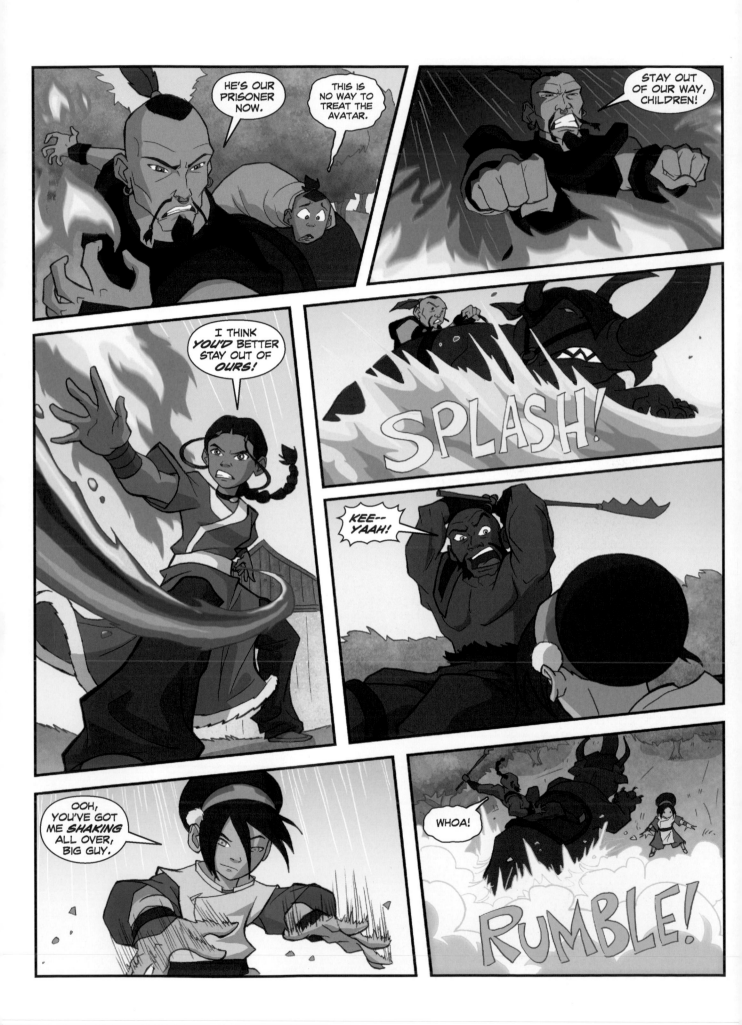

48

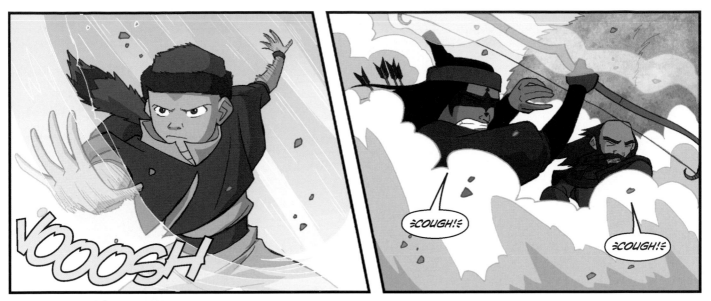

VOOOSH

≥COUGH!≤

≥COUGH!≤

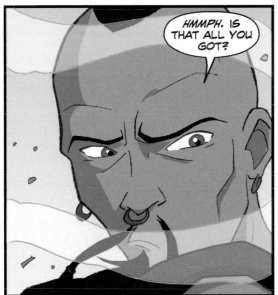

HMMPH. IS THAT ALL YOU GOT?

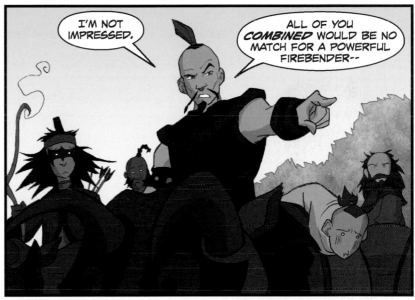

I'M NOT IMPRESSED.

ALL OF YOU *COMBINED* WOULD BE NO MATCH FOR A POWERFUL FIREBENDER--

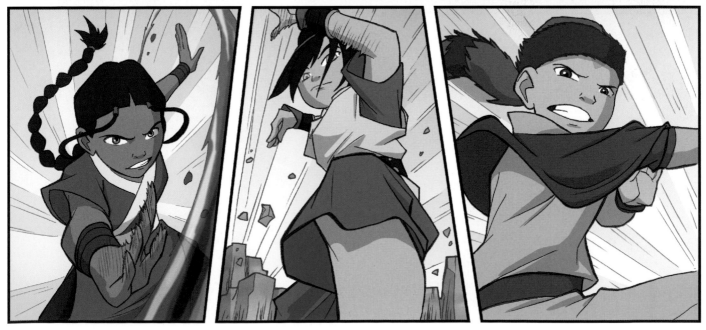

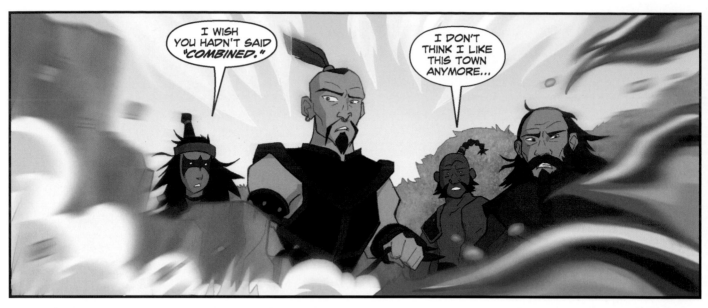

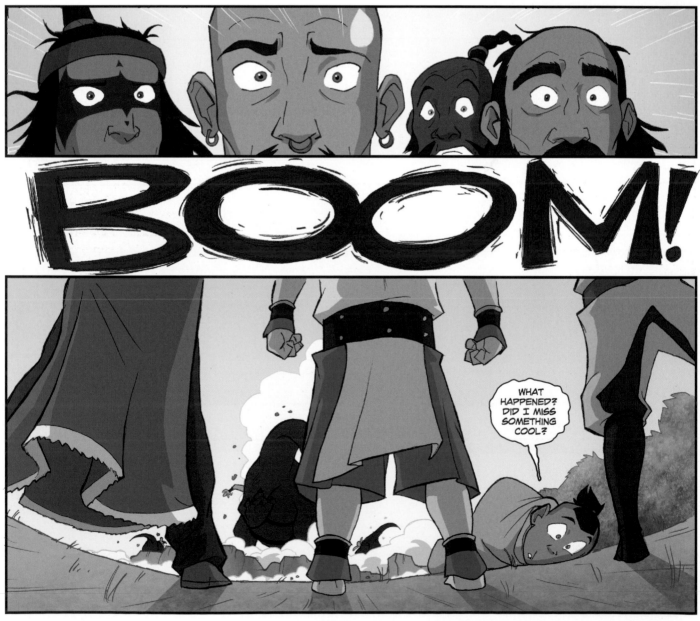

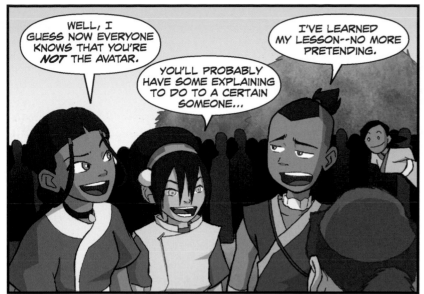

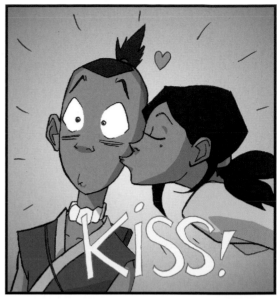

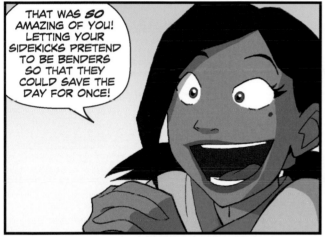

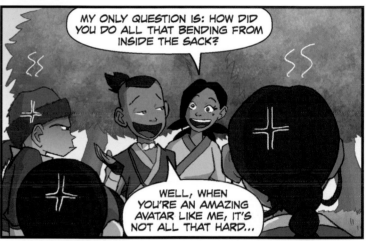

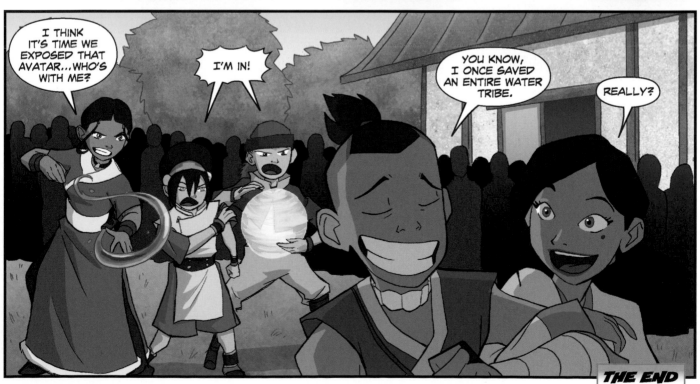

DIRTY IS ONLY SKIN DEEP

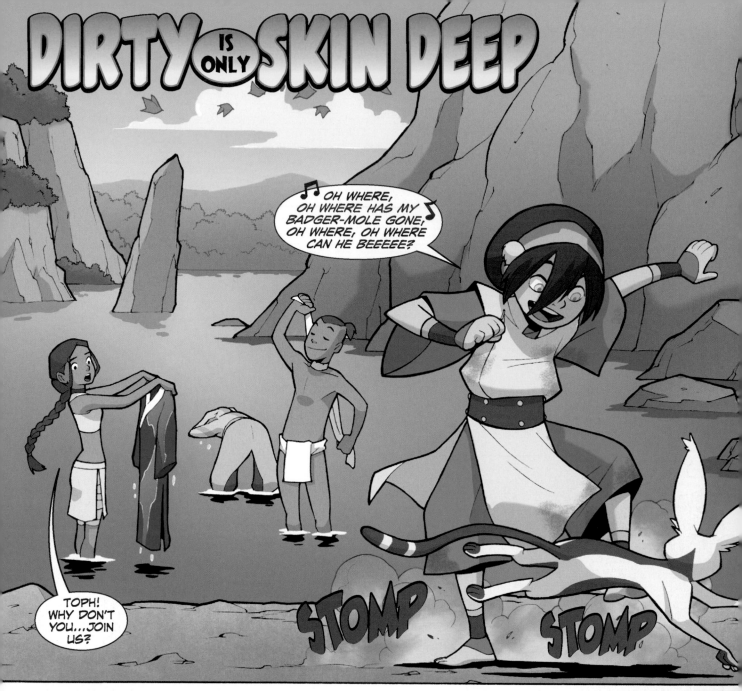

♪ OH WHERE, OH WHERE HAS MY BADGER-MOLE GONE, OH WHERE, OH WHERE CAN HE BEEEEE?

STOMP

STOMP

TOPH! WHY DON'T YOU...JOIN US?

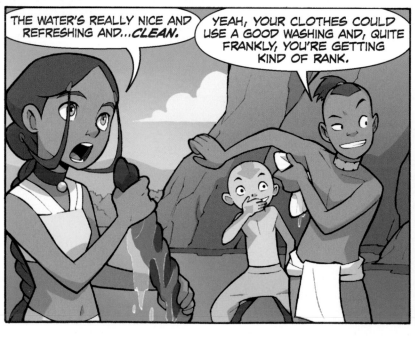

THE WATER'S REALLY NICE AND REFRESHING AND...*CLEAN.*

YEAH, YOUR CLOTHES COULD USE A GOOD WASHING AND, QUITE FRANKLY, YOU'RE GETTING KIND OF RANK.

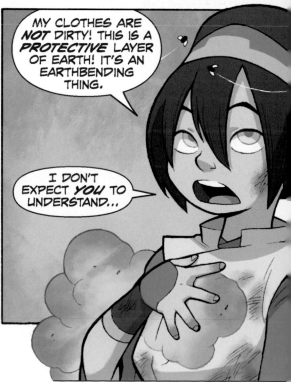

MY CLOTHES ARE *NOT* DIRTY! THIS IS A *PROTECTIVE* LAYER OF EARTH! IT'S AN EARTHBENDING THING.

I DON'T EXPECT *YOU* TO UNDERSTAND...

Story by J. Torres, art and colors by Gurihiru, and lettering by Comicraft.

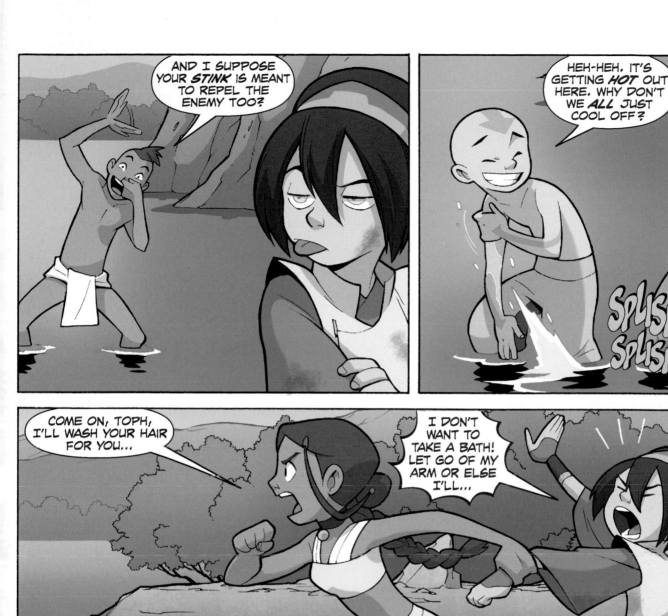

AND I SUPPOSE YOUR *STINK* IS MEANT TO REPEL THE ENEMY TOO?

HEH-HEH. IT'S GETTING *HOT* OUT HERE. WHY DON'T WE *ALL* JUST COOL OFF?

SPLISH SPLISH

COME ON, TOPH, I'LL WASH YOUR HAIR FOR YOU...

I DON'T WANT TO TAKE A BATH! LET GO OF MY ARM OR ELSE I'LL...

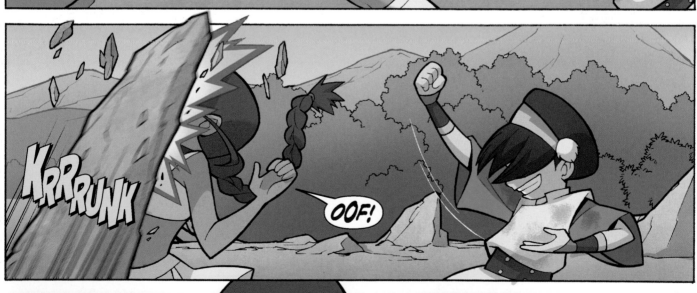

KRRRUNK

OOF!

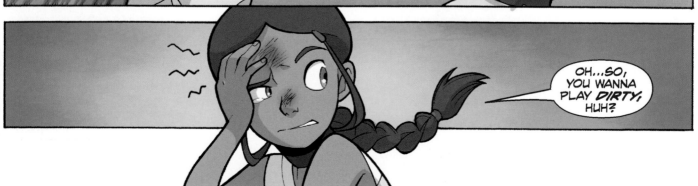

OH...SO, YOU WANNA PLAY *DIRTY*, HUH?

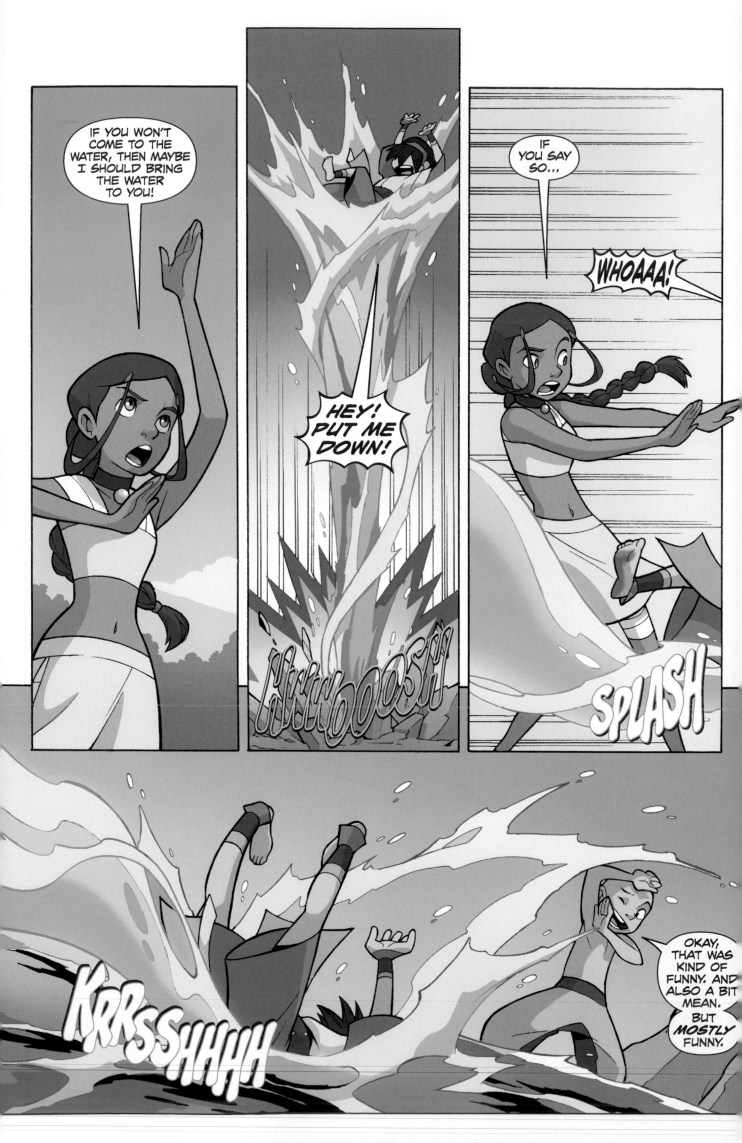

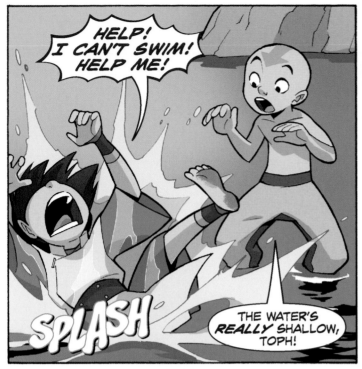

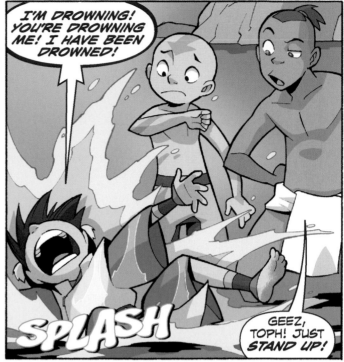

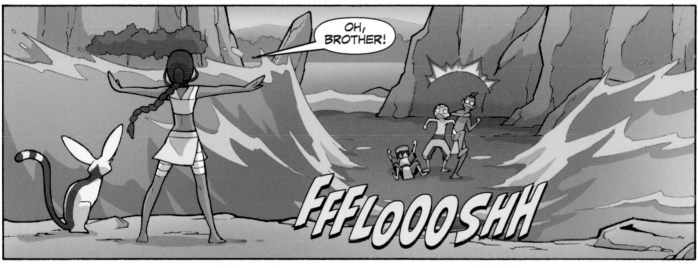

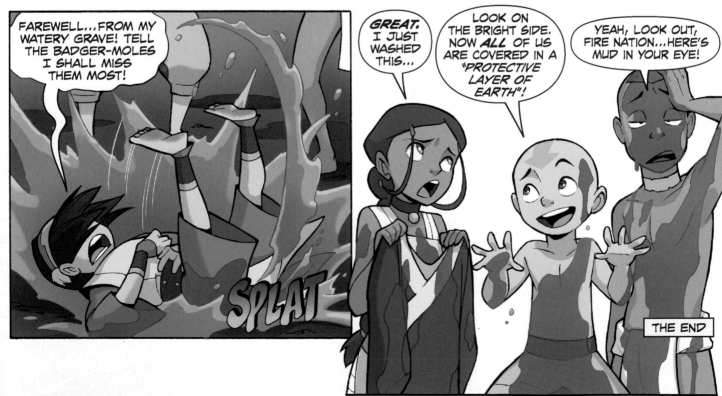

THE END

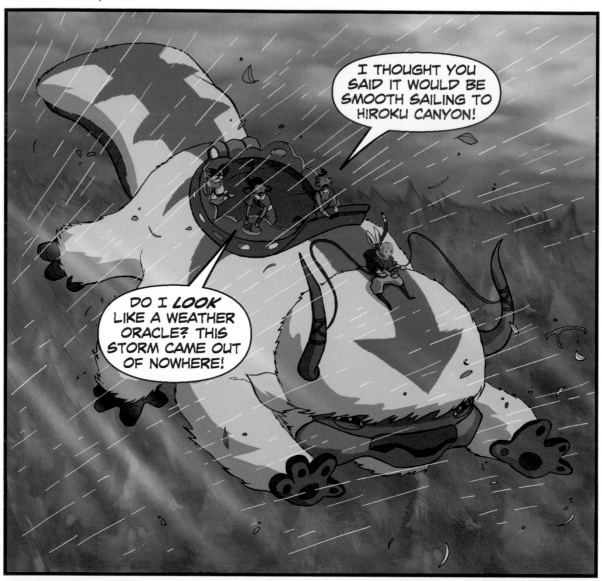

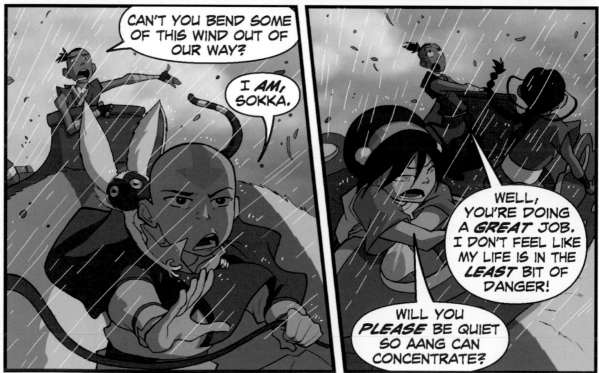

Story by Frank Pittarese, art by Justin Ridge, colors by Hye Jung Kim and Wes Dzioba, and lettering by Comicraft.

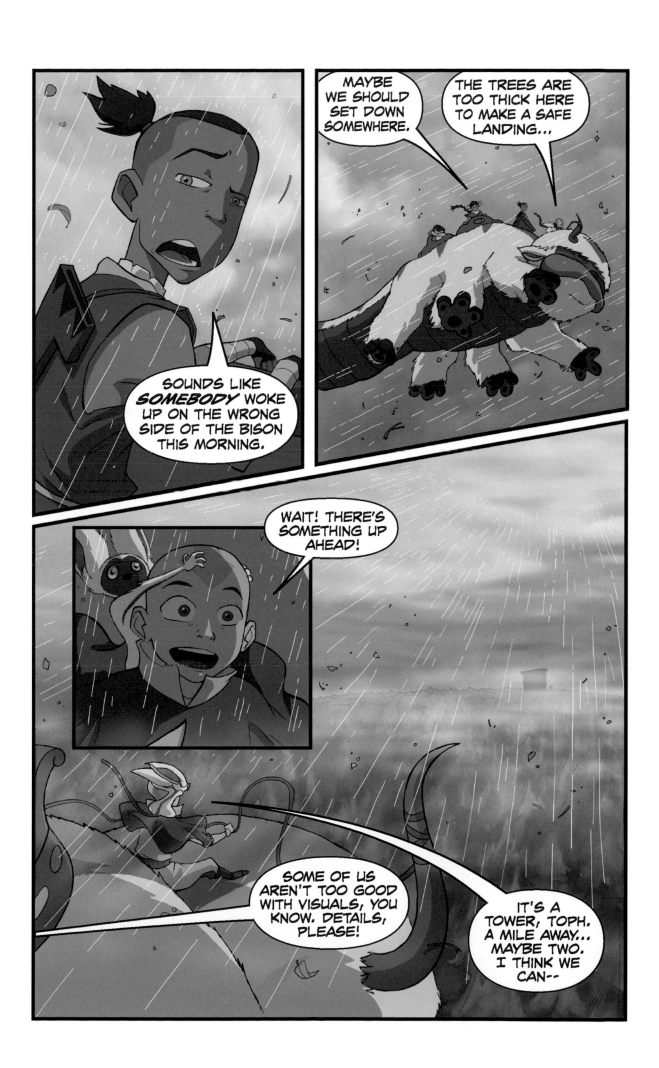

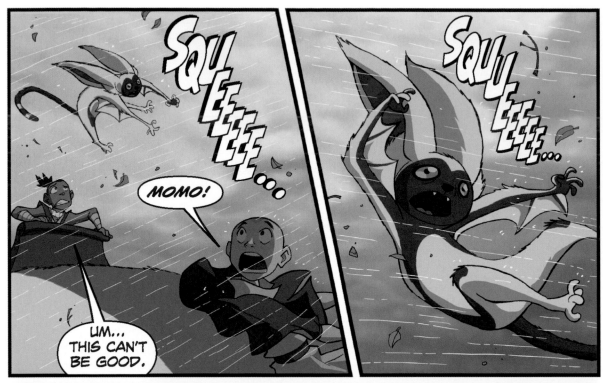

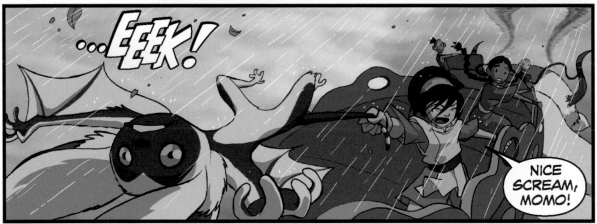

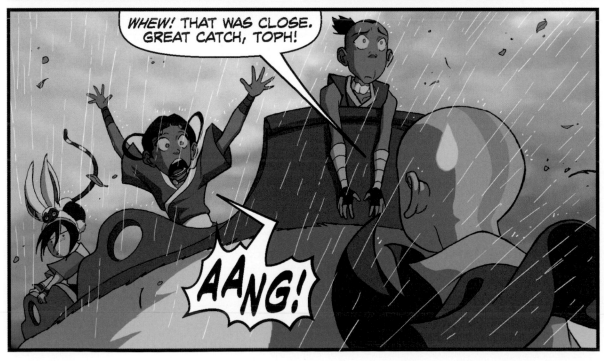

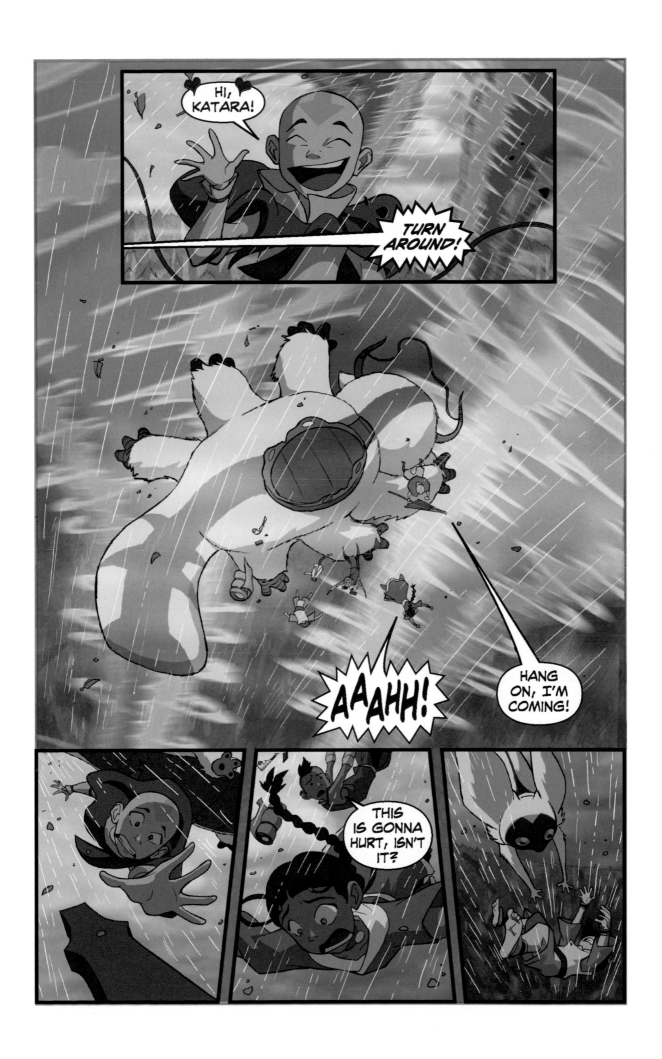

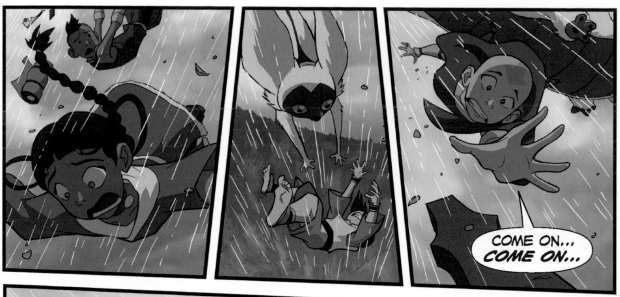

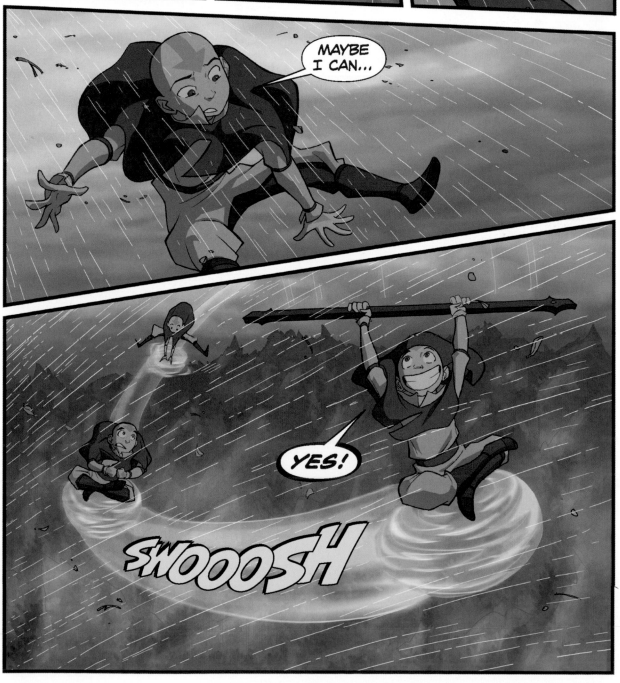

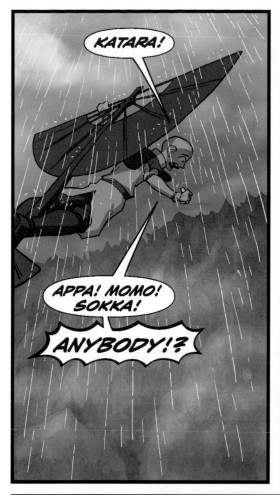

KATARA!

APPA! MOMO! SOKKA!

ANYBODY!?

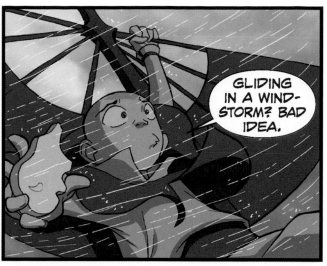

GLIDING IN A WIND-STORM? BAD IDEA.

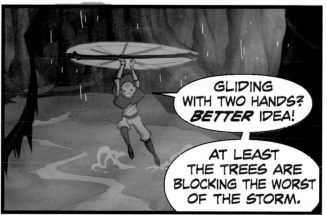

GLIDING WITH TWO HANDS? *BETTER* IDEA!

AT LEAST THE TREES ARE BLOCKING THE WORST OF THE STORM.

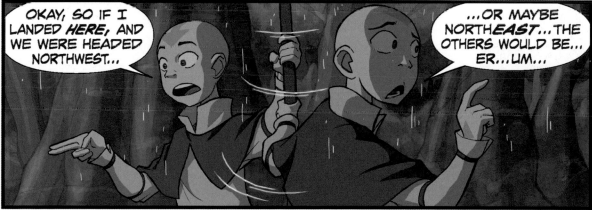

OKAY, SO IF I LANDED *HERE*, AND WE WERE HEADED NORTHWEST...

...OR MAYBE NORTH*EAST*...THE OTHERS WOULD BE... ER...UM...

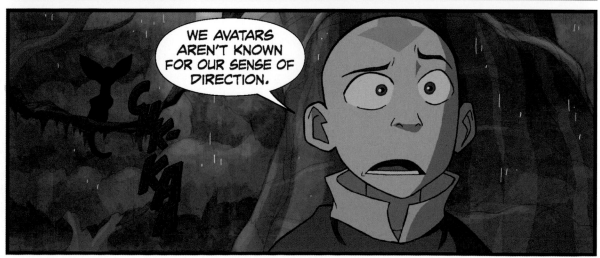

WE AVATARS AREN'T KNOWN FOR OUR SENSE OF DIRECTION.

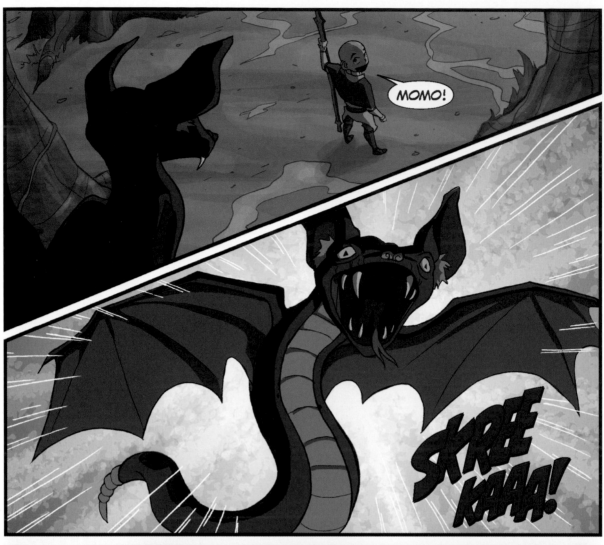

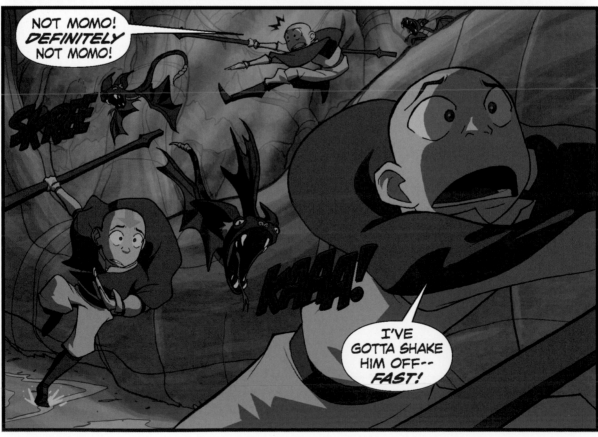

SKREE

GURK!

WHAM

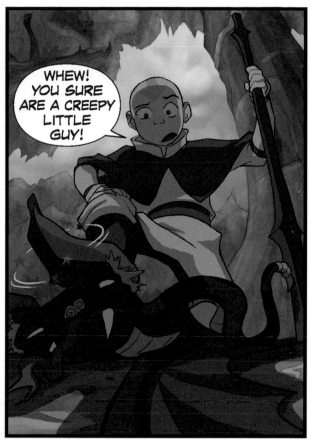

WHEW! YOU SURE ARE A CREEPY LITTLE GUY!

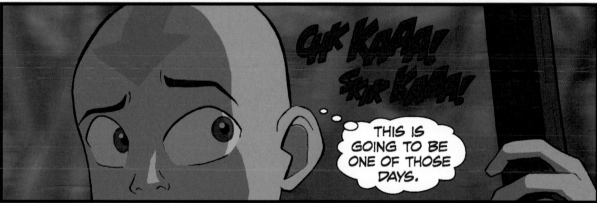

CHK KAAA! SKR KAAA!

THIS IS GOING TO BE ONE OF THOSE DAYS.

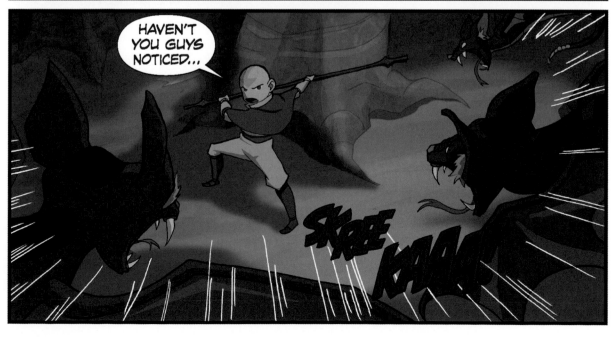

HAVEN'T YOU GUYS NOTICED...

SKREE KAAA!

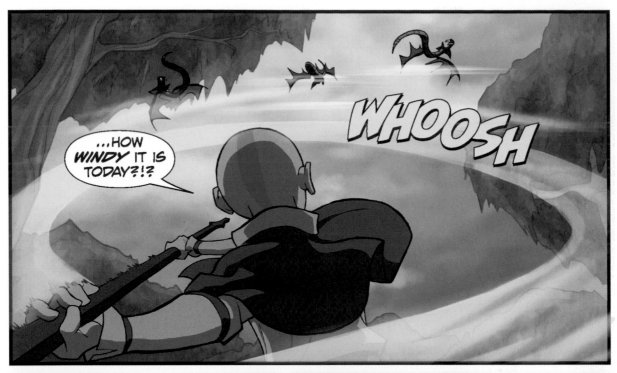

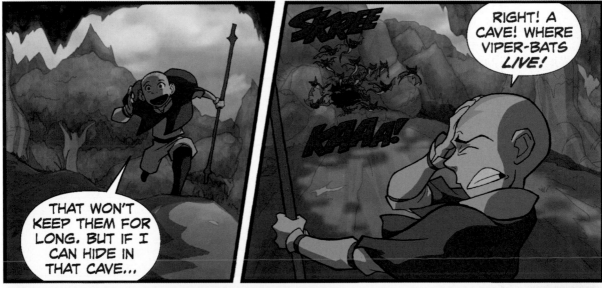

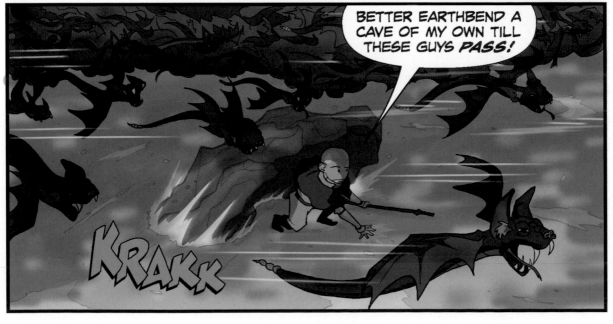

WELL, AT LEAST THE STORM'S OVER. IF I HEAD FOR THE TOWER, MAYBE I CAN FIND THE OTHERS.

MAYBE.

CHK KAA!

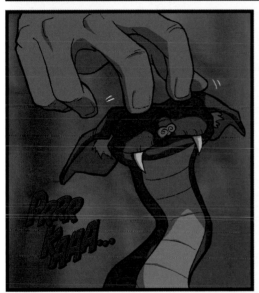

CHK KAA...

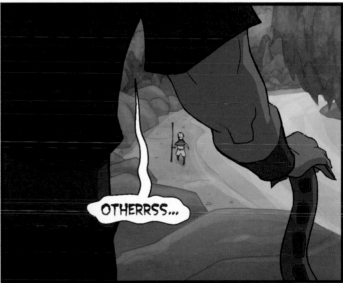

OTHERRSS...

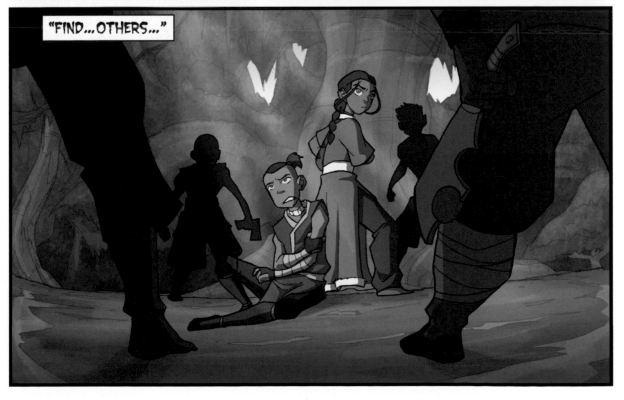

"FIND...OTHERS..."

65

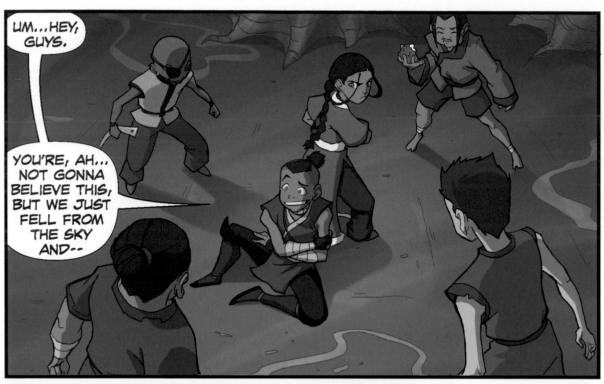

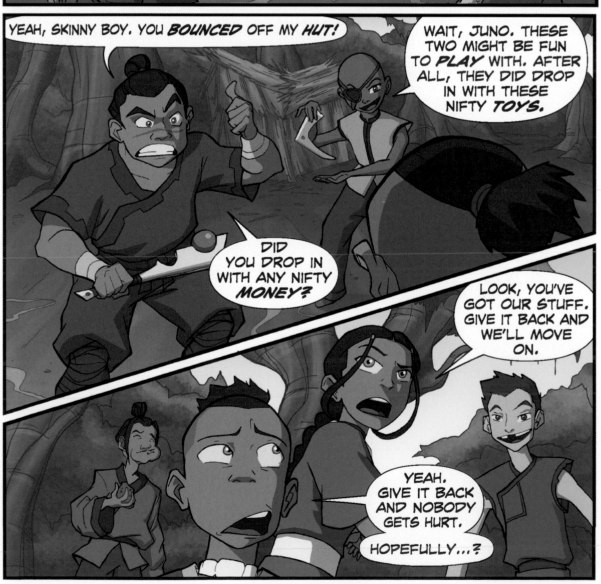

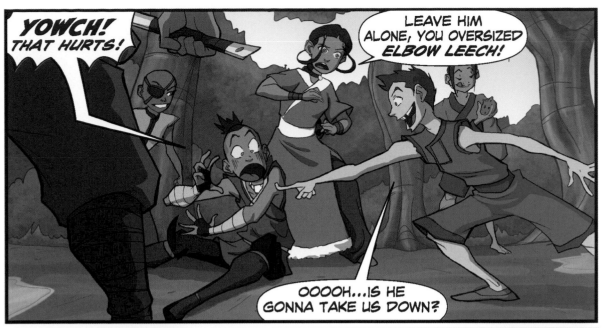

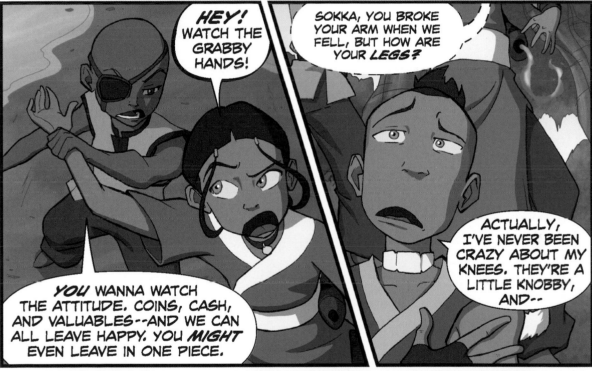

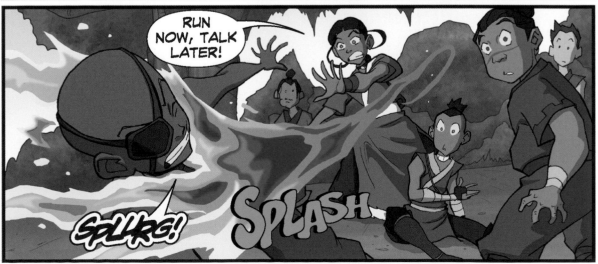

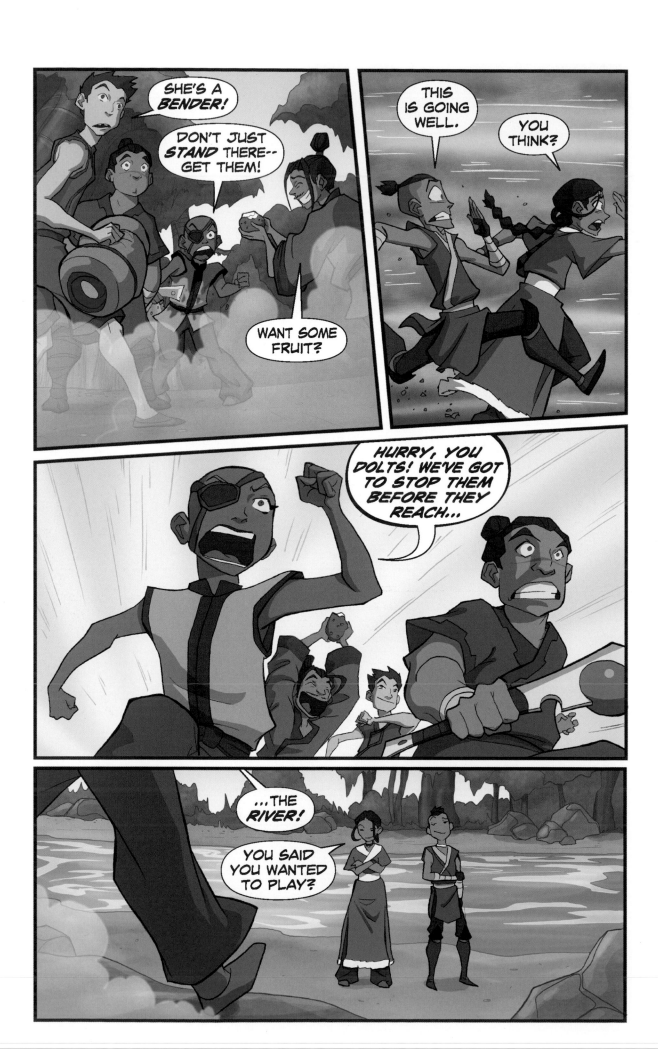

68

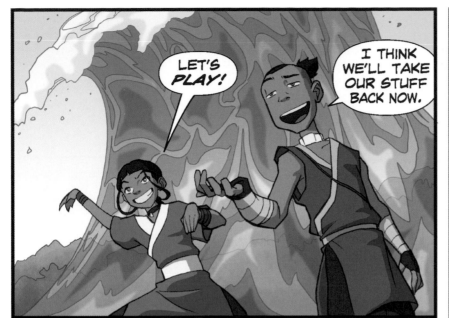

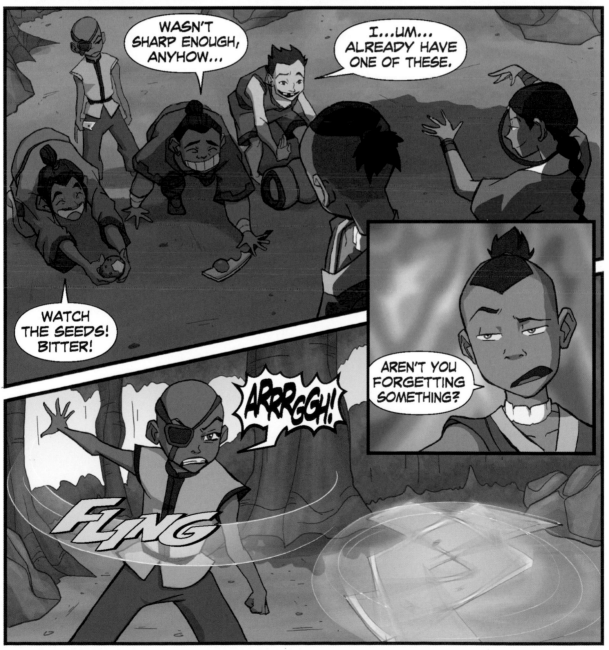

69

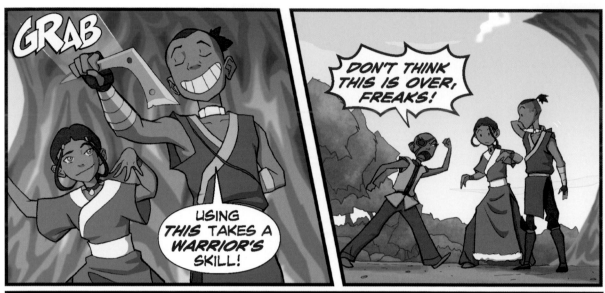

GRaB

USING *THIS* TAKES A *WARRIOR'S* SKILL!

DON'T THINK THIS IS OVER, FREAKS!

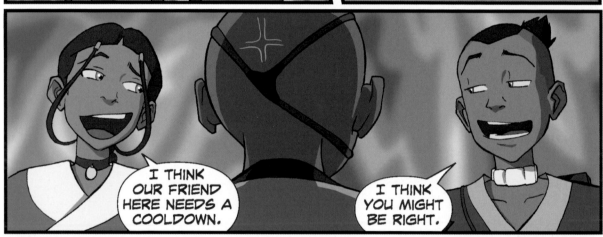

I THINK OUR FRIEND HERE NEEDS A COOLDOWN.

I THINK YOU MIGHT BE RIGHT.

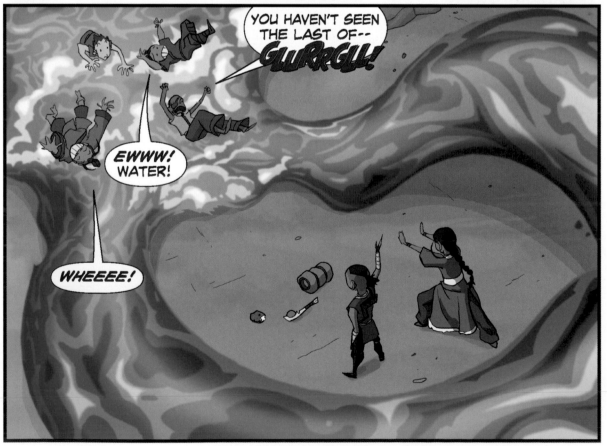

YOU HAVEN'T SEEN THE LAST OF-- GLURRGLL!

EWWW! WATER!

WHEEEE!

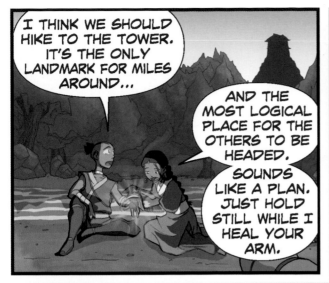

I THINK WE SHOULD HIKE TO THE TOWER. IT'S THE ONLY LANDMARK FOR MILES AROUND...

AND THE MOST LOGICAL PLACE FOR THE OTHERS TO BE HEADED.

SOUNDS LIKE A PLAN. JUST HOLD STILL WHILE I HEAL YOUR ARM.

THANKS, KATARA! I FEEL LIKE A NEW MAN!

GREAT! LET'S HOPE YOU'RE A STRONG ONE!

I THINK I LIKED IT BETTER WHEN MY ARM WAS BROKEN. LESS TO CARRY. NO CLIMBING.

KILLER THIEVES. YEAH, THOSE WERE GREAT TIMES.

YA KNOW, AANG'S THE AVATAR. HE'S *GOTTA* BE OKAY. APPA'S TOUGH. BUT MOMO...TOPH...

DON'T WORRY, SOKKA. MOMO'S A WILY LITTLE GUY. AND TOPH...?

"...I'M SURE TOPH'S *FINE*."

SMOOCH

THERE, NOW! DOESN'T GRANNY'S LITTLE PRINCESS LOOK *BEAUTIFUL!*

I GET KNOCKED OFF A SKY BISON, EARTHBEND MY WAY TO THE TOP OF A TOWER, GET DRESSED UP LIKE A PRINCESS...

...THEN I'M KISSED AND PINCHED BY THIS...PERSON. CAN MY DAY GET *ANY* WORSE?

AW...GRANNY'S PRINCESS IS CRANKY. I'LL MAKE HER SOME BEETLE-WORM SOUP.

YES, IT CAN.

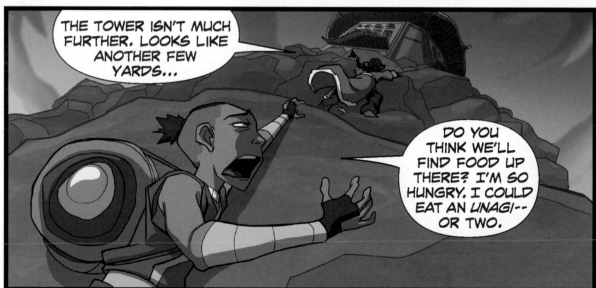

THE TOWER ISN'T MUCH FURTHER. LOOKS LIKE ANOTHER FEW YARDS...

DO YOU THINK WE'LL FIND FOOD UP THERE? I'M SO HUNGRY. I COULD EAT AN *UNAGI*-- OR TWO.

RUMMMMBBLLLL

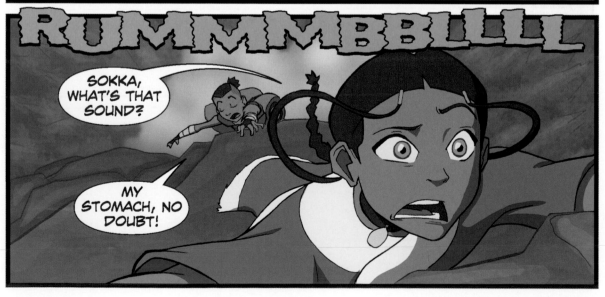

SOKKA, WHAT'S THAT SOUND?

MY STOMACH, NO DOUBT!

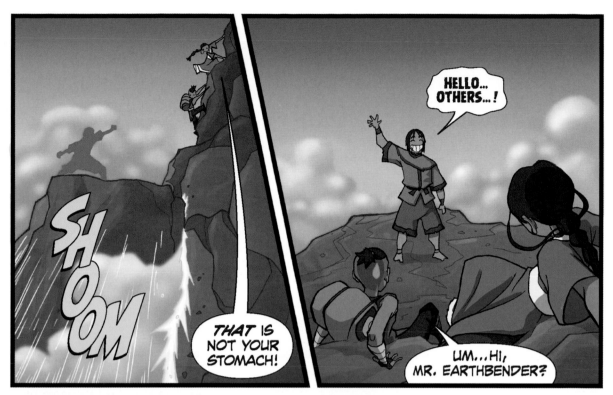

SHOOM

HELLO... OTHERS...!

THAT IS NOT YOUR STOMACH!

UM...HI, MR. EARTHBENDER?

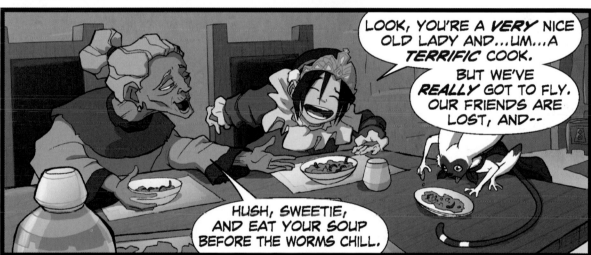

LOOK, YOU'RE A *VERY* NICE OLD LADY AND...UM....A *TERRIFIC* COOK.

BUT WE'VE *REALLY* GOT TO FLY. OUR FRIENDS ARE LOST, AND--

HUSH, SWEETIE, AND EAT YOUR SOUP BEFORE THE WORMS CHILL.

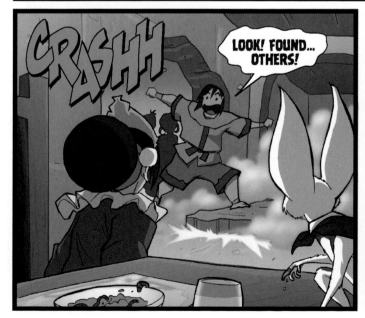

CRASHH

LOOK! FOUND... OTHERS!

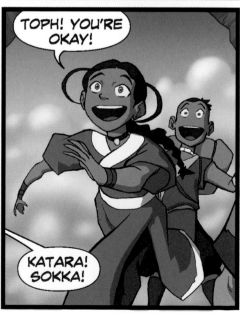

TOPH! YOU'RE OKAY!

KATARA! SOKKA!

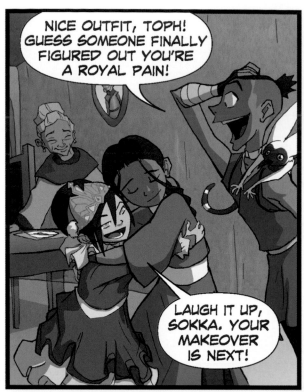

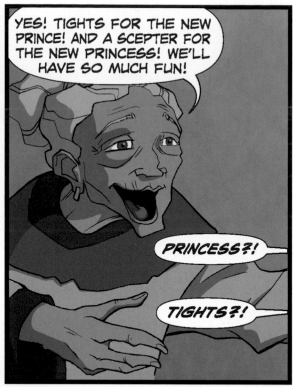

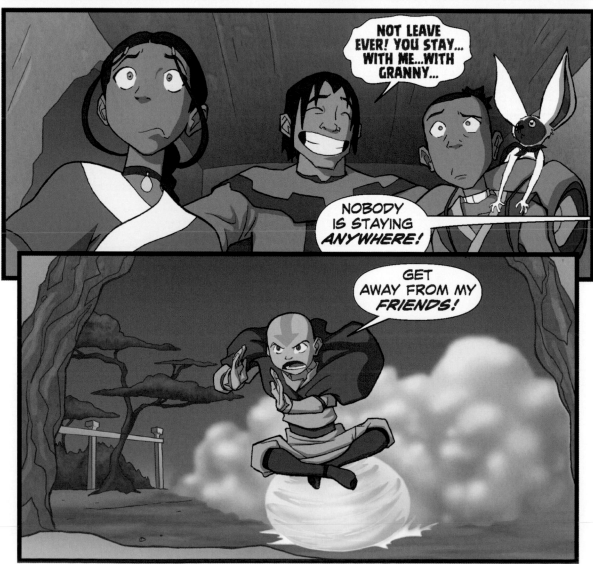

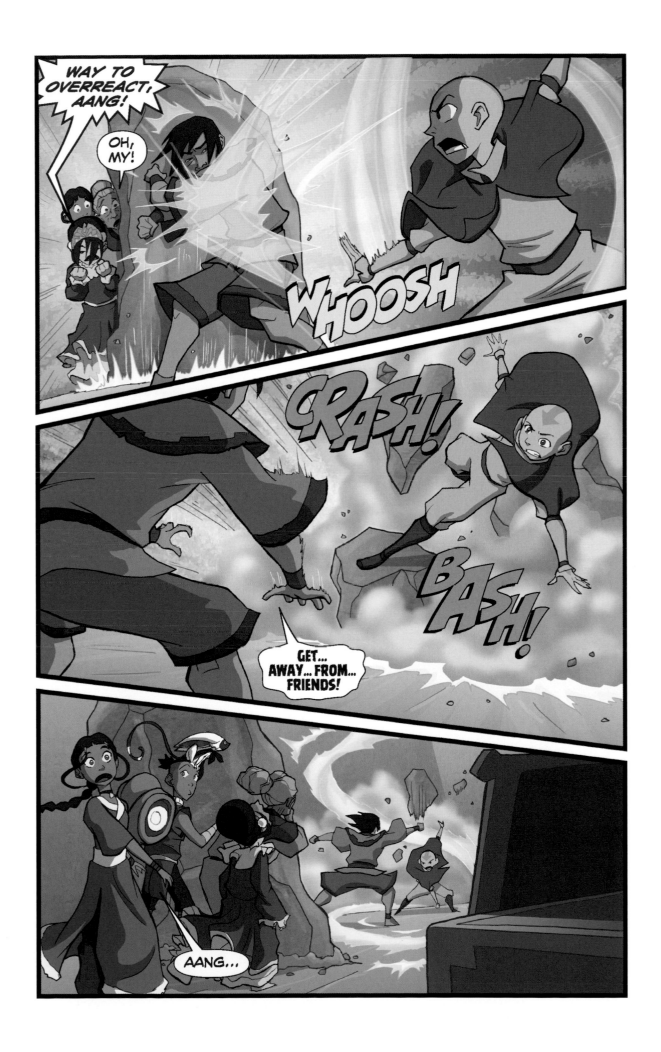

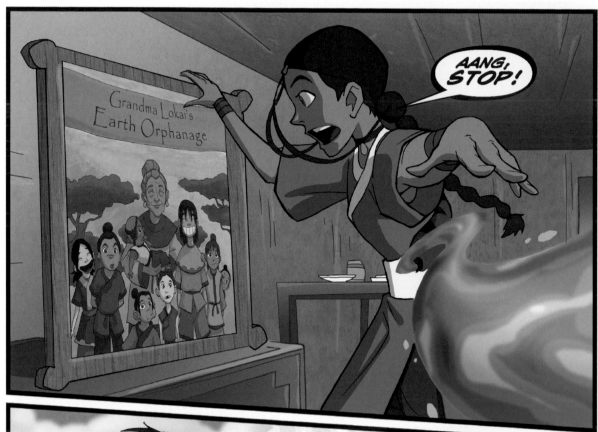

AANG, STOP!

Grandma Lokai's Earth Orphanage

HUH?

PLINK

WATER... BENDIE?

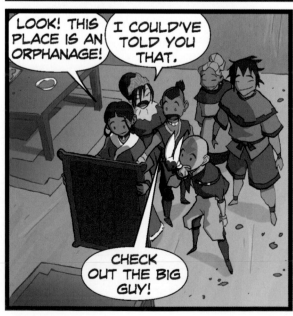

LOOK! THIS PLACE IS AN ORPHANAGE!

I COULD'VE TOLD YOU THAT.

CHECK OUT THE BIG GUY!

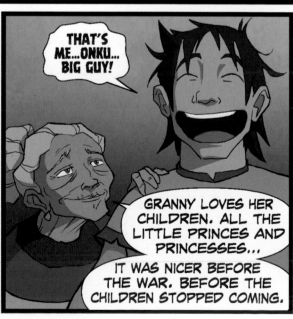

THAT'S ME...ONKU... BIG GUY!

GRANNY LOVES HER CHILDREN. ALL THE LITTLE PRINCES AND PRINCESSES...

IT WAS NICER BEFORE THE WAR. BEFORE THE CHILDREN STOPPED COMING.

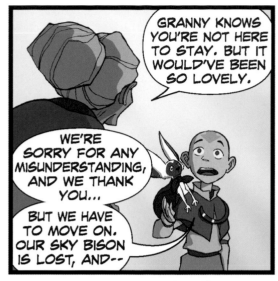

GRANNY KNOWS YOU'RE NOT HERE TO STAY. BUT IT WOULD'VE BEEN SO LOVELY.

WE'RE SORRY FOR ANY MISUNDERSTANDING, AND WE THANK YOU...

BUT WE HAVE TO MOVE ON. OUR SKY BISON IS LOST, AND--

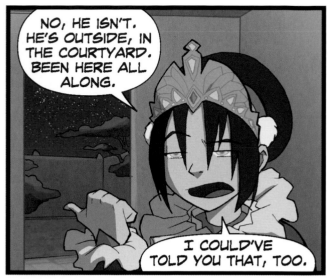

NO, HE ISN'T. HE'S OUTSIDE, IN THE COURTYARD. BEEN HERE ALL ALONG.

I COULD'VE TOLD YOU THAT, TOO.

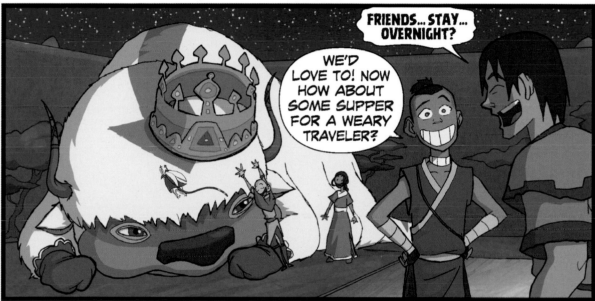

FRIENDS... STAY... OVERNIGHT?

WE'D LOVE TO! NOW HOW ABOUT SOME SUPPER FOR A WEARY TRAVELER?

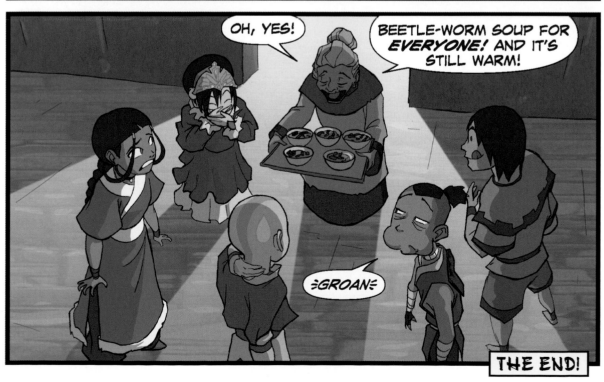

OH, YES!

BEETLE-WORM SOUP FOR *EVERYONE!* AND IT'S STILL WARM!

≋GROAN≋

THE END!

77

REACH FOR THE TOPH

Story by J. Torres, art and colors by Corey Lewis, and lettering by Comicraft.

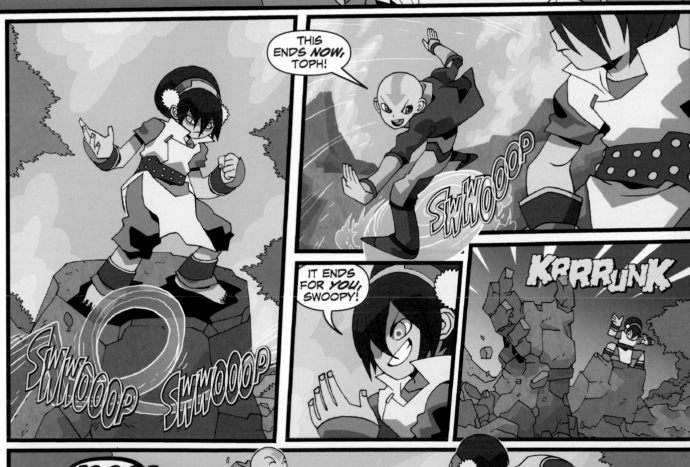

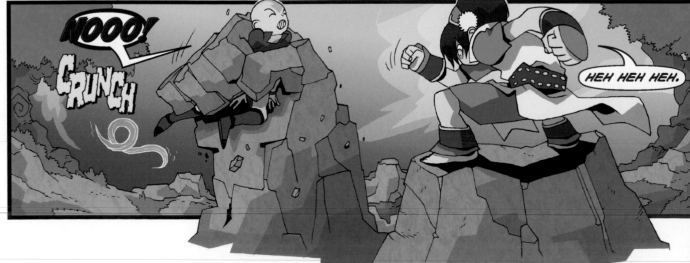

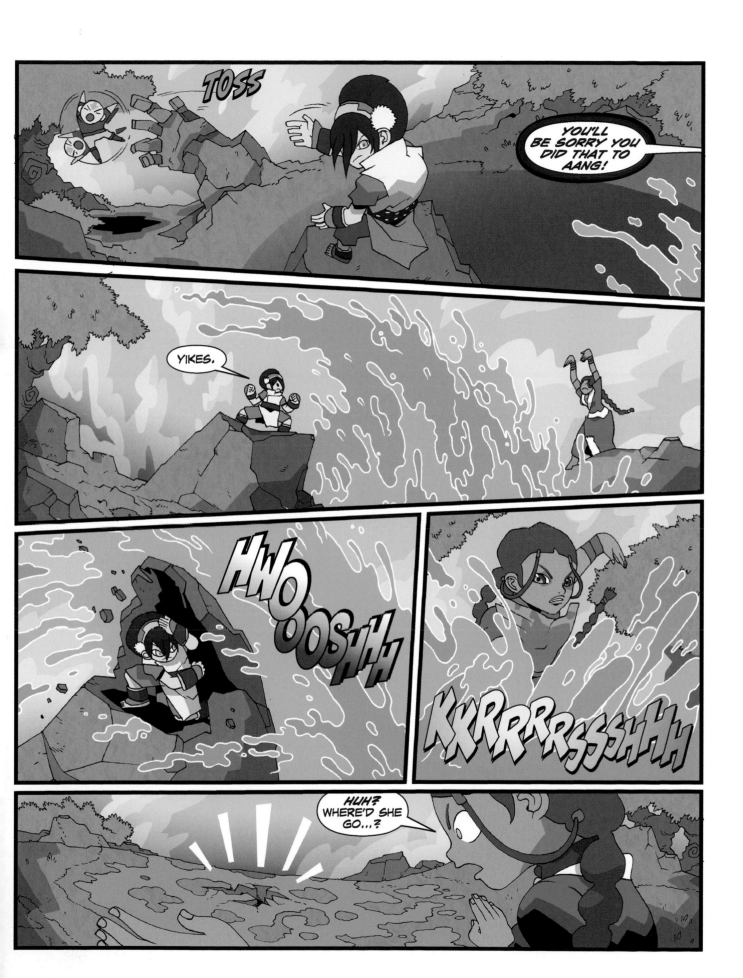

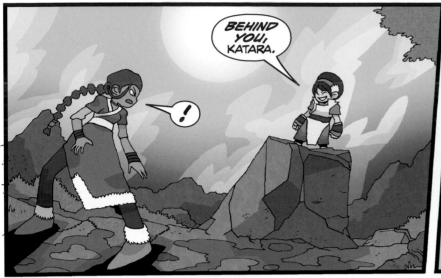

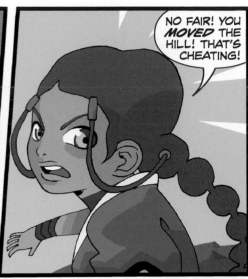

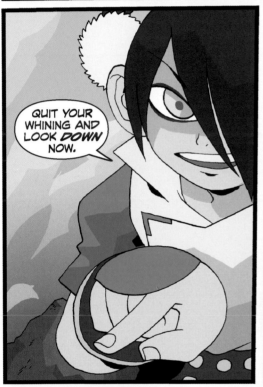

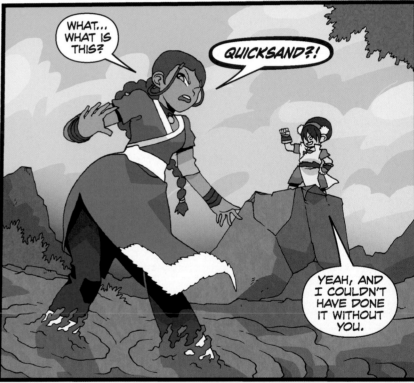

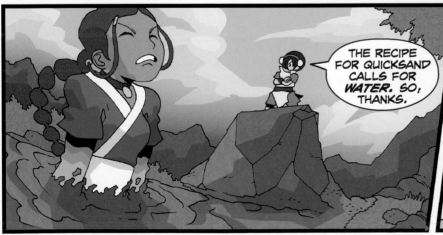

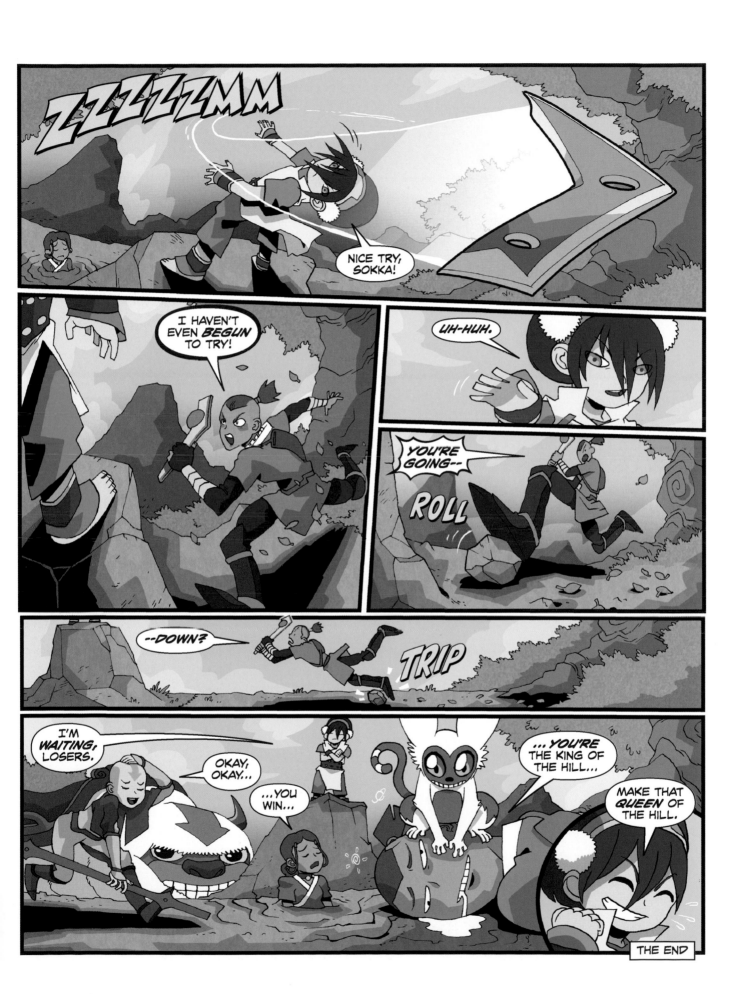

It's Only Natural

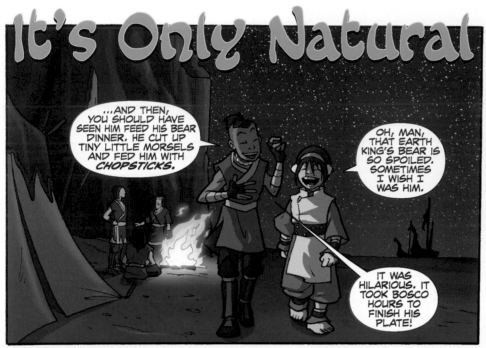

...AND THEN, YOU SHOULD HAVE SEEN HIM FEED HIS BEAR DINNER. HE CUT UP TINY LITTLE MORSELS AND FED HIM WITH *CHOPSTICKS.*

OH, MAN, THAT EARTH KING'S BEAR IS SO SPOILED. SOMETIMES I WISH I WAS HIM.

IT WAS HILARIOUS. IT TOOK BOSCO HOURS TO FINISH HIS PLATE!

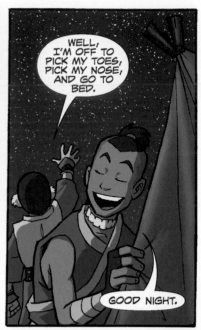

WELL, I'M OFF TO PICK MY TOES, PICK MY NOSE, AND GO TO BED.

GOOD NIGHT.

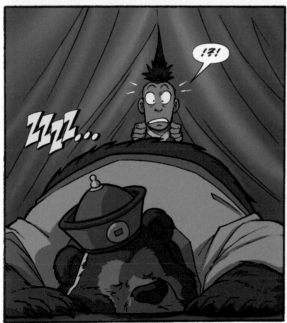

!?!

ZZZZ...

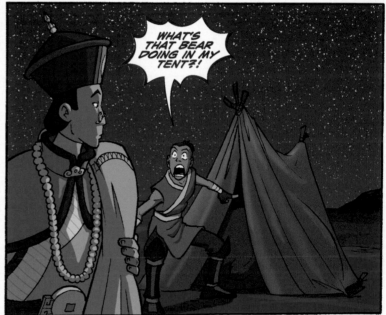

WHAT'S THAT BEAR DOING IN MY TENT?!

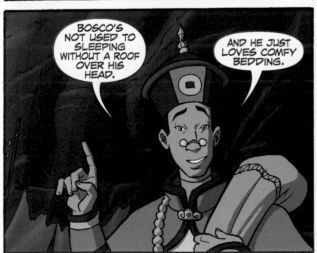

BOSCO'S NOT USED TO SLEEPING WITHOUT A ROOF OVER HIS HEAD.

AND HE JUST LOVES COMFY BEDDING.

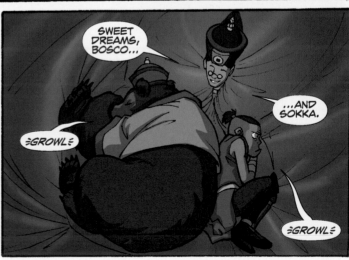

SWEET DREAMS, BOSCO...

...AND SOKKA.

≡GROWL≡

≡GROWL≡

Story by Johane Matte and Joshua Hamilton, art by Johane Matte, colors by Wes Dzioba, and lettering by Comicraft.

82

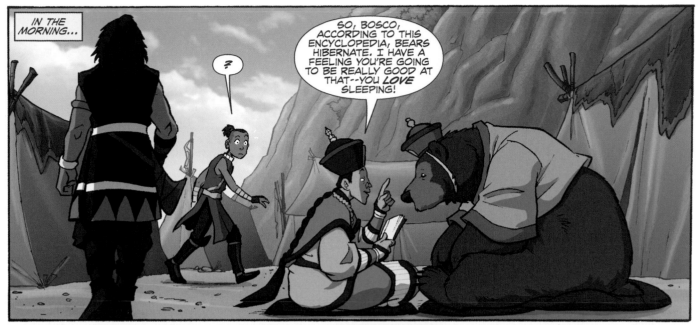

IN THE MORNING...

?

SO, BOSCO, ACCORDING TO THIS ENCYCLOPEDIA, BEARS HIBERNATE. I HAVE A FEELING YOU'RE GOING TO BE REALLY GOOD AT THAT--YOU *LOVE* SLEEPING!

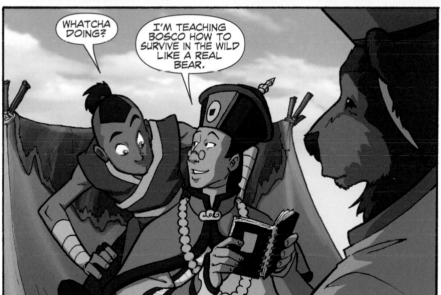

WHATCHA DOING?

I'M TEACHING BOSCO HOW TO SURVIVE IN THE WILD LIKE A REAL BEAR.

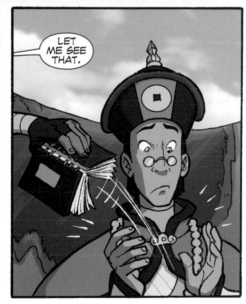

LET ME SEE THAT.

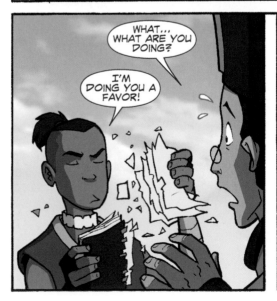

WHAT... WHAT ARE YOU DOING?

I'M DOING YOU A FAVOR!

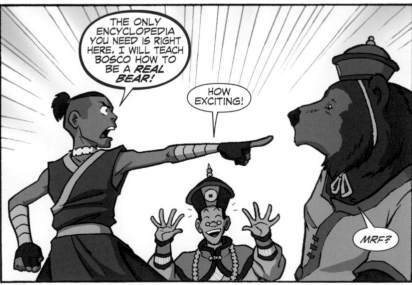

THE ONLY ENCYCLOPEDIA YOU NEED IS RIGHT HERE. I WILL TEACH BOSCO HOW TO BE A *REAL BEAR!*

HOW EXCITING!

MRF?

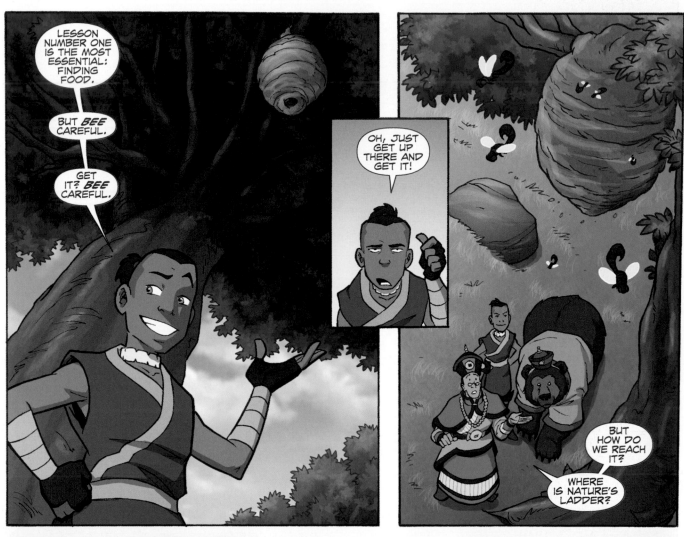

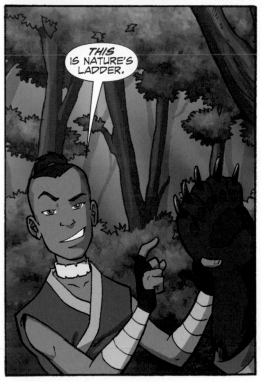

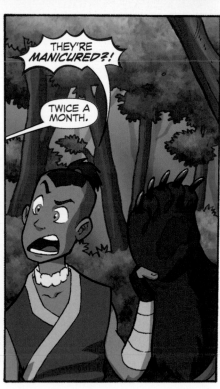

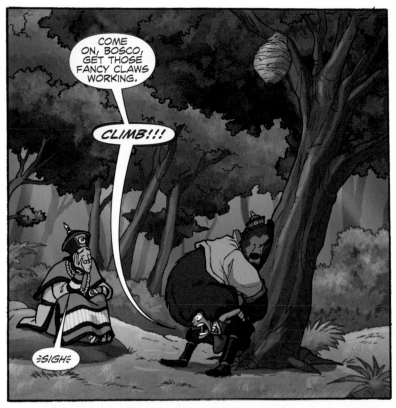

COME ON, BOSCO, GET THOSE FANCY CLAWS WORKING.

CLIMB!!!

=SIGH=

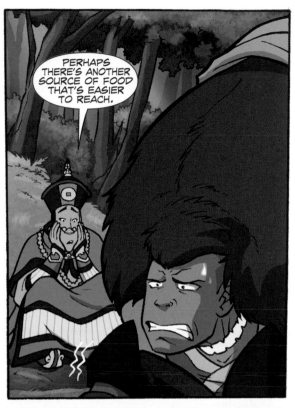

PERHAPS THERE'S ANOTHER SOURCE OF FOOD THAT'S EASIER TO REACH.

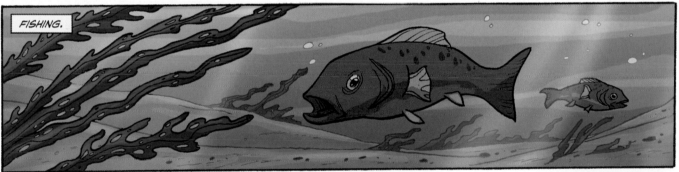

FISHING.

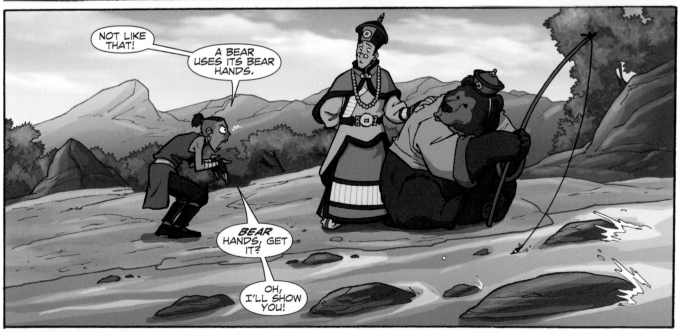

NOT LIKE THAT!

A BEAR USES ITS BEAR HANDS.

BEAR HANDS, GET IT?

OH, I'LL SHOW YOU!

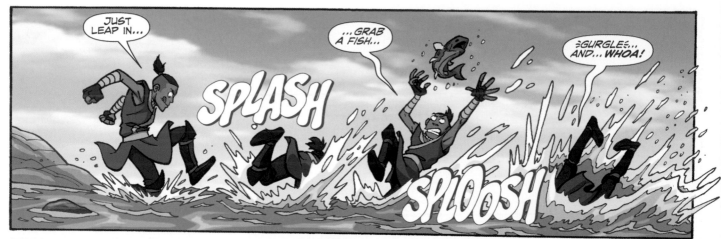

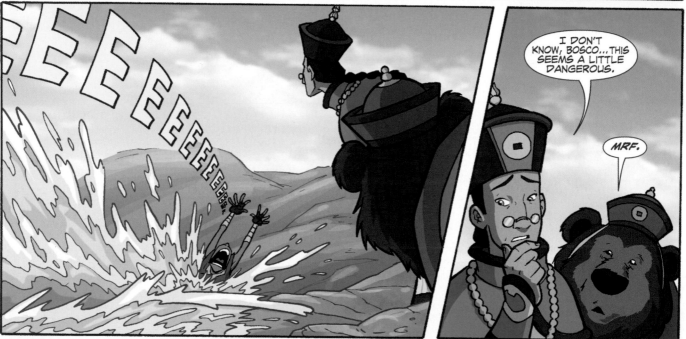

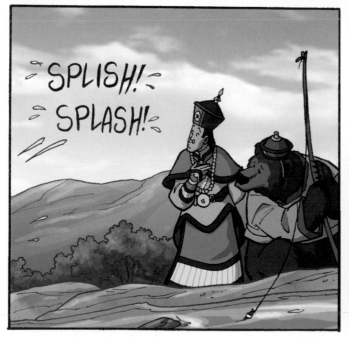

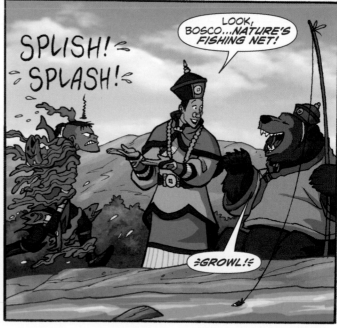

SHELTER.

FINDING SHELTER IS ALSO VERY IMPORTANT IN ORDER TO SURVIVE IN THE WILD.

AGH! BOARCUPINES!

I SUPPOSE YOU SHOULD ALWAYS MAKE SURE IT'S UNOCCUPIED FIRST.

TERRITORY.

IN ORDER TO DEFEND ONE'S TERRITORY, YOU'VE GOT TO SOUND *REALLY* FEROCIOUS. SO GIVE ME YOUR MOST FRIGHTENING ROAR.

UM, BOSCO DOESN'T ROAR. BUT HE IS A LOVELY WHISTLER.

SPLENDID WHISTLING, BOSCO.

YEAH, REALLY *FRIGHTENING*.

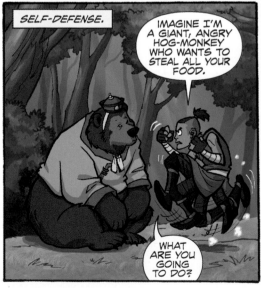

SELF-DEFENSE.

IMAGINE I'M A GIANT, ANGRY HOG-MONKEY WHO WANTS TO STEAL ALL YOUR FOOD.

WHAT ARE YOU GOING TO DO?

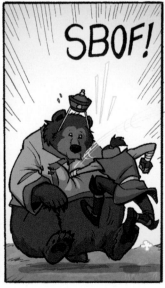

SBOF!

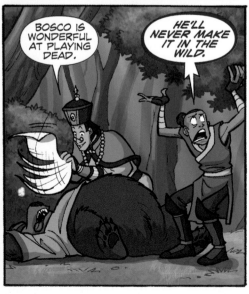

BOSCO IS WONDERFUL AT PLAYING DEAD.

HE'LL NEVER MAKE IT IN THE WILD.

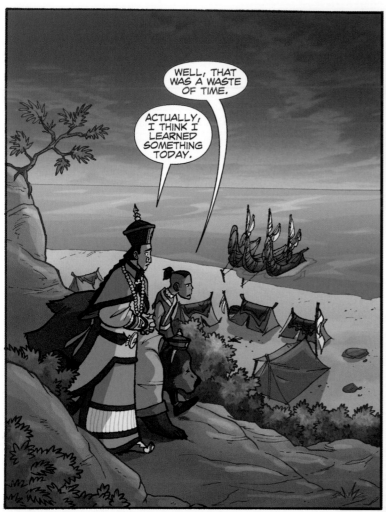

WELL, THAT WAS A WASTE OF TIME.

ACTUALLY, I THINK I LEARNED SOMETHING TODAY.

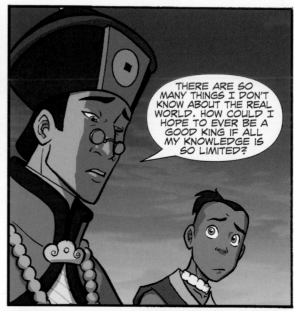

THERE ARE SO MANY THINGS I DON'T KNOW ABOUT THE REAL WORLD. HOW COULD I HOPE TO EVER BE A GOOD KING IF ALL MY KNOWLEDGE IS SO LIMITED?

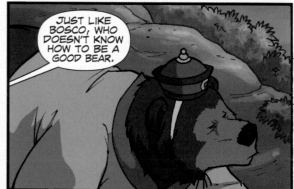

JUST LIKE BOSCO, WHO DOESN'T KNOW HOW TO BE A GOOD BEAR.

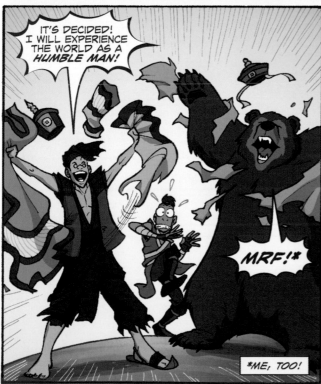

IT'S DECIDED! I WILL EXPERIENCE THE WORLD AS A *HUMBLE MAN!*

MRF!*

*ME, TOO!

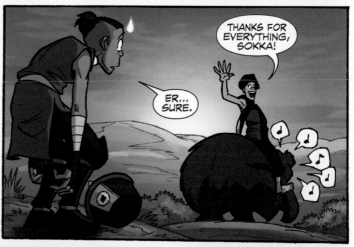

THANKS FOR EVERYTHING, SOKKA!

ER... SURE.

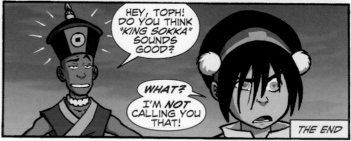

HEY, TOPH! DO YOU THINK *"KING SOKKA"* SOUNDS GOOD?

WHAT? I'M *NOT* CALLING YOU THAT!

THE END

GOING HOME AGAIN

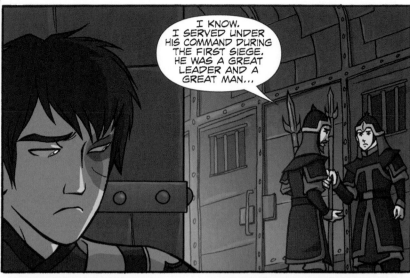

I KNOW. I SERVED UNDER HIS COMMAND DURING THE FIRST SIEGE. HE WAS A GREAT LEADER AND A GREAT MAN...

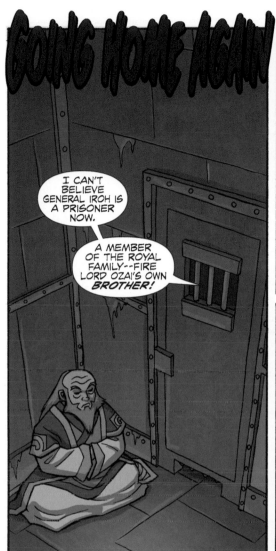

I CAN'T BELIEVE GENERAL IROH IS A PRISONER NOW.

A MEMBER OF THE ROYAL FAMILY--FIRE LORD OZAI'S OWN *BROTHER!*

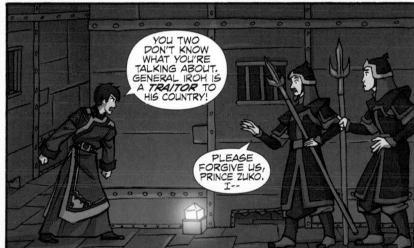

YOU TWO DON'T KNOW WHAT YOU'RE TALKING ABOUT. GENERAL IROH IS A *TRAITOR* TO HIS COUNTRY!

PLEASE FORGIVE US, PRINCE ZUKO. I--

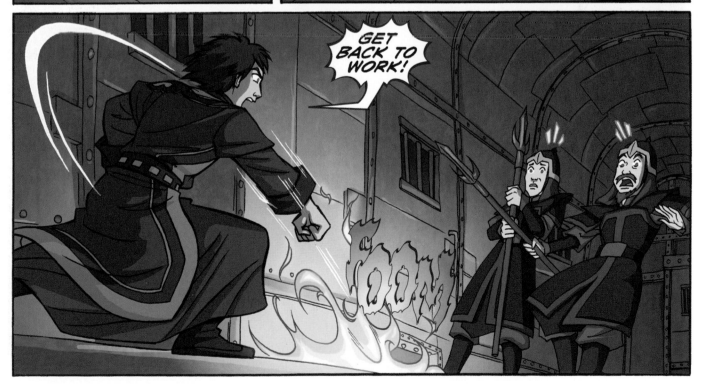

GET BACK TO WORK!

Story by Aaron Ehasz, May Chan, Katie Mattila, and Alison Wilgus, art by Amy Kim Ganter, colors by Wes Dzioba, and lettering by Comicraft.

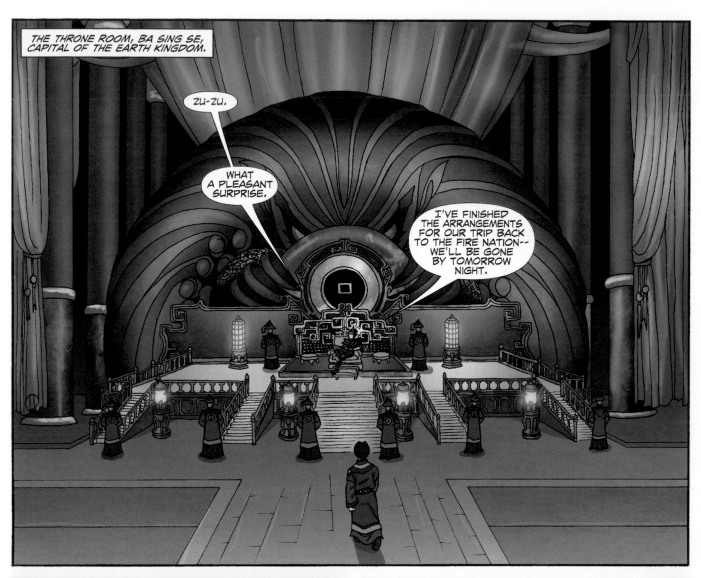

THE THRONE ROOM, BA SING SE, CAPITAL OF THE EARTH KINGDOM.

ZU-ZU.

WHAT A PLEASANT SURPRISE.

I'VE FINISHED THE ARRANGEMENTS FOR OUR TRIP BACK TO THE FIRE NATION-- WE'LL BE GONE BY TOMORROW NIGHT.

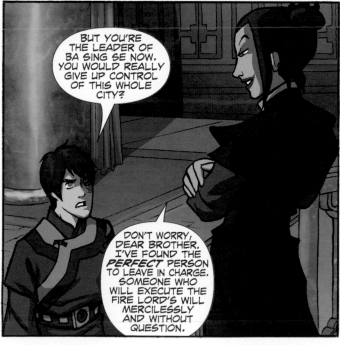

BUT YOU'RE THE LEADER OF BA SING SE NOW. YOU WOULD REALLY GIVE UP CONTROL OF THIS WHOLE CITY?

DON'T WORRY, DEAR BROTHER. I'VE FOUND THE *PERFECT* PERSON TO LEAVE IN CHARGE. SOMEONE WHO WILL EXECUTE THE FIRE LORD'S WILL MERCILESSLY AND WITHOUT QUESTION.

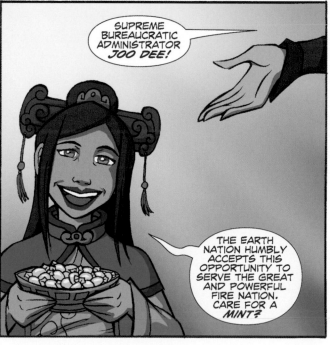

SUPREME BUREAUCRATIC ADMINISTRATOR *JOO DEE!*

THE EARTH NATION HUMBLY ACCEPTS THIS OPPORTUNITY TO SERVE THE GREAT AND POWERFUL FIRE NATION. CARE FOR A *MINT?*

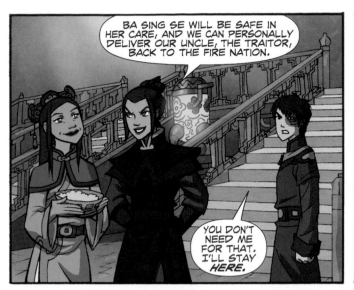
BA SING SE WILL BE SAFE IN HER CARE, AND WE CAN PERSONALLY DELIVER OUR UNCLE, THE TRAITOR, BACK TO THE FIRE NATION.

YOU DON'T NEED ME FOR THAT. I'LL STAY *HERE*.

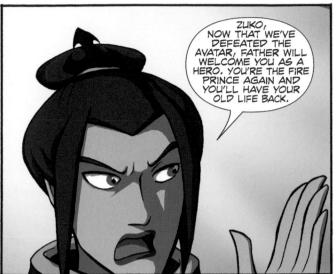
ZUKO, NOW THAT WE'VE DEFEATED THE AVATAR, FATHER WILL WELCOME YOU AS A HERO. YOU'RE THE FIRE PRINCE AGAIN AND YOU'LL HAVE YOUR OLD LIFE BACK.

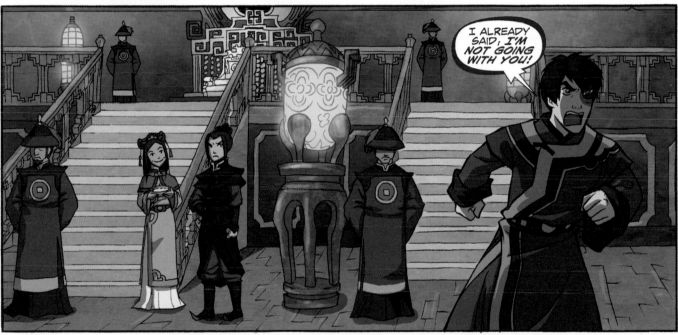
I ALREADY SAID, *I'M NOT GOING WITH YOU!*

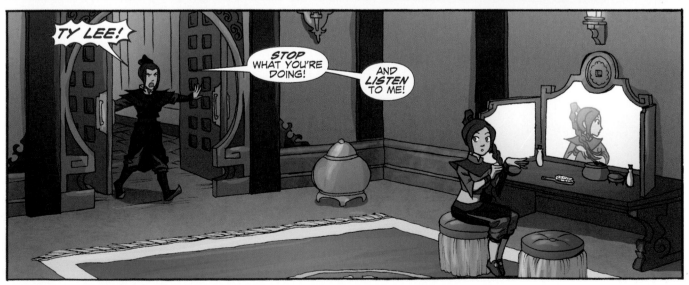
TY LEE!

STOP WHAT YOU'RE DOING!

AND LISTEN TO ME!

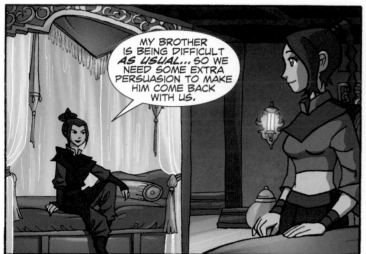

MY BROTHER IS BEING DIFFICULT *AS USUAL...* SO WE NEED SOME EXTRA PERSUASION TO MAKE HIM COME BACK WITH US.

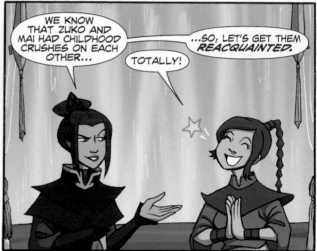

WE KNOW THAT ZUKO AND MAI HAD CHILDHOOD CRUSHES ON EACH OTHER...

TOTALLY!

...SO, LET'S GET THEM *REACQUAINTED.*

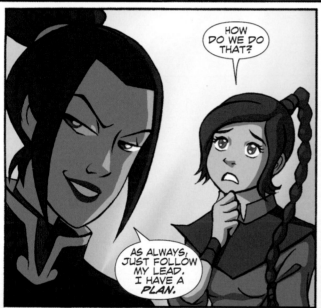

HOW DO WE DO THAT?

AS ALWAYS, JUST FOLLOW MY LEAD. I HAVE A *PLAN.*

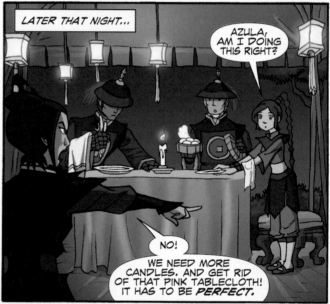

LATER THAT NIGHT...

AZULA, AM I DOING THIS RIGHT?

NO! WE NEED MORE CANDLES. AND GET RID OF THAT PINK TABLECLOTH! IT HAS TO BE *PERFECT.*

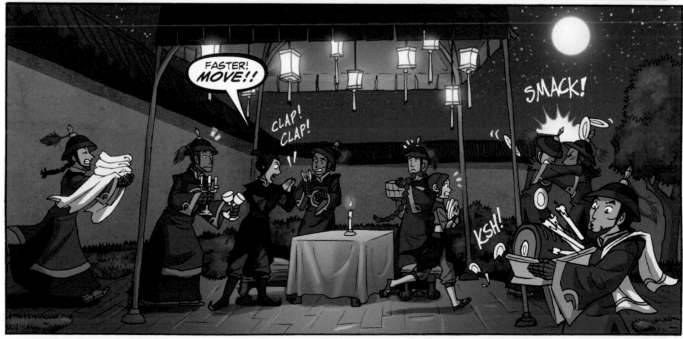

FASTER! *MOVE!!*

CLAP! CLAP!

SMACK!

KSH!

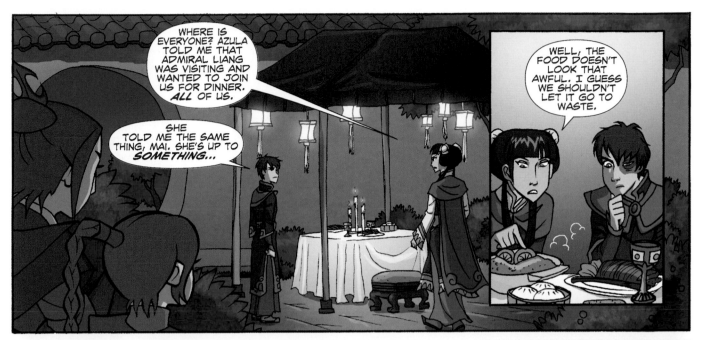

WHERE IS EVERYONE? AZULA TOLD ME THAT ADMIRAL LIANG WAS VISITING AND WANTED TO JOIN US FOR DINNER. *ALL* OF US.

SHE TOLD ME THE SAME THING, MAI. SHE'S UP TO *SOMETHING...*

WELL, THE FOOD DOESN'T LOOK THAT AWFUL. I GUESS WE SHOULDN'T LET IT GO TO WASTE.

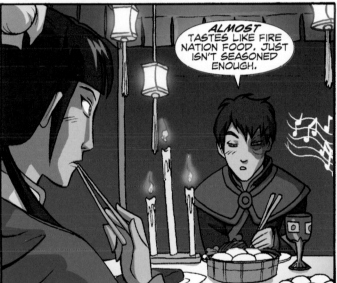

ALMOST TASTES LIKE FIRE NATION FOOD. JUST ISN'T SEASONED ENOUGH.

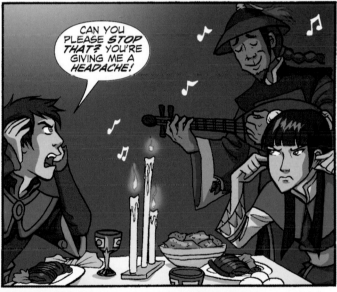

CAN YOU PLEASE *STOP THAT?* YOU'RE GIVING ME A *HEADACHE!*

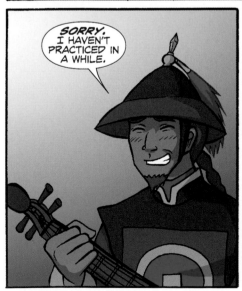

SORRY. I HAVEN'T PRACTICED IN A WHILE.

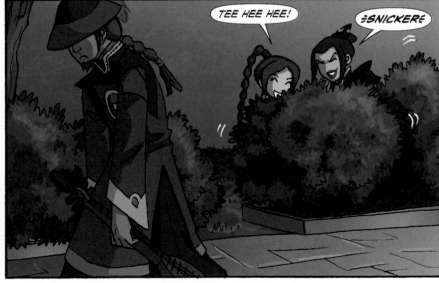

TEE HEE HEE!

≶SNICKER≶

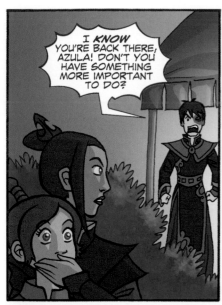

I **KNOW** YOU'RE BACK THERE, AZULA! DON'T YOU HAVE SOMETHING MORE IMPORTANT TO DO?

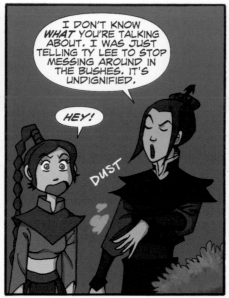

I DON'T KNOW **WHAT** YOU'RE TALKING ABOUT. I WAS JUST TELLING TY LEE TO STOP MESSING AROUND IN THE BUSHES. IT'S UNDIGNIFIED.

HEY!

DUST

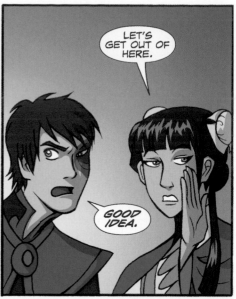

LET'S GET OUT OF HERE.

GOOD IDEA.

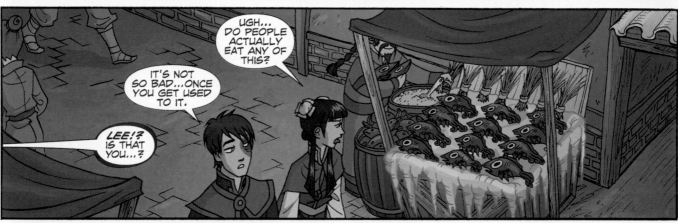

UGH... DO PEOPLE ACTUALLY EAT ANY OF THIS?

IT'S NOT SO BAD...ONCE YOU GET USED TO IT.

LEE!? IS THAT YOU...?

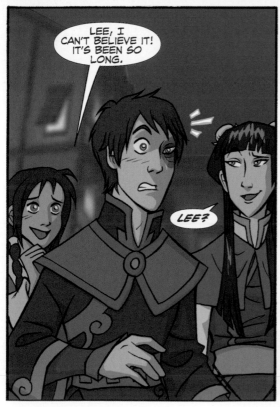

LEE, I CAN'T BELIEVE IT! IT'S BEEN SO LONG.

LEE?

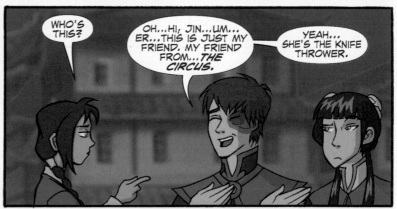

WHO'S THIS?

OH...HI, JIN...UM... ER...THIS IS JUST MY FRIEND. MY FRIEND FROM....**THE CIRCUS.**

YEAH... SHE'S THE KNIFE THROWER.

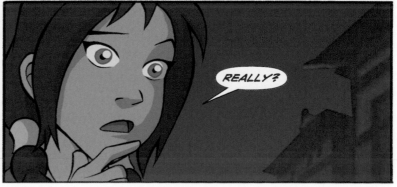

REALLY?

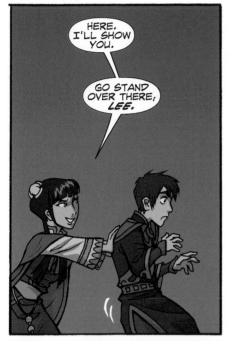

HERE. I'LL SHOW YOU.

GO STAND OVER THERE, *LEE.*

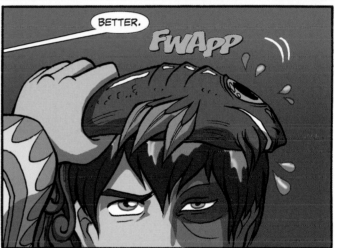

HAH! I HOPE SHE'S BETTER AT THROWING KNIVES THAN YOU ARE AT JUGGLING!

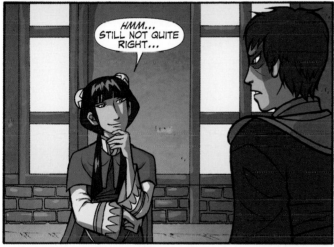

HMM... STILL NOT QUITE RIGHT...

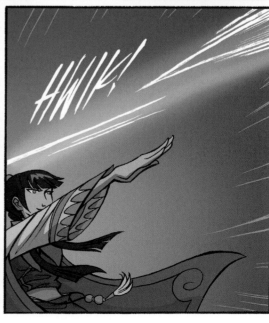

BETTER.

FWAPP

CRACK

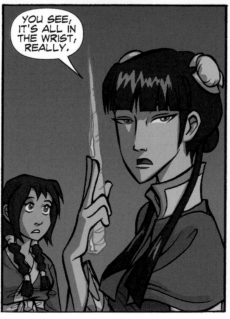

YOU SEE, IT'S ALL IN THE WRIST, REALLY.

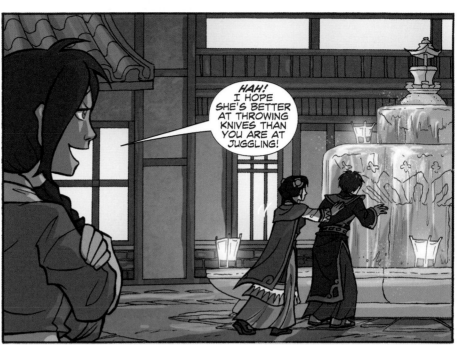

HWIK!

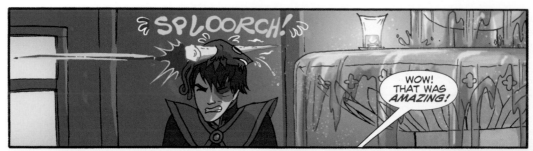

SPLOORCH!

WOW! THAT WAS *AMAZING!*

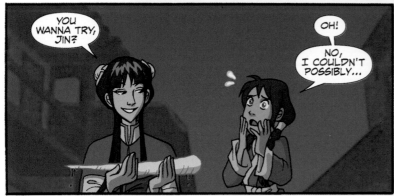

YOU WANNA TRY, JIN?

OH! NO, I COULDN'T POSSIBLY...

...WELL, MAYBE JUST ONE.

HWIK!

KSH!

DODGE

SLP...

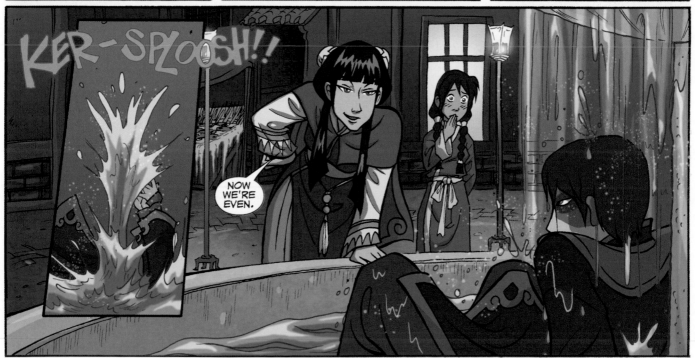

KER-SPLOOSH!!

NOW WE'RE EVEN.

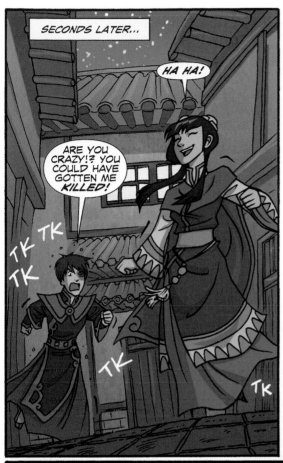

SECONDS LATER...

HA HA!

ARE YOU CRAZY!? YOU COULD HAVE GOTTEN ME *KILLED!*

TK TK
TK
TK

TK

TK

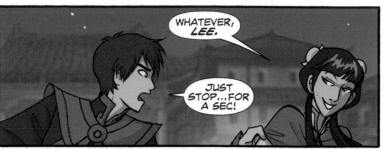

WHATEVER, *LEE.*

JUST STOP...FOR A SEC!

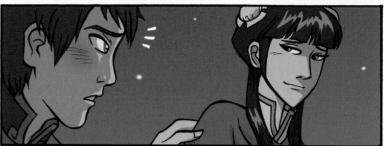

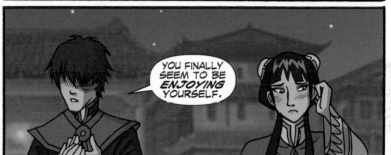

YOU FINALLY SEEM TO BE *ENJOYING* YOURSELF.

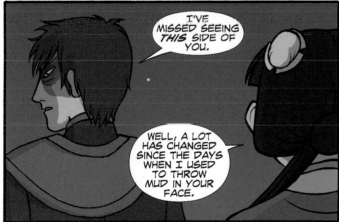

I'VE MISSED SEEING *THIS* SIDE OF YOU.

WELL, A LOT HAS CHANGED SINCE THE DAYS WHEN I USED TO THROW MUD IN YOUR FACE.

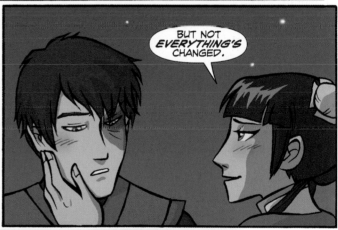

BUT NOT *EVERYTHING'S* CHANGED.

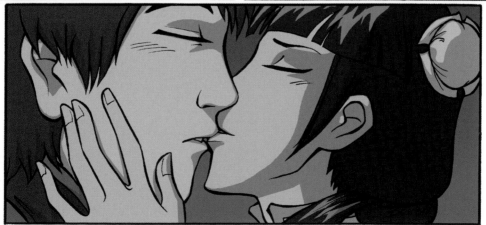

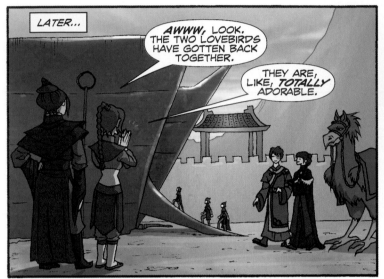

LATER...

AWWW, LOOK. THE TWO LOVEBIRDS HAVE GOTTEN BACK TOGETHER.

THEY ARE, LIKE, *TOTALLY* ADORABLE.

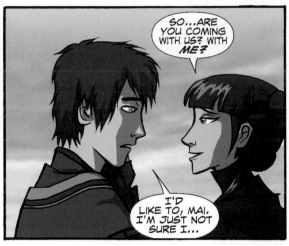

SO...ARE YOU COMING WITH US? WITH *ME?*

I'D LIKE TO, MAI. I'M JUST NOT SURE I...

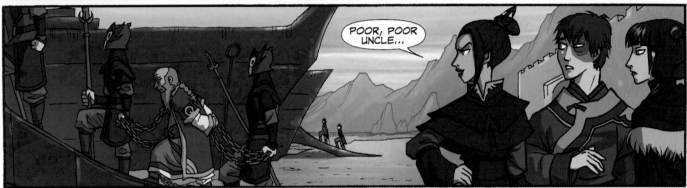

POOR, POOR UNCLE...

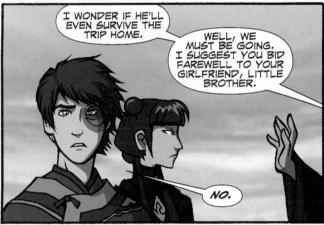

I WONDER IF HE'LL EVEN SURVIVE THE TRIP HOME.

WELL, WE MUST BE GOING. I SUGGEST YOU BID FAREWELL TO YOUR GIRLFRIEND, LITTLE BROTHER.

NO.

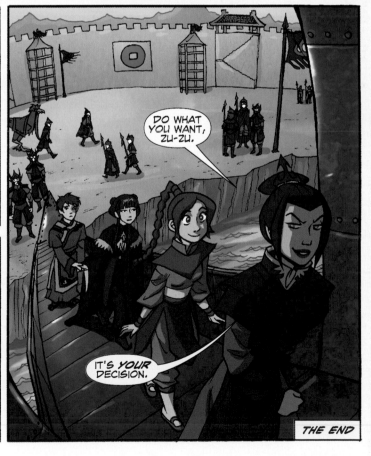

DO WHAT YOU WANT, ZU-ZU.

IT'S *YOUR* DECISION.

THE END

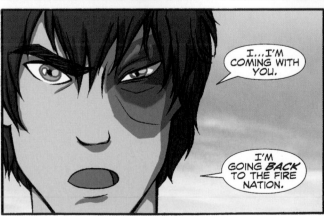

I...I'M COMING WITH YOU.

I'M GOING *BACK* TO THE FIRE NATION.

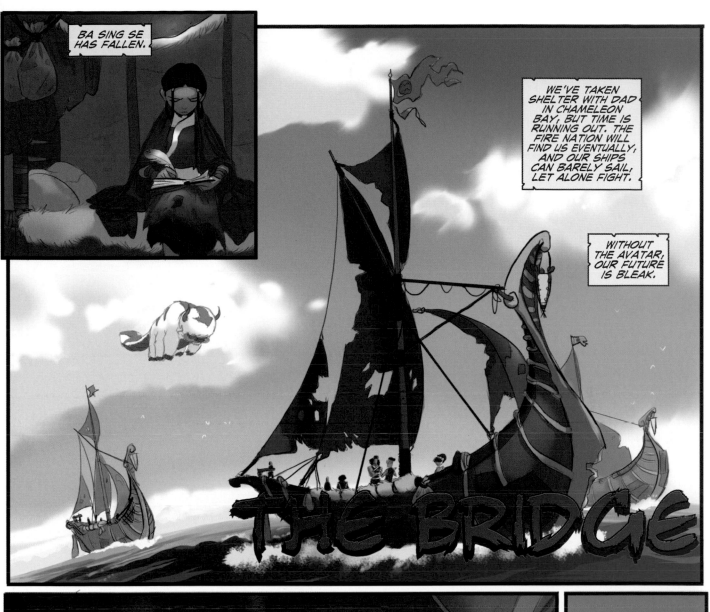

BA SING SE HAS FALLEN.

WE'VE TAKEN SHELTER WITH DAD IN CHAMELEON BAY, BUT TIME IS RUNNING OUT. THE FIRE NATION WILL FIND US EVENTUALLY, AND OUR SHIPS CAN BARELY SAIL, LET ALONE FIGHT.

WITHOUT THE AVATAR, OUR FUTURE IS BLEAK.

THE BRIDGE

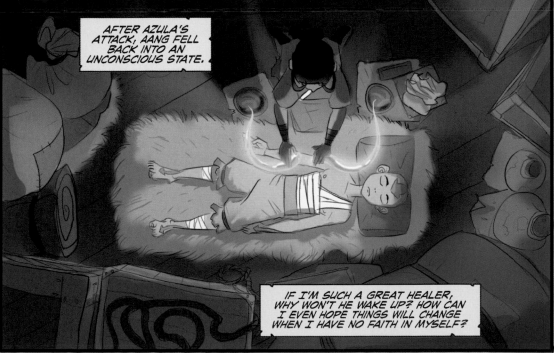

AFTER AZULA'S ATTACK, AANG FELL BACK INTO AN UNCONSCIOUS STATE.

IF I'M SUCH A GREAT HEALER, WHY WON'T HE WAKE UP? HOW CAN I EVEN HOPE THINGS WILL CHANGE WHEN I HAVE NO FAITH IN MYSELF?

Story by Joshua Hamilton, Tim Hedrick, Aaron Ehasz, and Frank Pittarese, art and colors by Reagan Lodge, and lettering by Comicraft.

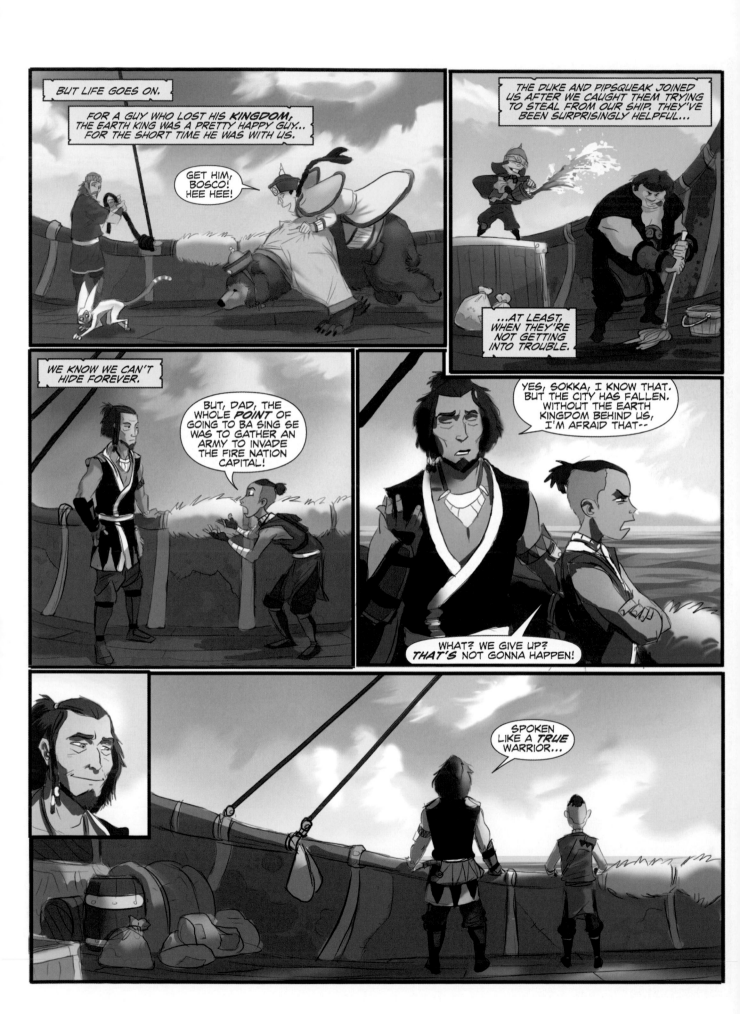

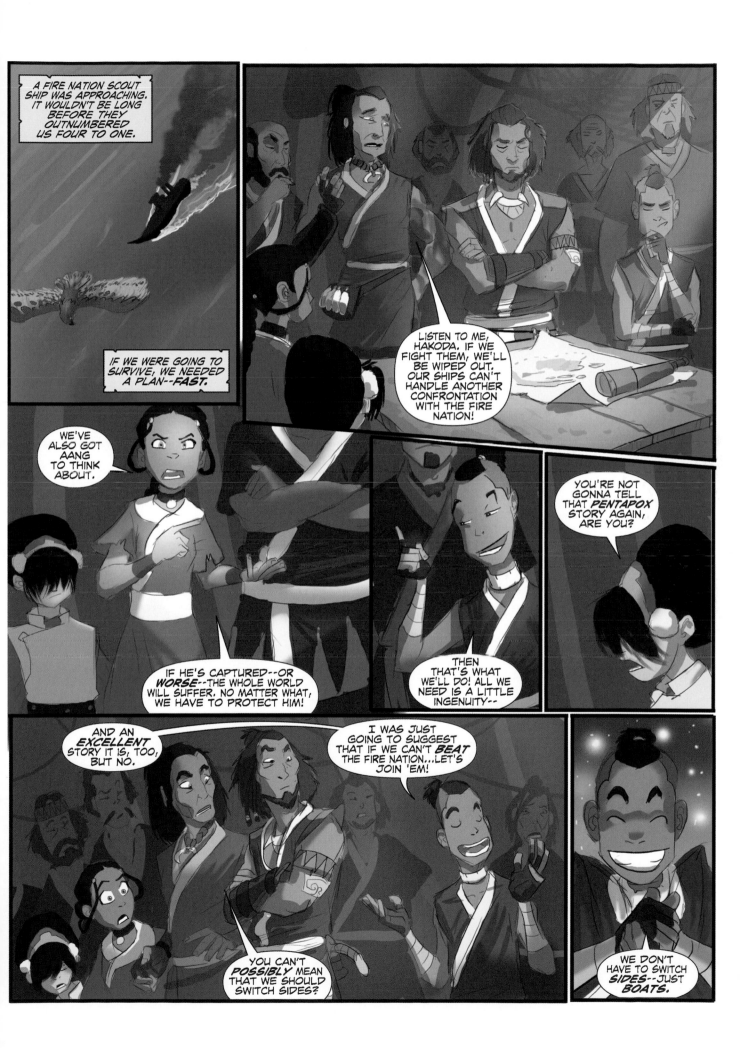

A FIRE NATION SCOUT SHIP WAS APPROACHING. IT WOULDN'T BE LONG BEFORE THEY OUTNUMBERED US FOUR TO ONE.

IF WE WERE GOING TO SURVIVE, WE NEEDED A PLAN--*FAST*.

LISTEN TO ME, HAKODA. IF WE FIGHT THEM, WE'LL BE WIPED OUT. OUR SHIPS CAN'T HANDLE ANOTHER CONFRONTATION WITH THE FIRE NATION!

WE'VE ALSO GOT AANG TO THINK ABOUT.

IF HE'S CAPTURED--OR *WORSE*--THE WHOLE WORLD WILL SUFFER. NO MATTER WHAT, WE HAVE TO PROTECT HIM!

THEN THAT'S WHAT WE'LL DO! ALL WE NEED IS A LITTLE INGENUITY--

YOU'RE NOT GONNA TELL THAT *PENTAPOX* STORY AGAIN, ARE YOU?

AND AN *EXCELLENT* STORY IT IS, TOO, BUT NO.

I WAS JUST GOING TO SUGGEST THAT IF WE CAN'T *BEAT* THE FIRE NATION...LET'S JOIN 'EM!

YOU CAN'T *POSSIBLY* MEAN THAT WE SHOULD SWITCH SIDES?

WE DON'T HAVE TO SWITCH *SIDES*--JUST *BOATS*.

101

IT WASN'T SOKKA'S **CRAZIEST** PLAN, BUT IT WAS A **RISKY** ONE. FIRST, WE FLOODED AND SANK OUR OWN SHIPS...

SPLASH

FWOOSH

BRAMM

KRAK

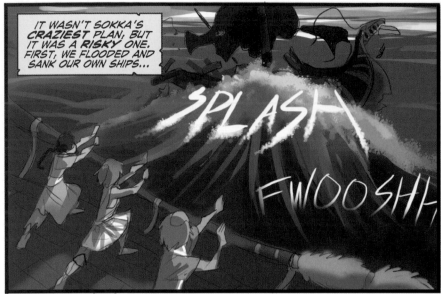
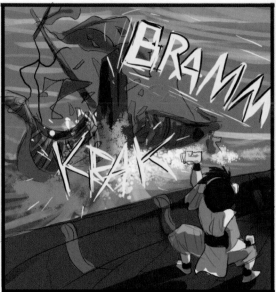

...THEN, WE **ABANDONED** THEM, LETTING THE FIRE NATION THINK WE'D ALREADY BEEN DEFEATED.

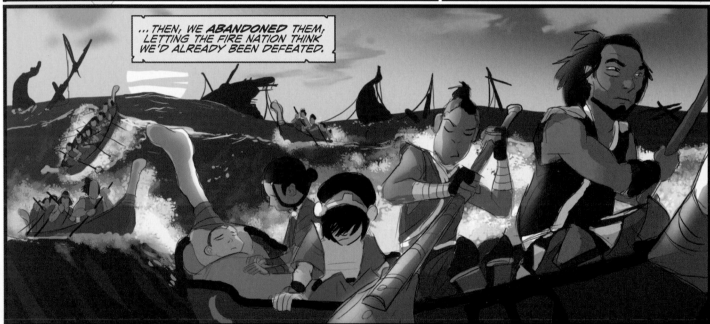

AND NOW, WE WAIT. JUST ONE BIG, HAPPY FAMILY.

BY THIS TIME TOMORROW, WE'LL BE BACK AT **SEA!**

KATARA, IT'S COLD. COME SIT BY THE FIRE...

I'M *FINE.*

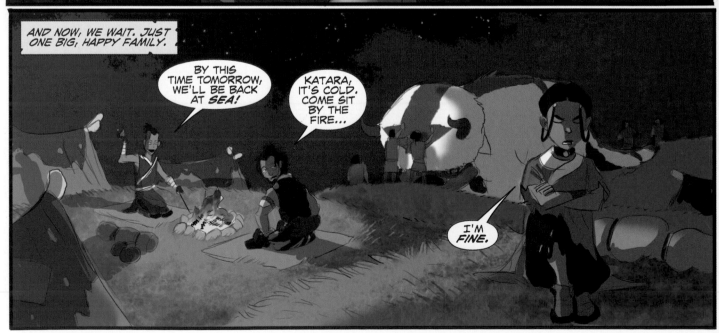

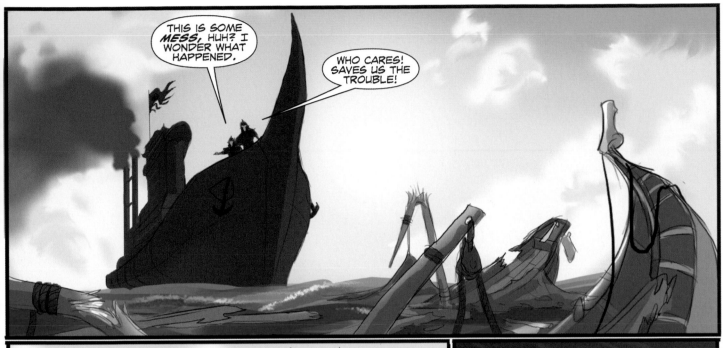

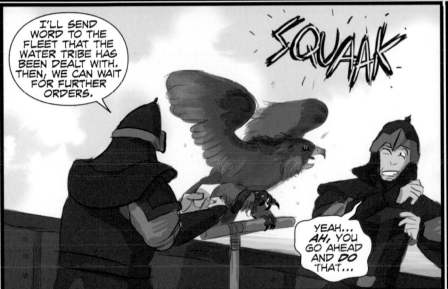

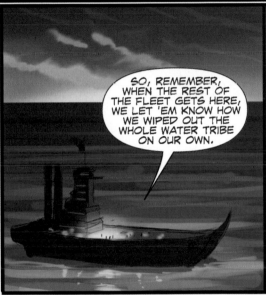

NEXT CAME THE **"EASY"** PART-- SNEAKING ABOARD A FIRE NATION SHIP IN THE DEAD OF NIGHT.

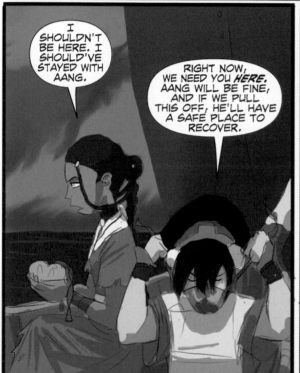

I SHOULDN'T BE HERE. I SHOULD'VE STAYED WITH AANG.

RIGHT NOW, WE NEED YOU **HERE.** AANG WILL BE FINE, AND IF WE PULL THIS OFF, HE'LL HAVE A SAFE PLACE TO RECOVER.

WE EXPECTED A **FIGHT.** BUT INSTEAD...

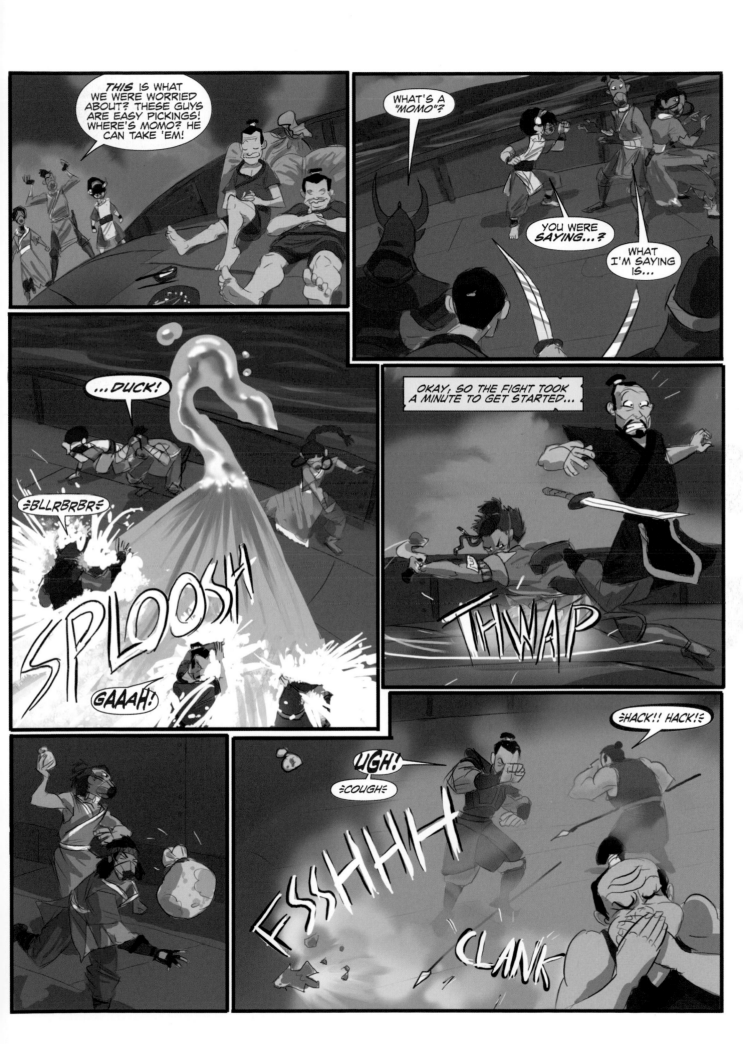

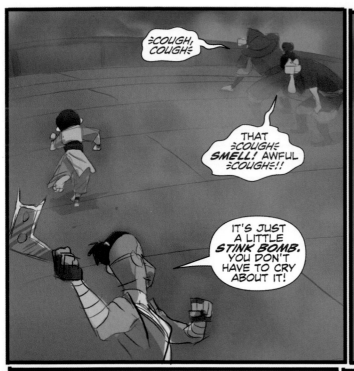

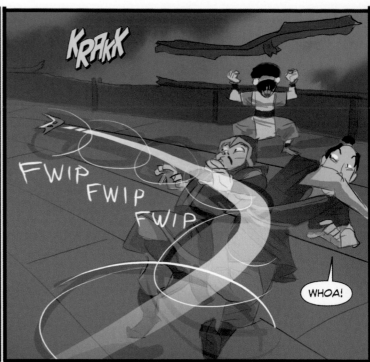

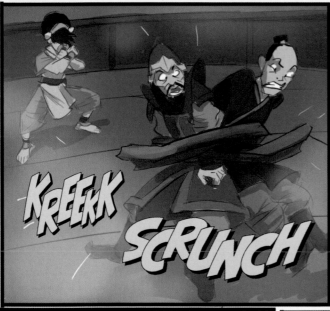

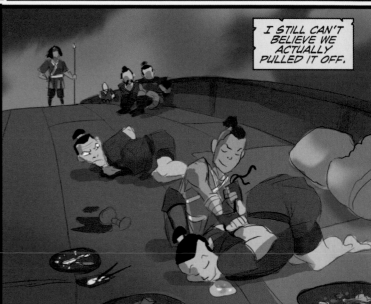

ONCE WE LEFT THE FLEET BEHIND US, IT WAS TIME FOR A CHANGE OF CLOTHES. LOOKS LIKE FIRE NATION RED IS IN FASHION THIS SEASON.

SOKKA SUGGESTED THAT WE HEAD FOR THE SERPENT'S PASS.

FROM THERE, WE CAN CUT ACROSS THE EARTH KINGDOM AND HEAD WEST FOR THE FIRE NATION.

BUT I DON'T THINK EVIL *BARRICADES* WERE ON HIS MAP.

YOU'VE GOT TO HAND IT TO THE FIRE NATION. THEY MIGHT BE TYRANTS, BUT THEY CERTAINLY ARE FINE *ENGINEERS*.

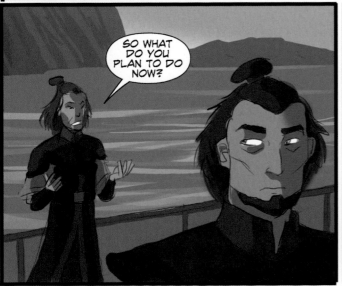

SO WHAT DO YOU PLAN TO DO NOW?

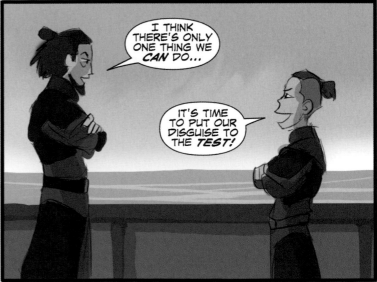

I THINK THERE'S ONLY ONE THING WE *CAN* DO...

IT'S TIME TO PUT OUR DISGUISE TO THE *TEST!*

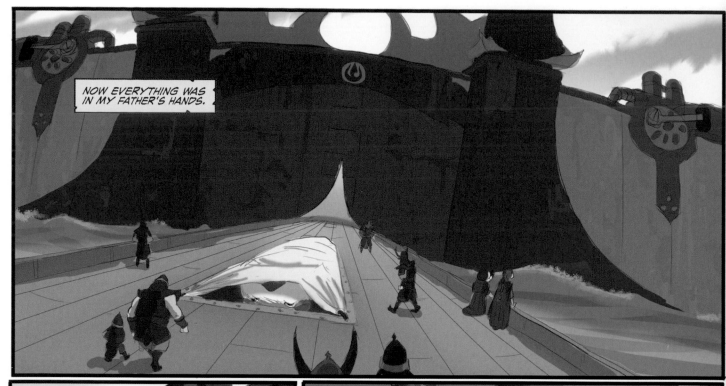

NOW EVERYTHING WAS IN MY FATHER'S HANDS.

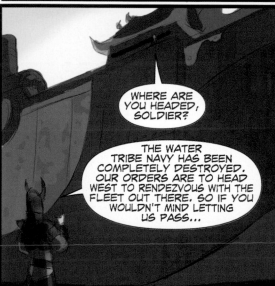

WHERE ARE YOU HEADED, SOLDIER?

THE WATER TRIBE NAVY HAS BEEN COMPLETELY DESTROYED. OUR ORDERS ARE TO HEAD WEST TO RENDEZVOUS WITH THE FLEET OUT THERE. SO IF YOU WOULDN'T MIND LETTING US PASS...

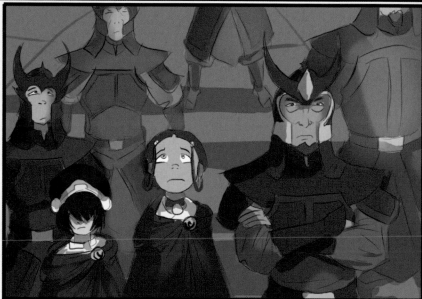

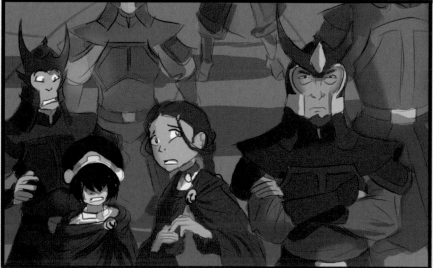

GOOD SAILING, SOLDIER!

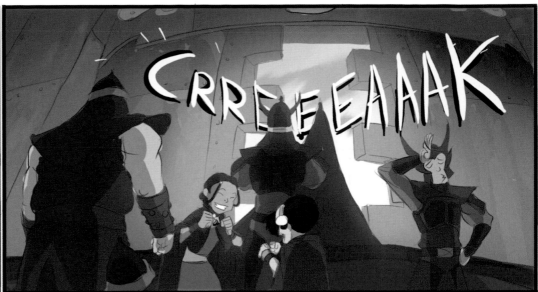

CRREEAAAK

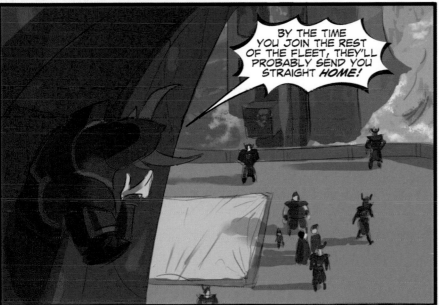

BY THE TIME YOU JOIN THE REST OF THE FLEET, THEY'LL PROBABLY SEND YOU STRAIGHT *HOME!*

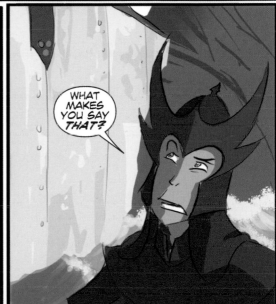

WHAT MAKES YOU SAY *THAT?*

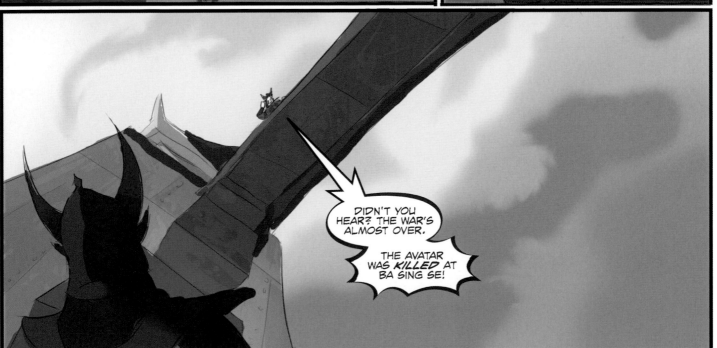

DIDN'T YOU HEAR? THE WAR'S ALMOST OVER.

THE AVATAR WAS *KILLED* AT BA SING SE!

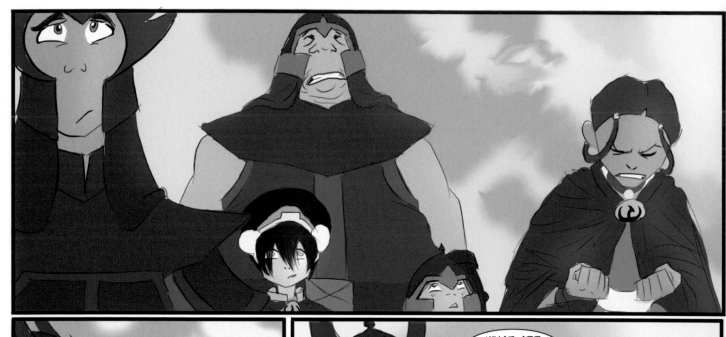

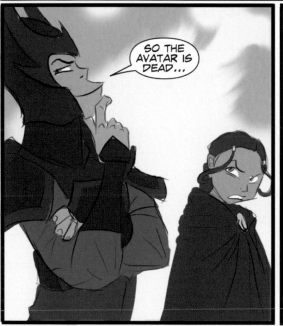

SO THE AVATAR IS DEAD...

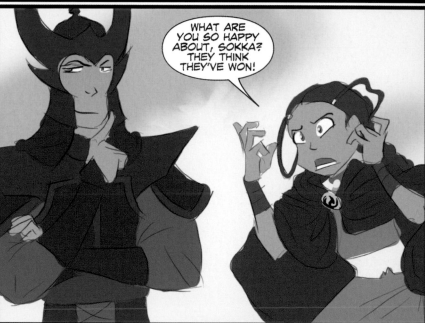

WHAT ARE YOU SO HAPPY ABOUT, SOKKA? THEY THINK THEY'VE WON!

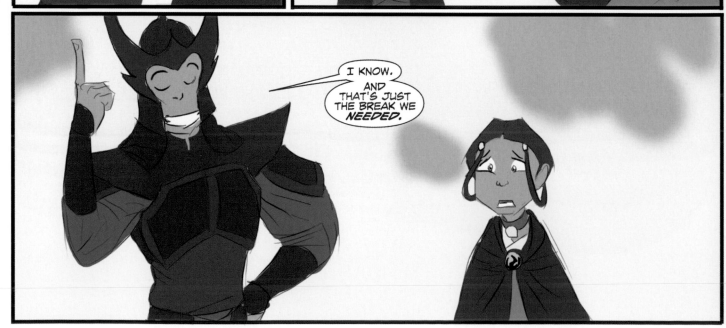

I KNOW. AND THAT'S JUST THE BREAK WE *NEEDED.*

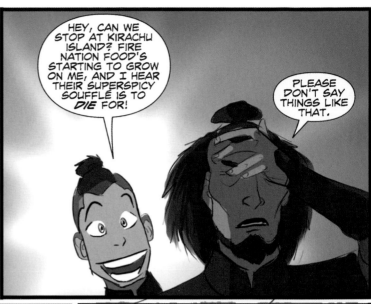

SOKKA WAS RIGHT--AGAIN. AANG'S "DEATH" WORKS TO OUR ADVANTAGE, AND NOBODY SUSPECTS WE'RE LIVING AS SOLDIERS OF THE FIRE NATION.

AND THAT'S THE BEST COURSE FOR US TO TAKE?

UNLESS YOU'VE GOT ANOTHER SUGGESTION. YOU KNOW, SON, WITH ANY LUCK, WE JUST MAY *SURVIVE* THIS EXPERIENCE.

HEY, CAN WE STOP AT KIRACHU ISLAND? FIRE NATION FOOD'S STARTING TO GROW ON ME, AND I HEAR THEIR SUPERSPICY SOUFFLE IS TO *DIE* FOR!

PLEASE DON'T SAY THINGS LIKE THAT.

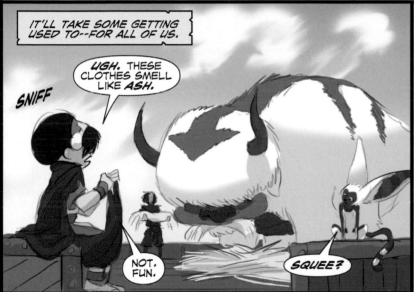

IT'LL TAKE SOME GETTING USED TO--FOR ALL OF US.

UGH. THESE CLOTHES SMELL LIKE *ASH.*

SNIFF

NOT. FUN.

SQUEE?

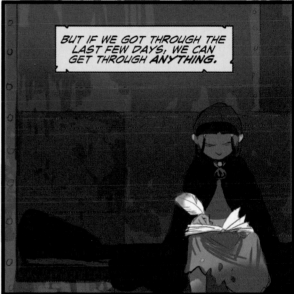

BUT IF WE GOT THROUGH THE LAST FEW DAYS, WE CAN GET THROUGH *ANYTHING.*

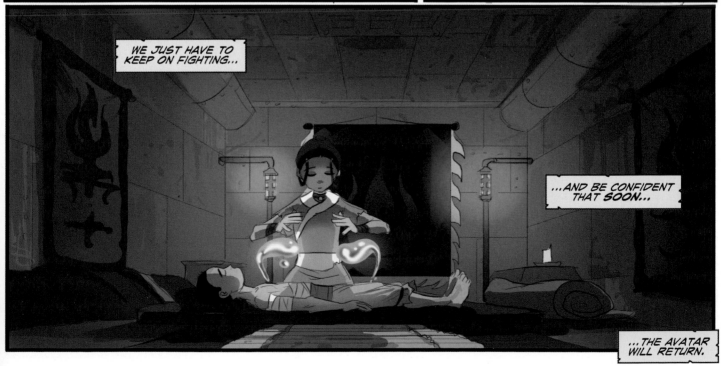

WE JUST HAVE TO KEEP ON FIGHTING...

...AND BE CONFIDENT THAT *SOON*...

...THE AVATAR WILL RETURN.

THE END

111

BOOK THREE
FIRE

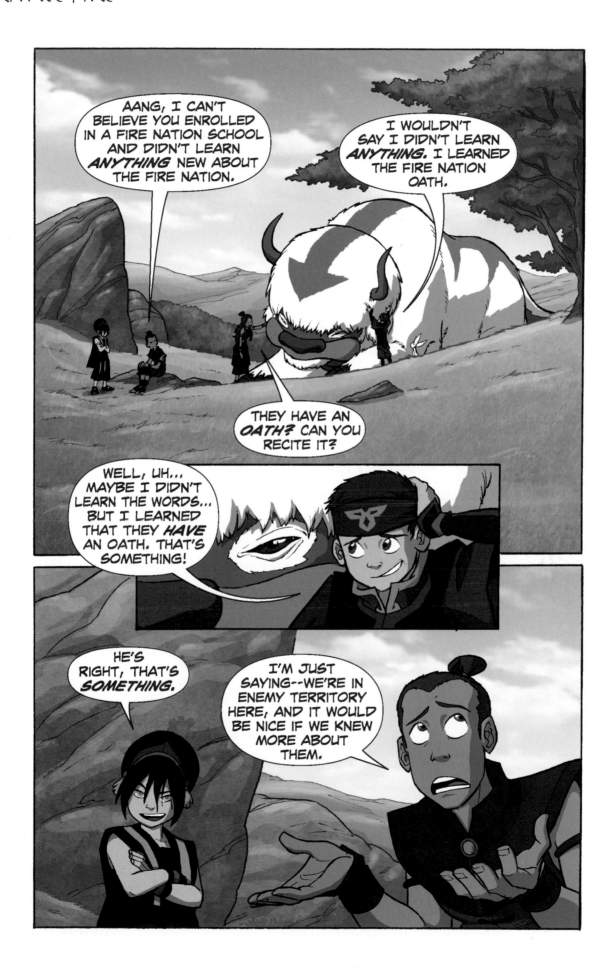

Story by Joshua Hamilton, art by Johane Matte, colors by Wes Dzioba, and lettering by Comicraft.

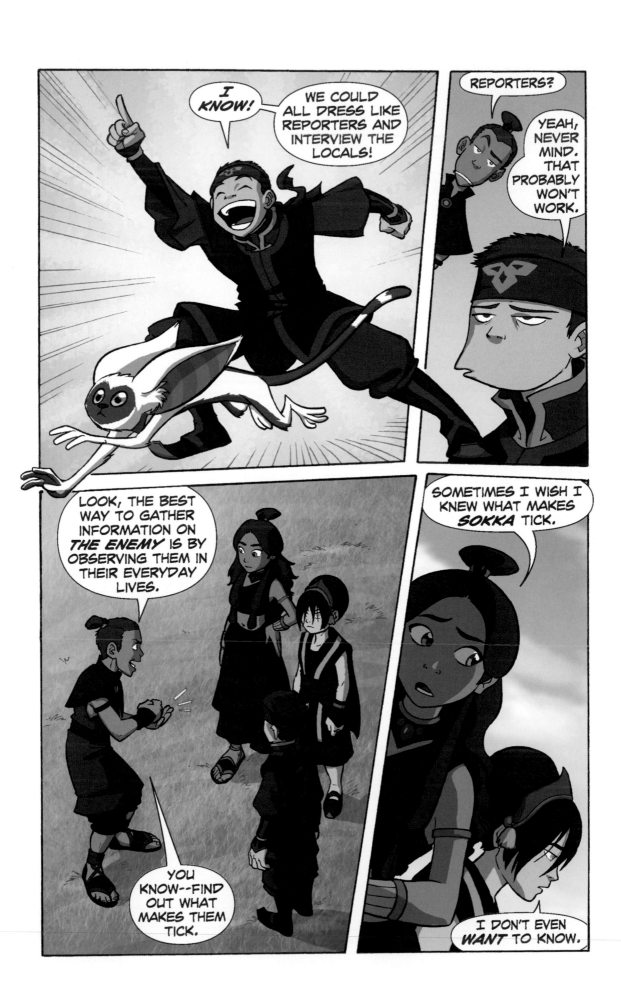

116

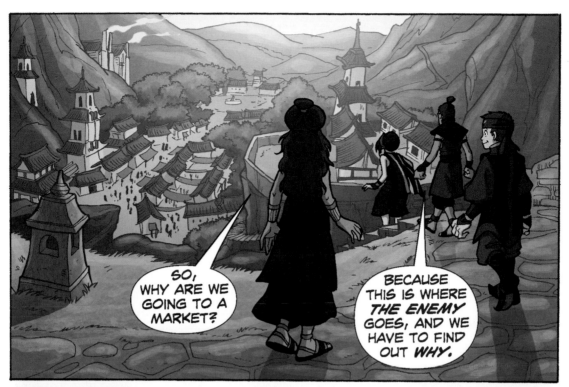

SO, WHY ARE WE GOING TO A MARKET?

BECAUSE THIS IS WHERE *THE ENEMY* GOES, AND WE HAVE TO FIND OUT *WHY.*

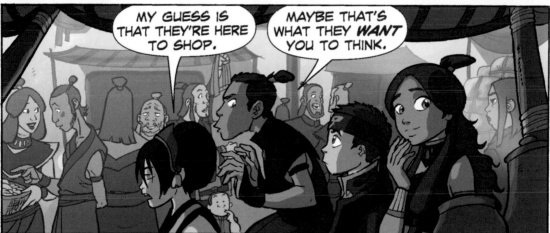

MY GUESS IS THAT THEY'RE HERE TO SHOP.

MAYBE THAT'S WHAT THEY *WANT* YOU TO THINK.

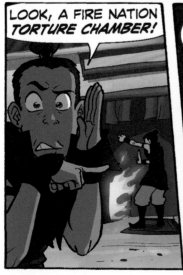

LOOK, A FIRE NATION *TORTURE CHAMBER!*

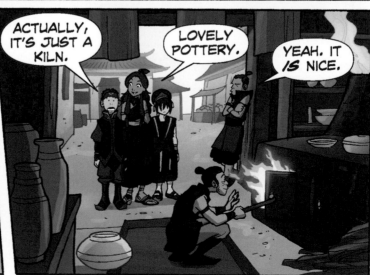

ACTUALLY, IT'S JUST A KILN.

LOVELY POTTERY.

YEAH. IT *IS* NICE.

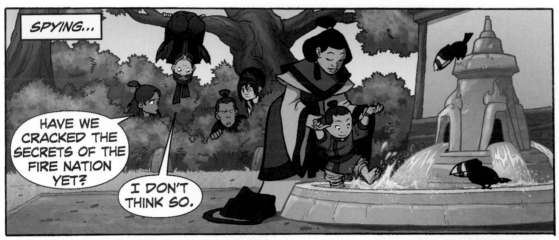

SPYING...

HAVE WE CRACKED THE SECRETS OF THE FIRE NATION YET?

I DON'T THINK SO.

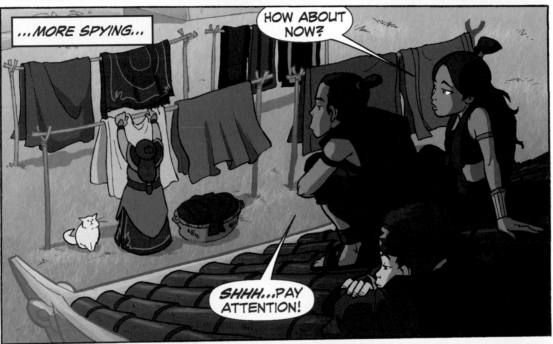

...MORE SPYING...

HOW ABOUT NOW?

SHHH...PAY ATTENTION!

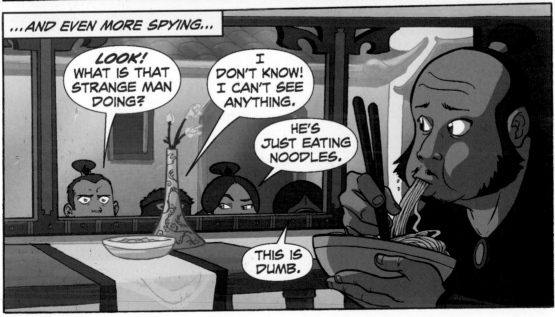

...AND EVEN MORE SPYING...

LOOK! WHAT IS THAT STRANGE MAN DOING?

I DON'T KNOW! I CAN'T SEE ANYTHING.

HE'S JUST EATING NOODLES.

THIS IS DUMB.

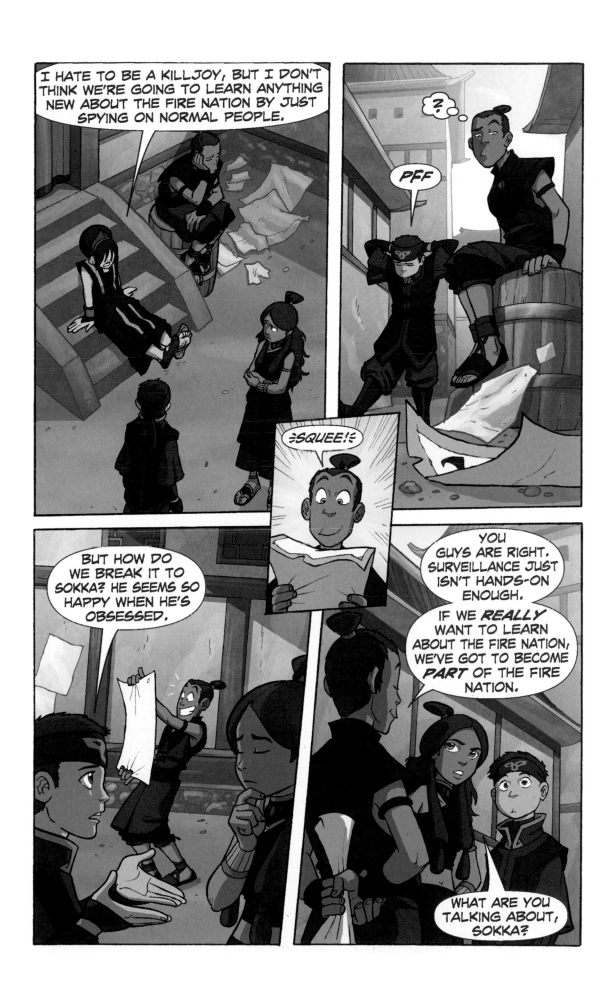

I HATE TO BE A KILLJOY, BUT I DON'T THINK WE'RE GOING TO LEARN ANYTHING NEW ABOUT THE FIRE NATION BY JUST SPYING ON NORMAL PEOPLE.

?

PFF

≶SQUEE!≶

BUT HOW DO WE BREAK IT TO SOKKA? HE SEEMS SO HAPPY WHEN HE'S OBSESSED.

YOU GUYS ARE RIGHT. SURVEILLANCE JUST ISN'T HANDS-ON ENOUGH.

IF WE *REALLY* WANT TO LEARN ABOUT THE FIRE NATION, WE'VE GOT TO BECOME *PART* OF THE FIRE NATION.

WHAT ARE YOU TALKING ABOUT, SOKKA?

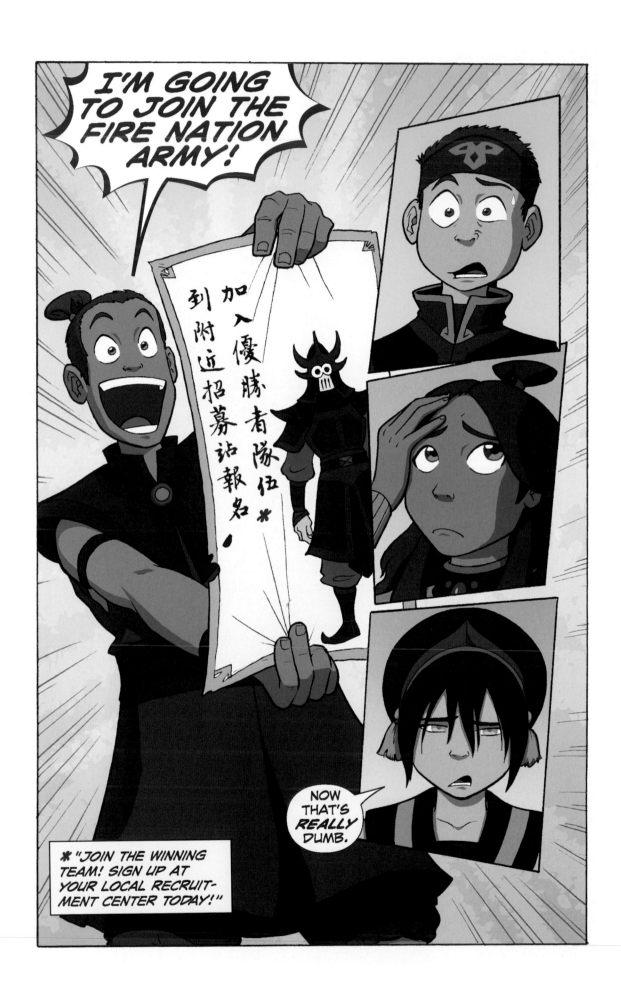

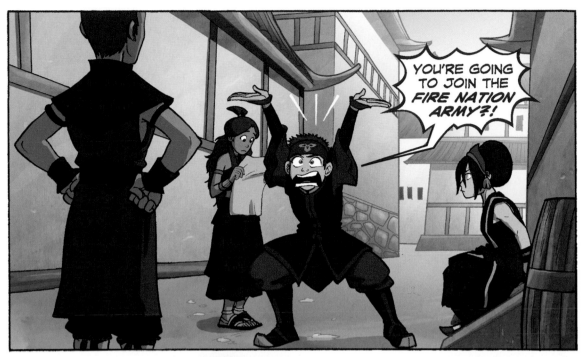

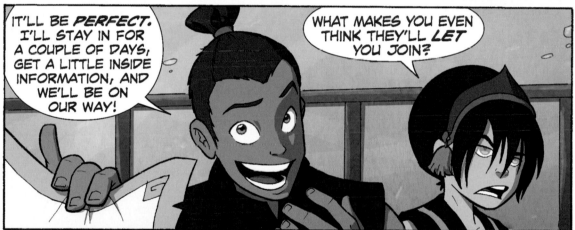

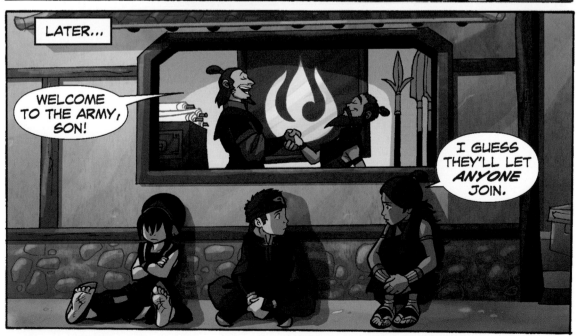

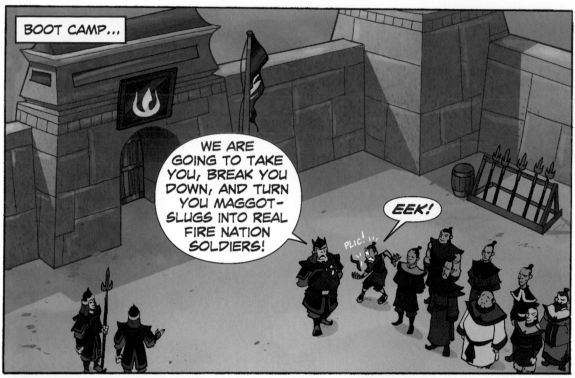

BOOT CAMP...

WE ARE GOING TO TAKE YOU, BREAK YOU DOWN, AND TURN YOU MAGGOT-SLUGS INTO REAL FIRE NATION SOLDIERS!

PLIC!

EEK!

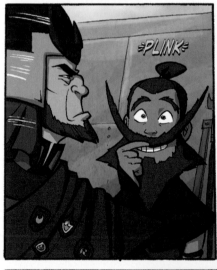

PLINK

?

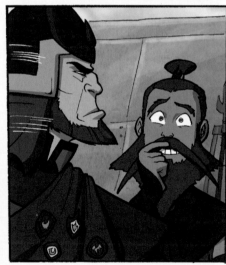

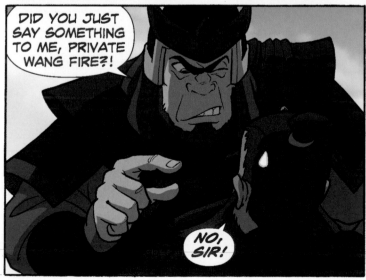

DID YOU JUST SAY SOMETHING TO ME, PRIVATE WANG FIRE?!

NO, SIR!

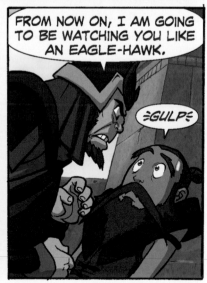

FROM NOW ON, I AM GOING TO BE WATCHING YOU LIKE AN EAGLE-HAWK.

GULP

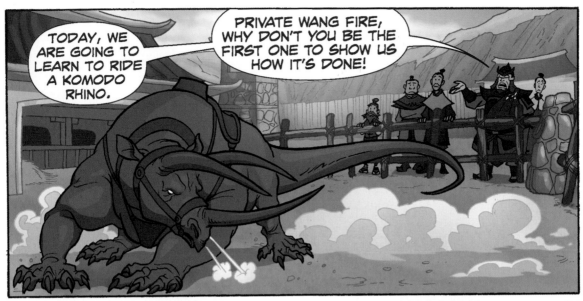

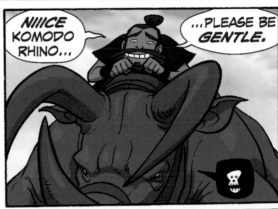

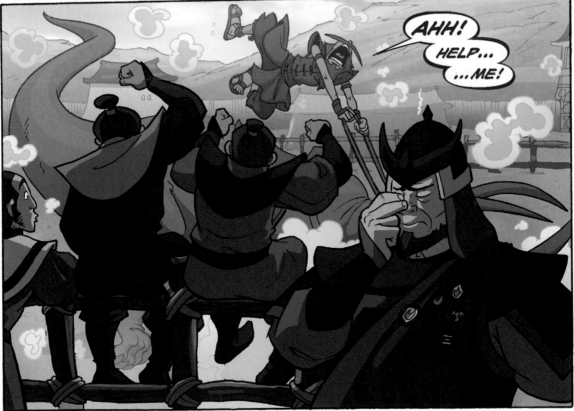

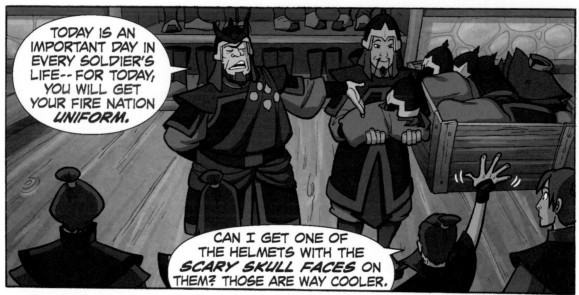

TODAY IS AN IMPORTANT DAY IN EVERY SOLDIER'S LIFE-- FOR TODAY, YOU WILL GET YOUR FIRE NATION *UNIFORM.*

CAN I GET ONE OF THE HELMETS WITH THE *SCARY SKULL FACES* ON THEM? THOSE ARE WAY COOLER.

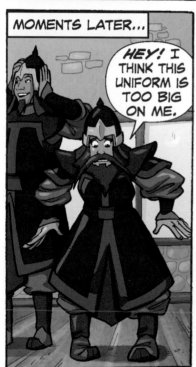

MOMENTS LATER...

HEY! I THINK THIS UNIFORM IS TOO BIG ON ME.

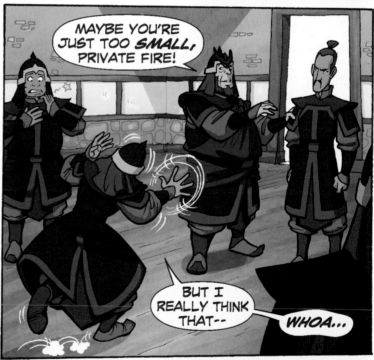

MAYBE YOU'RE JUST TOO *SMALL,* PRIVATE FIRE!

BUT I REALLY THINK THAT--

WHOA...

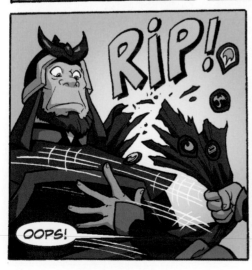

RIP!

OOPS!

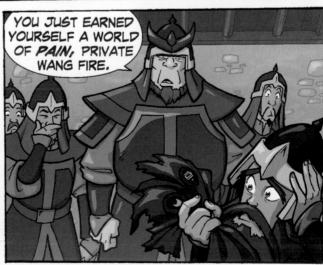

YOU JUST EARNED YOURSELF A WORLD OF *PAIN,* PRIVATE WANG FIRE.

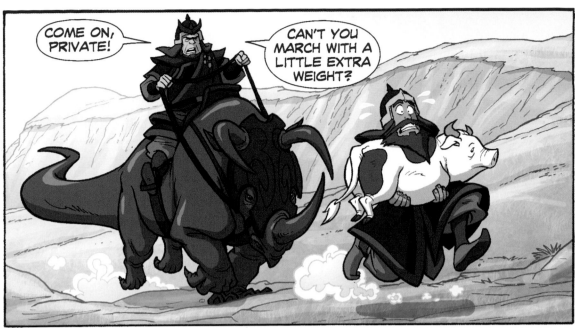

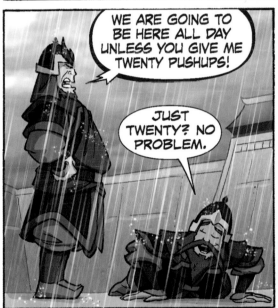

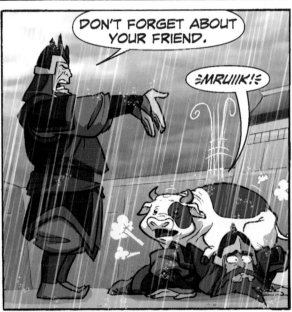

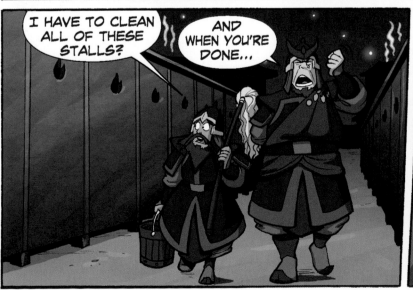

LATER...

DID YOU HEAR THE NEWS?

NEWS?!

IT'S UNBELIEVABLE. THESE GUYS BARELY HAVE ANY TRAINING.

WELL, IT LOOKS LIKE THE DECISION'S ALREADY BEEN MADE...

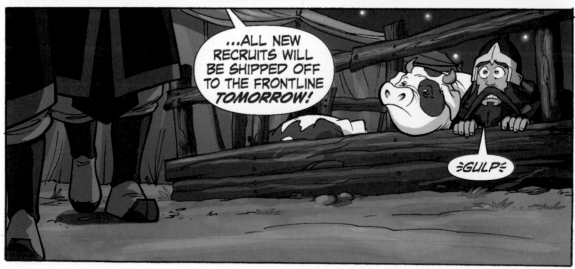

...ALL NEW RECRUITS WILL BE SHIPPED OFF TO THE FRONTLINE TOMORROW!

=GULP=

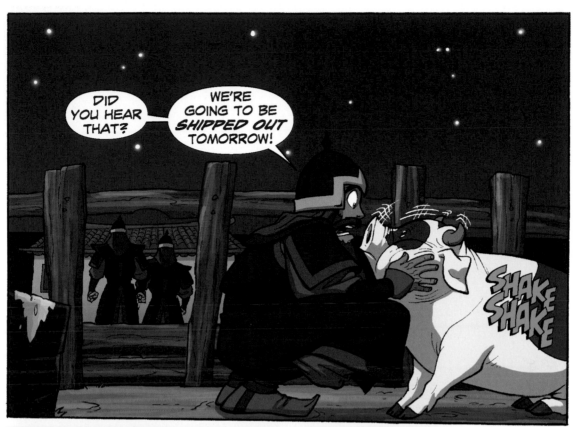

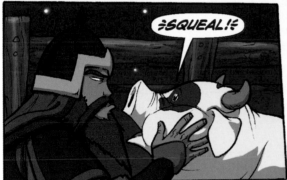

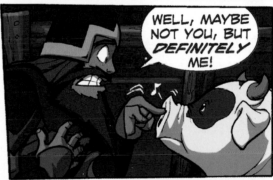

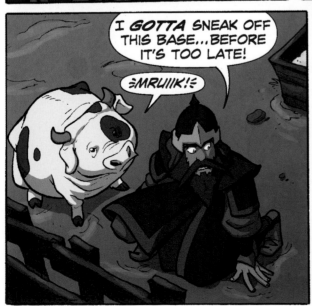

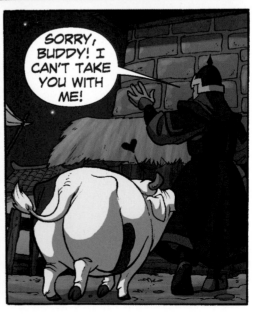

127

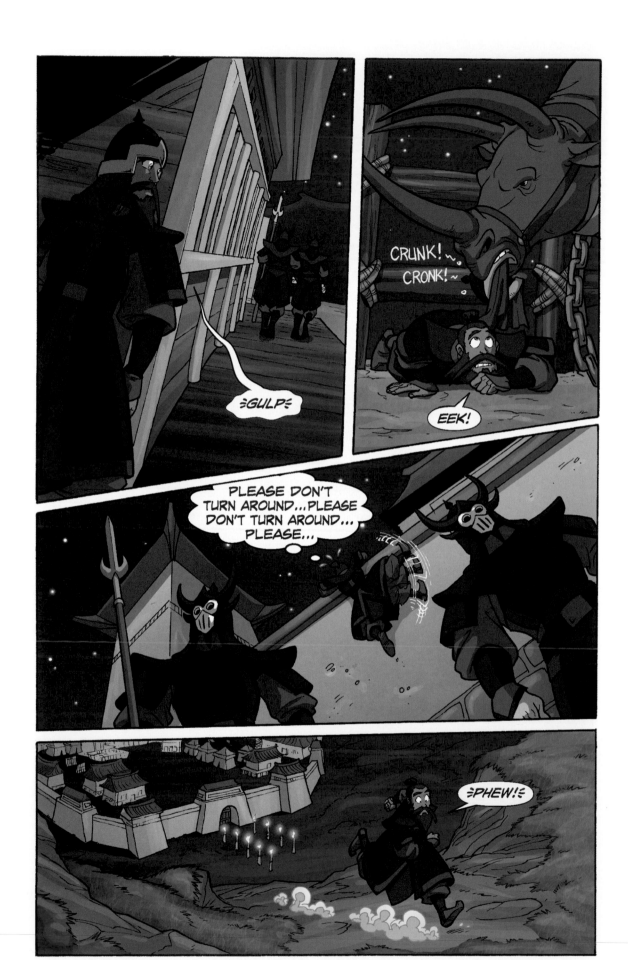

RISE AND
SHINE!

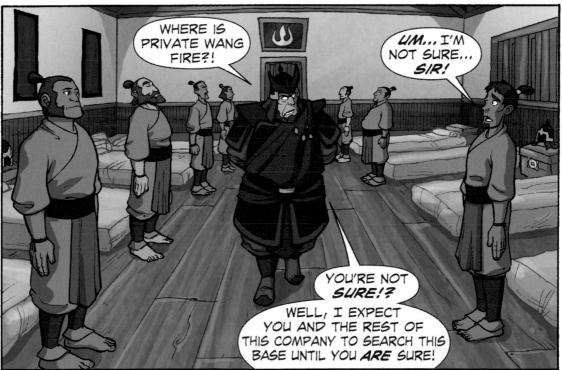

WHERE IS
PRIVATE WANG
FIRE?!

UM... I'M
NOT SURE...
SIR!

YOU'RE NOT
SURE!?

WELL, I EXPECT
YOU AND THE REST OF
THIS COMPANY TO SEARCH THIS
BASE UNTIL YOU ARE SURE!

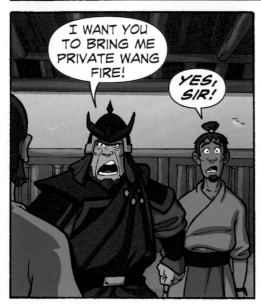

I WANT YOU
TO BRING ME
PRIVATE WANG
FIRE!

YES,
SIR!

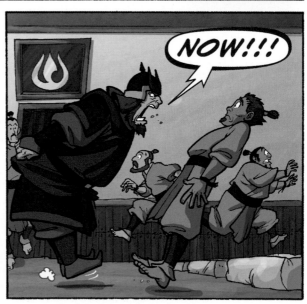

NOW!!!

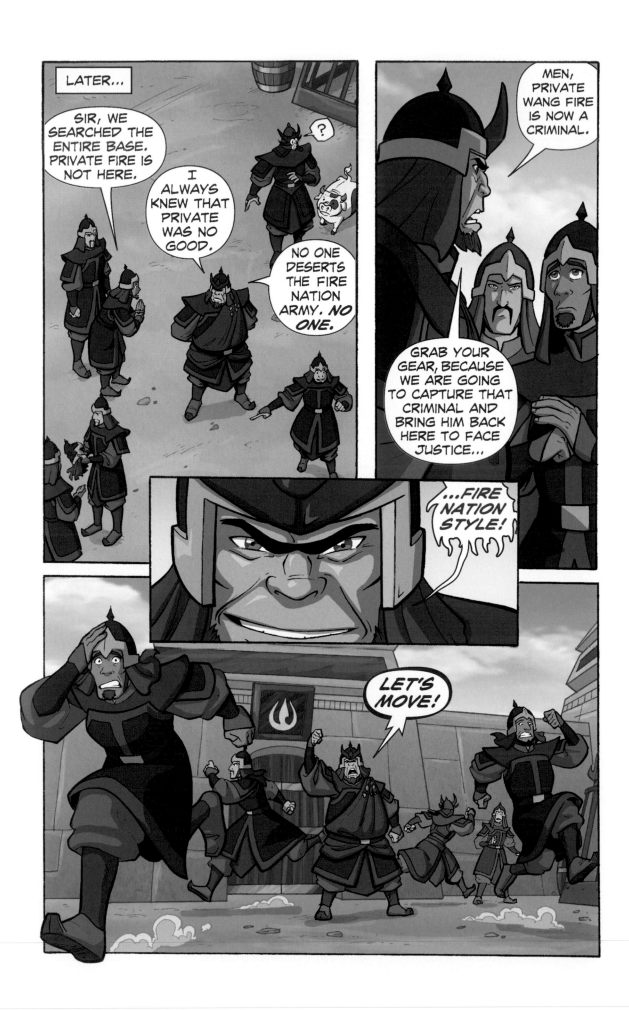

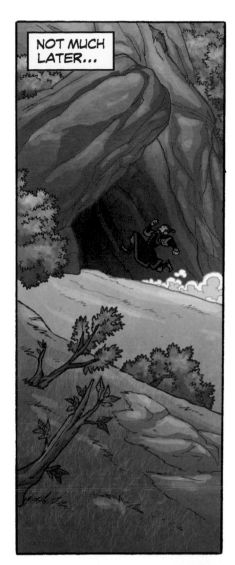

NOT MUCH LATER...

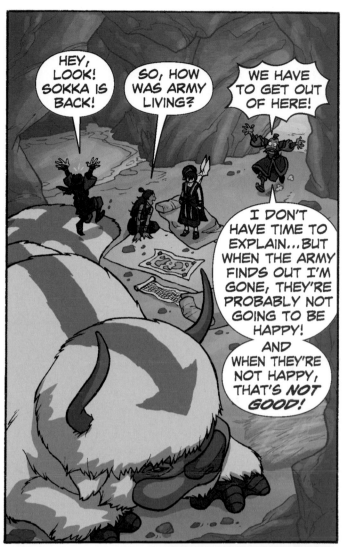

HEY, LOOK! SOKKA IS BACK!

SO, HOW WAS ARMY LIVING?

WE HAVE TO GET OUT OF HERE!

I DON'T HAVE TIME TO EXPLAIN...BUT WHEN THE ARMY FINDS OUT I'M GONE, THEY'RE PROBABLY NOT GOING TO BE HAPPY!

AND WHEN THEY'RE NOT HAPPY, THAT'S *NOT GOOD!*

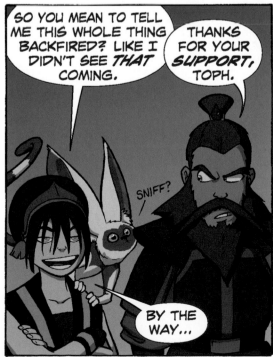

SO YOU MEAN TO TELL ME THIS WHOLE THING BACKFIRED? LIKE I DIDN'T SEE *THAT* COMING.

THANKS FOR YOUR *SUPPORT,* TOPH.

SNIFF?

BY THE WAY...

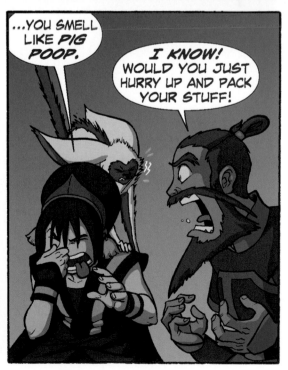

...YOU SMELL LIKE *PIG POOP.*

I KNOW! WOULD YOU JUST HURRY UP AND PACK YOUR STUFF!

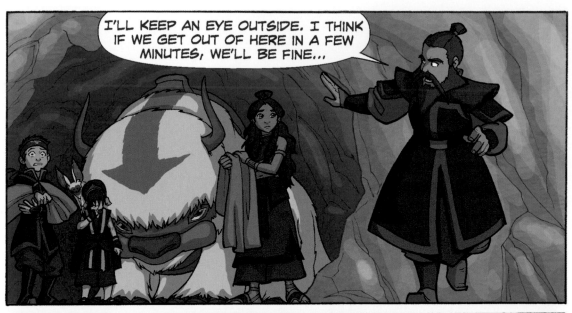

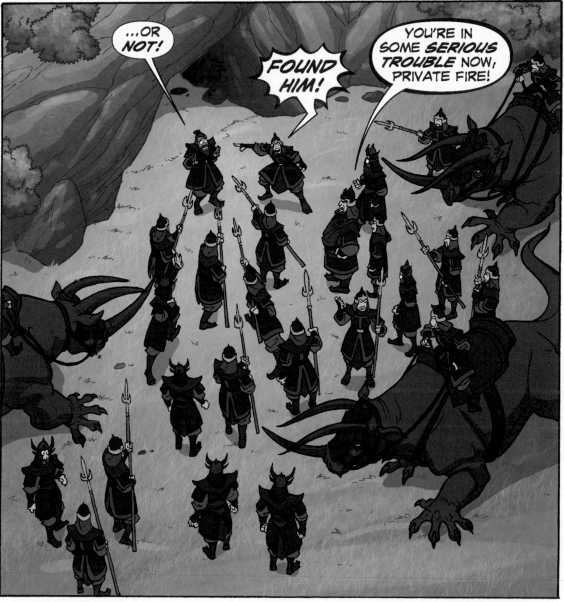

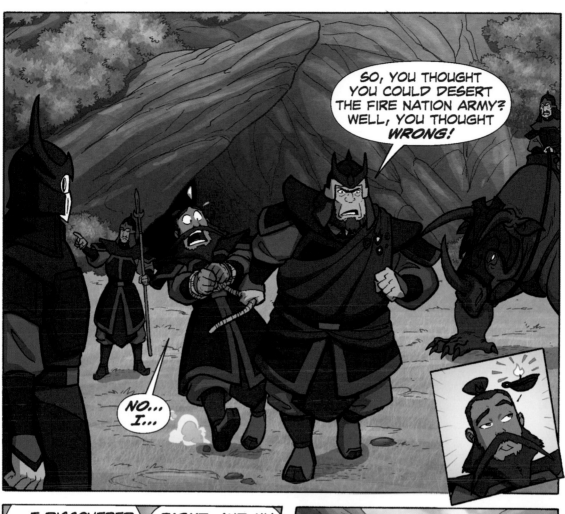

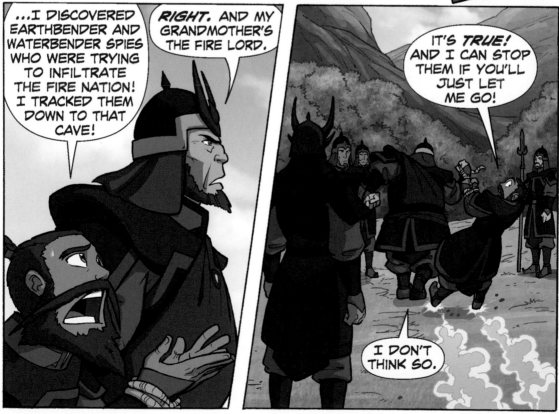

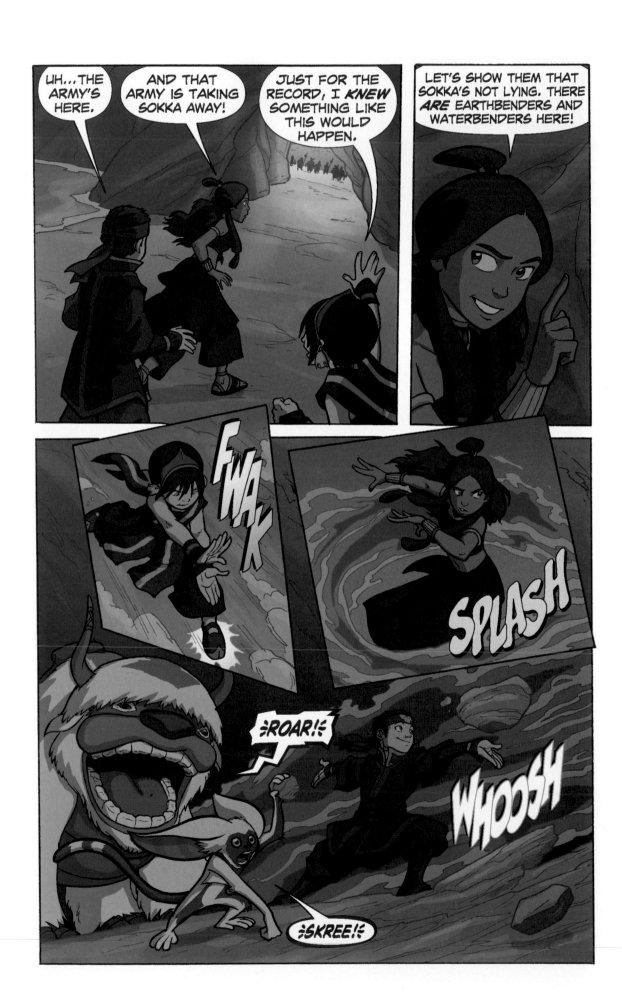

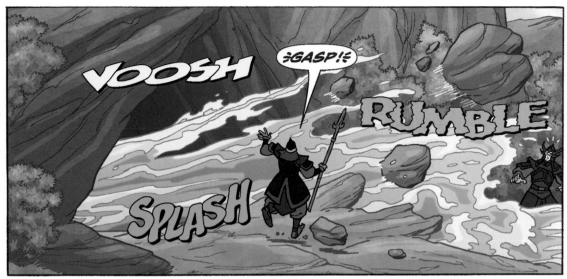

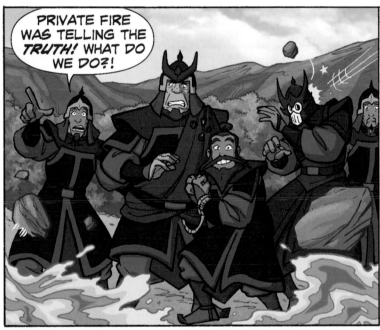

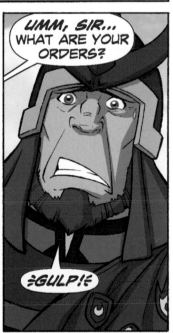

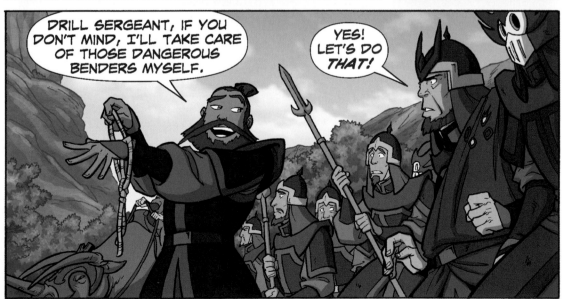

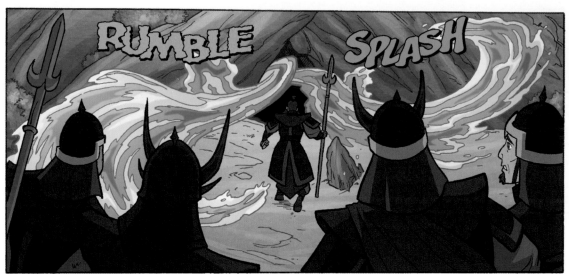

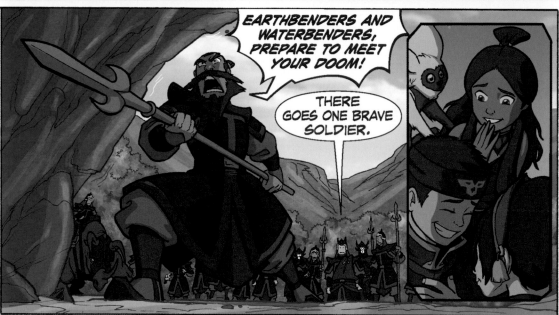

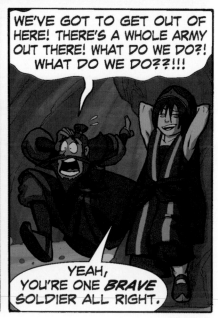

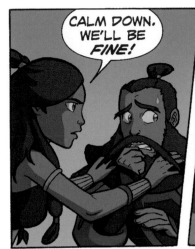

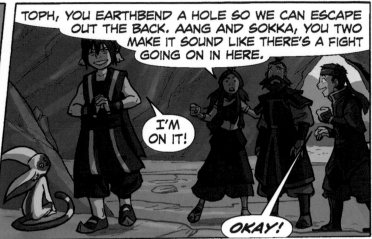

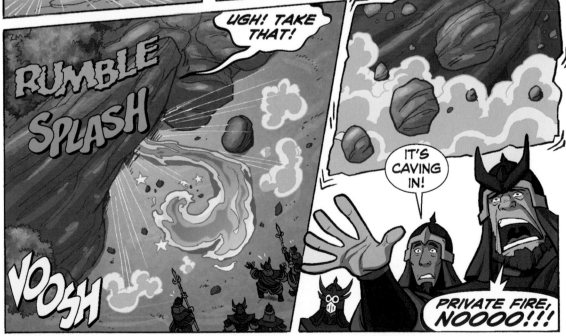

137

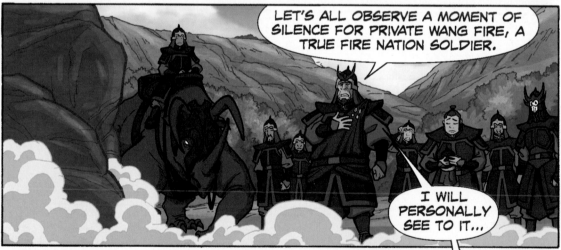

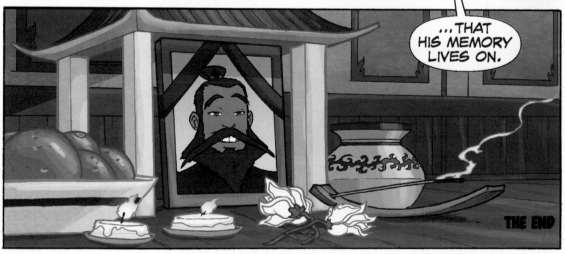

THE END

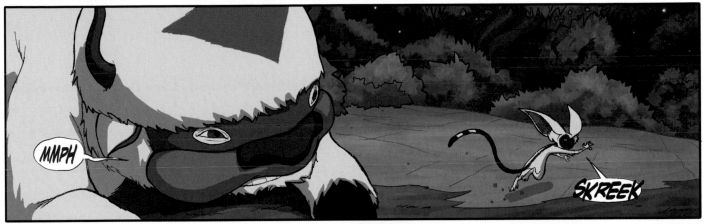

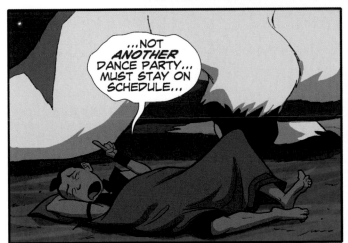

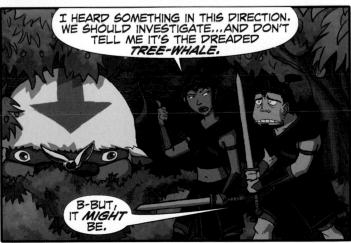

Story by Katie Mattila, art by Justin Ridge, colors by Wes Dzioba, and lettering by Comicraft.

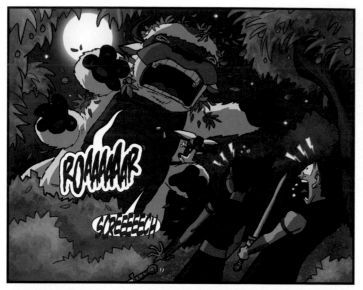

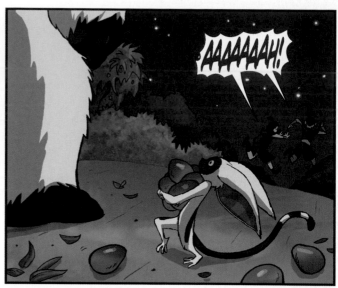

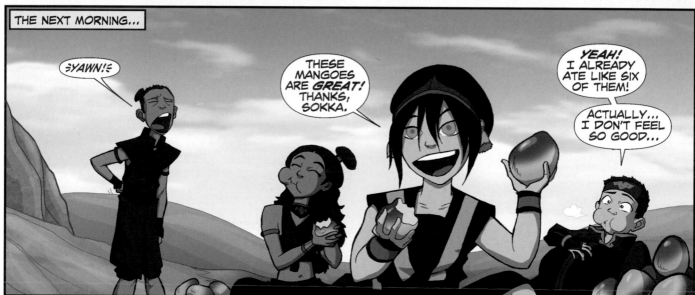

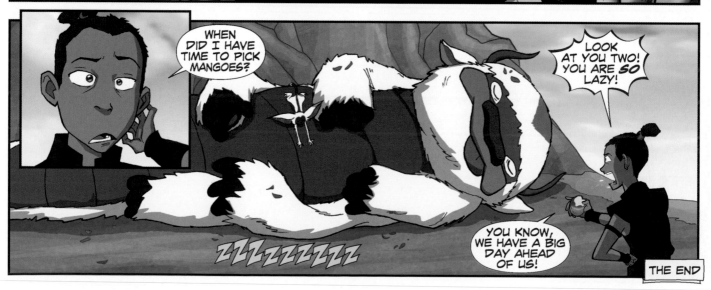

THE END

Boys' Day Out

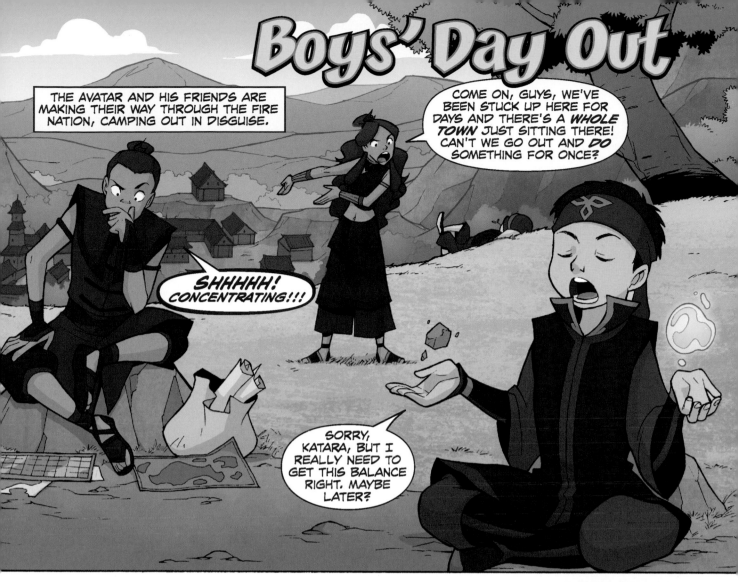

THE AVATAR AND HIS FRIENDS ARE MAKING THEIR WAY THROUGH THE FIRE NATION, CAMPING OUT IN DISGUISE.

COME ON, GUYS, WE'VE BEEN STUCK UP HERE FOR DAYS AND THERE'S A *WHOLE TOWN* JUST SITTING THERE! CAN'T WE GO OUT AND *DO* SOMETHING FOR ONCE?

SHHHHH! CONCENTRATING!!!

SORRY, KATARA, BUT I REALLY NEED TO GET THIS BALANCE RIGHT. MAYBE LATER?

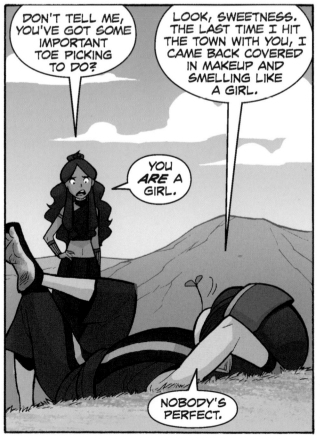

DON'T TELL ME, YOU'VE GOT SOME IMPORTANT TOE PICKING TO DO?

LOOK, SWEETNESS. THE LAST TIME I HIT THE TOWN WITH YOU, I CAME BACK COVERED IN MAKEUP AND SMELLING LIKE A GIRL.

YOU *ARE* A GIRL.

NOBODY'S PERFECT.

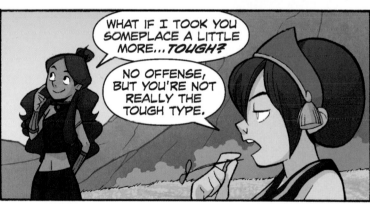

WHAT IF I TOOK YOU SOMEPLACE A LITTLE MORE...*TOUGH?*

NO OFFENSE, BUT YOU'RE NOT REALLY THE TOUGH TYPE.

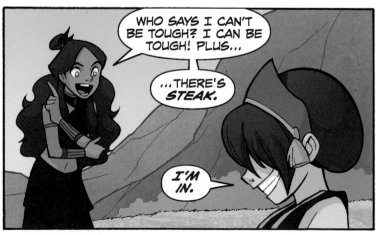

WHO SAYS I CAN'T BE TOUGH? I CAN BE TOUGH! PLUS...

...THERE'S *STEAK.*

I'M IN.

Story by Alison Wilgus, art and colors by Gurihiru, and lettering by Comicraft.

NICE.

VERY NICE.

SLURP CLANK

WHOO HOO!

I GOTTA HAND IT TO YOU, KATARA. THIS ACTUALLY SEEMS LIKE IT COULD BE *FUN.*

CAN I *HELP* YOU?

YES, ACTUALLY! TWO FOR DINNER, PLEASE!

SNORT

I DON'T THINK SO, KID.

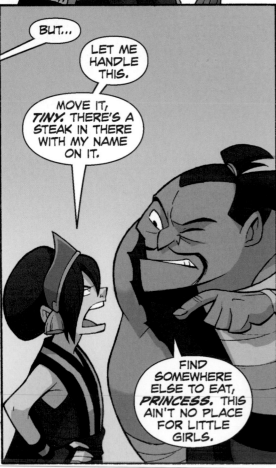

BUT...

LET ME HANDLE THIS.

MOVE IT, *TINY.* THERE'S A STEAK IN THERE WITH MY NAME ON IT.

FIND SOMEWHERE ELSE TO EAT, *PRINCESS.* THIS AIN'T NO PLACE FOR LITTLE GIRLS.

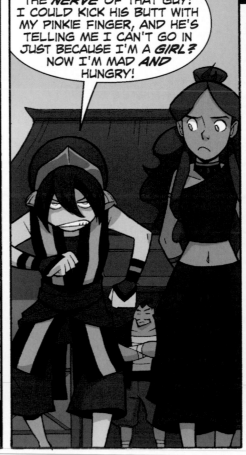

THE *NERVE* OF THAT GUY! I COULD KICK HIS BUTT WITH MY PINKIE FINGER, AND HE'S TELLING ME I CAN'T GO IN JUST BECAUSE I'M A *GIRL?* NOW I'M MAD *AND* HUNGRY!

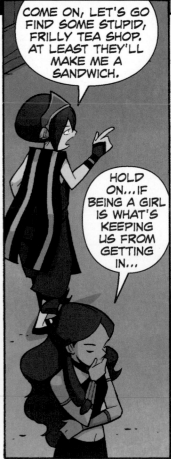

COME ON, LET'S GO FIND SOME STUPID, FRILLY TEA SHOP. AT LEAST THEY'LL MAKE ME A SANDWICH.

HOLD ON...IF BEING A GIRL IS WHAT'S KEEPING US FROM GETTING IN...

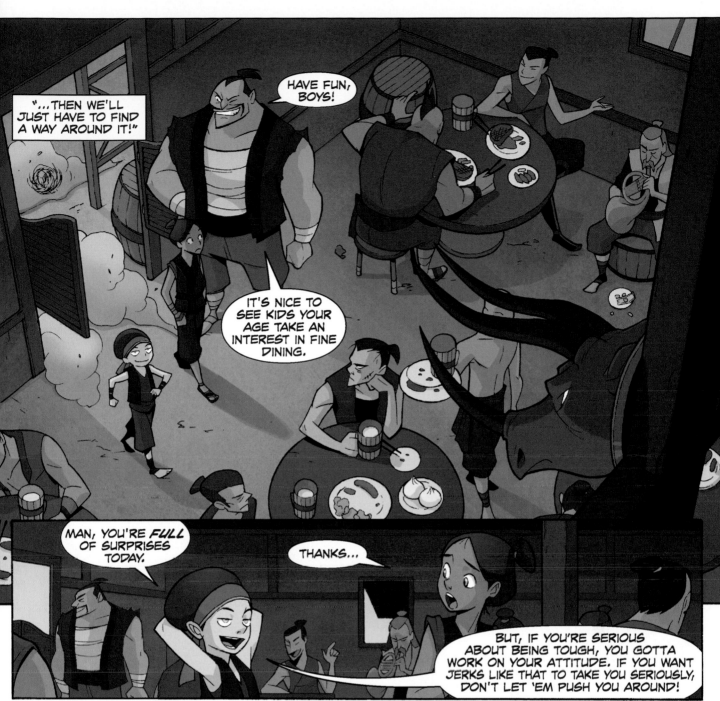

"...THEN WE'LL JUST HAVE TO FIND A WAY AROUND IT!"

HAVE FUN, BOYS!

IT'S NICE TO SEE KIDS YOUR AGE TAKE AN INTEREST IN FINE DINING.

MAN, YOU'RE *FULL* OF SURPRISES TODAY.

THANKS...

BUT, IF YOU'RE SERIOUS ABOUT BEING TOUGH, YOU GOTTA WORK ON YOUR ATTITUDE. IF YOU WANT JERKS LIKE THAT TO TAKE YOU SERIOUSLY, DON'T LET 'EM PUSH YOU AROUND!

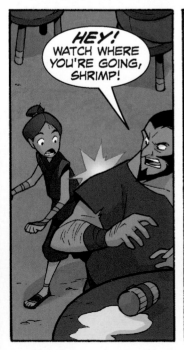

HEY! WATCH WHERE YOU'RE GOING, SHRIMP!

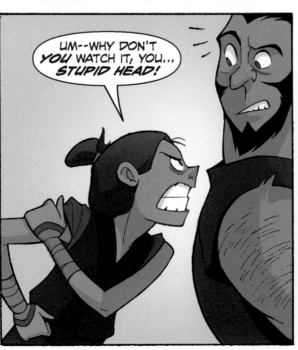

UM--WHY DON'T *YOU* WATCH IT, YOU... *STUPID HEAD!*

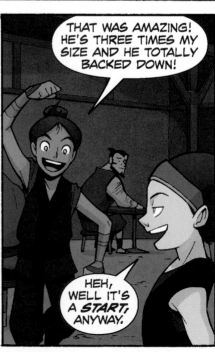

THAT WAS AMAZING! HE'S THREE TIMES MY SIZE AND HE TOTALLY BACKED DOWN!

HEH, WELL IT'S A *START*, ANYWAY.

143

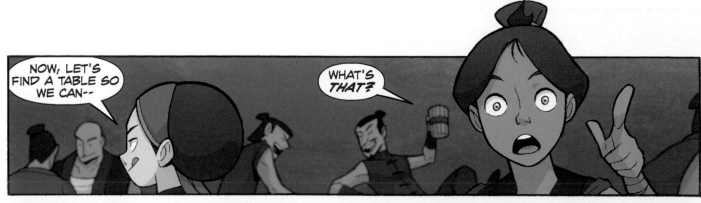

NOW, LET'S FIND A TABLE SO WE CAN--

WHAT'S *THAT?*

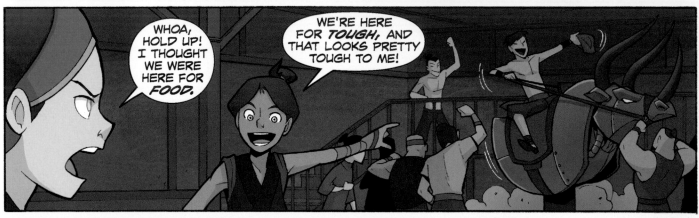

WHOA, HOLD UP! I THOUGHT WE WERE HERE FOR *FOOD.*

WE'RE HERE FOR *TOUGH,* AND THAT LOOKS PRETTY TOUGH TO ME!

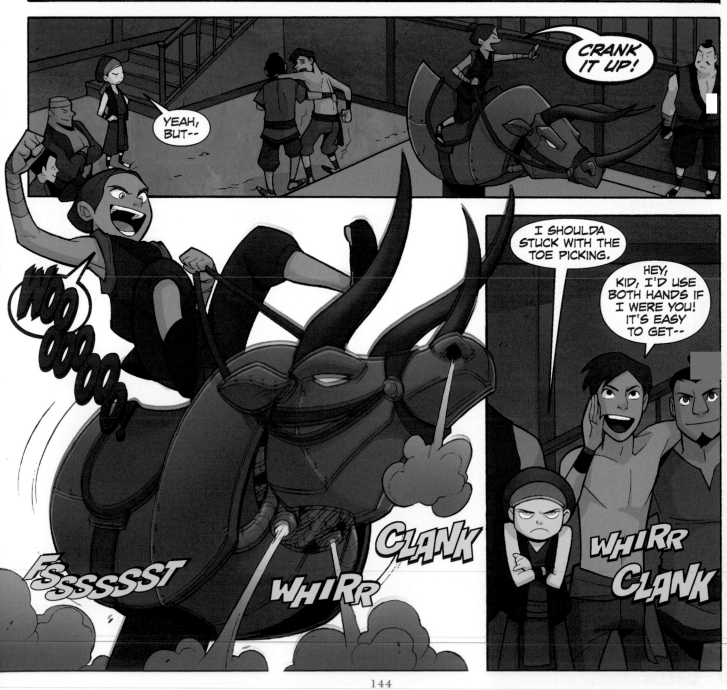

YEAH, BUT--

CRANK IT UP!

HOOOOOOO

I SHOULDA STUCK WITH THE TOE PICKING.

HEY, KID, I'D USE BOTH HANDS IF I WERE YOU! IT'S EASY TO GET--

FSSSSSST

WHIRR

CLANK

WHIRR

CLANK

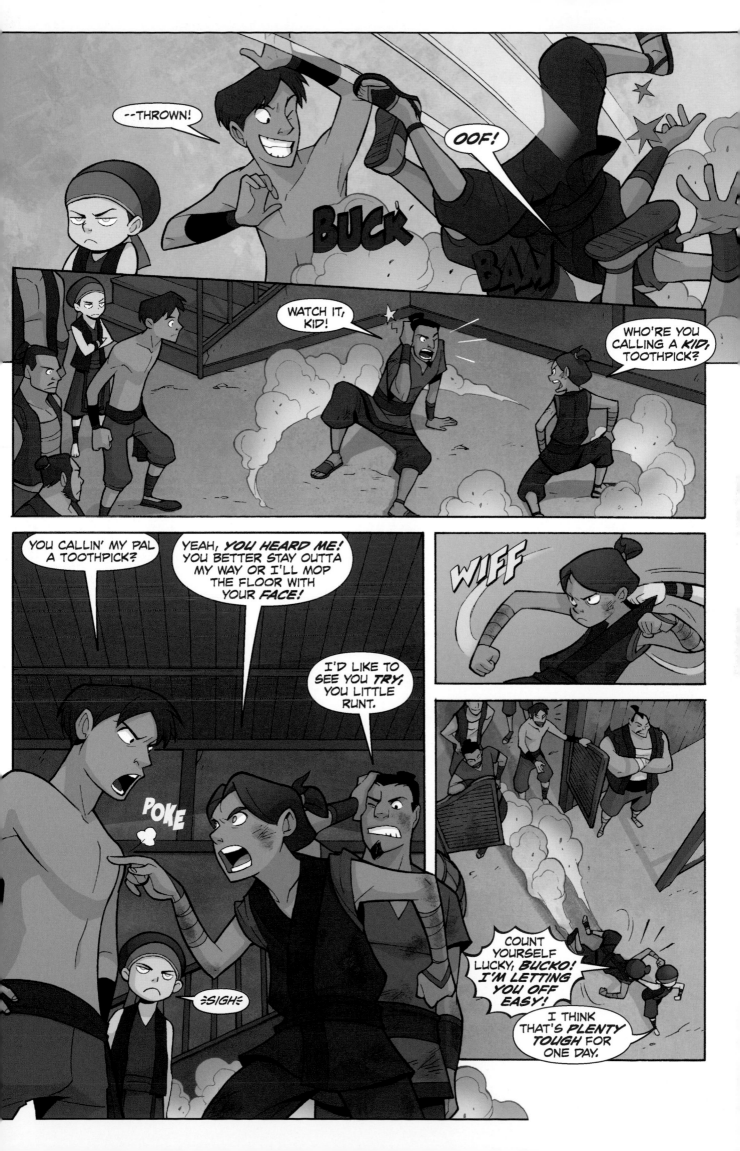

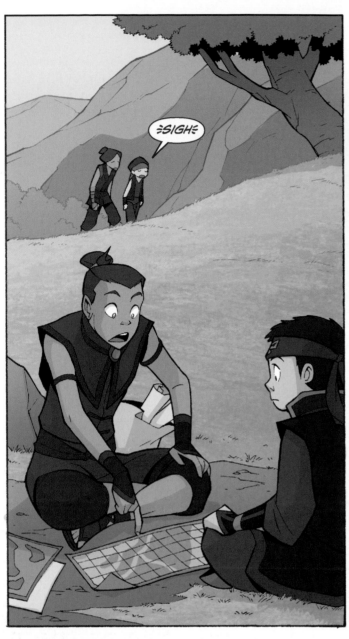

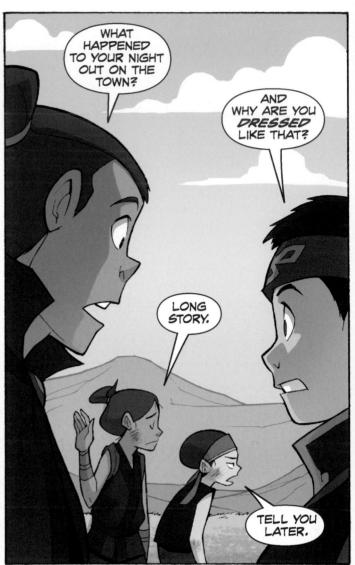

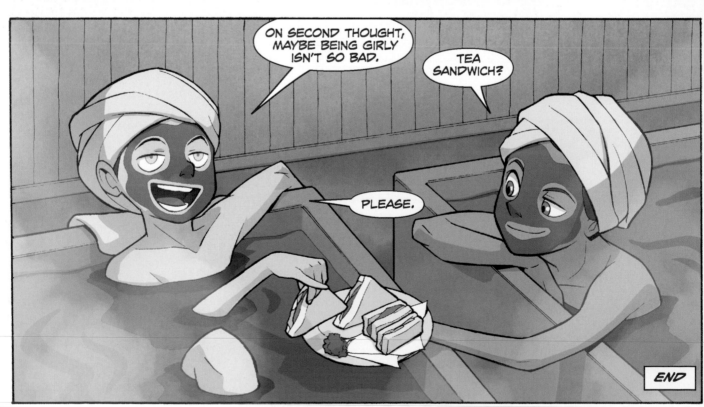

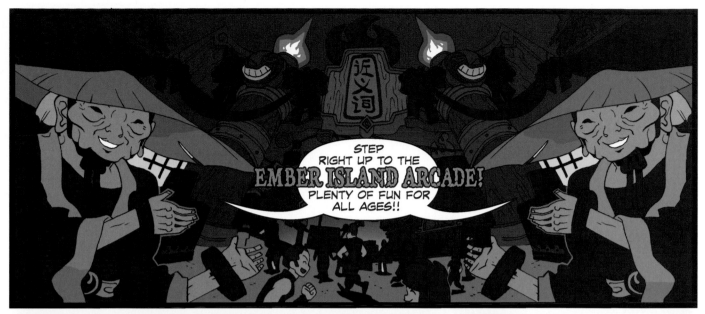

STEP RIGHT UP TO THE **EMBER ISLAND ARCADE!** PLENTY OF FUN FOR ALL AGES!!

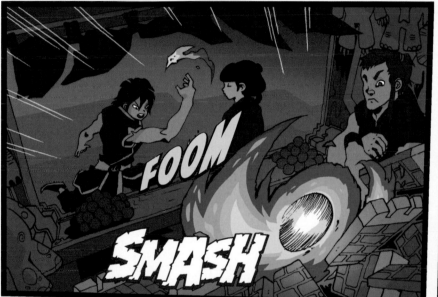

FOOM

SMASH

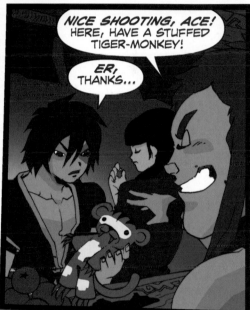

NICE SHOOTING, ACE! HERE, HAVE A STUFFED TIGER-MONKEY!

ER, THANKS...

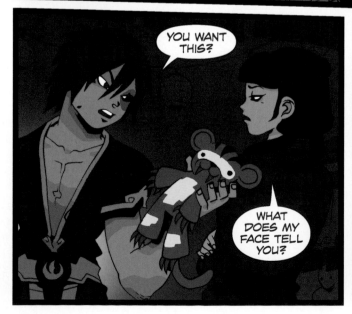

YOU WANT THIS?

WHAT DOES MY FACE TELL YOU?

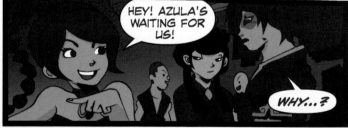

HEY! AZULA'S WAITING FOR US!

WHY...?

EVERYONE! COME OVER HERE, QUICKLY!

OOH! CUTE TIGER-MONKEY!

Story, art, and colors by Corey Lewis, and lettering by Comicraft.

WHAT IS *THIS* THING?

WELL GEE, ZUKO. THIS IS AN ARCADE. YOU THINK MAYBE IT'S A *GAME?*

SOME KIND OF *"BOOM! POW!"* FIGHTING GAME!

TY LEE, YOU'RE EXACTLY CORRECT.

THIS, MY FRIENDS, IS *"STREET BENDER,"* THE MOST STATE-OF-THE-ART IN FIRE NATION ARCADE ENTERTAINMENT.

TWO PLAYERS FACE EACH OTHER USING CUTE LITTLE WARRIOR DOLLS IN THE MOST *BRUTAL* OF SIMULATED BATTLES...

AZULA, HOW DO YOU KNOW SO MUCH ABOUT THIS THING?

SHE'S BEEN BEATING LITTLE KIDS AT IT ALL WEEKEND.

A PRINCESS HAS TO LAY A FIRM IRON FIST UPON HER SUBJECTS, AFTER ALL.

WHAT DO YOU SAY, LITTLE BROTHER...CARE FOR A MATCH?

NO WAY. THIS IS KID'S STUFF.

OH COME NOW, DEAR BROTHER, DON'T BE SO DROLL. AFTER ALL, THIS IS AN *AVATAR*-THEMED VERSION OF THE GAME. LOOK! EVEN YOU AND I ARE IN IT.

BUT DON'T WORRY, I'LL SPARE YOU THE HUMILIATION AND *REFRAIN* FROM PICKING MY OWN CHARACTER.

HERE'S AN OPPONENT MORE YOUR SPEED. OR ARE YOU AFRAID OF FIGHTING THIS LITTLE GUY?

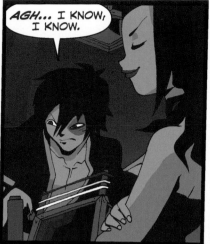

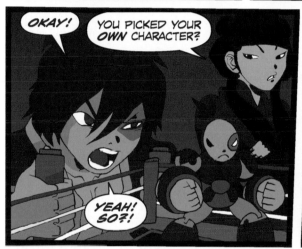

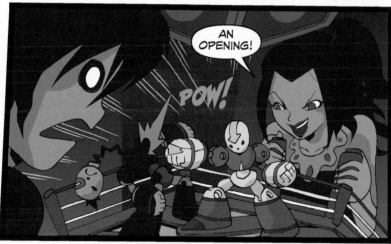

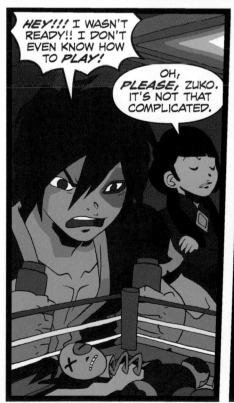

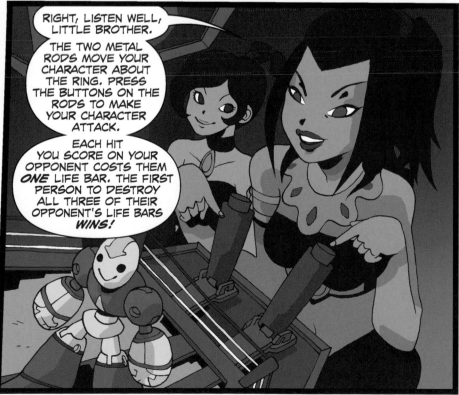

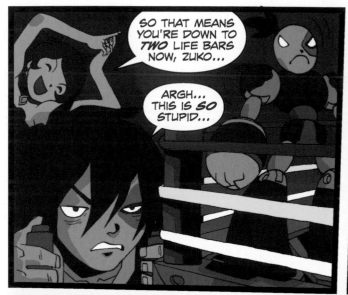

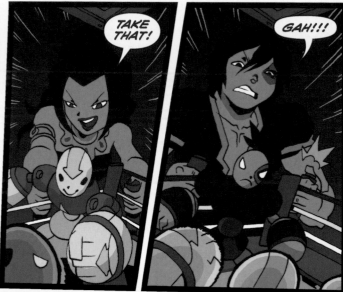

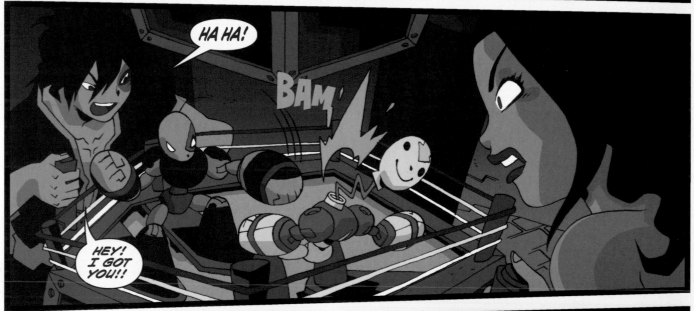

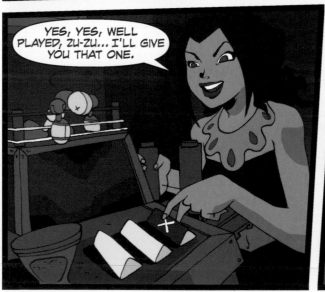

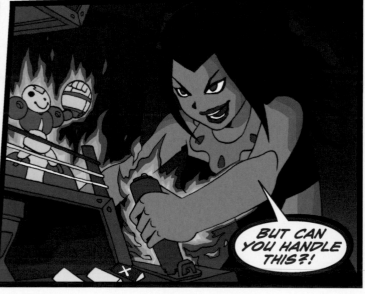

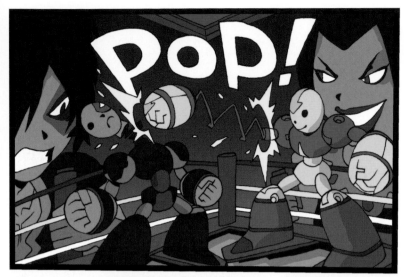

POP!

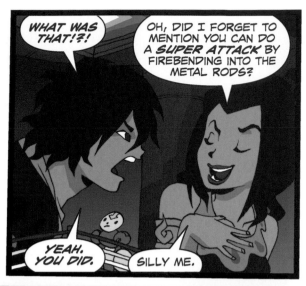

WHAT WAS THAT!?!

OH, DID I FORGET TO MENTION YOU CAN DO A *SUPER ATTACK* BY FIREBENDING INTO THE METAL RODS?

YEAH. YOU DID.

SILLY ME.

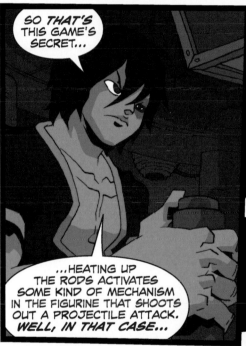

SO *THAT'S* THIS GAME'S SECRET...

...HEATING UP THE RODS ACTIVATES SOME KIND OF MECHANISM IN THE FIGURINE THAT SHOOTS OUT A PROJECTILE ATTACK. *WELL, IN THAT CASE...*

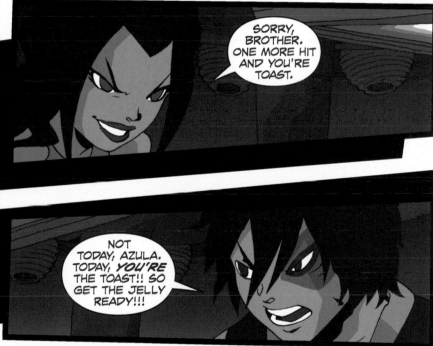

SORRY, BROTHER. ONE MORE HIT AND YOU'RE TOAST.

NOT TODAY, AZULA. TODAY, *YOU'RE* THE TOAST!! SO GET THE JELLY READY!!!

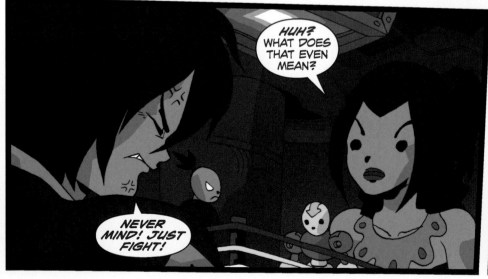

HUH? WHAT DOES THAT EVEN MEAN?

NEVER MIND! JUST FIGHT!

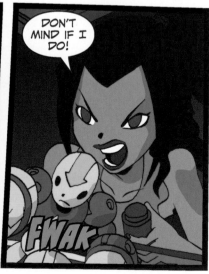

DON'T MIND IF I DO!

FWAK

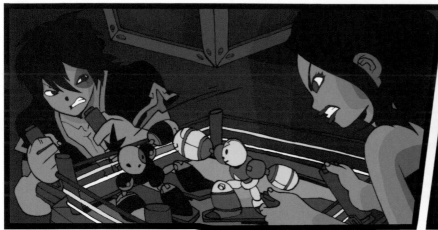

NOW'S MY CHANCE!!

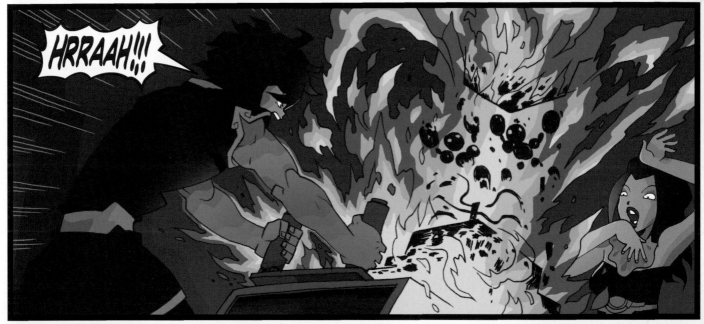

HRRAAH!!!

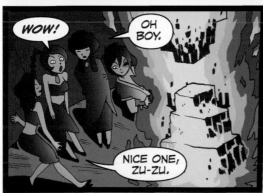

WOW!

OH BOY.

NICE ONE, ZU-ZU.

HMPH. NOW *THAT'S* ENTERTAINING.

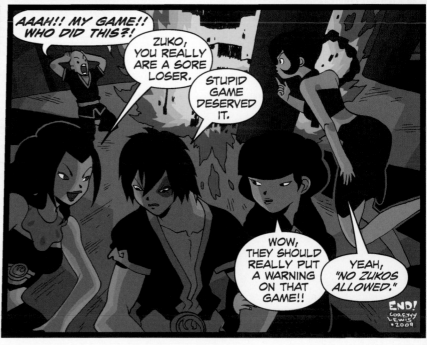

AAAH!! MY GAME!! WHO DID THIS?!

ZUKO, YOU REALLY ARE A SORE LOSER.

STUPID GAME DESERVED IT.

WOW, THEY SHOULD REALLY PUT A WARNING ON THAT GAME!!

YEAH, "NO ZUKOS ALLOWED."

END!
COREY LEWIS 2009

152

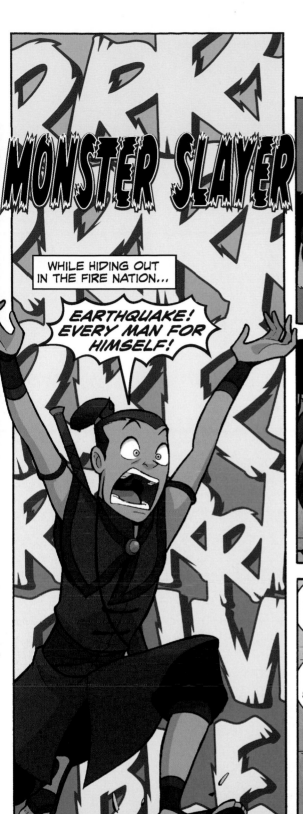

MONSTER SLAYER

WHILE HIDING OUT IN THE FIRE NATION...

EARTHQUAKE! EVERY MAN FOR HIMSELF!

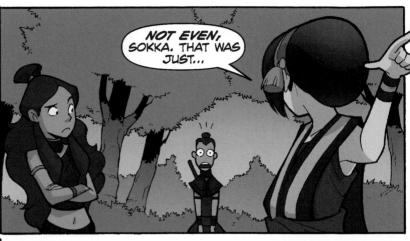

NOT EVEN, SOKKA. THAT WAS JUST...

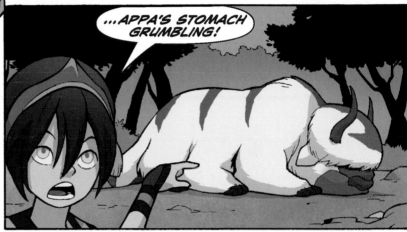

...APPA'S STOMACH GRUMBLING!

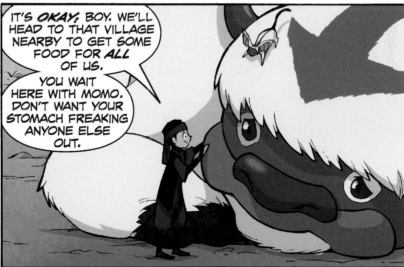

IT'S *OKAY*, BOY. WE'LL HEAD TO THAT VILLAGE NEARBY TO GET SOME FOOD FOR *ALL* OF US.

YOU WAIT HERE WITH MOMO. DON'T WANT YOUR STOMACH FREAKING ANYONE ELSE OUT.

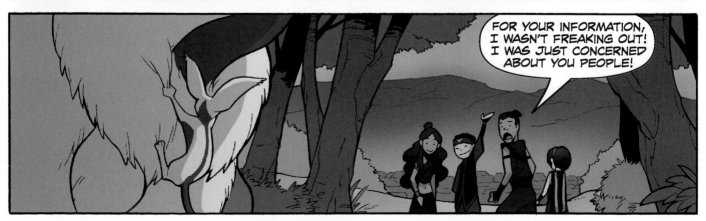

FOR YOUR INFORMATION, I WASN'T FREAKING OUT! I WAS JUST CONCERNED ABOUT YOU PEOPLE!

Story by J. Torres, art and colors by Gurihiru, and lettering by Comicraft.

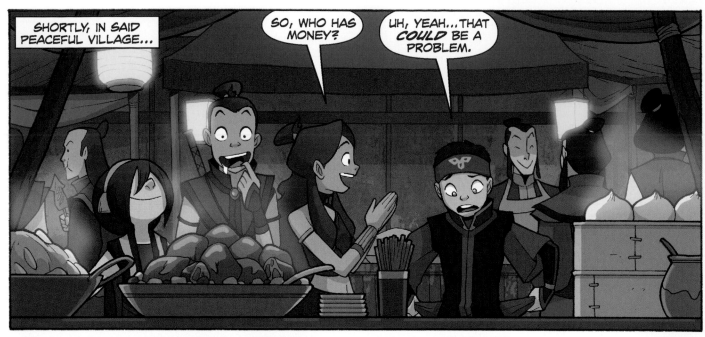

SHORTLY, IN SAID PEACEFUL VILLAGE...

SO, WHO HAS MONEY?

UH, YEAH...THAT *COULD* BE A PROBLEM.

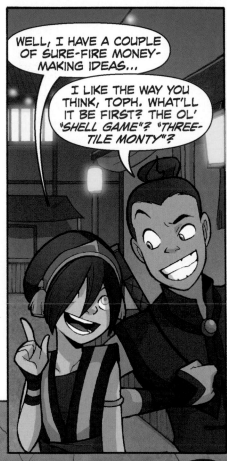

WELL, I HAVE A COUPLE OF SURE-FIRE MONEY-MAKING IDEAS...

I LIKE THE WAY YOU THINK, TOPH. WHAT'LL IT BE FIRST? THE OL' "SHELL GAME"? "THREE-TILE MONTY"?

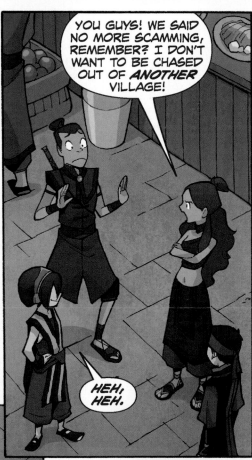

YOU GUYS! WE SAID NO MORE SCAMMING, REMEMBER? I DON'T WANT TO BE CHASED OUT OF *ANOTHER* VILLAGE!

HEH, HEH.

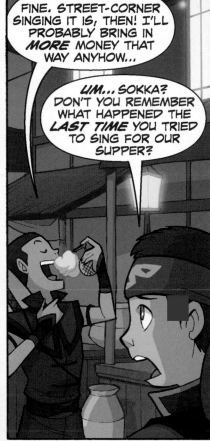

FINE. STREET-CORNER SINGING IT IS, THEN! I'LL PROBABLY BRING IN *MORE* MONEY THAT WAY ANYHOW...

*UM...*SOKKA? DON'T YOU REMEMBER WHAT HAPPENED THE *LAST TIME* YOU TRIED TO SING FOR OUR SUPPER?

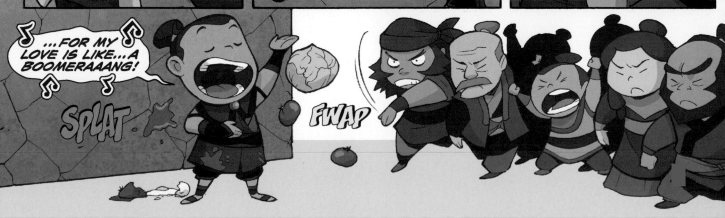

...FOR MY LOVE IS LIKE...A BOOMERAAANG!

SPLAT

FWAP

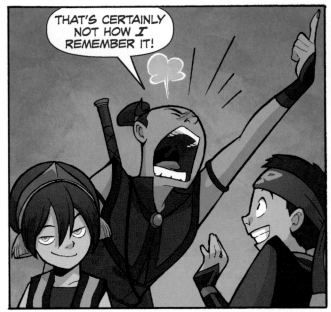

THAT'S CERTAINLY NOT HOW *I* REMEMBER IT!

HELP! HELP! IN THE FOREST!

IT'S A M-M-MONSTER!

WHOOPS, IT'S PROBABLY JUST APPA...I'D BETTER CLEAR THINGS--

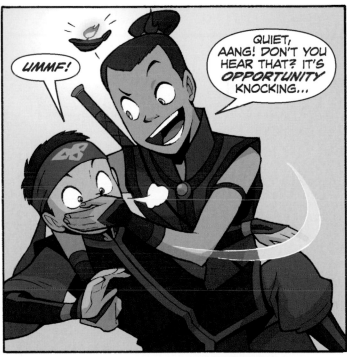

UMMF!

QUIET, AANG! DON'T YOU HEAR THAT? IT'S *OPPORTUNITY* KNOCKING...

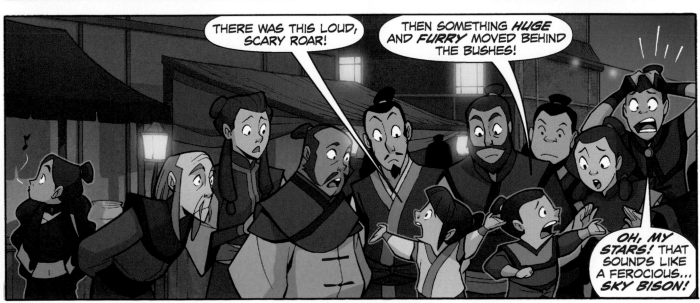

THERE WAS THIS LOUD, SCARY ROAR!

THEN SOMETHING *HUGE* AND *FURRY* MOVED BEHIND THE BUSHES!

OH, MY STARS! THAT SOUNDS LIKE A FEROCIOUS... SKY BISON!

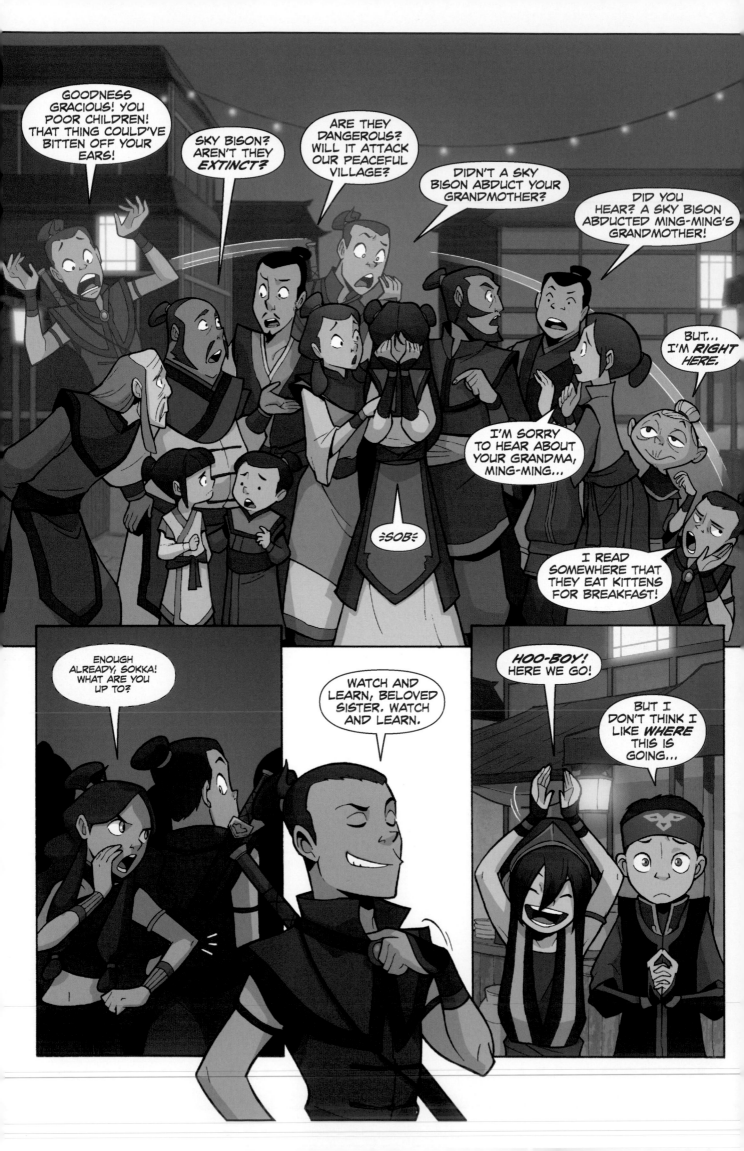

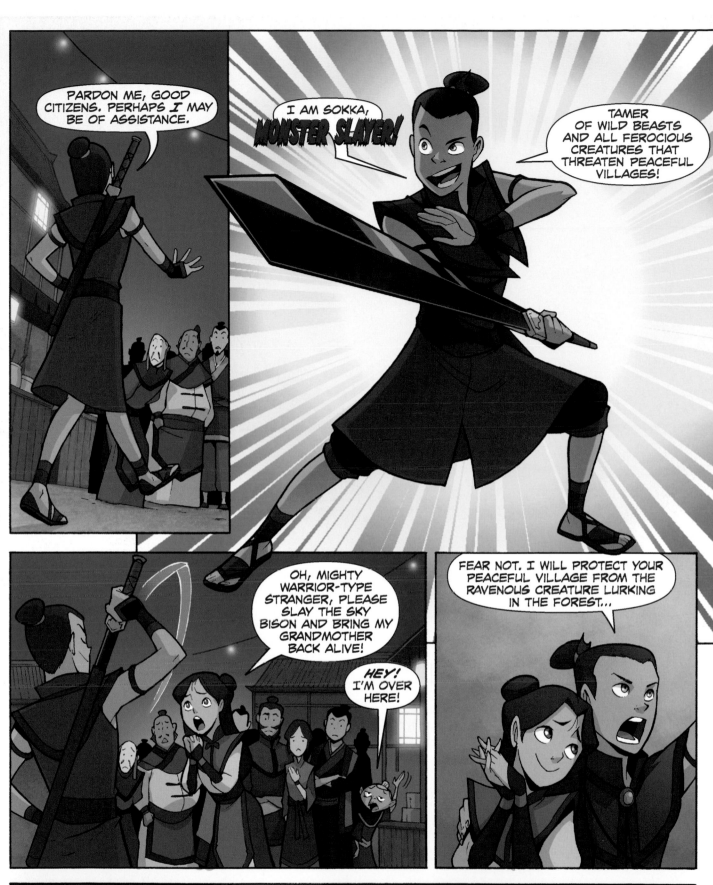

PARDON ME, GOOD CITIZENS. PERHAPS *I* MAY BE OF ASSISTANCE.

I AM SOKKA, **MONSTER SLAYER!**

TAMER OF WILD BEASTS AND ALL FEROCIOUS CREATURES THAT THREATEN PEACEFUL VILLAGES!

OH, MIGHTY WARRIOR-TYPE STRANGER, PLEASE SLAY THE SKY BISON AND BRING MY GRANDMOTHER BACK ALIVE!

HEY! I'M OVER HERE!

FEAR NOT. I WILL PROTECT YOUR PEACEFUL VILLAGE FROM THE RAVENOUS CREATURE LURKING IN THE FOREST...

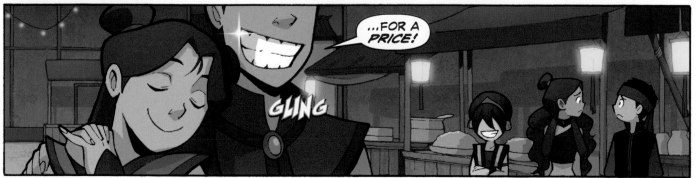

...FOR A *PRICE!*

GLING

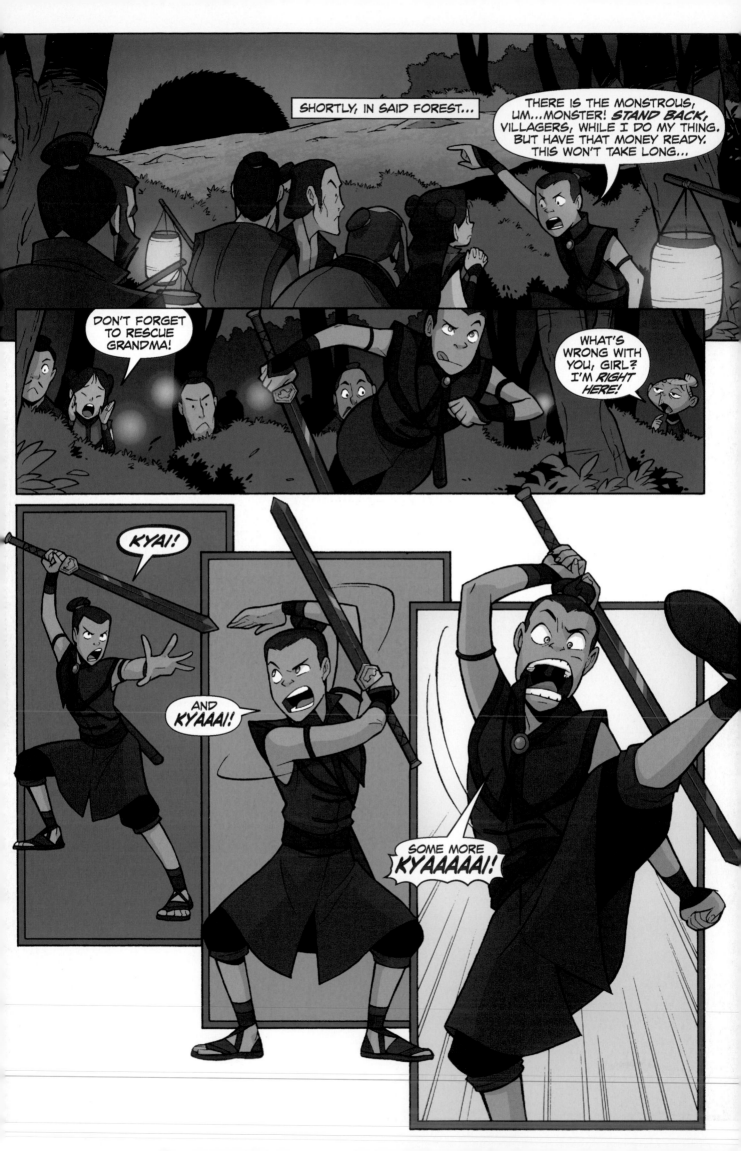

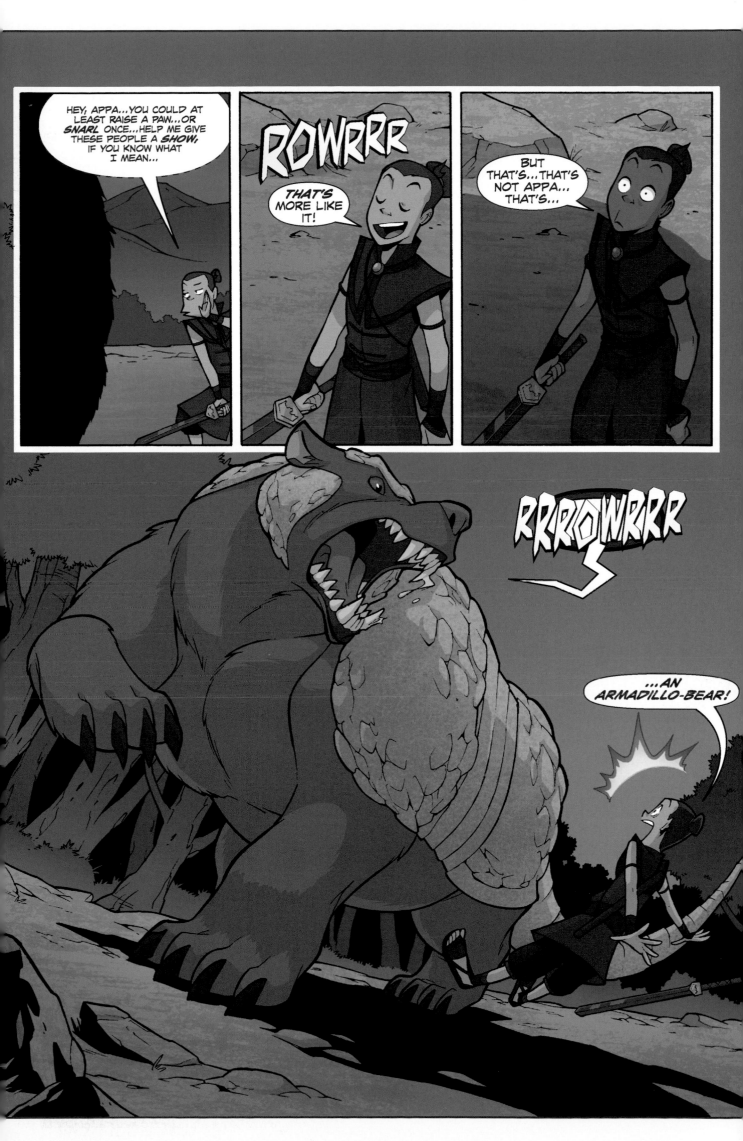

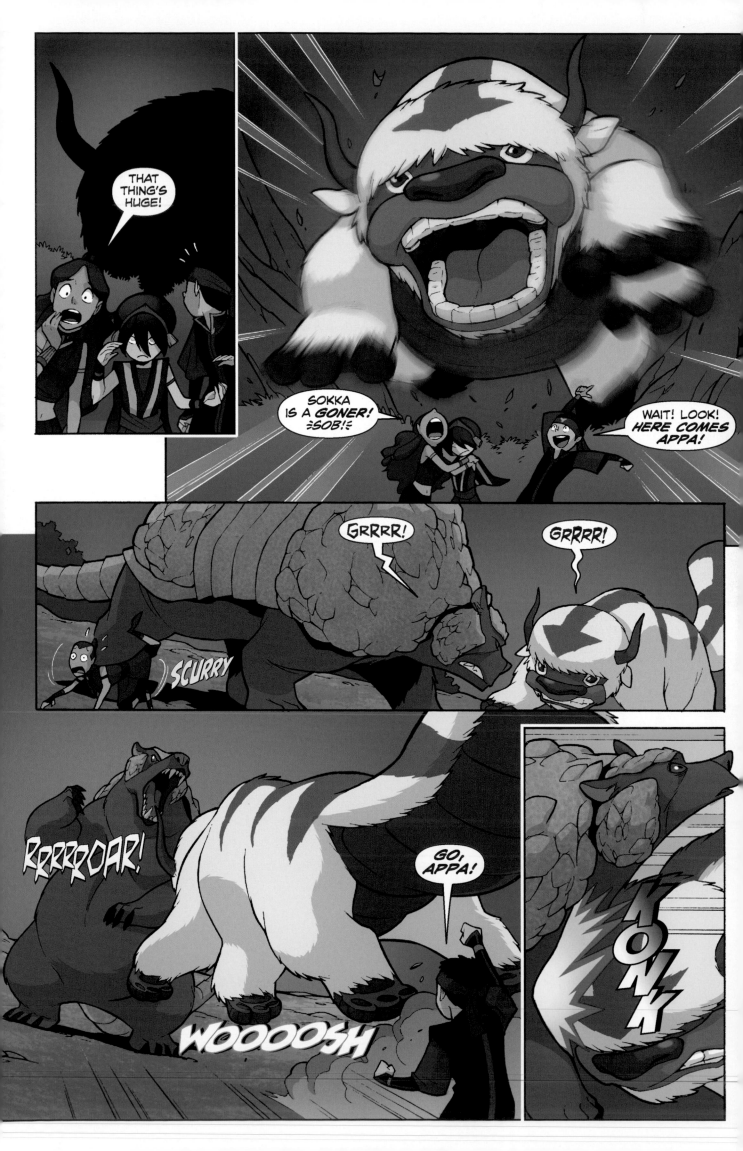

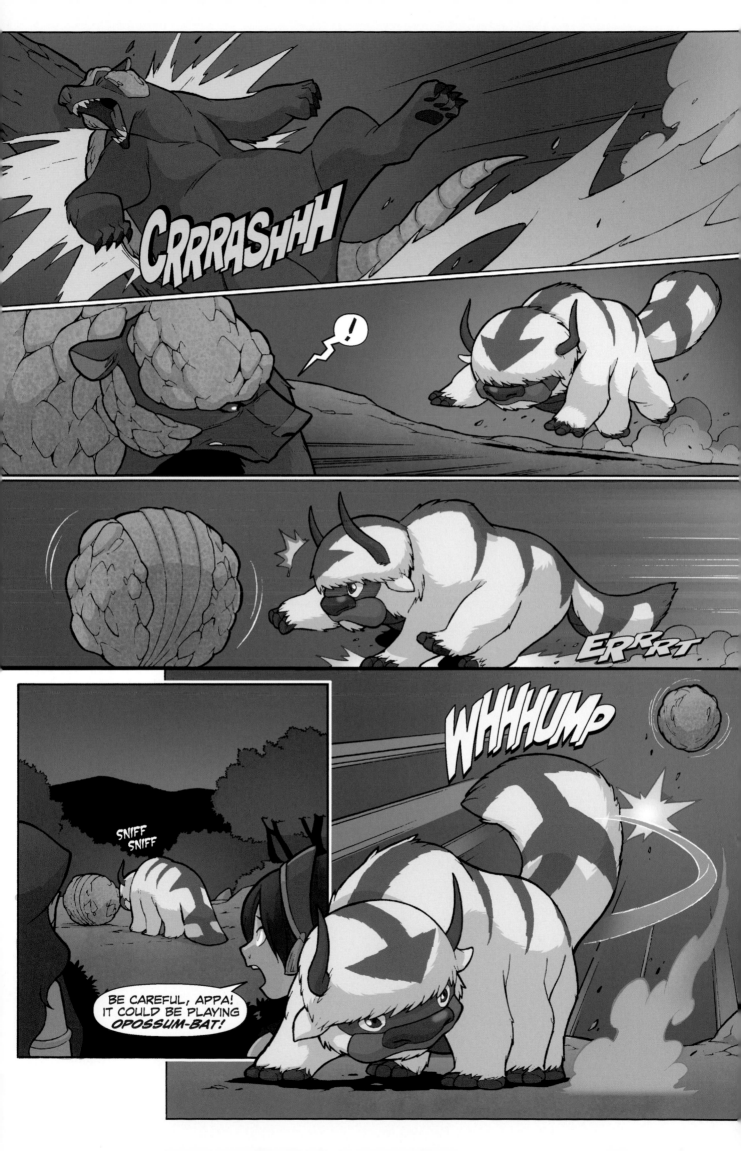

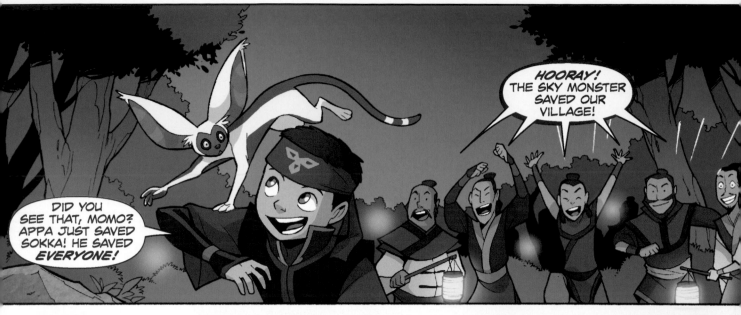

DID YOU SEE THAT, MOMO? APPA JUST SAVED SOKKA! HE SAVED *EVERYONE!*

HOORAY! THE SKY MONSTER SAVED OUR VILLAGE!

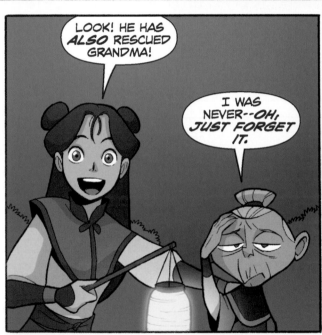

LOOK! HE HAS *ALSO* RESCUED GRANDMA!

I WAS NEVER--*OH, JUST FORGET IT.*

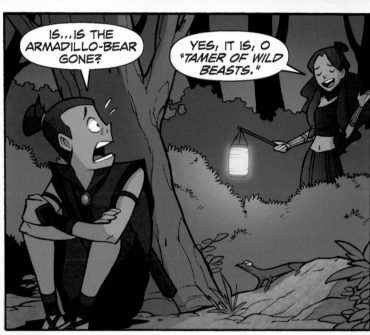

IS...IS THE ARMADILLO-BEAR GONE?

YES, IT IS, O *"TAMER OF WILD BEASTS."*

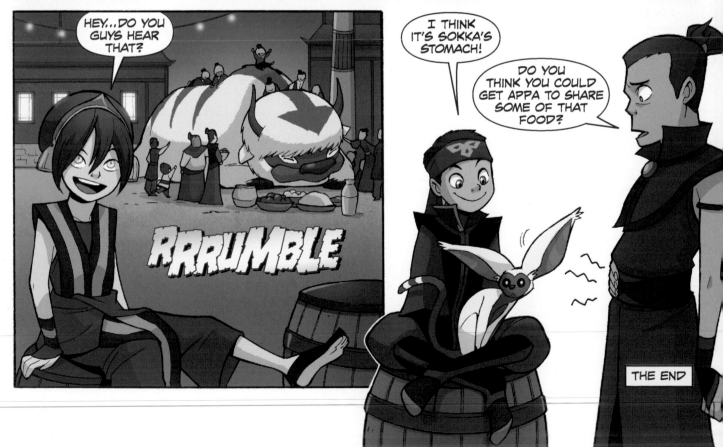

HEY...DO YOU GUYS HEAR THAT?

RRRUMBLE

I THINK IT'S SOKKA'S STOMACH!

DO YOU THINK YOU COULD GET APPA TO SHARE SOME OF THAT FOOD?

THE END

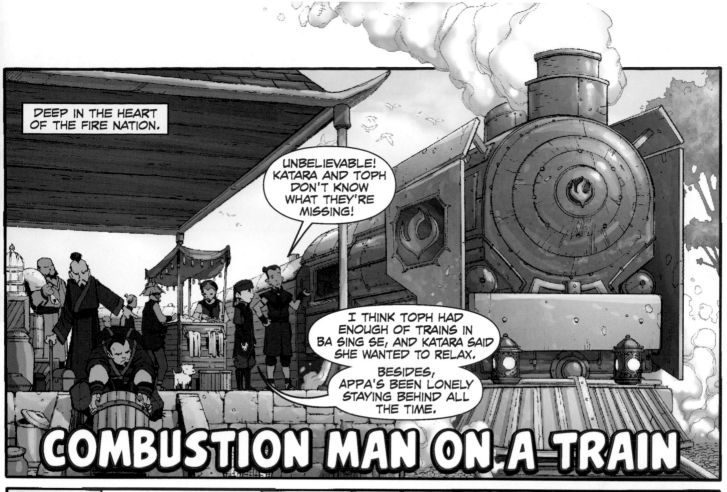

DEEP IN THE HEART OF THE FIRE NATION.

UNBELIEVABLE! KATARA AND TOPH DON'T KNOW WHAT THEY'RE MISSING!

I THINK TOPH HAD ENOUGH OF TRAINS IN BA SING SE, AND KATARA SAID SHE WANTED TO RELAX.

BESIDES, APPA'S BEEN LONELY STAYING BEHIND ALL THE TIME.

COMBUSTION MAN ON A TRAIN

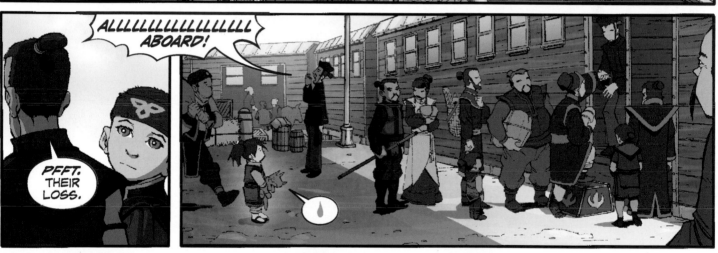

ALLLLLLLLLLLLLLLLLL ABOARD!

PFFT. THEIR LOSS.

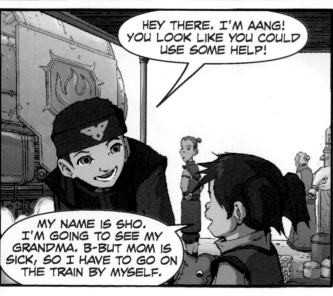

HEY THERE. I'M AANG! YOU LOOK LIKE YOU COULD USE SOME HELP!

MY NAME IS SHO. I'M GOING TO SEE MY GRANDMA. B-BUT MOM IS SICK, SO I HAVE TO GO ON THE TRAIN BY MYSELF.

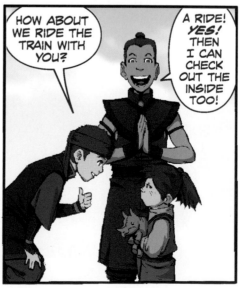

HOW ABOUT WE RIDE THE TRAIN WITH YOU?

A RIDE! YES! THEN I CAN CHECK OUT THE INSIDE TOO!

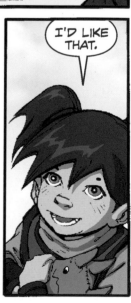

I'D LIKE THAT.

Story by Alison Wilgus and Rawles Lumumba, art by Tom McWeeney, colors by Wes Dzioba, and lettering by Comicraft.

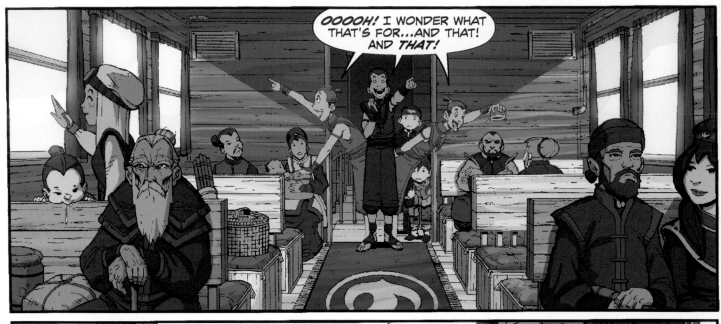

OOOOH! I WONDER WHAT THAT'S FOR...AND THAT! AND *THAT!*

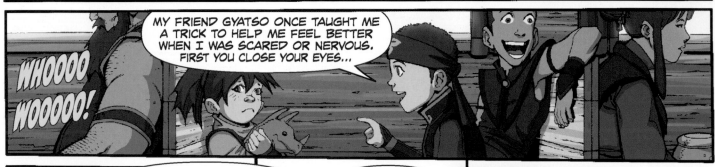

WHOOOO WOOOOO!

MY FRIEND GYATSO ONCE TAUGHT ME A TRICK TO HELP ME FEEL BETTER WHEN I WAS SCARED OR NERVOUS. FIRST YOU CLOSE YOUR EYES...

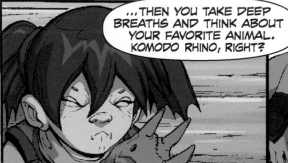

...THEN YOU TAKE DEEP BREATHS AND THINK ABOUT YOUR FAVORITE ANIMAL. KOMODO RHINO, RIGHT?

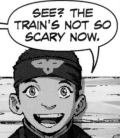

SEE? THE TRAIN'S NOT SO SCARY NOW.

NO...

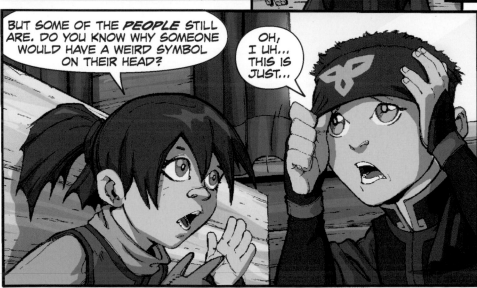

BUT SOME OF THE *PEOPLE* STILL ARE. DO YOU KNOW WHY SOMEONE WOULD HAVE A WEIRD SYMBOL ON THEIR HEAD?

OH, I UH... THIS IS JUST...

NOT *YOU,* SILLY. I MEAN *THAT* GUY!

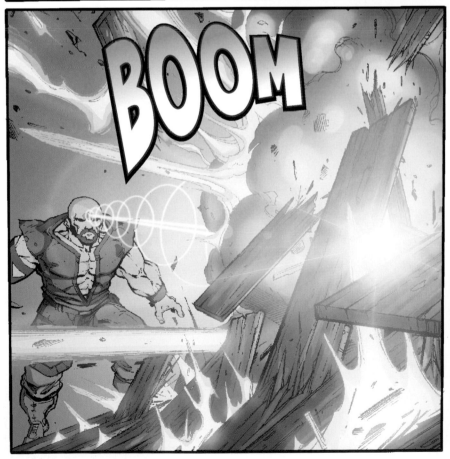

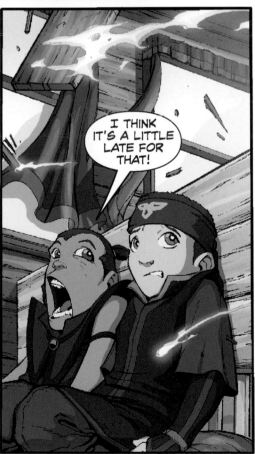

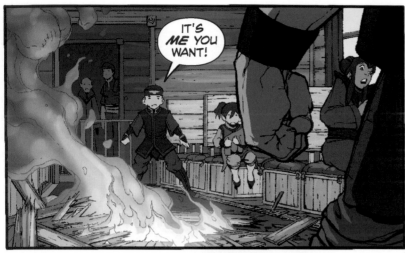

IT'S ME YOU WANT!

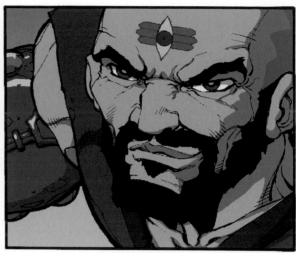

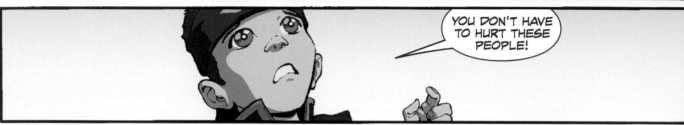

YOU DON'T HAVE TO HURT THESE PEOPLE!

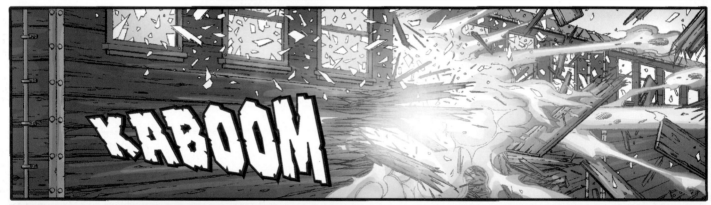

KABOOM

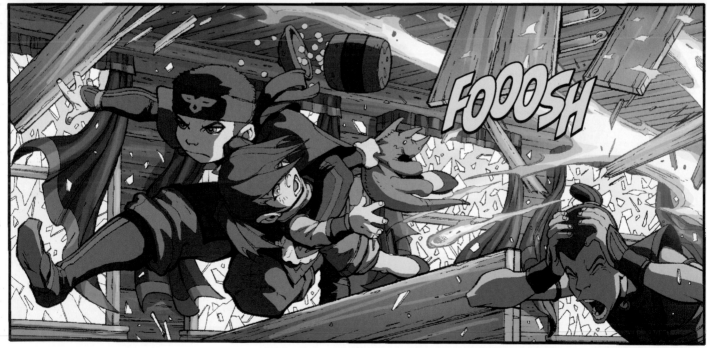

FOOOSH

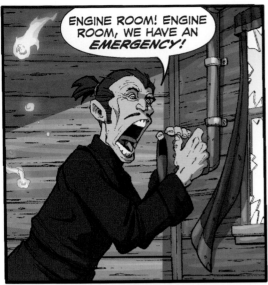

ENGINE ROOM! ENGINE ROOM, WE HAVE AN *EMERGENCY!*

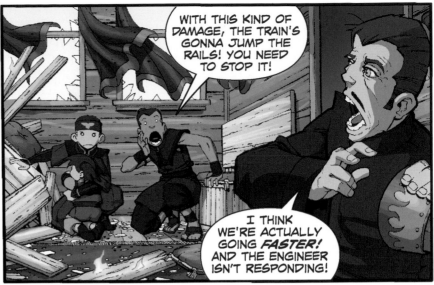

WITH THIS KIND OF DAMAGE, THE TRAIN'S GONNA JUMP THE RAILS! YOU NEED TO STOP IT!

I THINK WE'RE ACTUALLY GOING *FASTER!* AND THE ENGINEER ISN'T RESPONDING!

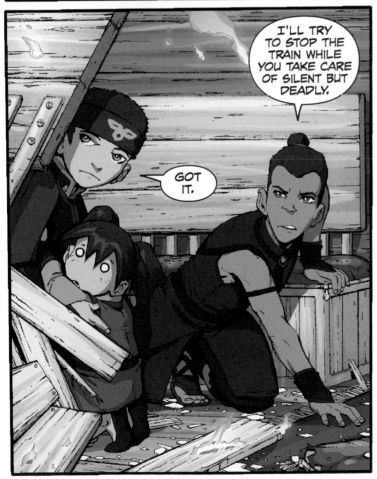

I'LL TRY TO STOP THE TRAIN WHILE YOU TAKE CARE OF SILENT BUT DEADLY.

GOT IT.

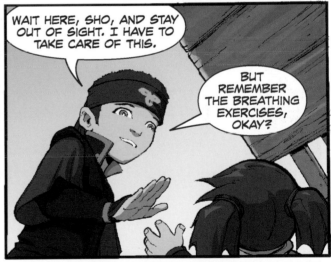

WAIT HERE, SHO, AND STAY OUT OF SIGHT. I HAVE TO TAKE CARE OF THIS.

BUT REMEMBER THE BREATHING EXERCISES, OKAY?

O-OKAY...

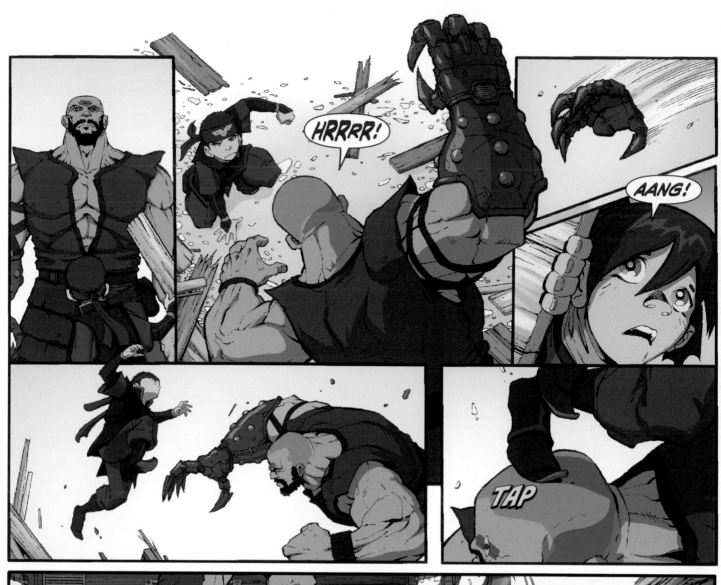

168

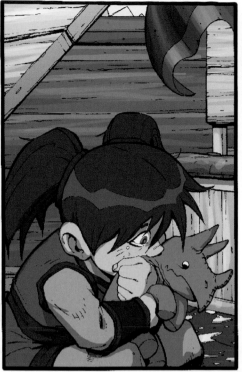

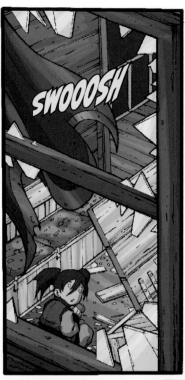

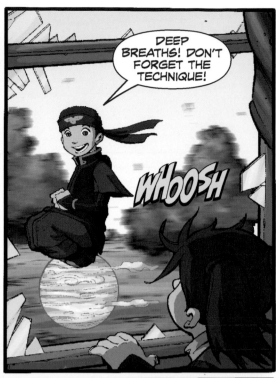

DEEP BREATHS! DON'T FORGET THE TECHNIQUE!

WHOOSH

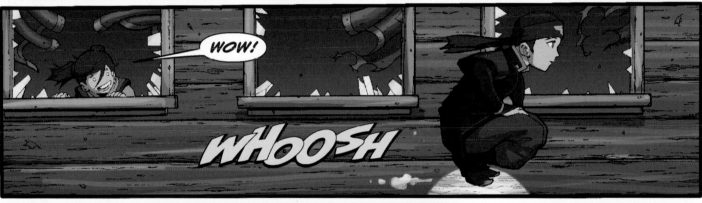

WOW!

WHOOSH

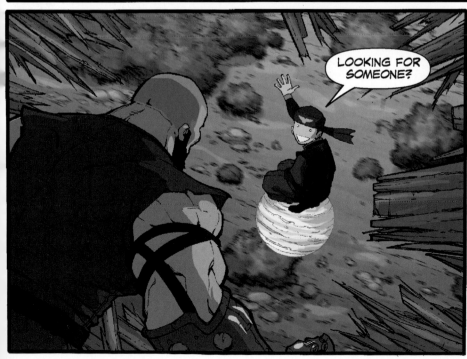

LOOKING FOR SOMEONE?

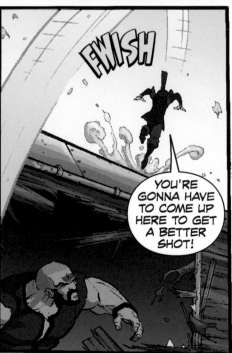

FWISH

YOU'RE GONNA HAVE TO COME UP HERE TO GET A BETTER SHOT!

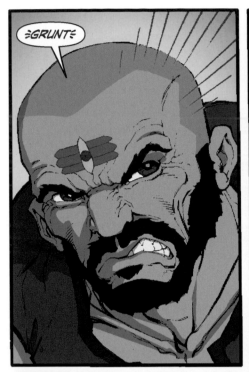

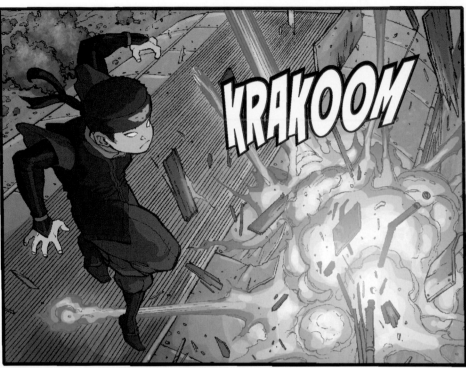

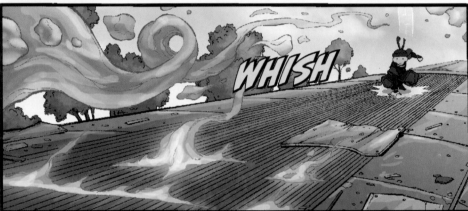

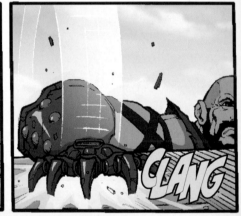

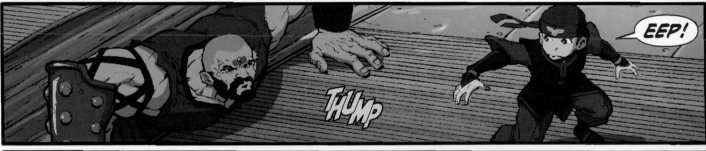

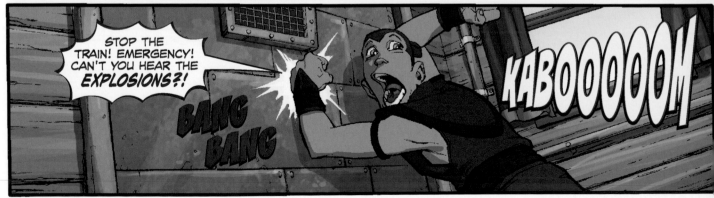

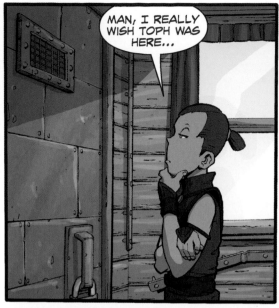

MAN, I REALLY WISH TOPH WAS HERE...

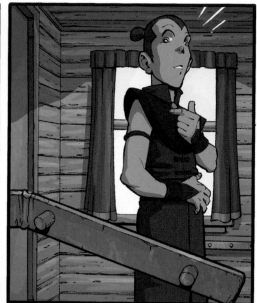

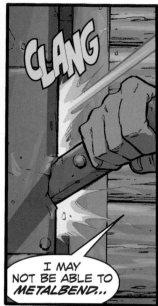

CLANG

I MAY NOT BE ABLE TO *METALBEND*...

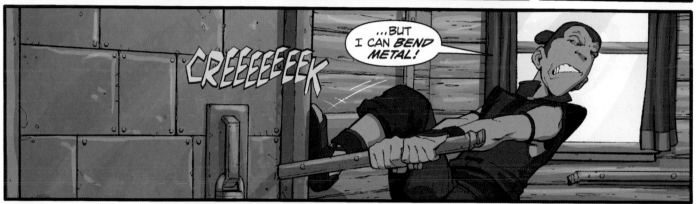

CREEEEEEEK

...BUT I CAN *BEND METAL!*

HE MUST'VE HIT HIS HEAD DURING ONE OF THE EXPLOSIONS.

IT CAN'T BE *THAT* HARD TO DRIVE THIS THING, RIGHT?

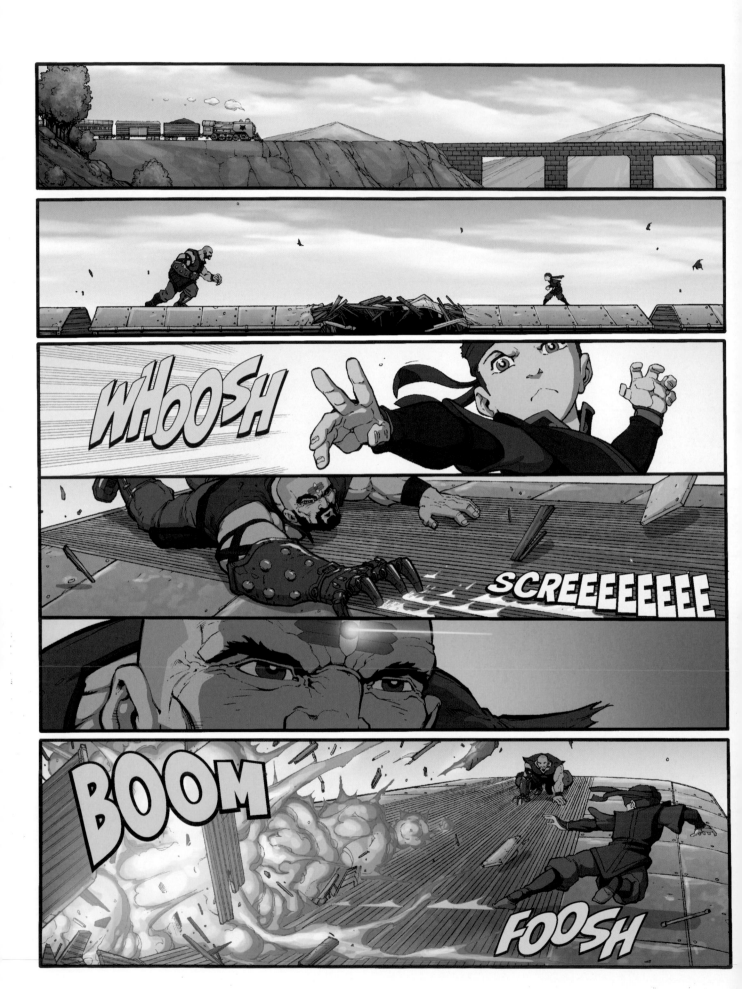

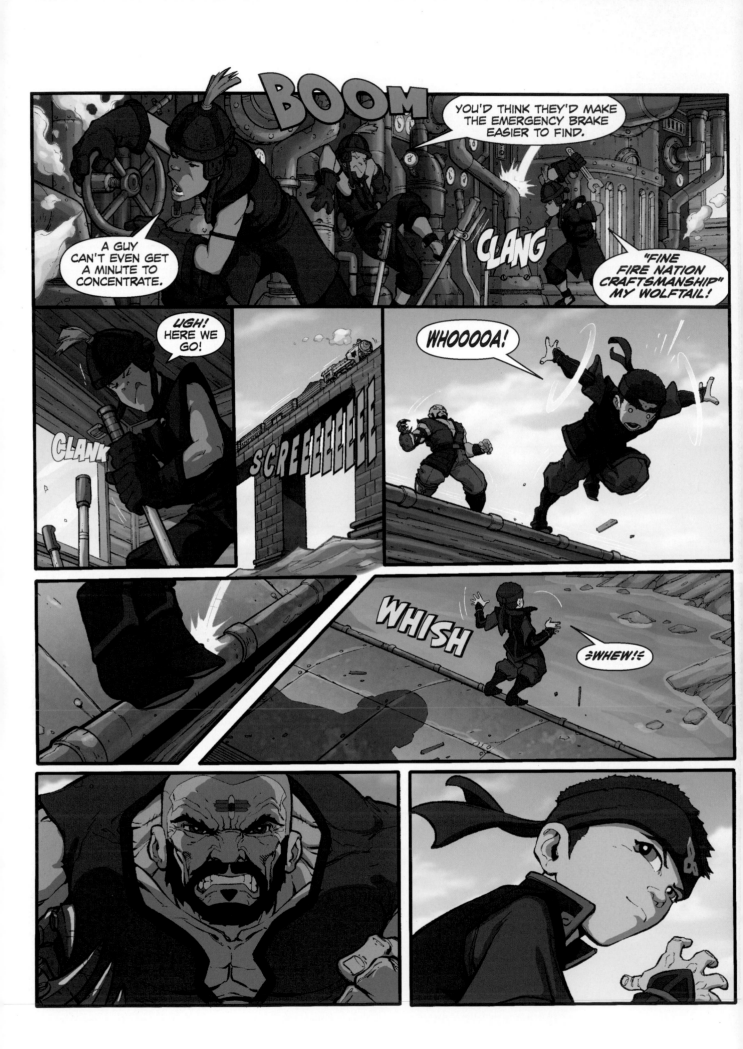

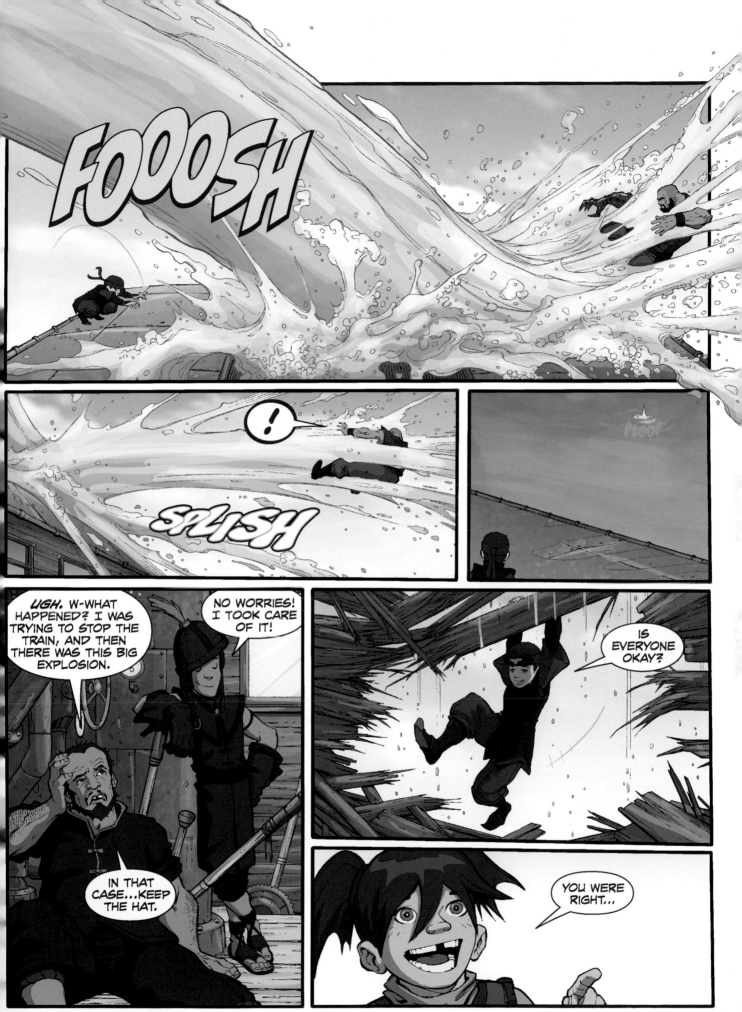

FOOOSH

SPLISH

!

PLOOF

UGH. W-WHAT HAPPENED? I WAS TRYING TO STOP THE TRAIN, AND THEN THERE WAS THIS BIG EXPLOSION.

NO WORRIES! I TOOK CARE OF IT!

IN THAT CASE...KEEP THE HAT.

IS EVERYONE OKAY?

YOU WERE RIGHT...

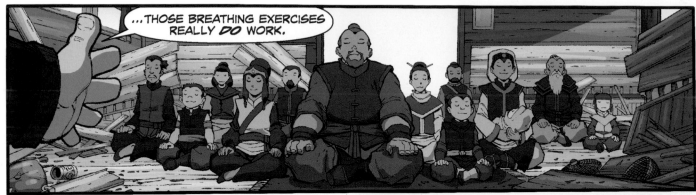

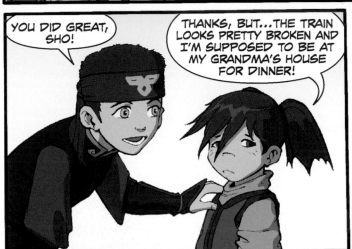

THE END

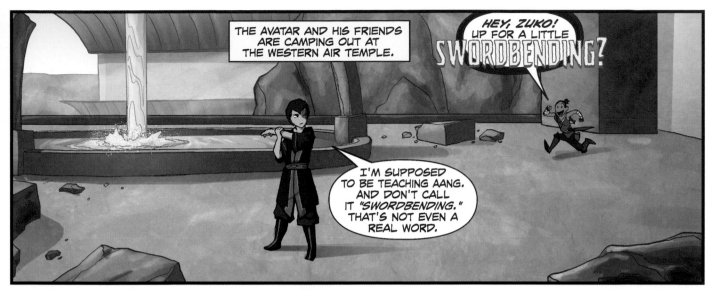

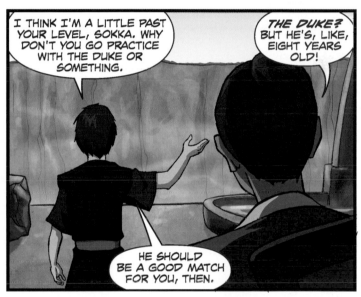

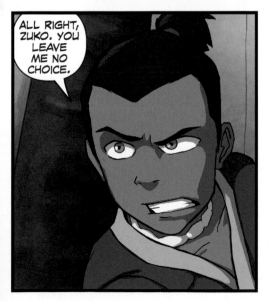

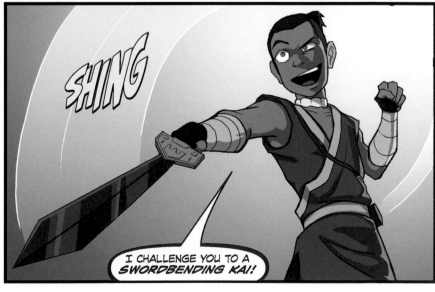

Story by Alison Wilgus, art by Justin Ridge, colors by Wes Dzioba, and lettering by Comicraft.

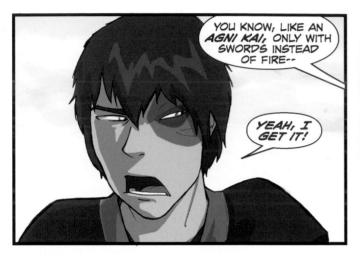

YOU KNOW, LIKE AN *AGNI KAI*, ONLY WITH SWORDS INSTEAD OF FIRE--

YEAH, I GET IT!

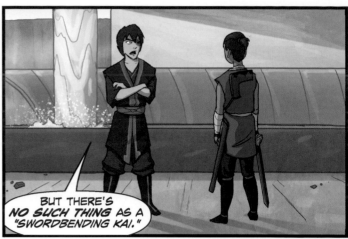

BUT THERE'S *NO SUCH THING* AS A "SWORDBENDING KAI."

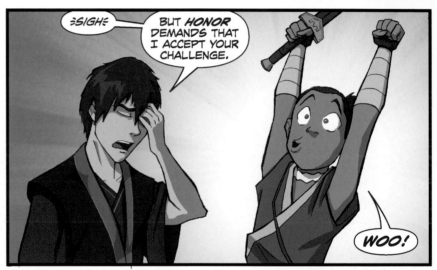

≋SIGH≋

BUT *HONOR* DEMANDS THAT I ACCEPT YOUR CHALLENGE.

WOO!

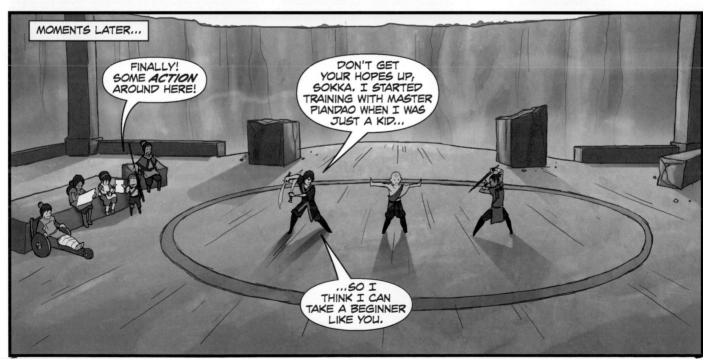

MOMENTS LATER...

FINALLY! SOME *ACTION* AROUND HERE!

DON'T GET YOUR HOPES UP, SOKKA. I STARTED TRAINING WITH MASTER PIANDAO WHEN I WAS JUST A KID...

...SO I THINK I CAN TAKE A BEGINNER LIKE YOU.

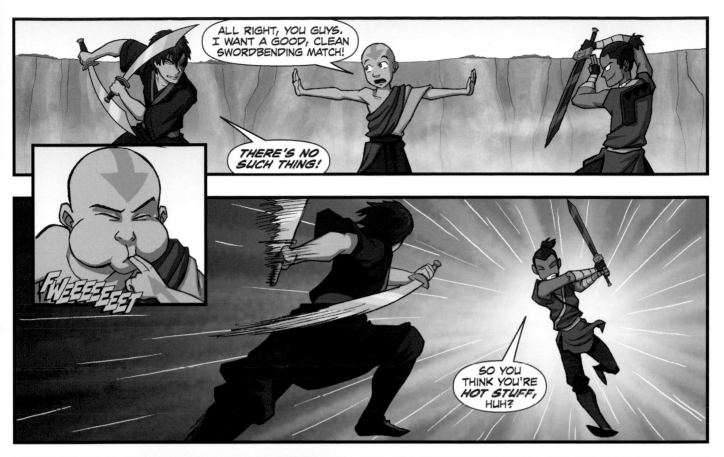

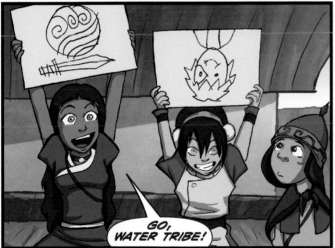

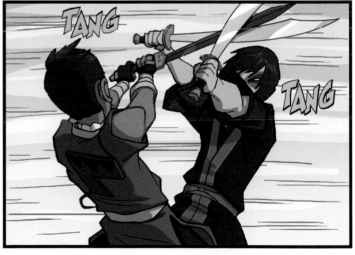

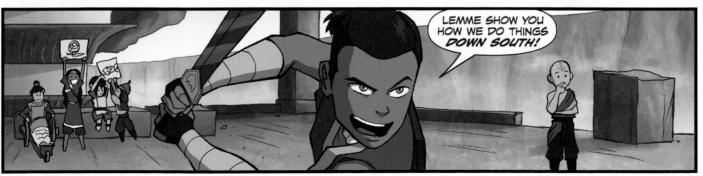

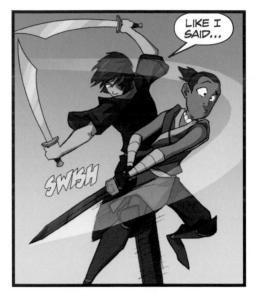

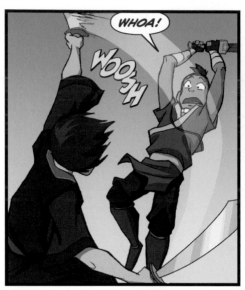

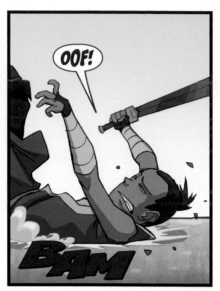

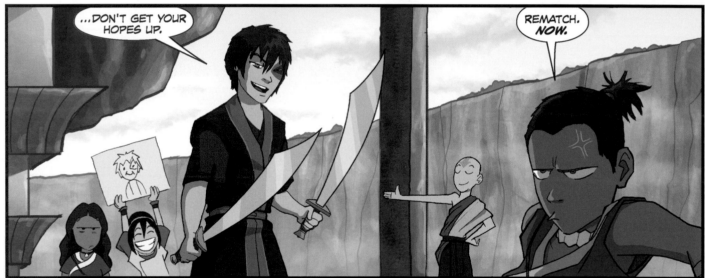

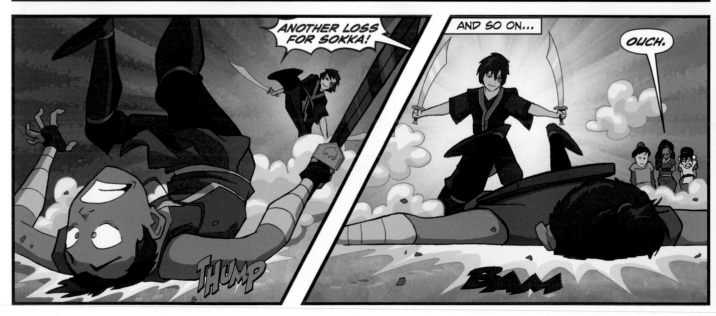

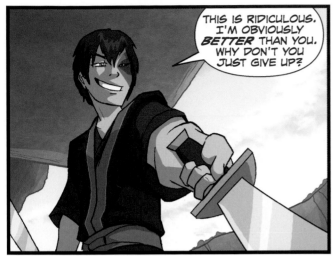

THIS IS RIDICULOUS. I'M OBVIOUSLY *BETTER* THAN YOU. WHY DON'T YOU JUST GIVE UP?

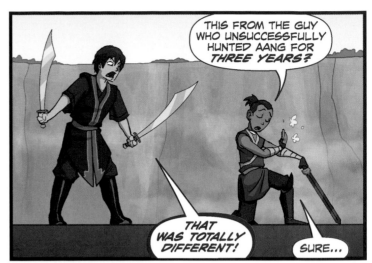

THIS FROM THE GUY WHO UNSUCCESSFULLY HUNTED AANG FOR *THREE YEARS?*

THAT WAS TOTALLY *DIFFERENT!*

SURE...

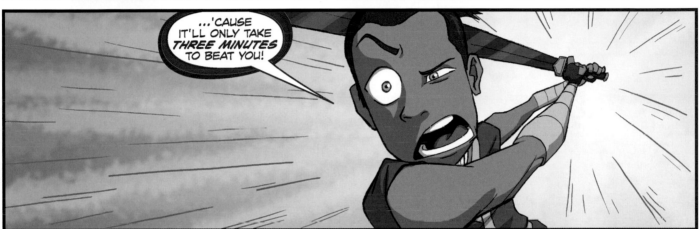

...'CAUSE IT'LL ONLY TAKE *THREE MINUTES* TO BEAT YOU!

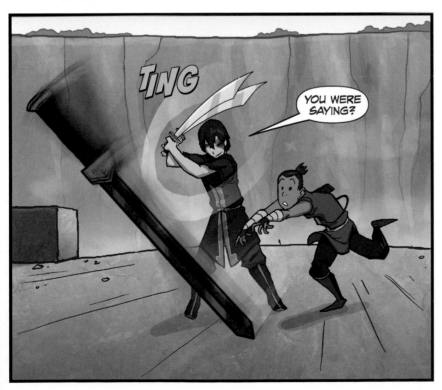

TING

YOU WERE SAYING?

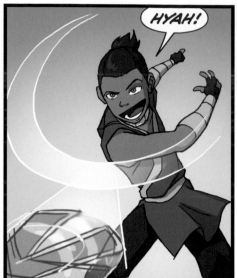

HYAH!

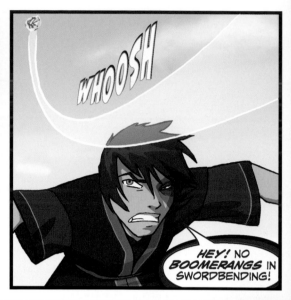

WHOOSH

HEY! NO *BOOMERANGS* IN SWORDBENDING!

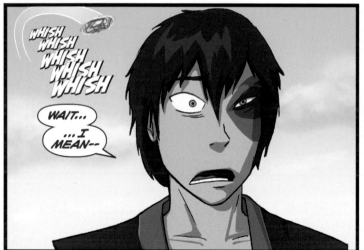

WHISH WHISH WHISH WHISH WHISH

WAIT...

...I MEAN--

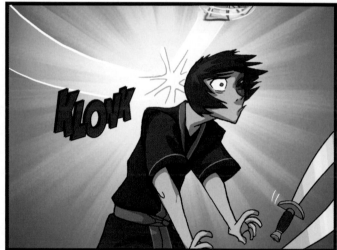

KLONK

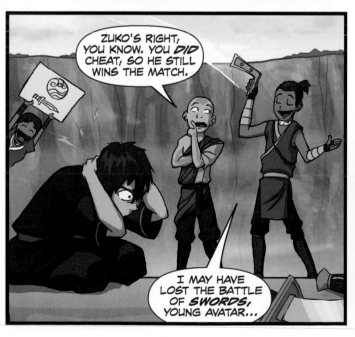

ZUKO'S RIGHT, YOU KNOW. YOU *DID* CHEAT, SO HE STILL WINS THE MATCH.

I MAY HAVE LOST THE BATTLE OF *SWORDS,* YOUNG AVATAR...

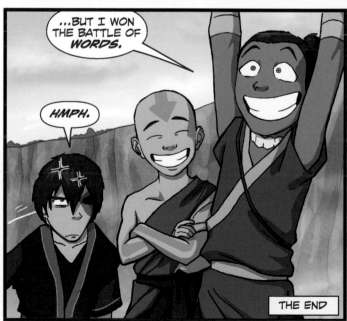

...BUT I WON THE BATTLE OF *WORDS.*

HMPH.

THE END

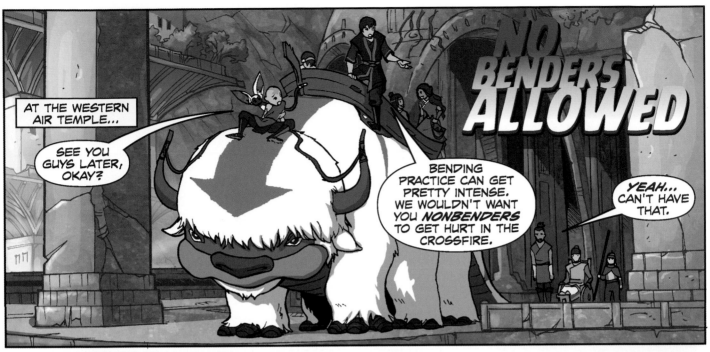

NO BENDERS ALLOWED

AT THE WESTERN AIR TEMPLE...

SEE YOU GUYS LATER, OKAY?

BENDING PRACTICE CAN GET PRETTY INTENSE. WE WOULDN'T WANT YOU *NONBENDERS* TO GET HURT IN THE CROSSFIRE.

YEAH... CAN'T HAVE THAT.

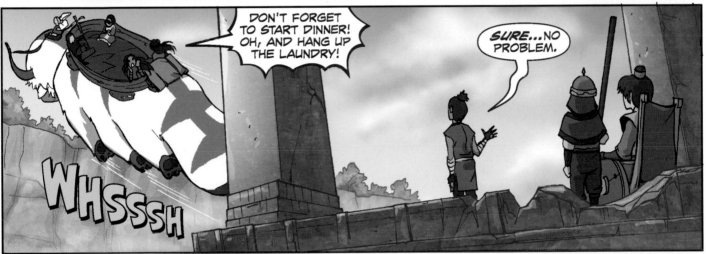

DON'T FORGET TO START DINNER! OH, AND HANG UP THE LAUNDRY!

SURE...NO PROBLEM.

WHSSSH

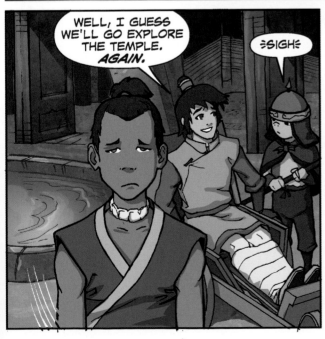

WELL, I GUESS WE'LL GO EXPLORE THE TEMPLE. *AGAIN.*

≥SIGH≥

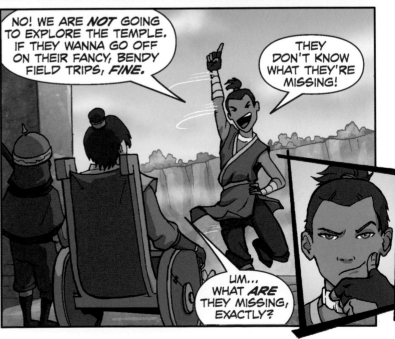

NO! WE ARE *NOT* GOING TO EXPLORE THE TEMPLE. IF THEY WANNA GO OFF ON THEIR FANCY, BENDY FIELD TRIPS, *FINE.*

THEY DON'T KNOW WHAT THEY'RE MISSING!

UM... WHAT *ARE* THEY MISSING, EXACTLY?

Story by Alison Wilgus, art by Elsa Garagarza, colors by Wes Dzioba, and lettering by Comicraft.

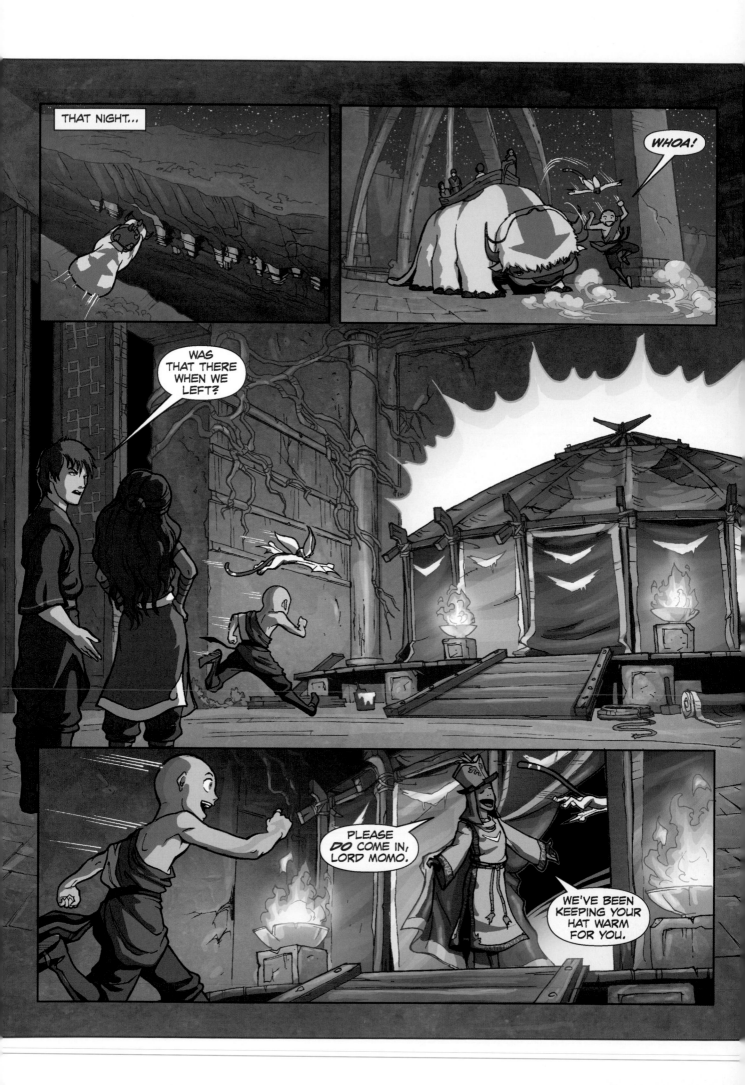

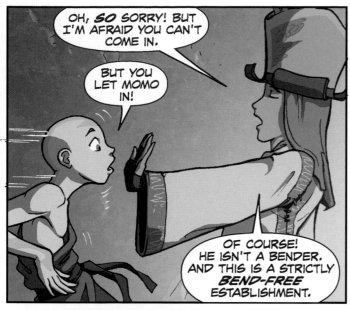

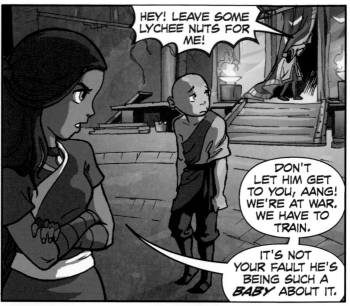

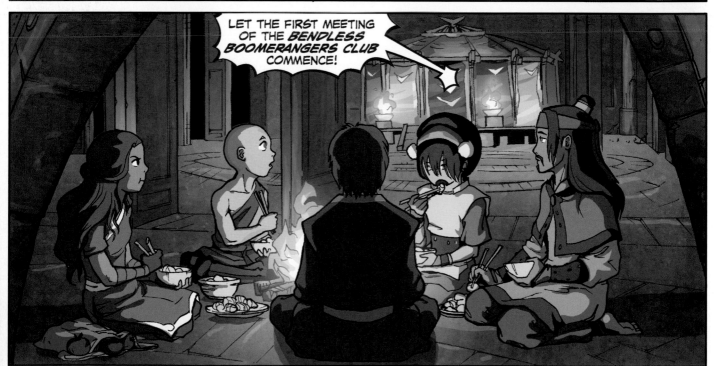

BEVERAGES AND SNACKS WILL BE SERVED IN THE MAIN HALL, FOLLOWED BY ADVANCED BOOMERANG LESSONS IN THE FOYER!

HE NEVER SHOWED *ME* HOW TO USE A BOOMERANG...

AANG, YOU CAN THROW ROCKS *WITH YOUR MIND!*

STILL...

WHUP WHUP

WHUP WHUP

HEY! WHAT'S THAT!?

SNATCH

WOW, THIS WENT A LONG WAY!

COME ON, LET'S GO BACK AND TEST OUT THE OTHER ONES I MADE!

SO CLOSE...

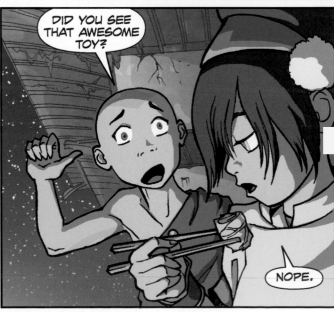

DID YOU SEE THAT AWESOME TOY?

NOPE.

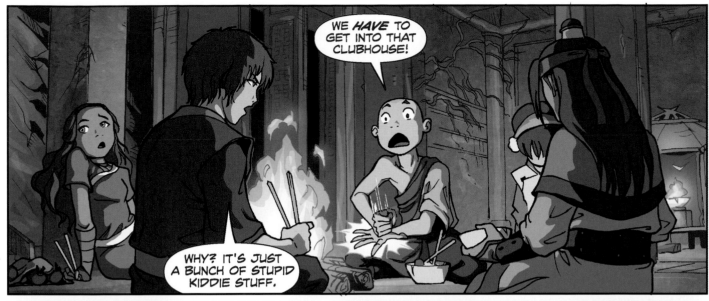

WE *HAVE* TO GET INTO THAT CLUBHOUSE!

WHY? IT'S JUST A BUNCH OF STUPID KIDDIE STUFF.

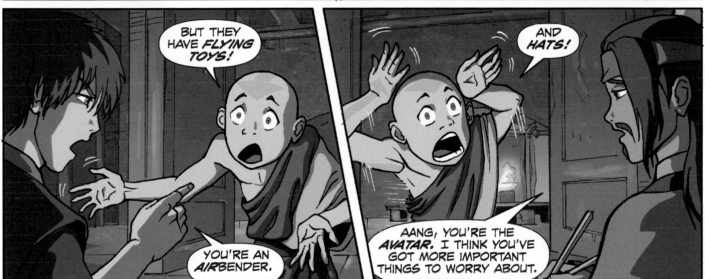

BUT THEY HAVE *FLYING TOYS!*

YOU'RE AN *AIR*BENDER.

AND *HATS!*

AANG, YOU'RE THE *AVATAR.* I THINK YOU'VE GOT MORE IMPORTANT THINGS TO WORRY ABOUT.

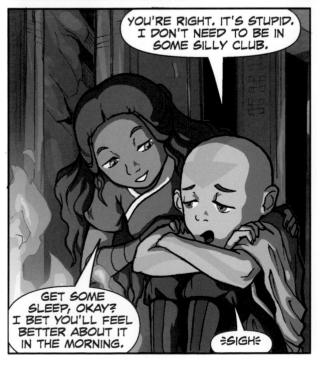

YOU'RE RIGHT. IT'S STUPID. I DON'T NEED TO BE IN SOME SILLY CLUB.

GET SOME SLEEP, OKAY? I BET YOU'LL FEEL BETTER ABOUT IT IN THE MORNING.

≈SIGH≈

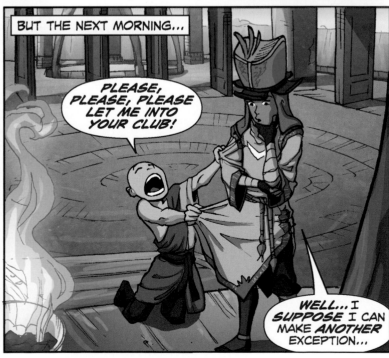

BUT THE NEXT MORNING...

PLEASE, PLEASE, PLEASE LET ME INTO YOUR CLUB!

WELL...I *SUPPOSE* I CAN MAKE *ANOTHER* EXCEPTION...

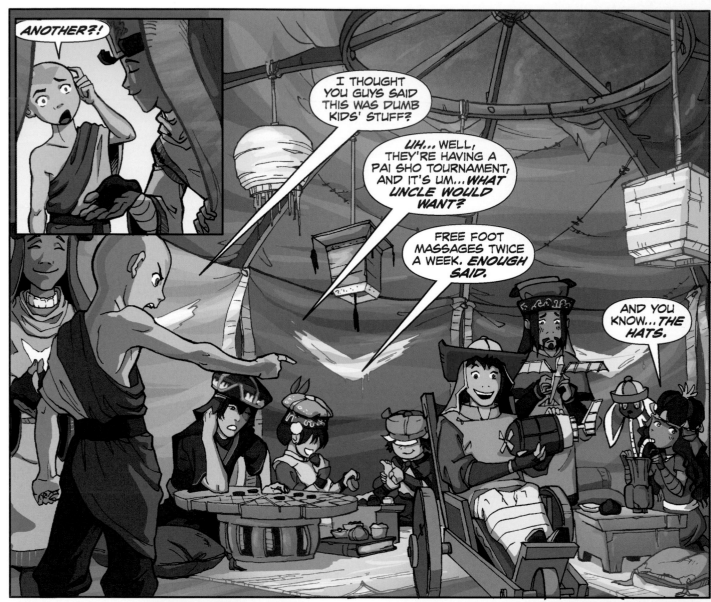

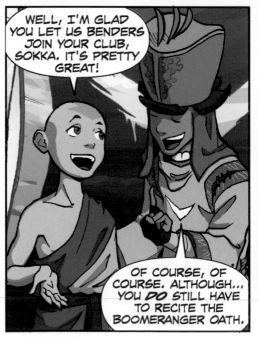

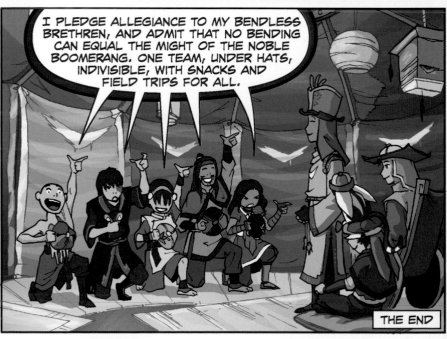

THE END

Love Is a Battlefield

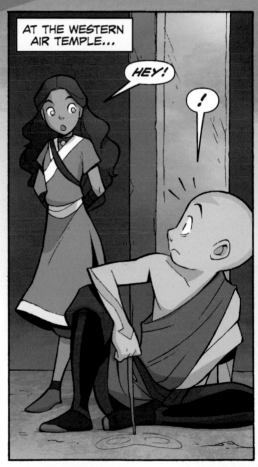

AT THE WESTERN AIR TEMPLE...

HEY!

!

WHAT ARE YOU DOING OVER THERE?

UH... NOTHING, KATARA!

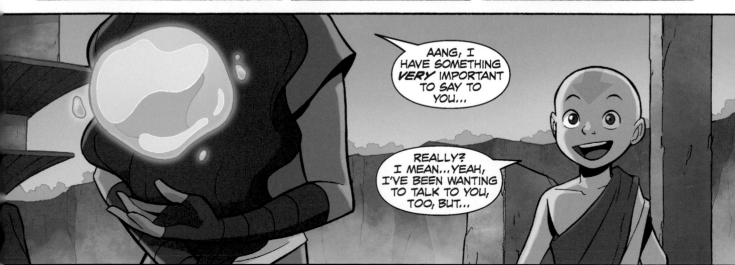

AANG, I HAVE SOMETHING *VERY* IMPORTANT TO SAY TO YOU...

REALLY? I MEAN...YEAH, I'VE BEEN WANTING TO TALK TO YOU, TOO, BUT...

Story by J. Torres, art and colors by Gurihiru, and lettering by Comicraft.

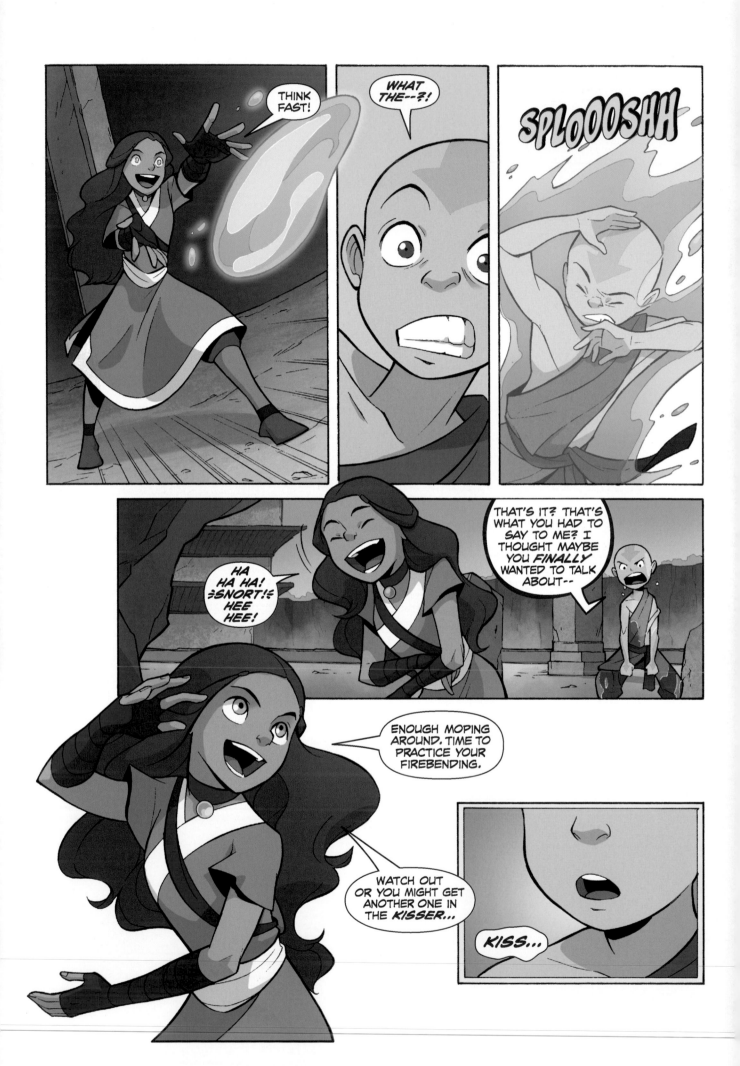

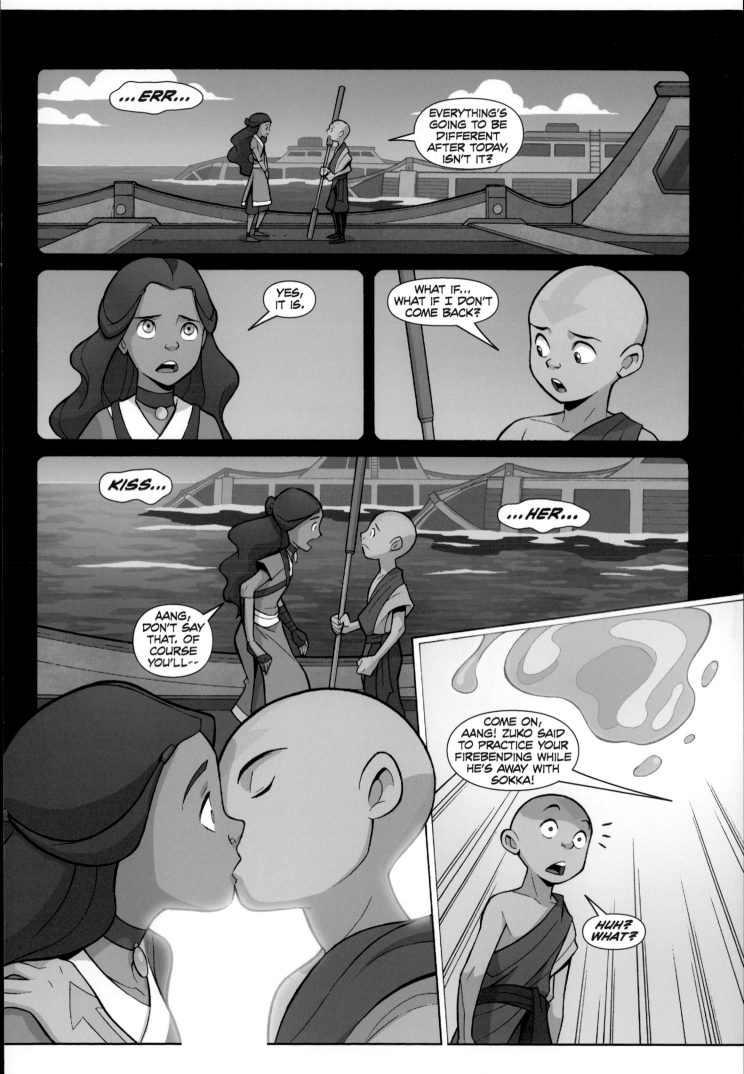

191

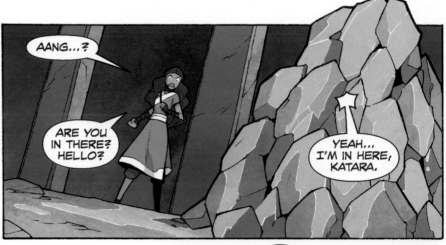

AANG...?

ARE YOU IN THERE? HELLO?

YEAH... I'M IN HERE, KATARA.

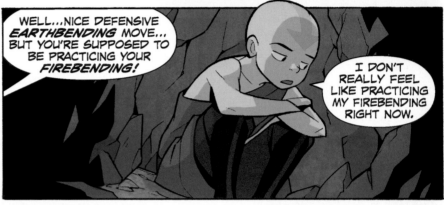

WELL...NICE DEFENSIVE *EARTHBENDING* MOVE... BUT YOU'RE SUPPOSED TO BE PRACTICING YOUR *FIREBENDING!*

I DON'T REALLY FEEL LIKE PRACTICING MY FIREBENDING RIGHT NOW.

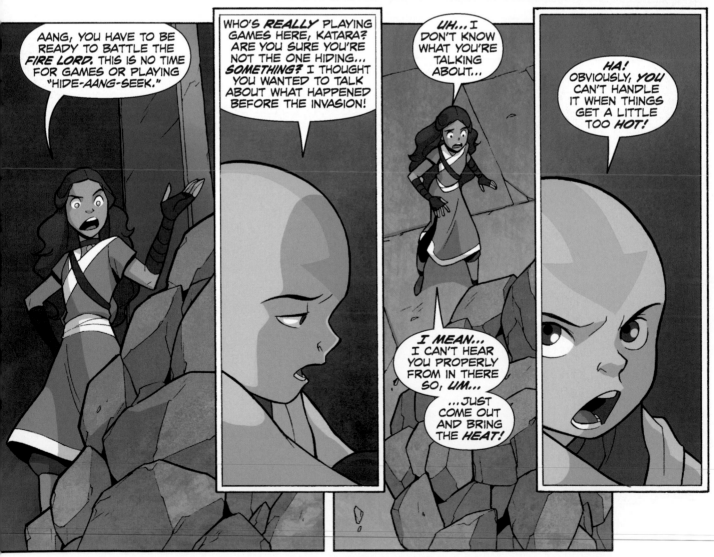

AANG, YOU HAVE TO BE READY TO BATTLE THE *FIRE LORD.* THIS IS NO TIME FOR GAMES OR PLAYING "HIDE-AANG-SEEK."

WHO'S *REALLY* PLAYING GAMES HERE, KATARA? ARE YOU SURE YOU'RE NOT THE ONE HIDING... *SOMETHING?* I THOUGHT YOU WANTED TO TALK ABOUT WHAT HAPPENED BEFORE THE INVASION!

UH...I DON'T KNOW WHAT YOU'RE TALKING ABOUT...

HA! OBVIOUSLY, *YOU* CAN'T HANDLE IT WHEN THINGS GET A LITTLE TOO *HOT!*

I MEAN... I CAN'T HEAR YOU PROPERLY FROM IN THERE SO, UM...

...JUST COME OUT AND BRING THE *HEAT!*

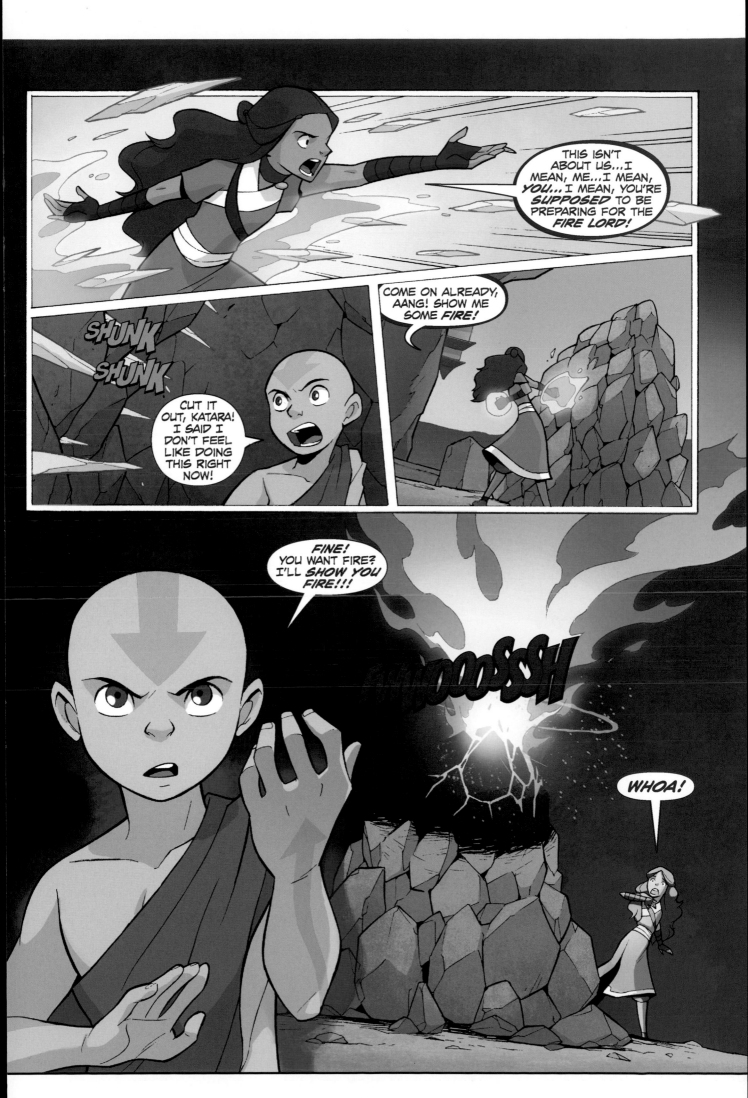

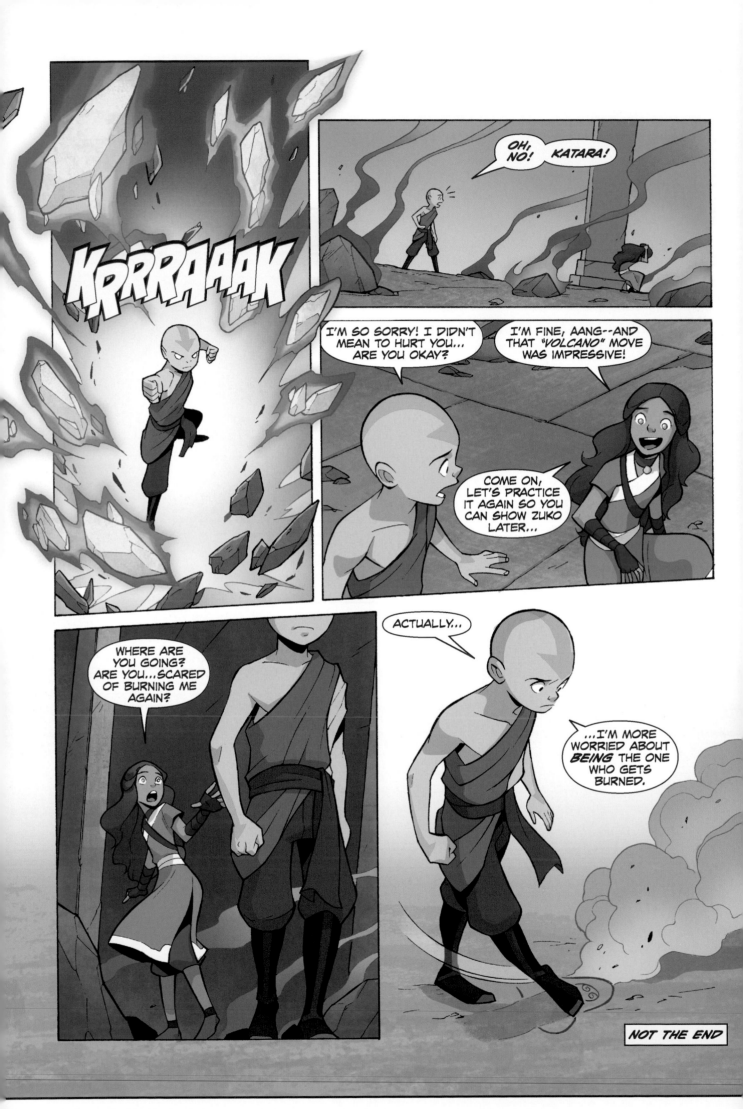

DRAGON DAYS

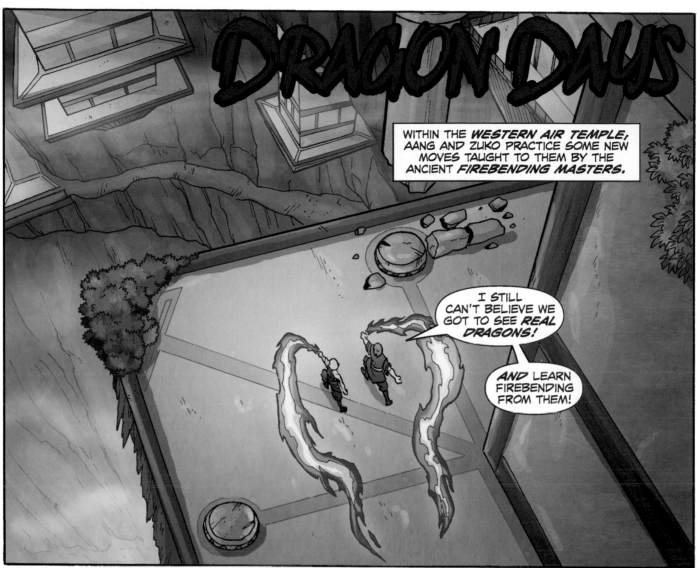

WITHIN THE *WESTERN AIR TEMPLE*, AANG AND ZUKO PRACTICE SOME NEW MOVES TAUGHT TO THEM BY THE ANCIENT *FIREBENDING MASTERS*.

I STILL CAN'T BELIEVE WE GOT TO SEE *REAL DRAGONS*!

AND LEARN FIREBENDING FROM THEM!

I DIDN'T THINK THERE WERE ANY LEFT!

FOOOM

THERE WERE *LOTS* OF DRAGONS AROUND 100 YEARS AGO.

THEY WERE PRETTY SHY, THOUGH. MOST OF THEM LIVED WAY UP IN THE MOUNTAINS.

THEY DIDN'T SEEM SHY TO *ME*.

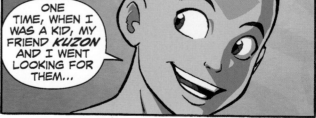

ONE TIME, WHEN I WAS A KID, MY FRIEND *KUZON* AND I WENT LOOKING FOR THEM...

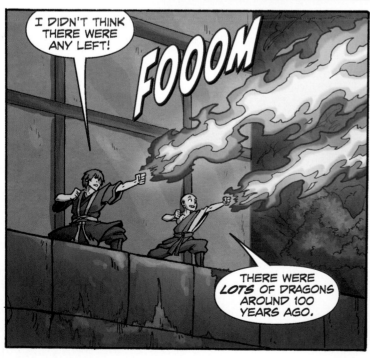

Story by Alison Wilgus, art by Johane Matte (frame) and Tom McWeeney (flashback), colors by Wes Dzioba, and lettering by Comicraft.

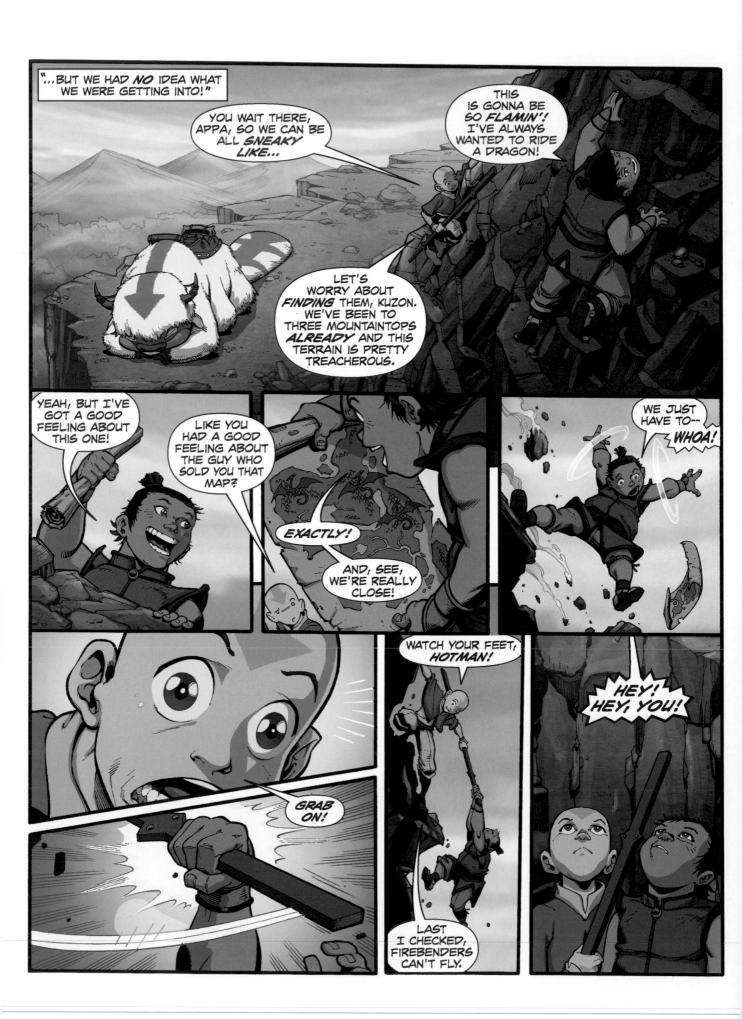

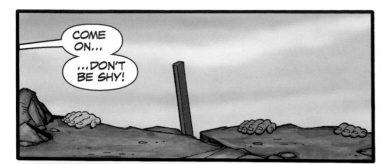

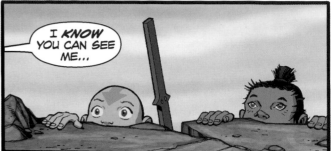

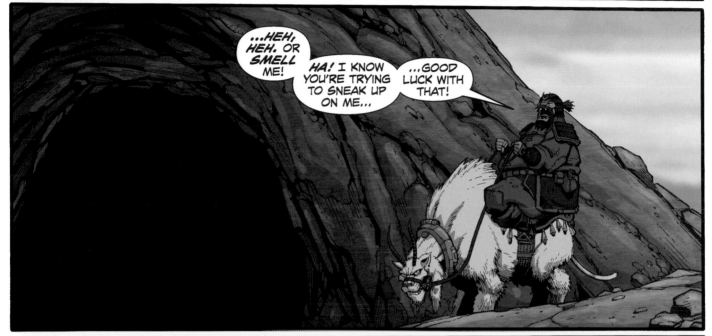

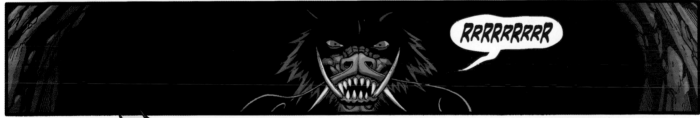

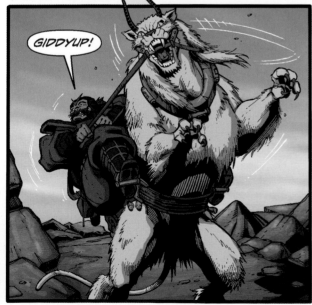

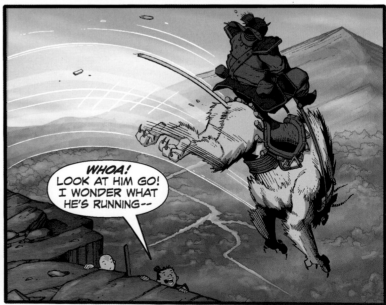

197

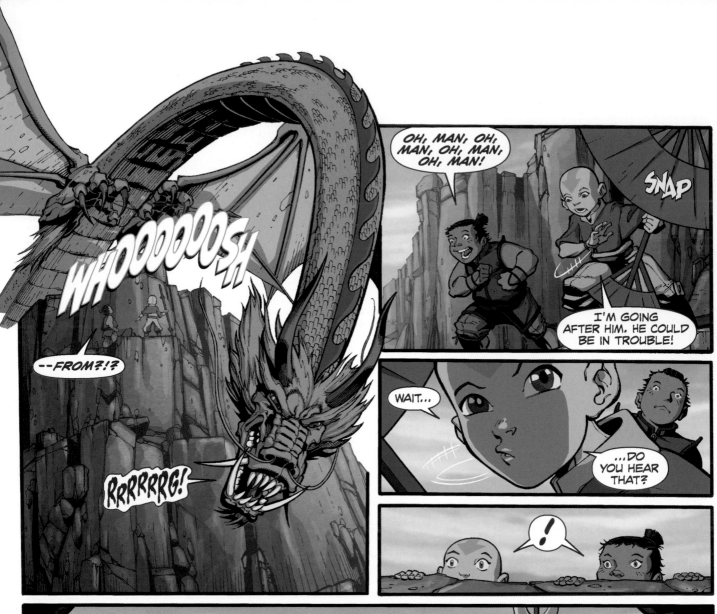

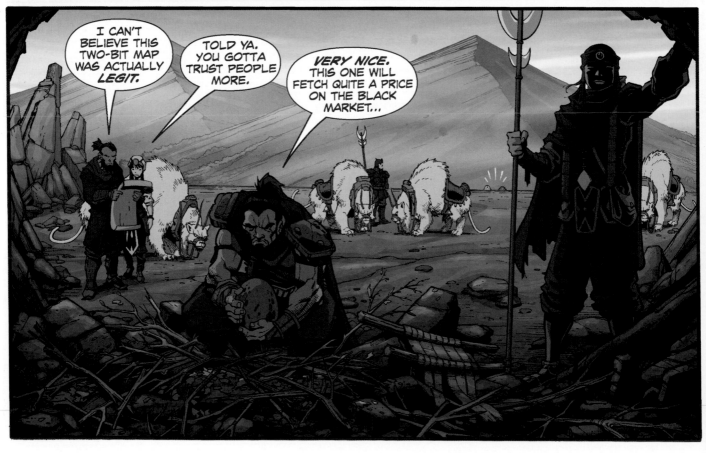

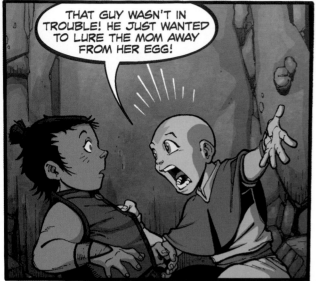

THAT GUY WASN'T IN TROUBLE! HE JUST WANTED TO LURE THE MOM AWAY FROM HER EGG!

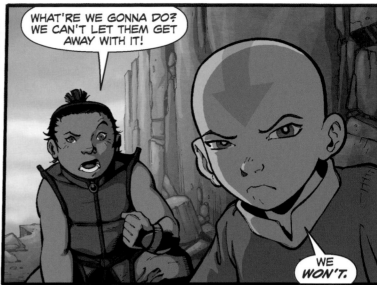

WHAT'RE WE GONNA DO? WE CAN'T LET THEM GET AWAY WITH IT!

WE WON'T.

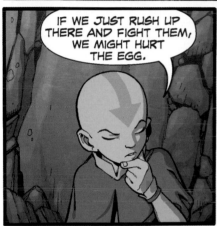

IF WE JUST RUSH UP THERE AND FIGHT THEM, WE MIGHT HURT THE EGG.

BUT MAYBE...

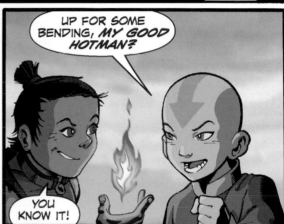

UP FOR SOME BENDING, MY GOOD HOTMAN?

YOU KNOW IT!

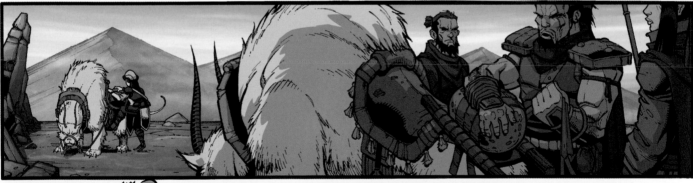

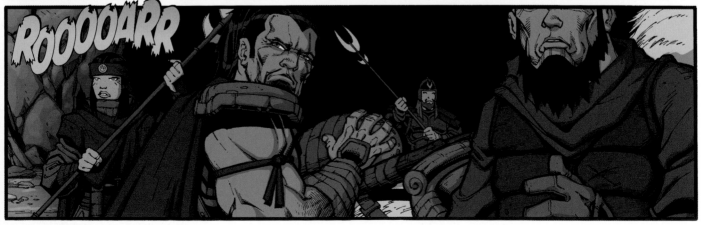

ROOOOARR

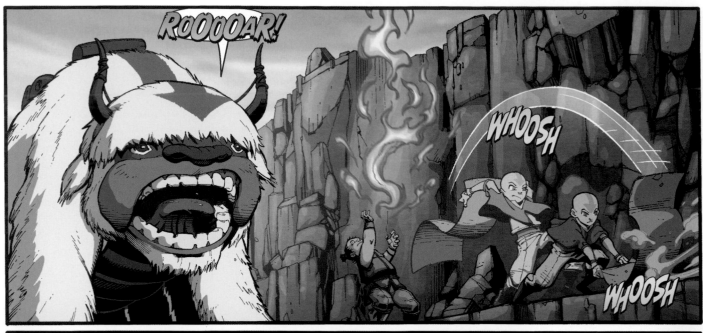

ROOOOAR!

WHOOSH

WHOOSH

COULD SHE BE BACK *ALREADY?*

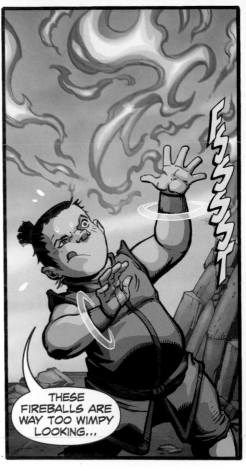

THESE FIREBALLS ARE WAY TOO WIMPY LOOKING...

FSSSSSI

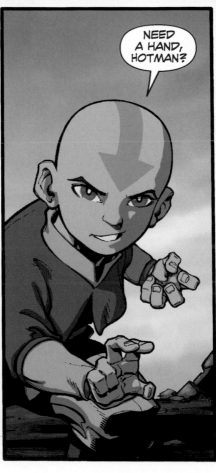

NEED A HAND, HOTMAN?

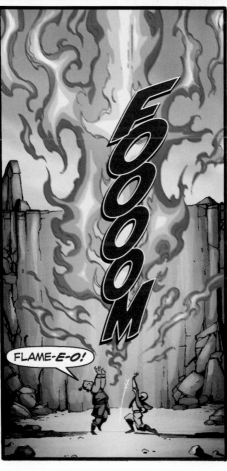

FOOOOM

FLAME-*E-O!*

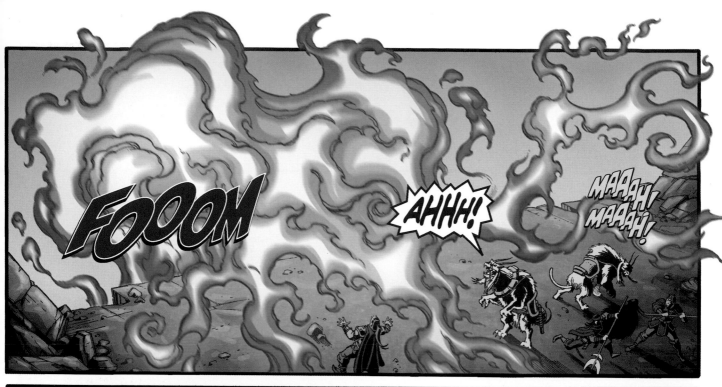

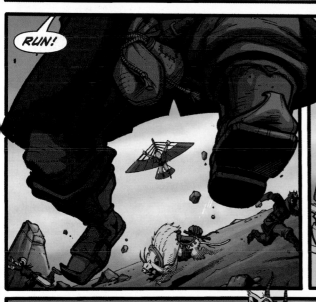

RUN!

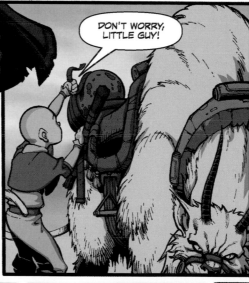

DON'T WORRY, LITTLE GUY!

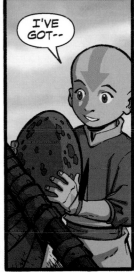

I'VE GOT--

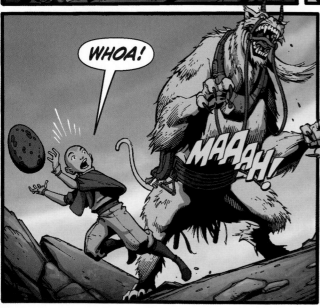

WHOA!

MAAAH!

WHEW!

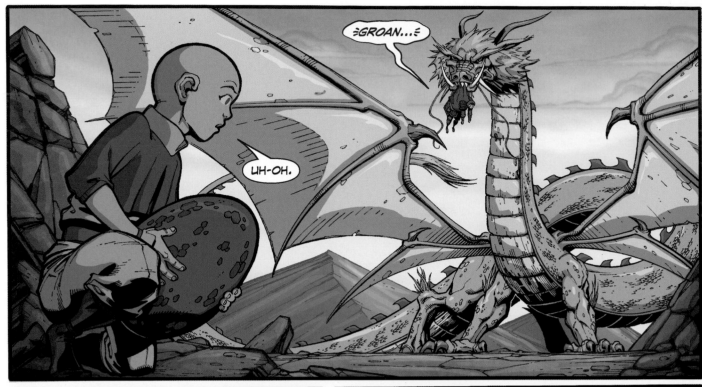

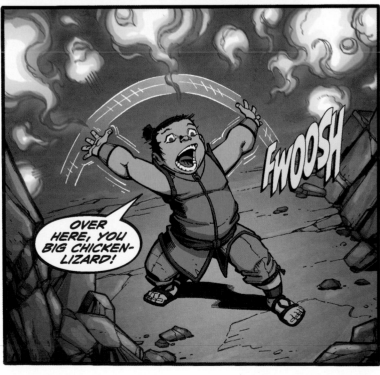

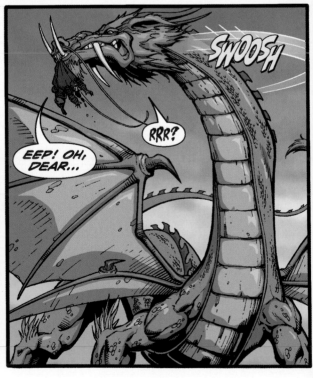

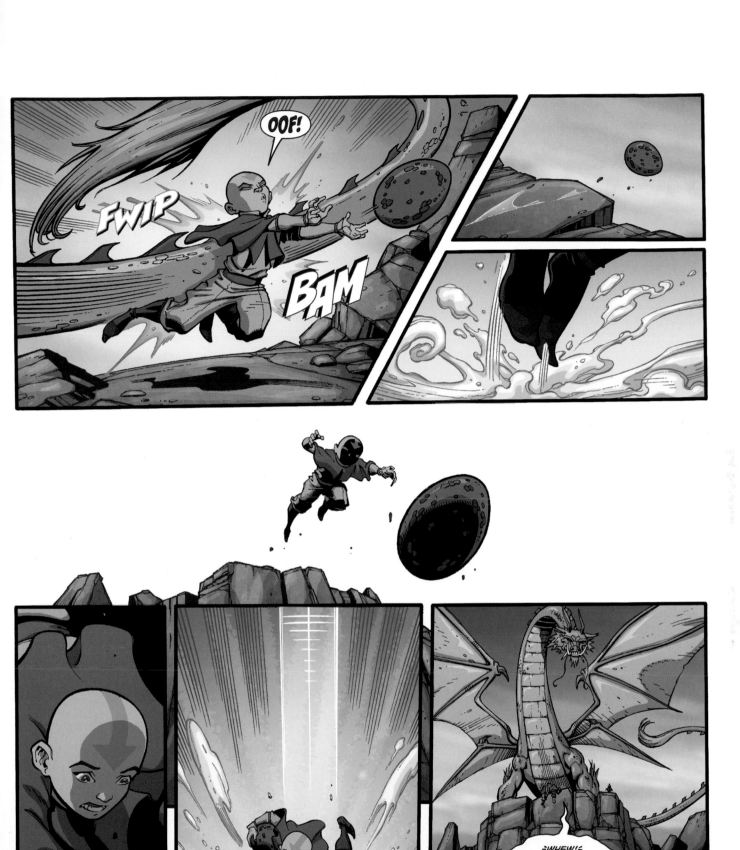

THE END

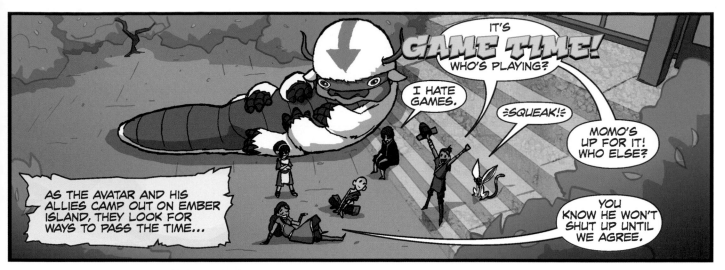

AS THE AVATAR AND HIS ALLIES CAMP OUT ON EMBER ISLAND, THEY LOOK FOR WAYS TO PASS THE TIME...

IT'S **GAME TIME!** WHO'S PLAYING?

I HATE GAMES.

≈SQUEAK!≈

MOMO'S UP FOR IT! WHO ELSE?

YOU KNOW HE WON'T SHUT UP UNTIL WE AGREE.

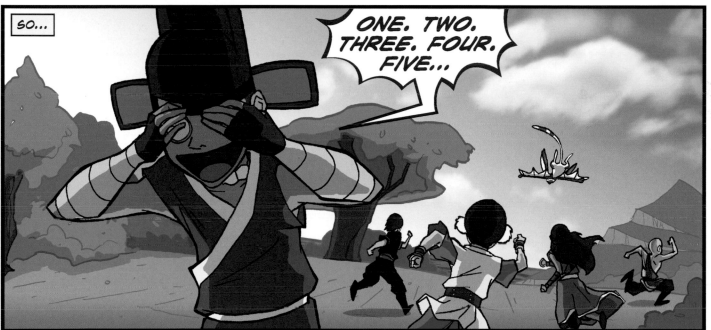

SO...

ONE. TWO. THREE. FOUR. FIVE...

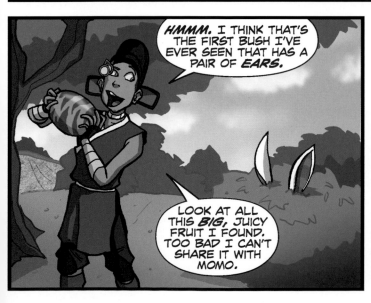

HMMM. I THINK THAT'S THE FIRST BUSH I'VE EVER SEEN THAT HAS A PAIR OF *EARS.*

LOOK AT ALL THIS *BIG,* JUICY FRUIT I FOUND. TOO BAD I CAN'T SHARE IT WITH MOMO.

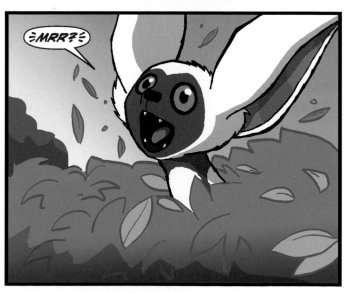

≈MRR?≈

Story by Katie Mattila, art by Justin Ridge, colors by Hye Jung Kim, and lettering by Comicraft.

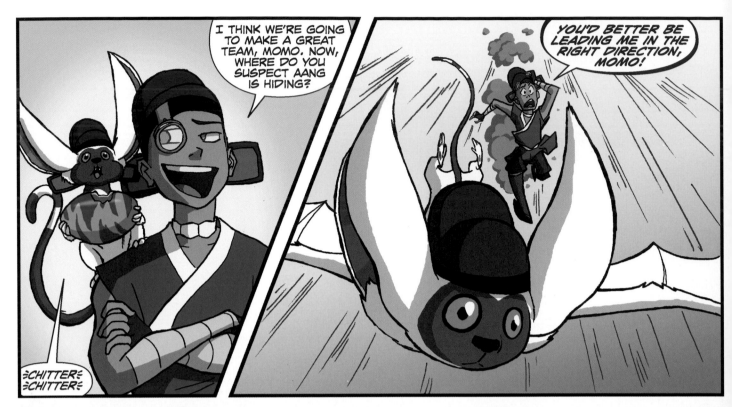

HMMM. THESE FOOTPRINTS SEEM TO BE THE *EXACT* SIZE OF KATARA'S FEET.

AND THEY SEEM TO END RIGHT NEAR THAT *WATERFALL.*

≷SIGH≷ THAT WAS WAY TOO EASY.

I THINK WE SHOULD JUST LET HER CONTINUE *WATERBENDING* FOR A WHILE.

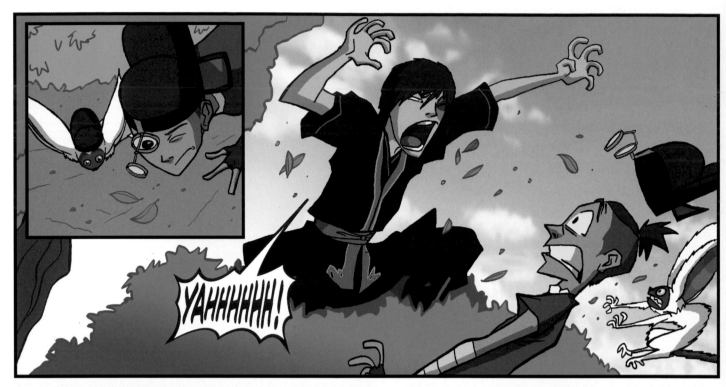

YAHHHHHH!

WHAT WAS THAT?

HA! GOT YOU! I WIN HIDE-AND-SHRIEK!

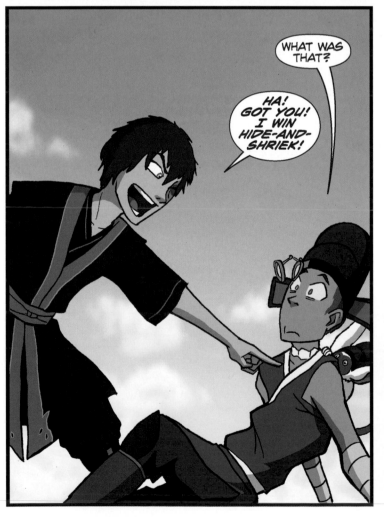

IT'S HIDE-AND-SEEK, ZUKO.

I GOT YOU.

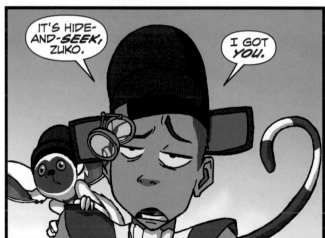

I REALLY HATE GAMES.

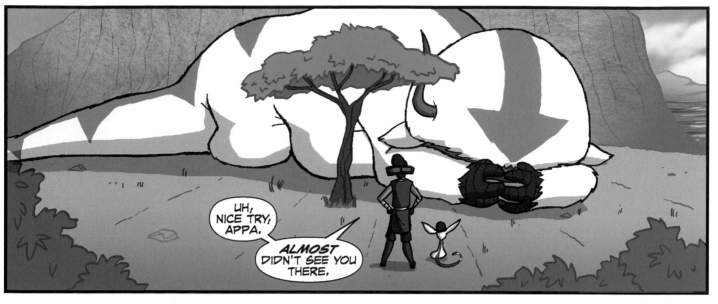

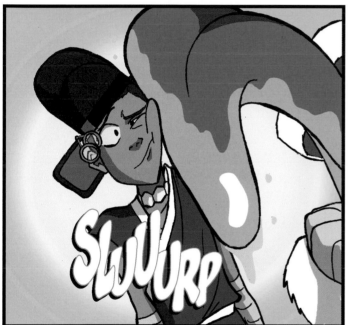

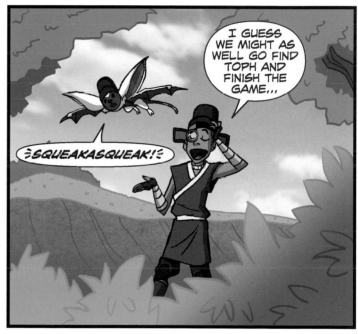

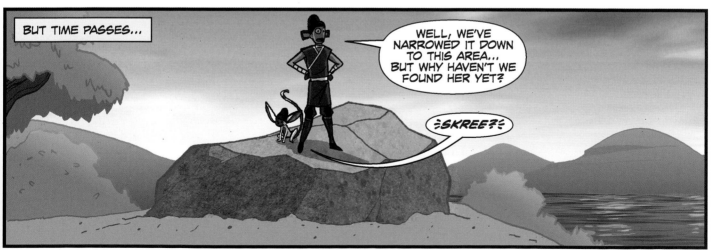

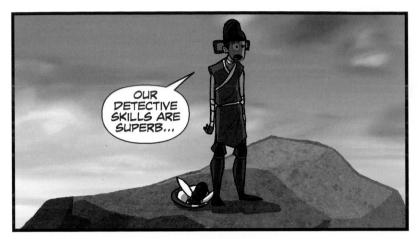

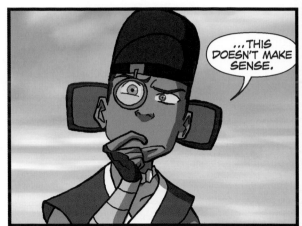

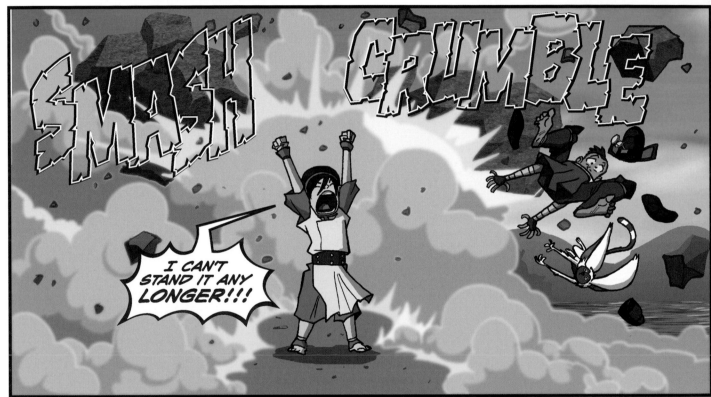

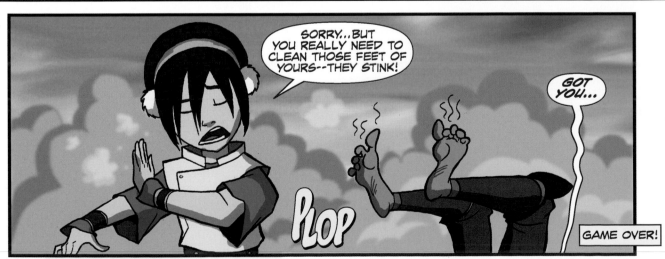

210

BUMI vs. TOPH
Round 1

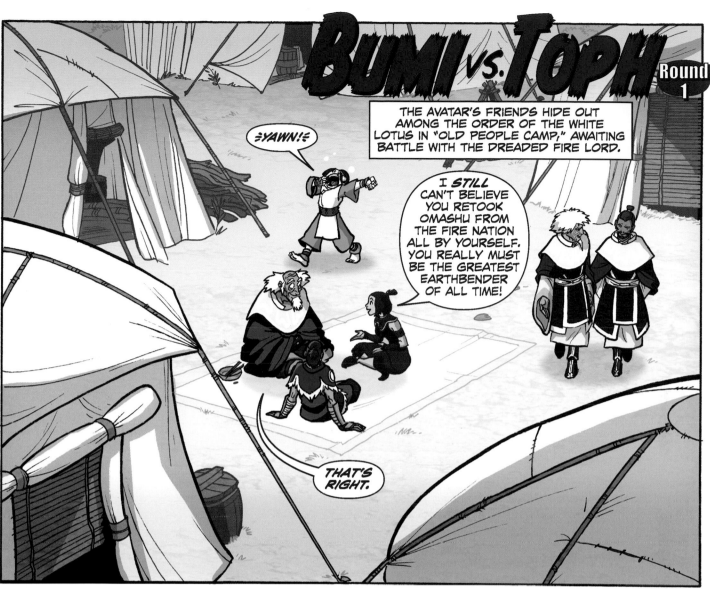

THE AVATAR'S FRIENDS HIDE OUT AMONG THE ORDER OF THE WHITE LOTUS IN "OLD PEOPLE CAMP," AWAITING BATTLE WITH THE DREADED FIRE LORD.

≷YAWN!≷

I *STILL* CAN'T BELIEVE YOU RETOOK OMASHU FROM THE FIRE NATION ALL BY YOURSELF. YOU REALLY MUST BE THE GREATEST EARTHBENDER OF ALL TIME!

THAT'S RIGHT.

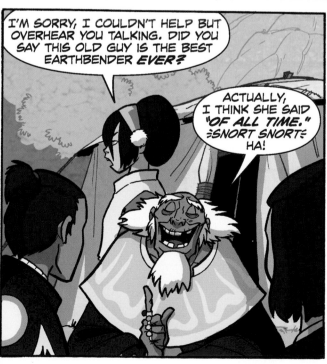

I'M SORRY, I COULDN'T HELP BUT OVERHEAR YOU TALKING. DID YOU SAY THIS OLD GUY IS THE BEST EARTHBENDER *EVER?*

ACTUALLY, I THINK SHE SAID *"OF ALL TIME."* ≷SNORT SNORT≷ HA!

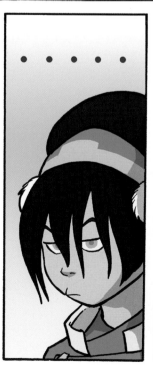

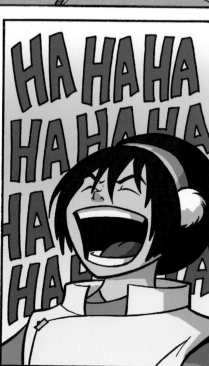

HA HA HA HA HA HA HA HA

Story by Johane Matte and Joshua Hamilton, art by Johane Matte, colors by Hye Jung Kim, and lettering by Comicraft.

211

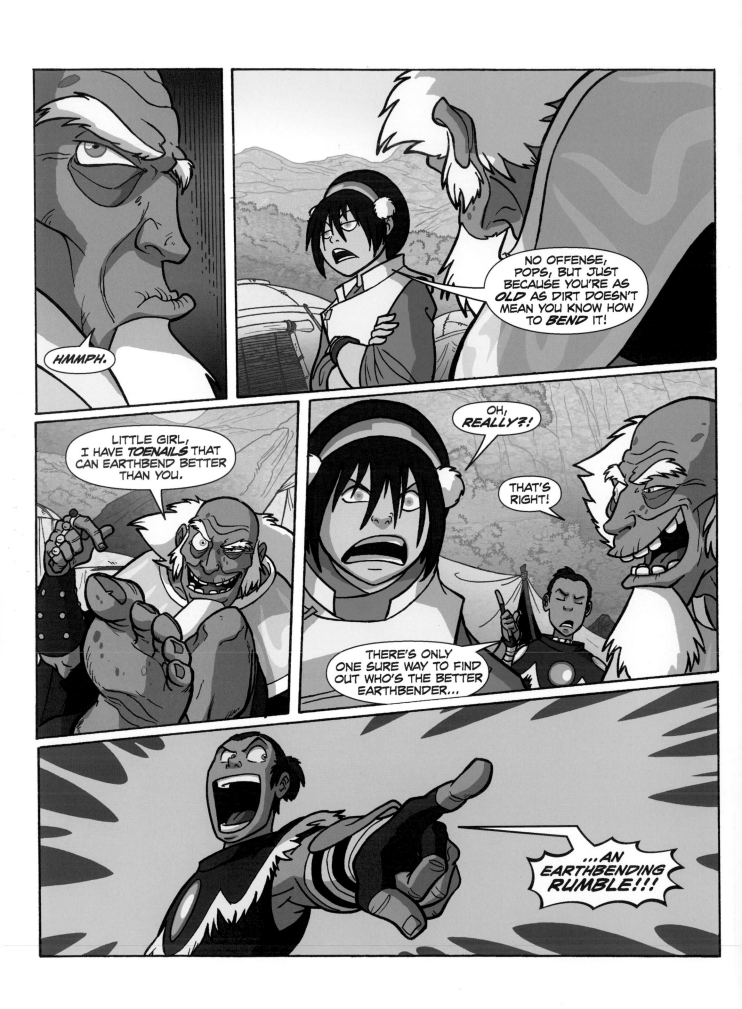

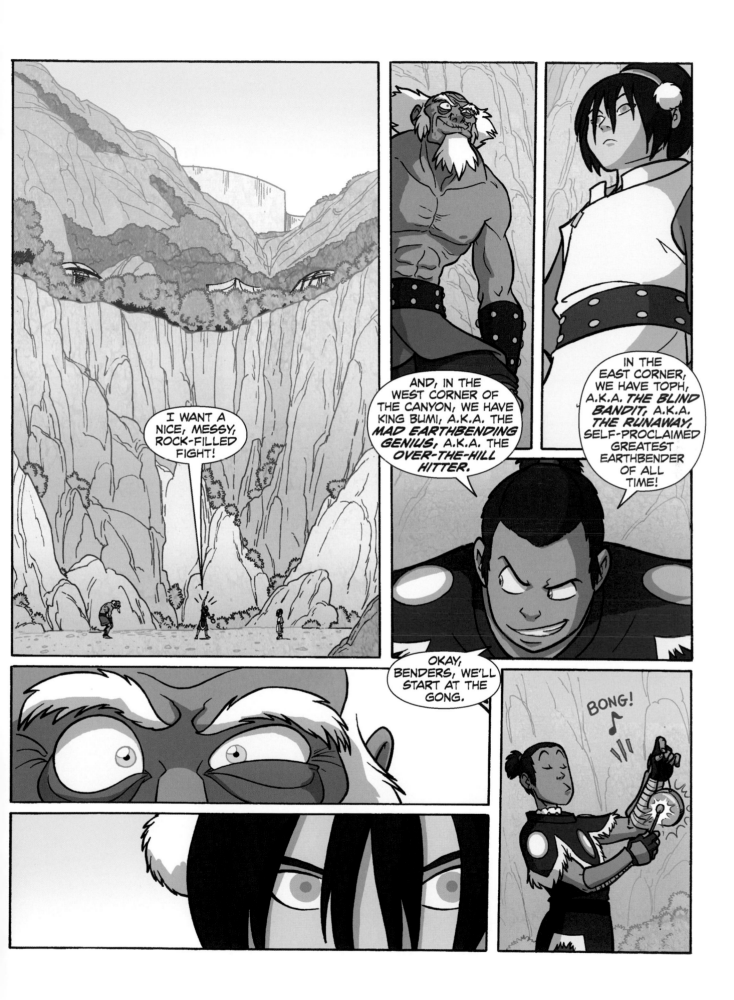

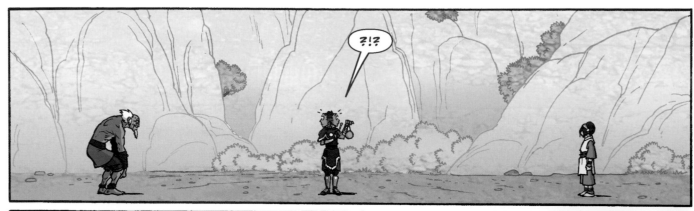

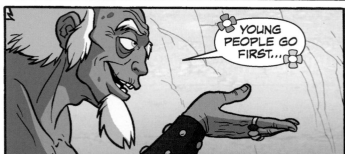

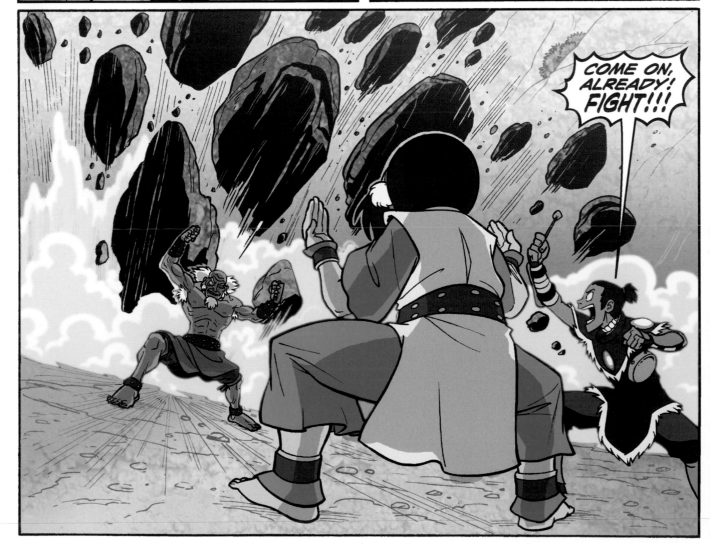

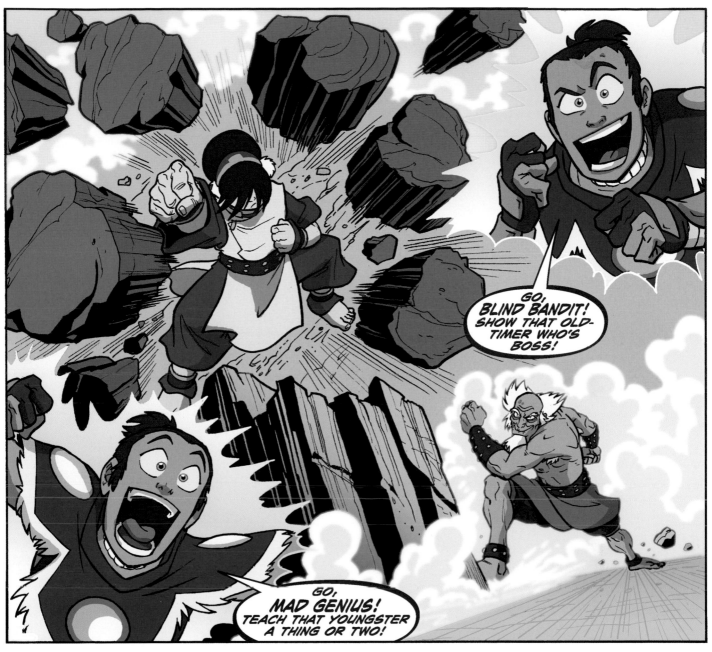

215

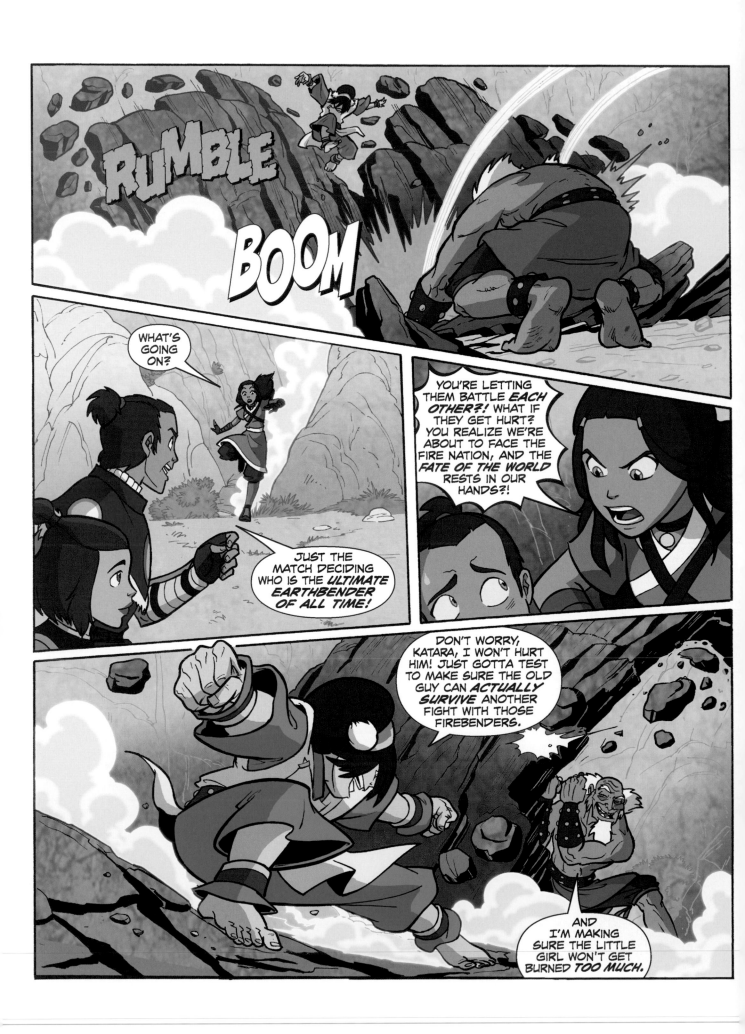

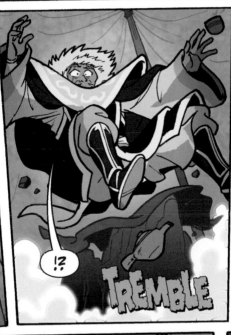

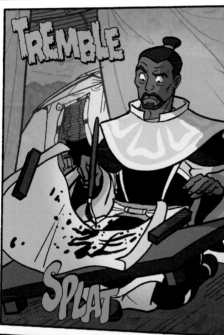

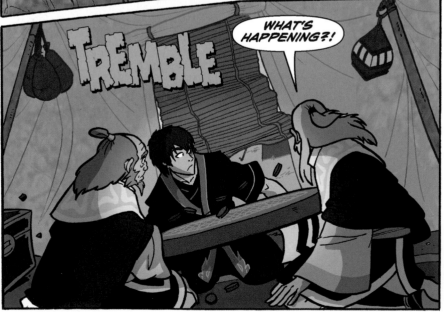

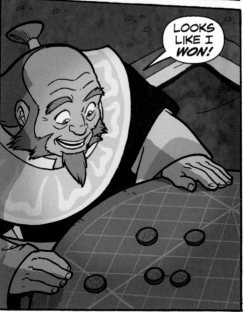

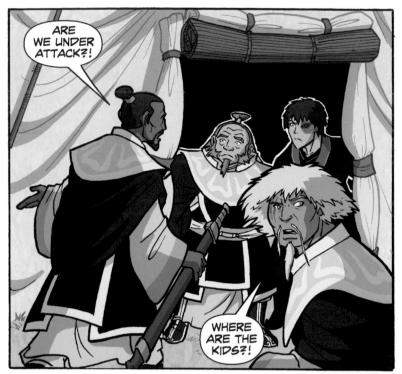

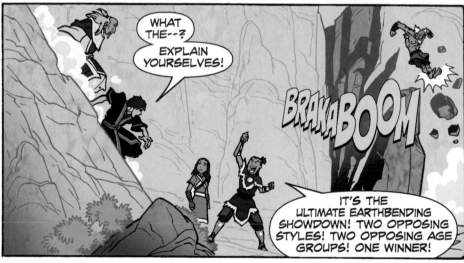

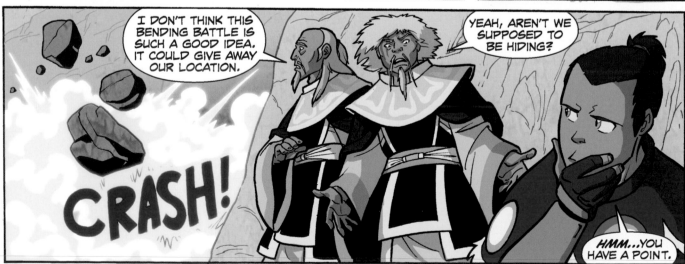

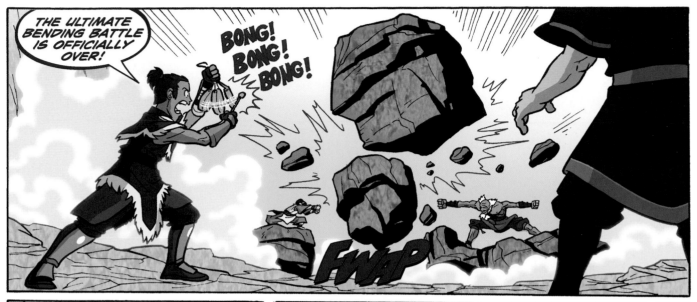

THE ULTIMATE BENDING BATTLE IS OFFICIALLY OVER!

BONG! BONG! BONG!

FWAP

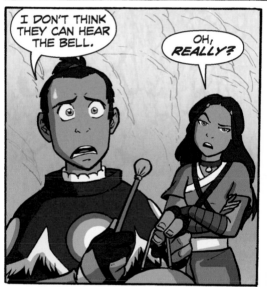

I DON'T THINK THEY CAN HEAR THE BELL.

OH, REALLY?

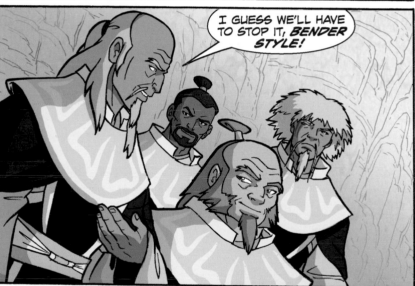

I GUESS WE'LL HAVE TO STOP IT, BENDER STYLE!

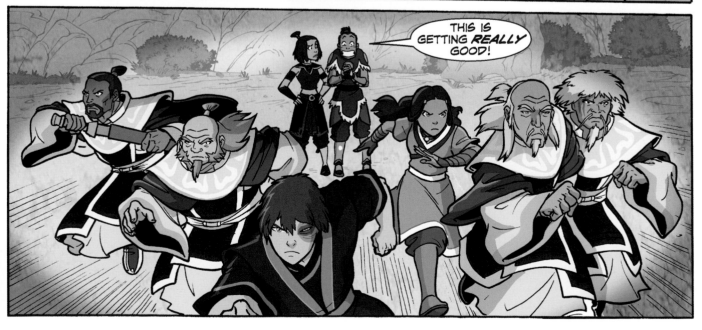

THIS IS GETTING REALLY GOOD!

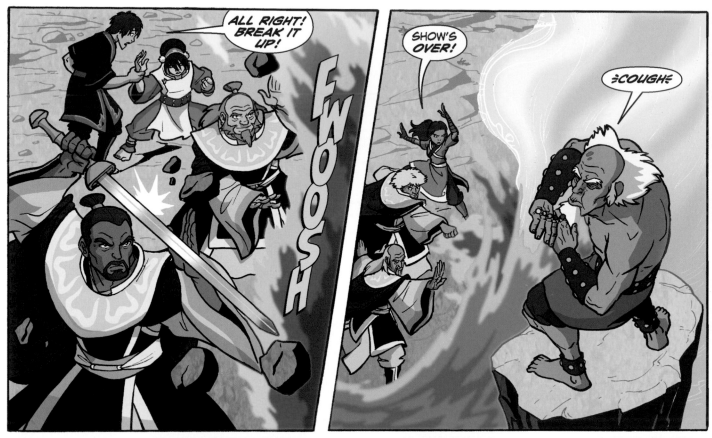

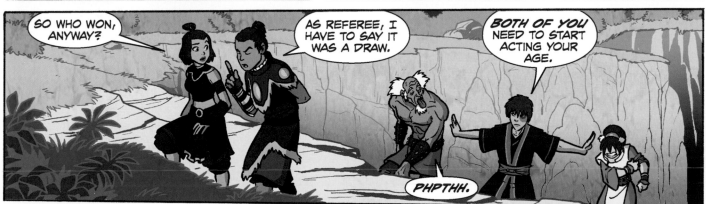

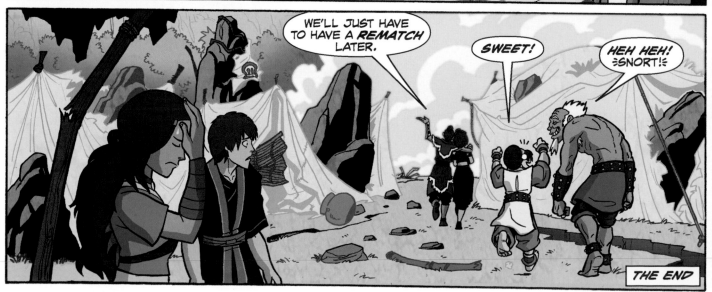

THE END

BOOK FOUR
OTHER
STORIES

NEW RECRUITS

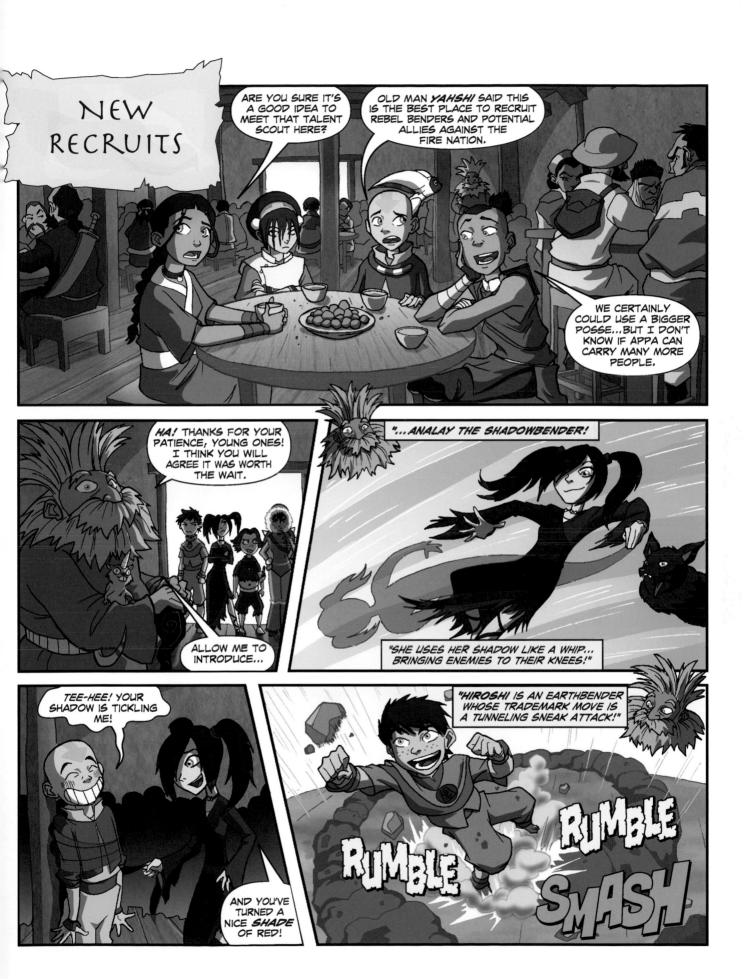

ARE YOU SURE IT'S A GOOD IDEA TO MEET THAT TALENT SCOUT HERE?

OLD MAN *YAHSHI* SAID THIS IS THE BEST PLACE TO RECRUIT REBEL BENDERS AND POTENTIAL ALLIES AGAINST THE FIRE NATION.

WE CERTAINLY COULD USE A BIGGER POSSE...BUT I DON'T KNOW IF APPA CAN CARRY MANY MORE PEOPLE.

HA! THANKS FOR YOUR PATIENCE, YOUNG ONES! I THINK YOU WILL AGREE IT WAS WORTH THE WAIT.

ALLOW ME TO INTRODUCE...

"...ANALAY THE SHADOWBENDER!"

"SHE USES HER SHADOW LIKE A WHIP... BRINGING ENEMIES TO THEIR KNEES!"

TEE-HEE! YOUR SHADOW IS TICKLING ME!

AND YOU'VE TURNED A NICE *SHADE* OF RED!

"HIROSHI IS AN EARTHBENDER WHOSE TRADEMARK MOVE IS A TUNNELING SNEAK ATTACK!"

RUMBLE

RUMBLE

SMASH

Story by Dave Roman, art by Justin Ridge, colors by Sno Cone Studios and Hye Jung Kim, and lettering by Comicraft.

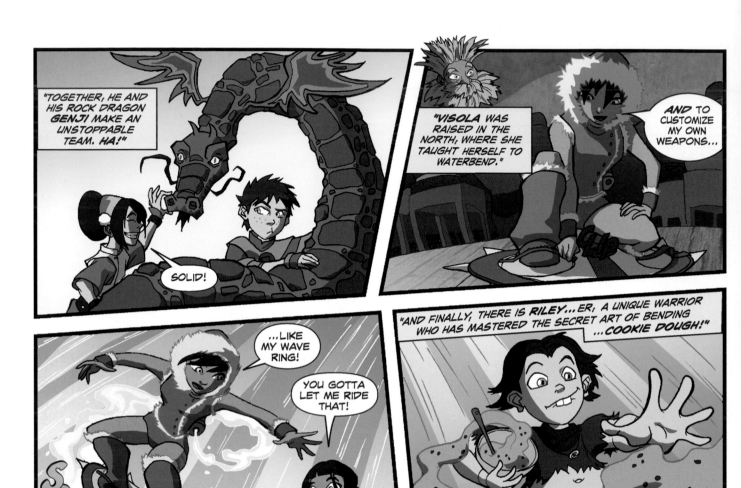

"TOGETHER, HE AND HIS ROCK DRAGON *GENJI* MAKE AN UNSTOPPABLE TEAM. *HA!*"

SOLID!

"*VISOLA* WAS RAISED IN THE NORTH, WHERE SHE TAUGHT HERSELF TO WATERBEND."

AND TO CUSTOMIZE MY OWN WEAPONS...

...LIKE MY WAVE RING!

YOU GOTTA LET ME RIDE THAT!

SPLASH

"AND FINALLY, THERE IS *RILEY*...ER, A UNIQUE WARRIOR WHO HAS MASTERED THE SECRET ART OF BENDING ...*COOKIE DOUGH!*"

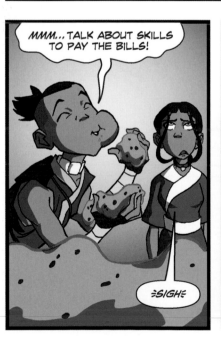

MMM...TALK ABOUT SKILLS TO PAY THE BILLS!

≡SIGH≡

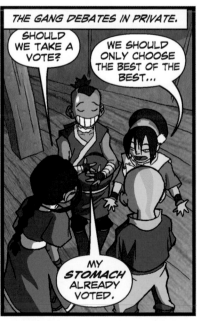

THE GANG DEBATES IN PRIVATE.

SHOULD WE TAKE A VOTE?

WE SHOULD ONLY CHOOSE THE BEST OF THE BEST...

MY *STOMACH* ALREADY VOTED.

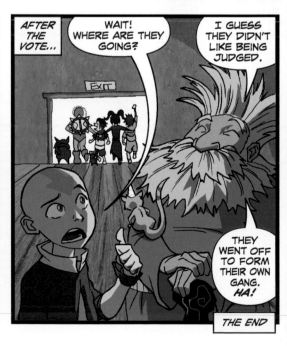

AFTER THE VOTE...

WAIT! WHERE ARE THEY GOING?

I GUESS THEY DIDN'T LIKE BEING JUDGED.

THEY WENT OFF TO FORM THEIR OWN GANG. *HA!*

EXIT

THE END

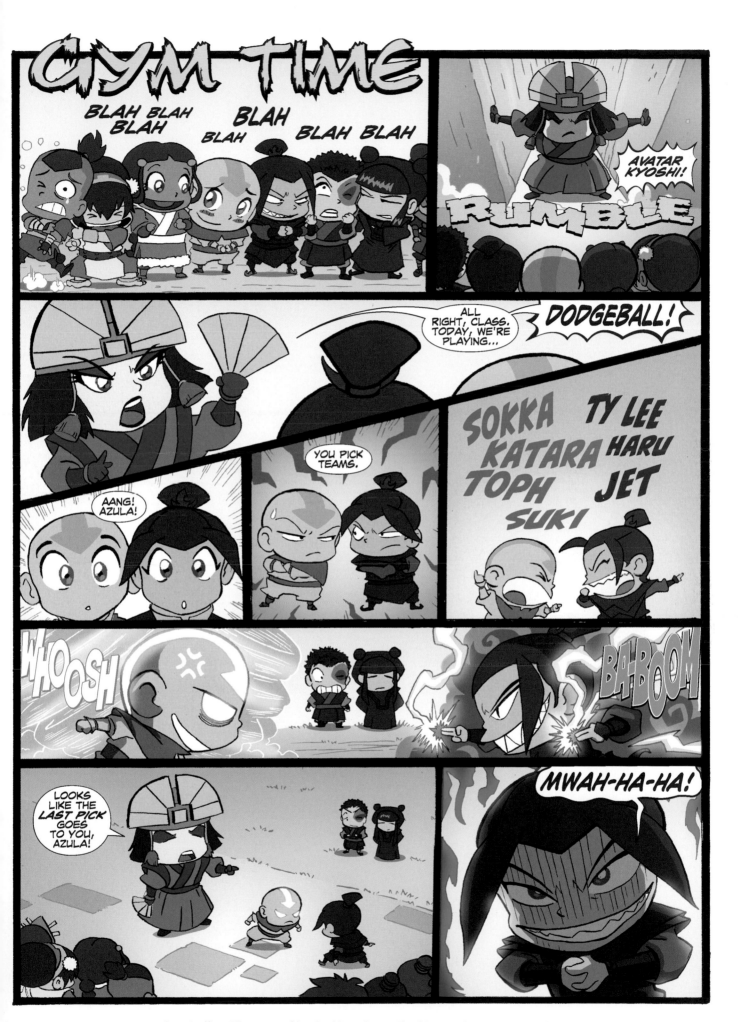

Story by Alison Wilgus, art by Ethan Spaulding, colors by Wes Dzioba, and lettering by Comicraft.

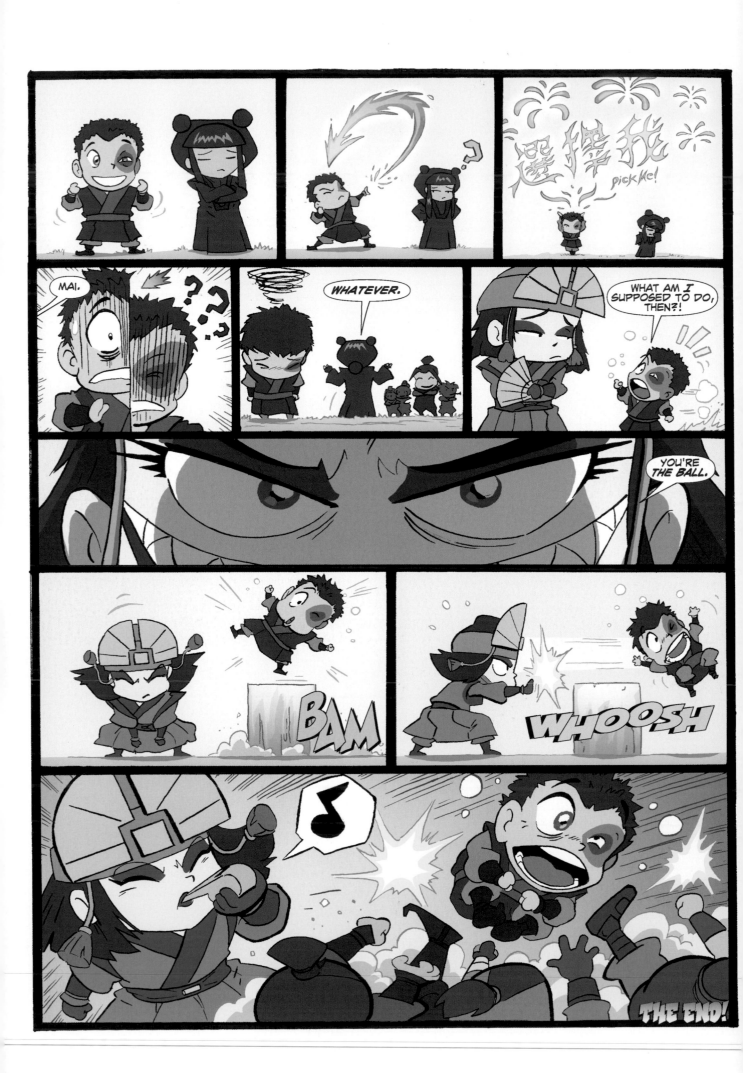

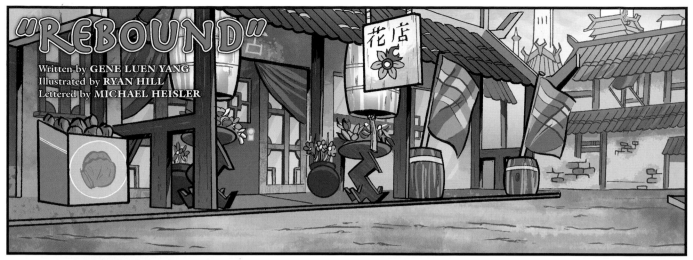

"REBOUND"

Written by **GENE LUEN YANG**
Illustrated by **RYAN HILL**
Lettered by **MICHAEL HEISLER**

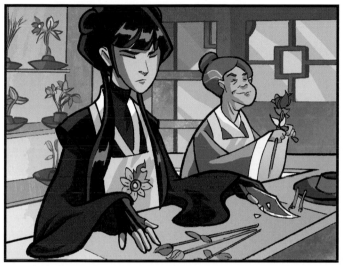

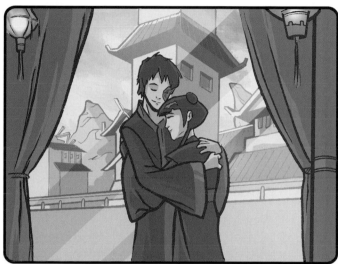

MAI, I DIDN'T HIRE YOU JUST BECAUSE I NEEDED THE HELP. I'D ALSO HOPED THAT BEING AROUND FLOWERS ALL DAY WOULD CHEER YOU UP.

I APPRECIATE THE JOB, AUNTIE MURA, BUT WHAT GAVE YOU THE IDEA THAT I NEED CHEERING UP?

... WHY DON'T YOU KEEP WORKING ON THAT ARRANGEMENT? YOU'LL GET THE HANG OF IT SOON.

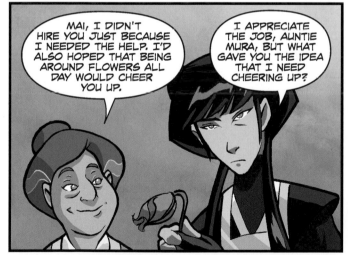

ding ding

AH... HELLO? I'M LOOKING FOR A BOUQUET TO GIVE A SPECIAL SOMEONE.

I'M SURE MY ASSISTANT MAI WILL BE HAPPY TO HELP A HANDSOME YOUNG MAN LIKE YOU!

≋SIGH.≋

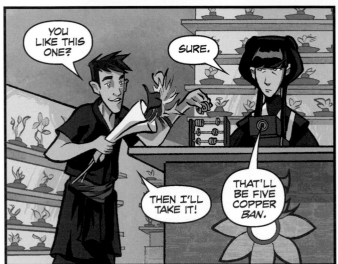

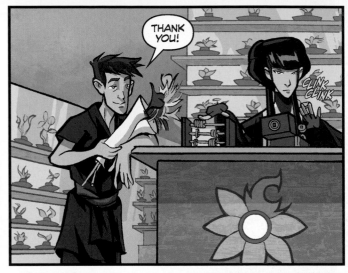

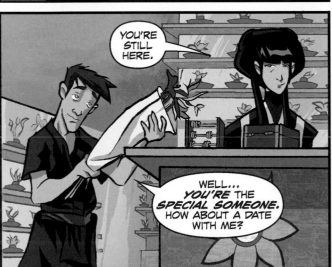

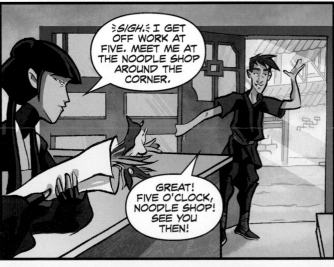

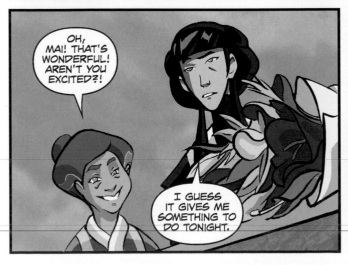

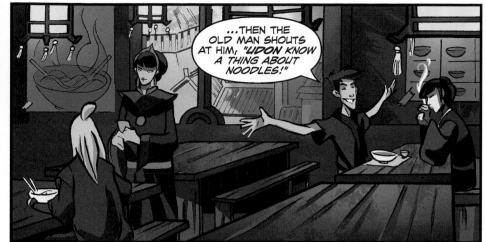

...THEN THE OLD MAN SHOUTS AT HIM, *"UDON KNOW A THING ABOUT NOODLES!"*

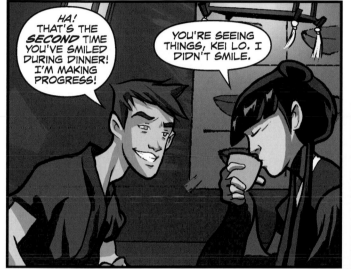

HA! THAT'S THE *SECOND* TIME YOU'VE SMILED DURING DINNER! I'M MAKING PROGRESS!

YOU'RE SEEING THINGS, KEI LO. I DIDN'T SMILE.

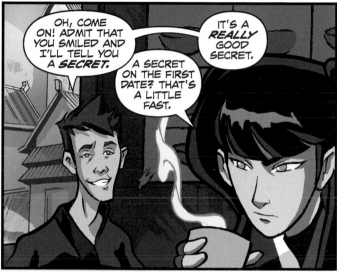

OH, COME ON! ADMIT THAT YOU SMILED AND I'LL TELL YOU A *SECRET.*

IT'S A *REALLY* GOOD SECRET.

A SECRET ON THE FIRST DATE? THAT'S A LITTLE FAST.

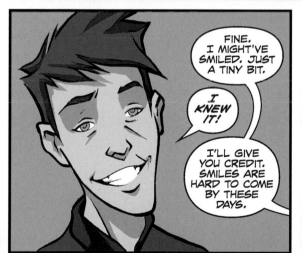

FINE. I MIGHT'VE SMILED. JUST A TINY BIT.

I *KNEW* IT!

I'LL GIVE YOU CREDIT. SMILES ARE HARD TO COME BY THESE DAYS.

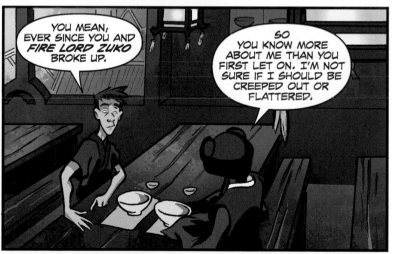

YOU MEAN, EVER SINCE YOU AND *FIRE LORD ZUKO* BROKE UP.

SO YOU KNOW MORE ABOUT ME THAN YOU FIRST LET ON. I'M NOT SURE IF I SHOULD BE CREEPED OUT OR FLATTERED.

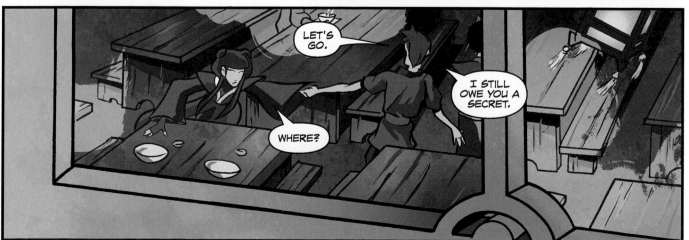

LET'S GO.

WHERE?

I STILL OWE YOU A SECRET.

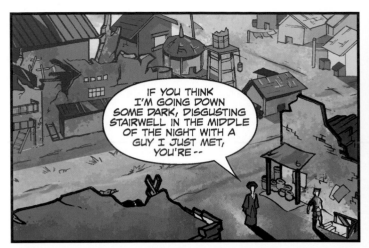

IF YOU THINK I'M GOING DOWN SOME DARK, DISGUSTING STAIRWELL IN THE MIDDLE OF THE NIGHT WITH A GUY I JUST MET, YOU'RE --

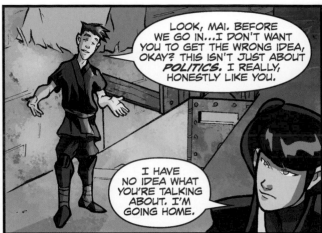

LOOK, MAI. BEFORE WE GO IN...I DON'T WANT YOU TO GET THE WRONG IDEA, OKAY? THIS ISN'T JUST ABOUT *POLITICS*. I REALLY, HONESTLY LIKE YOU.

I HAVE NO IDEA WHAT YOU'RE TALKING ABOUT. I'M GOING HOME.

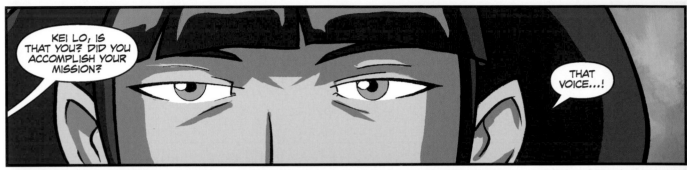

KEI LO, IS THAT YOU? DID YOU ACCOMPLISH YOUR MISSION?

THAT VOICE...!

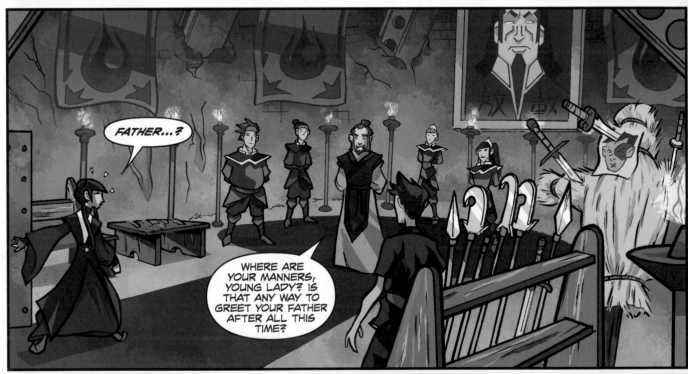

FATHER...?

WHERE ARE YOUR MANNERS, YOUNG LADY? IS THAT ANY WAY TO GREET YOUR FATHER AFTER ALL THIS TIME?

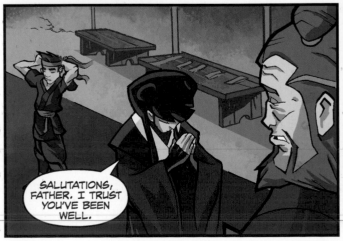

SALUTATIONS, FATHER. I TRUST YOU'VE BEEN WELL.

GOOD WORK, KEI LO. PLEASE, TAKE YOUR PLACE.

THANK YOU, GOVERNOR.

I HEARD THAT *TRAITOROUS USURPER* HAD YOU TOSSED OUT OF HIS PALACE LIKE A PIECE OF GARBAGE.

IT WASN'T LIKE THAT.

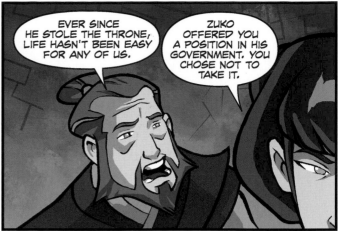

EVER SINCE HE STOLE THE THRONE, LIFE HASN'T BEEN EASY FOR ANY OF US.

ZUKO OFFERED YOU A POSITION IN HIS GOVERNMENT. YOU CHOSE NOT TO TAKE IT.

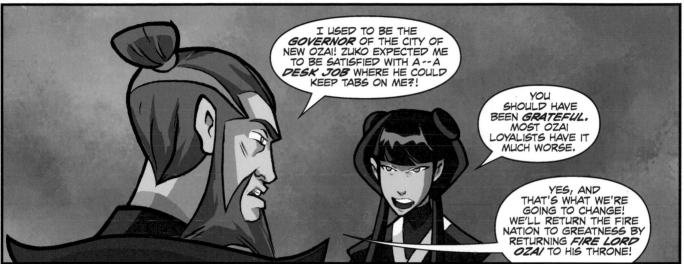

I USED TO BE THE *GOVERNOR* OF THE CITY OF NEW OZAI! ZUKO EXPECTED ME TO BE SATISFIED WITH A -- A *DESK JOB* WHERE HE COULD KEEP TABS ON ME?!

YOU SHOULD HAVE BEEN *GRATEFUL.* MOST OZAI LOYALISTS HAVE IT MUCH WORSE.

YES, AND THAT'S WHAT WE'RE GOING TO CHANGE! WE'LL RETURN THE FIRE NATION TO GREATNESS BY RETURNING *FIRE LORD OZAI* TO HIS THRONE!

MAI!

TOM-TOM?!

I MISSED YOU SO MUCH!

YOU BROUGHT MY LITTLE BROTHER TO A PLACE LIKE THIS?!

I DIDN'T INTRODUCE YOU TO THE DUTIES OF FIRE NATION CITIZENSHIP EARLY ENOUGH. I DON'T INTEND TO MAKE THE SAME MISTAKE WITH MY SON.

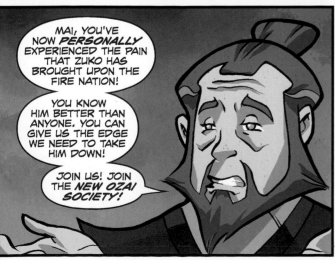

MAI, YOU'VE NOW *PERSONALLY* EXPERIENCED THE PAIN THAT ZUKO HAS BROUGHT UPON THE FIRE NATION!

YOU KNOW HIM BETTER THAN ANYONE. YOU CAN GIVE US THE EDGE WE NEED TO TAKE HIM DOWN!

JOIN US! JOIN THE *NEW OZAI SOCIETY!*

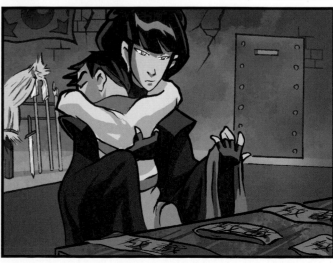

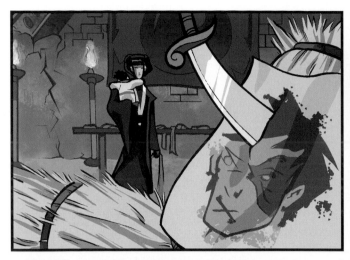

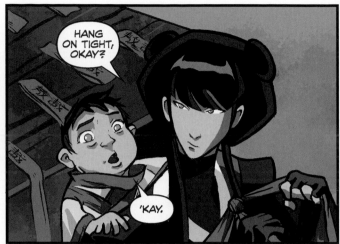

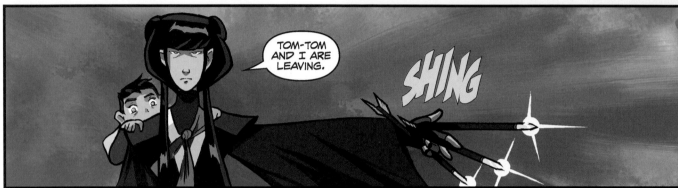

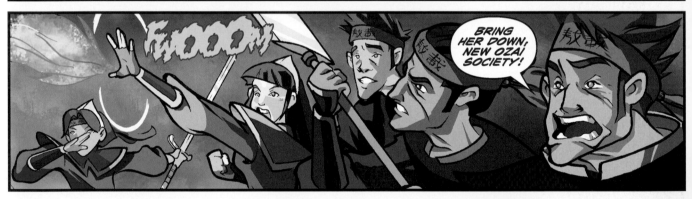

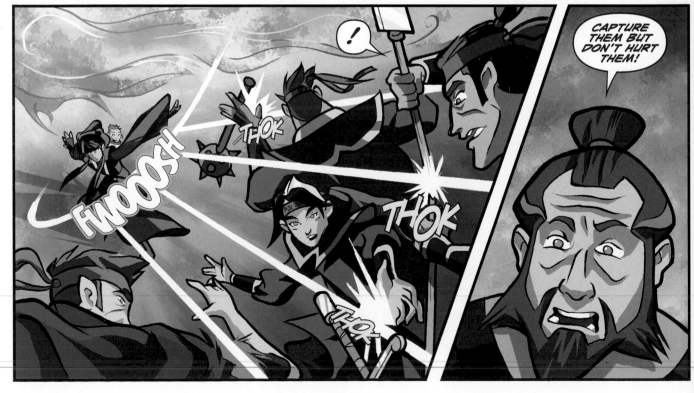

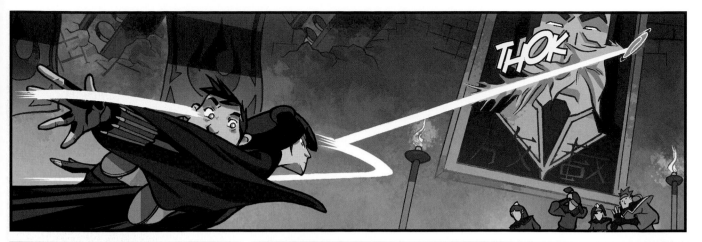

WHAT--?!

CRASH

MAI...LISTEN...I MEANT WHAT I SAID EARLIER. I REALLY, HONESTLY --

CONSIDER THIS THE END OF OUR DATE.

WACK

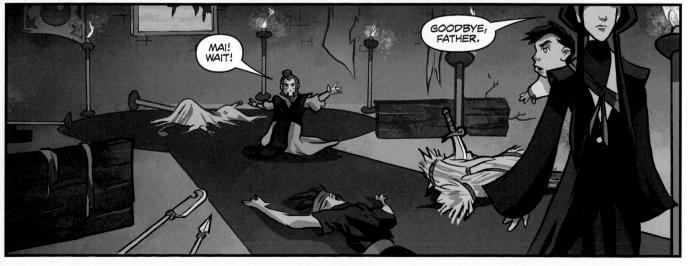

MAI! WAIT!

GOODBYE, FATHER.

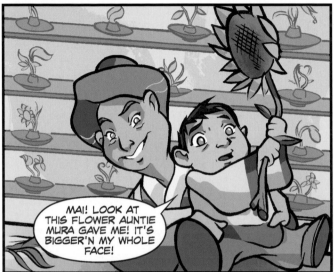

MAI! LOOK AT THIS FLOWER AUNTIE MURA GAVE ME! IT'S BIGGER'N MY WHOLE FACE!

MAI?

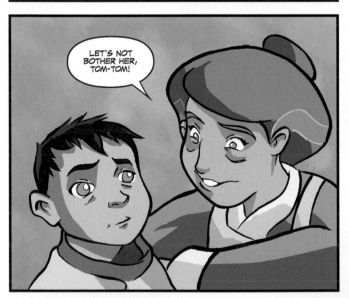

LET'S NOT BOTHER HER, TOM-TOM!

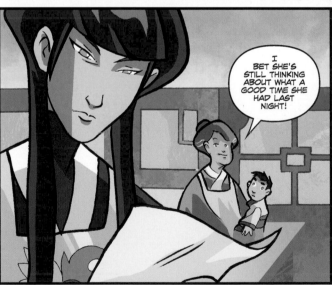

I BET SHE'S STILL THINKING ABOUT WHAT A GOOD TIME SHE HAD LAST NIGHT!

END

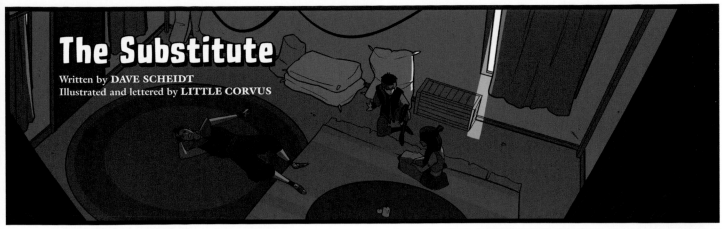

The Substitute

Written by DAVE SCHEIDT
Illustrated and lettered by LITTLE CORVUS

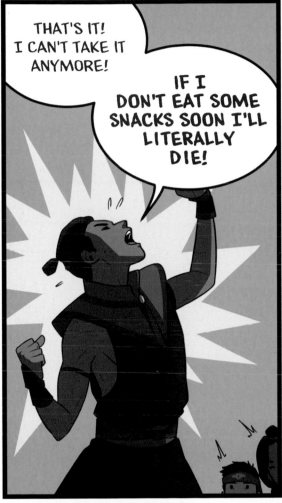

THAT'S IT! I CAN'T TAKE IT ANYMORE!

IF I DON'T EAT SOME SNACKS SOON I'LL LITERALLY DIE!

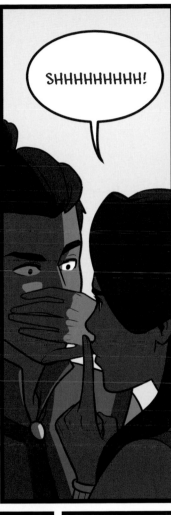

SHHHHHHHHH!

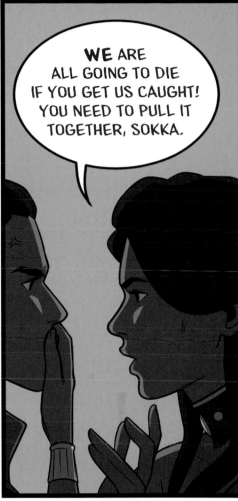

WE ARE ALL GOING TO DIE IF YOU GET US CAUGHT! YOU NEED TO PULL IT TOGETHER, SOKKA.

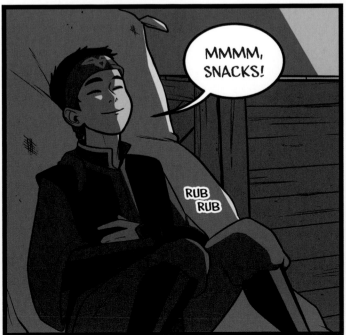

MMMM, SNACKS!

RUB RUB

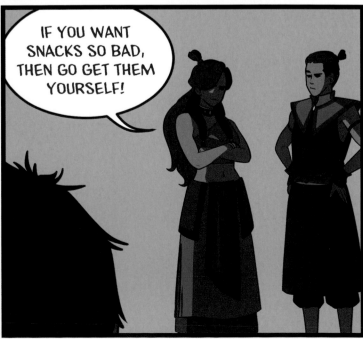

IF YOU WANT SNACKS SO BAD, THEN GO GET THEM YOURSELF!

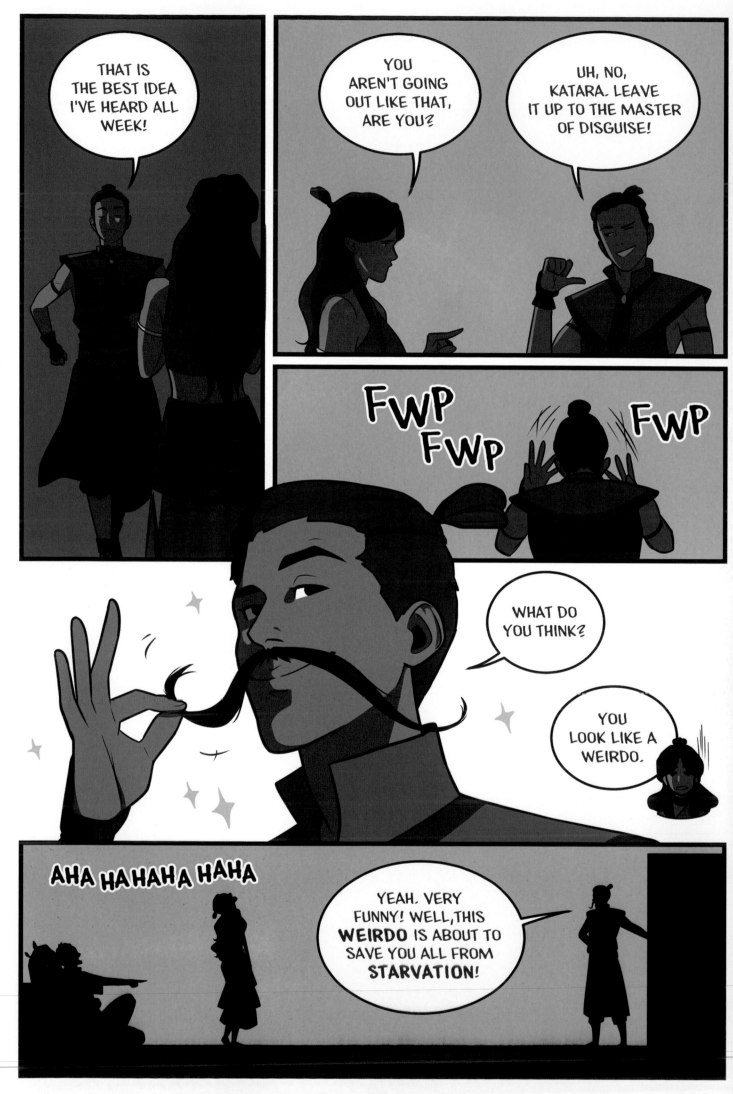

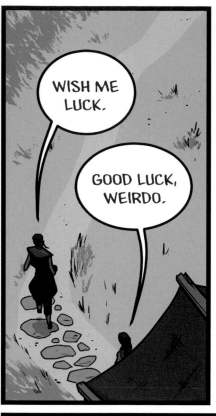

WISH ME LUCK.

GOOD LUCK, WEIRDO.

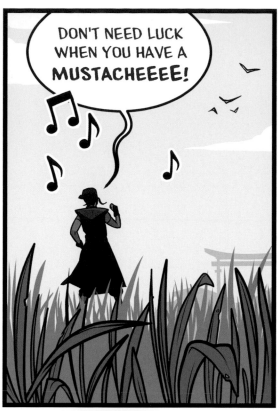

DON'T NEED LUCK WHEN YOU HAVE A **MUSTACHEEEE!**

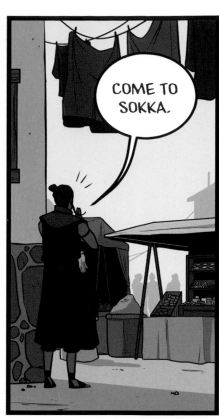

COME TO SOKKA.

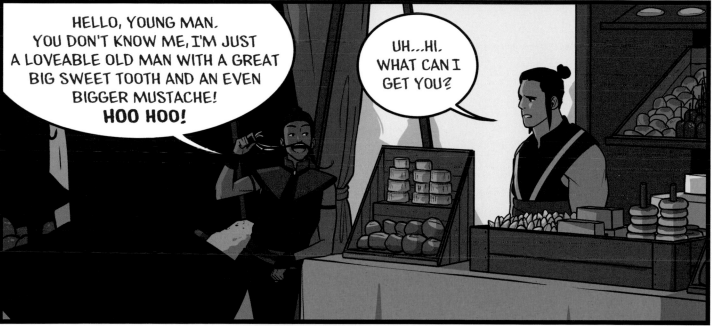

HELLO, YOUNG MAN. YOU DON'T KNOW ME, I'M JUST A LOVEABLE OLD MAN WITH A GREAT BIG SWEET TOOTH AND AN EVEN BIGGER MUSTACHE! **HOO HOO!**

UH...HI. WHAT CAN I GET YOU?

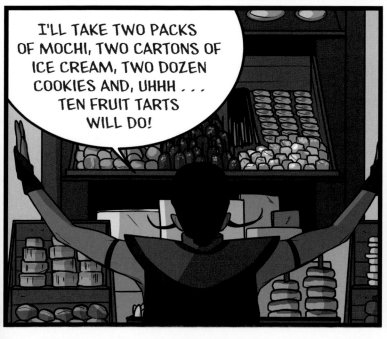

I'LL TAKE TWO PACKS OF MOCHI, TWO CARTONS OF ICE CREAM, TWO DOZEN COOKIES AND, UHHH . . . TEN FRUIT TARTS WILL DO!

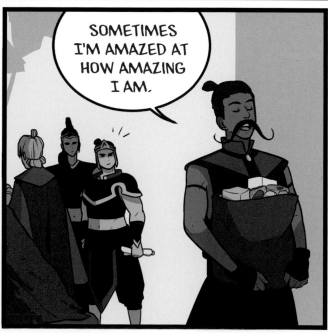

SOMETIMES I'M AMAZED AT HOW AMAZING I AM.

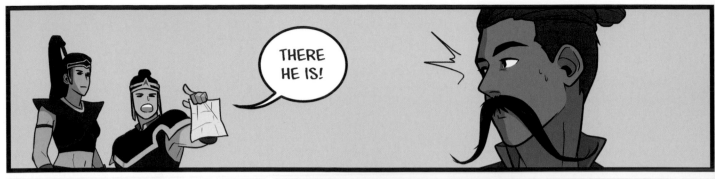

THERE HE IS!

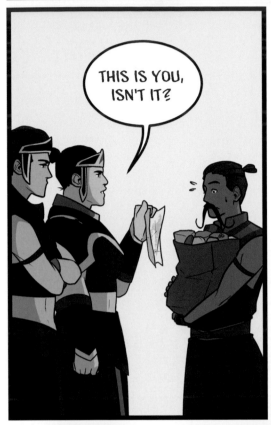

THIS IS YOU, ISN'T IT?

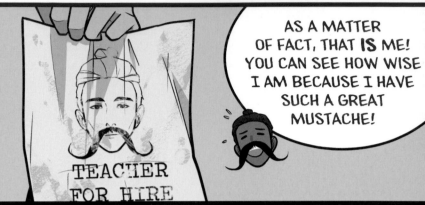

AS A MATTER OF FACT, THAT **IS** ME! YOU CAN SEE HOW WISE I AM BECAUSE I HAVE SUCH A GREAT MUSTACHE!

TEACHER FOR HIRE

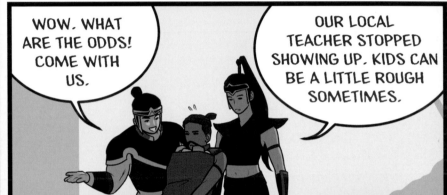

WOW. WHAT ARE THE ODDS! COME WITH US.

OUR LOCAL TEACHER STOPPED SHOWING UP. KIDS CAN BE A LITTLE ROUGH SOMETIMES.

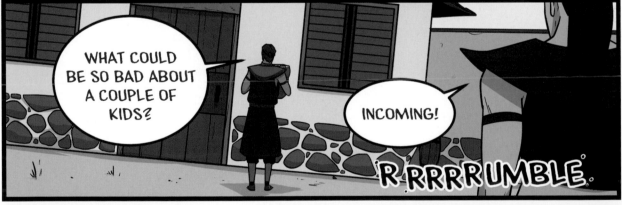

WHAT COULD BE SO BAD ABOUT A COUPLE OF KIDS?

INCOMING!

RRRRRUMBLE.

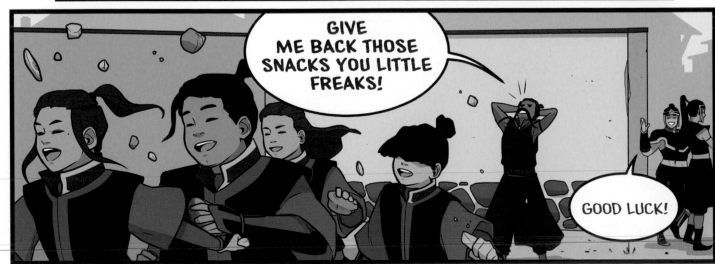

GIVE ME BACK THOSE SNACKS YOU LITTLE FREAKS!

GOOD LUCK!

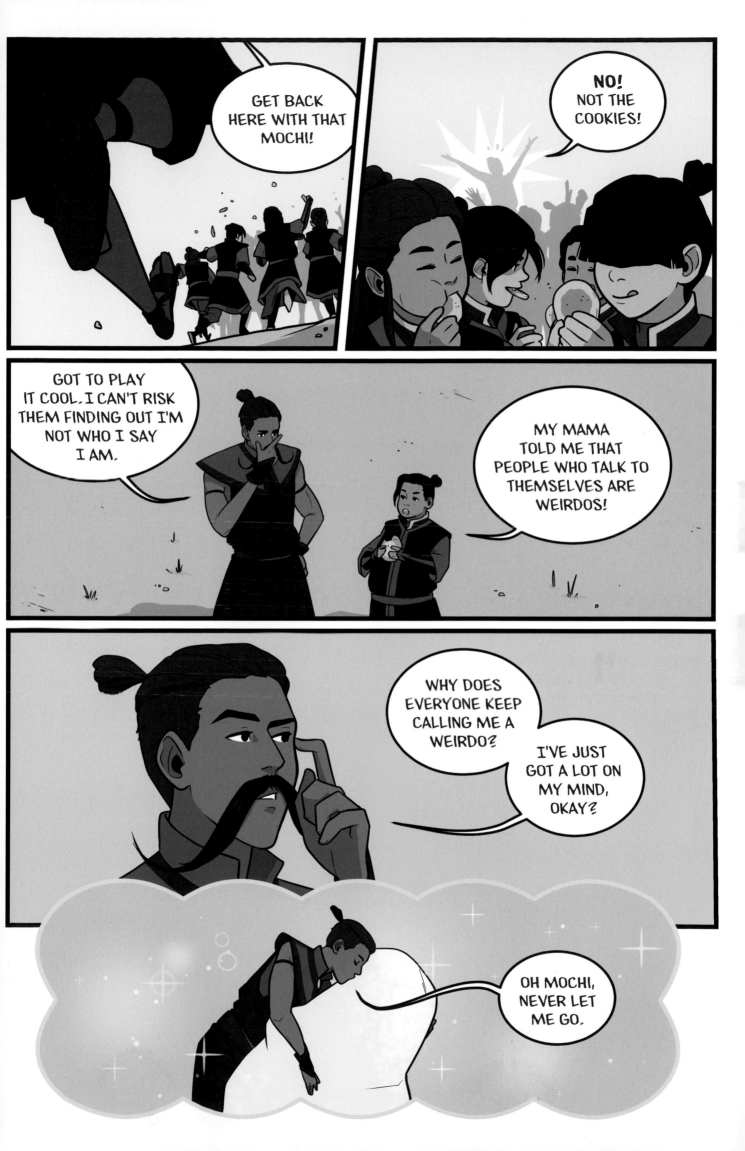

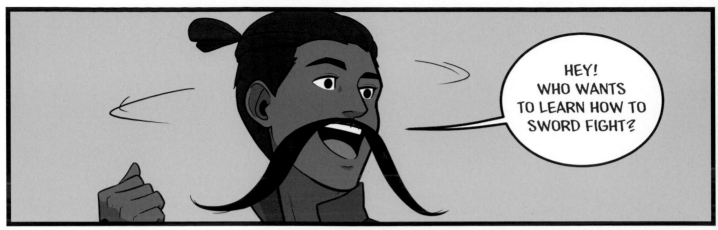

HEY! WHO WANTS TO LEARN HOW TO SWORD FIGHT?

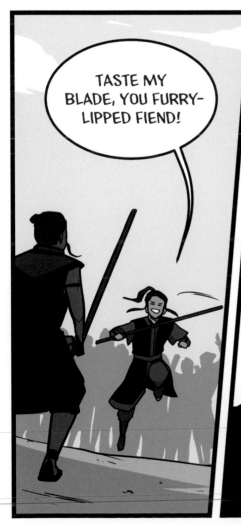

TASTE MY BLADE, YOU FURRY-LIPPED FIEND!

RIPPPP

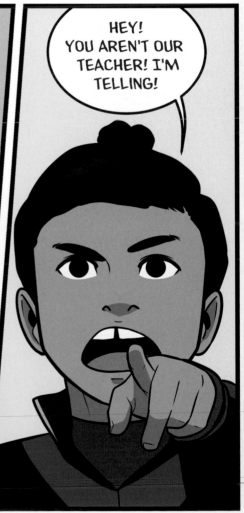

HEY! YOU AREN'T OUR TEACHER! I'M TELLING!

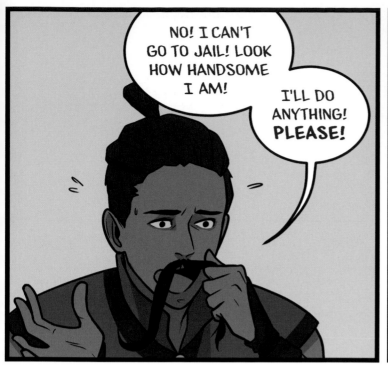

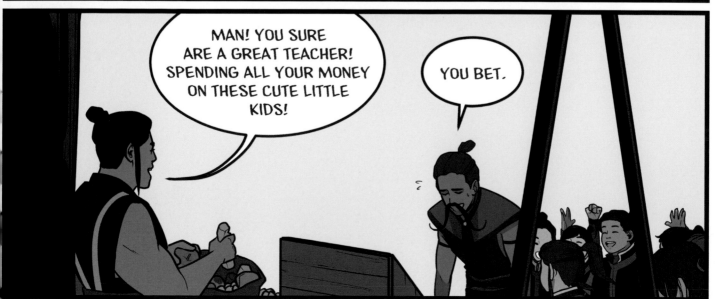

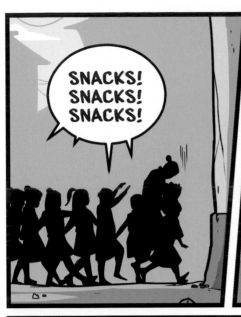
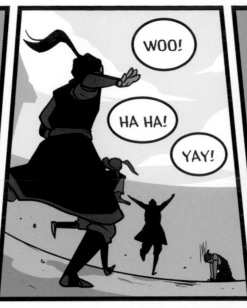
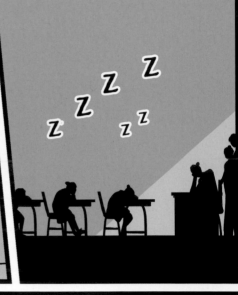
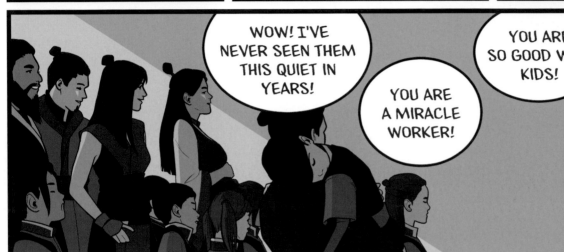
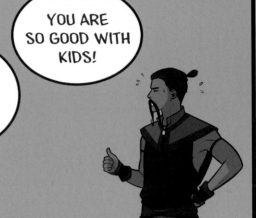

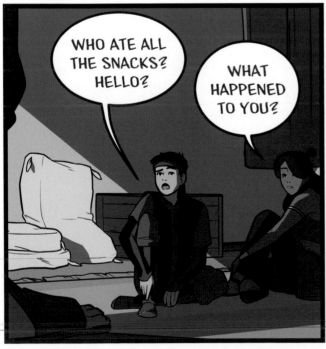

THE END

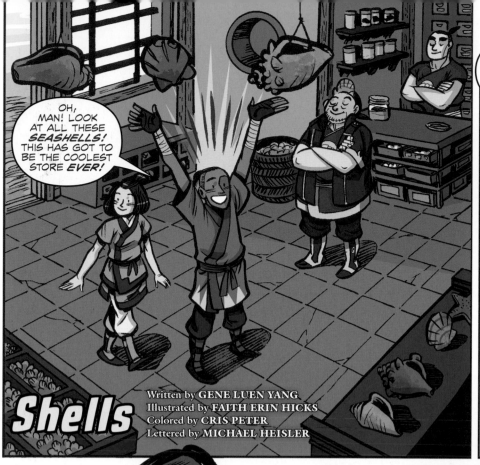

OH, MAN! LOOK AT ALL THESE *SEASHELLS!* THIS HAS GOT TO BE THE COOLEST STORE *EVER!*

Shells

Written by **GENE LUEN YANG**
Illustrated by **FAITH ERIN HICKS**
Colored by **CRIS PETER**
Lettered by **MICHAEL HEISLER**

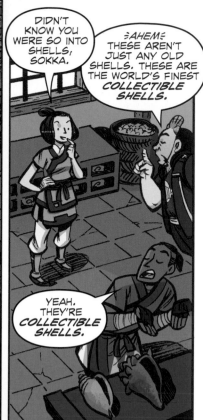

DIDN'T KNOW YOU WERE SO INTO SHELLS, SOKKA.

≋AHEM≋ THESE AREN'T JUST ANY OLD SHELLS. THESE ARE THE WORLD'S FINEST *COLLECTIBLE SHELLS.*

YEAH. THEY'RE *COLLECTIBLE SHELLS.*

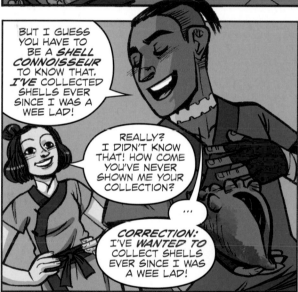

BUT I GUESS YOU HAVE TO BE A *SHELL CONNOISSEUR* TO KNOW THAT. *I'VE* COLLECTED SHELLS EVER SINCE I WAS A WEE LAD!

REALLY? I DIDN'T KNOW THAT! HOW COME YOU'VE NEVER SHOWN ME YOUR COLLECTION?

...

CORRECTION: I'VE *WANTED TO* COLLECT SHELLS EVER SINCE I WAS A WEE LAD!

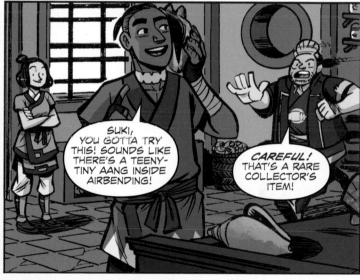

SUKI, YOU GOTTA TRY THIS! SOUNDS LIKE THERE'S A TEENY-TINY AANG INSIDE AIRBENDING!

CAREFUL! THAT'S A RARE COLLECTOR'S ITEM!

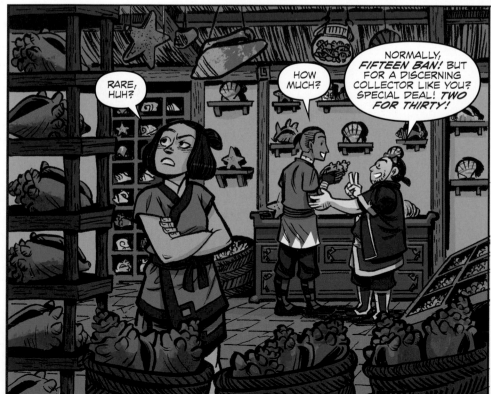

RARE, HUH?

HOW MUCH?

NORMALLY, *FIFTEEN BAN!* BUT FOR A DISCERNING COLLECTOR LIKE YOU? SPECIAL DEAL! *TWO FOR THIRTY!*

WOW! YOU HEAR THAT? SPECIAL --

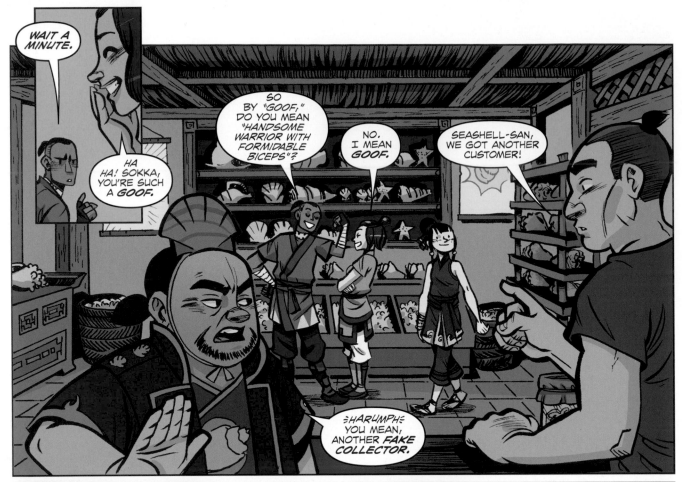

WAIT A MINUTE.

HA HA! SOKKA, YOU'RE SUCH A *GOOF*.

SO BY *"GOOF,"* DO YOU MEAN *"HANDSOME WARRIOR WITH FORMIDABLE BICEPS"*?

NO. I MEAN *GOOF*.

SEASHELL-SAN, WE GOT ANOTHER CUSTOMER!

≡HARUMPH≡ YOU MEAN, ANOTHER *FAKE COLLECTOR*.

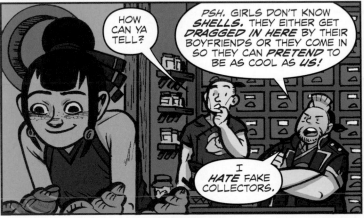

HOW CAN YA TELL?

PSH. GIRLS DON'T KNOW *SHELLS*. THEY EITHER GET *DRAGGED IN HERE* BY THEIR BOYFRIENDS OR THEY COME IN SO THEY CAN *PRETEND* TO BE AS COOL AS *US*!

I *HATE* FAKE COLLECTORS.

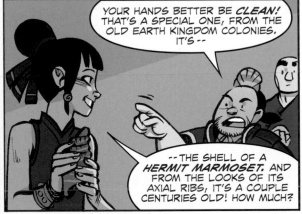

YOUR HANDS BETTER BE *CLEAN*! THAT'S A SPECIAL ONE, FROM THE OLD EARTH KINGDOM COLONIES. IT'S --

-- THE SHELL OF A *HERMIT MARMOSET*. AND FROM THE LOOKS OF ITS AXIAL RIBS, IT'S A COUPLE CENTURIES OLD! HOW MUCH?

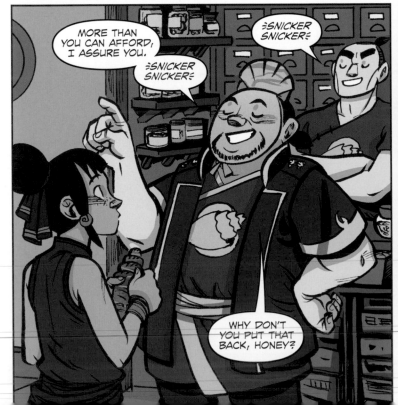

MORE THAN YOU CAN AFFORD, I ASSURE YOU.

≡SNICKER SNICKER≡

≡SNICKER SNICKER≡

WHY DON'T YOU PUT THAT BACK, HONEY?

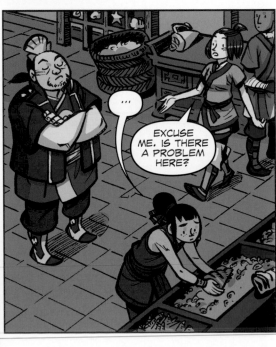

...

EXCUSE ME. IS THERE A PROBLEM HERE?

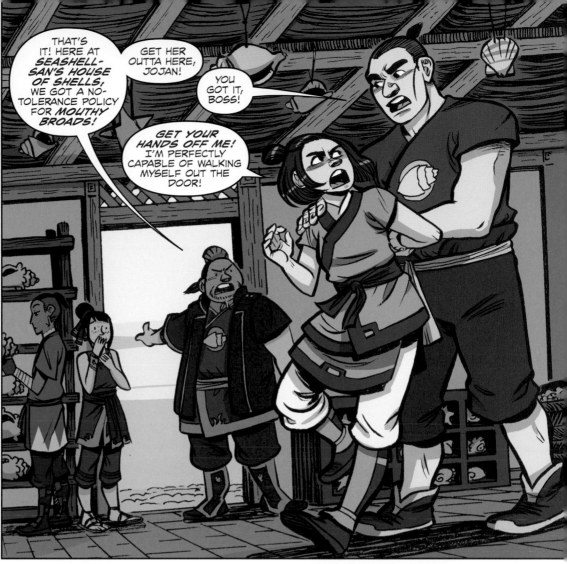

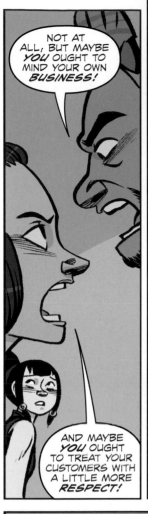

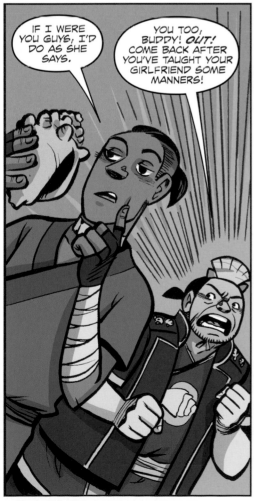

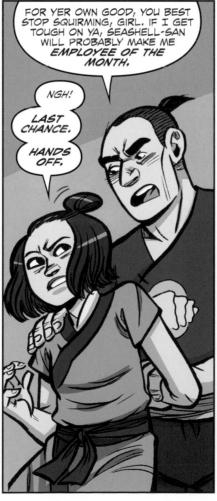

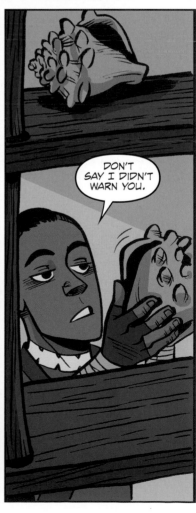

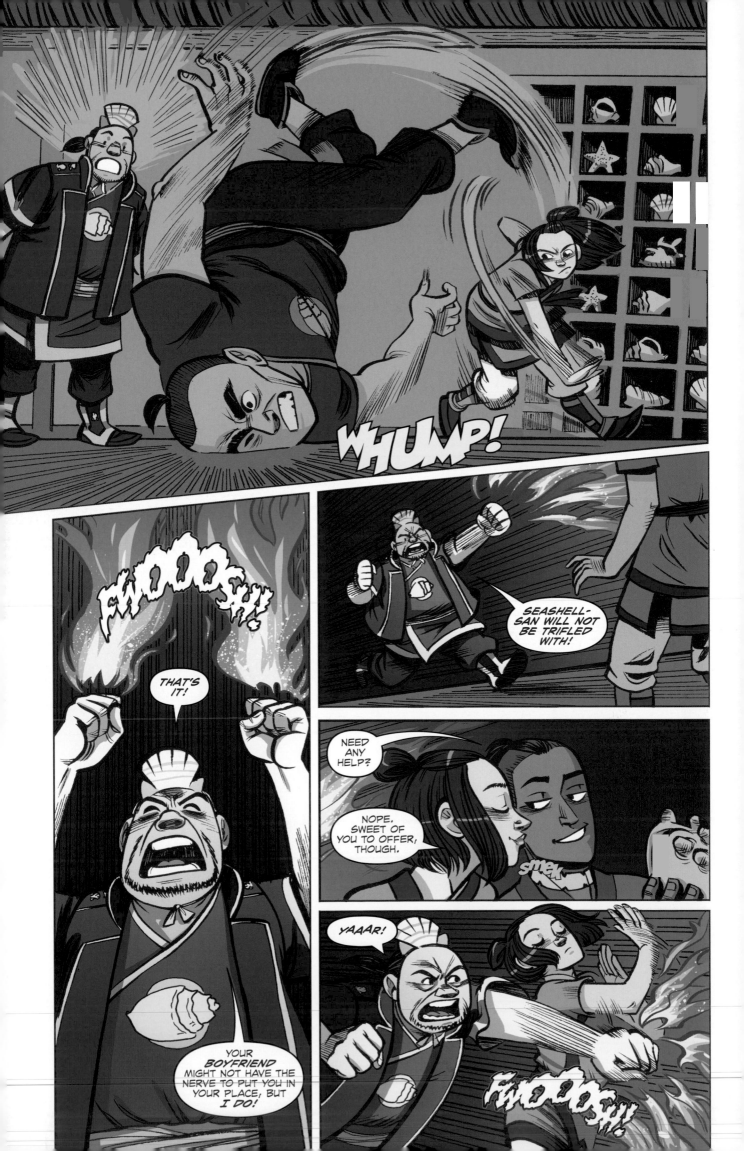

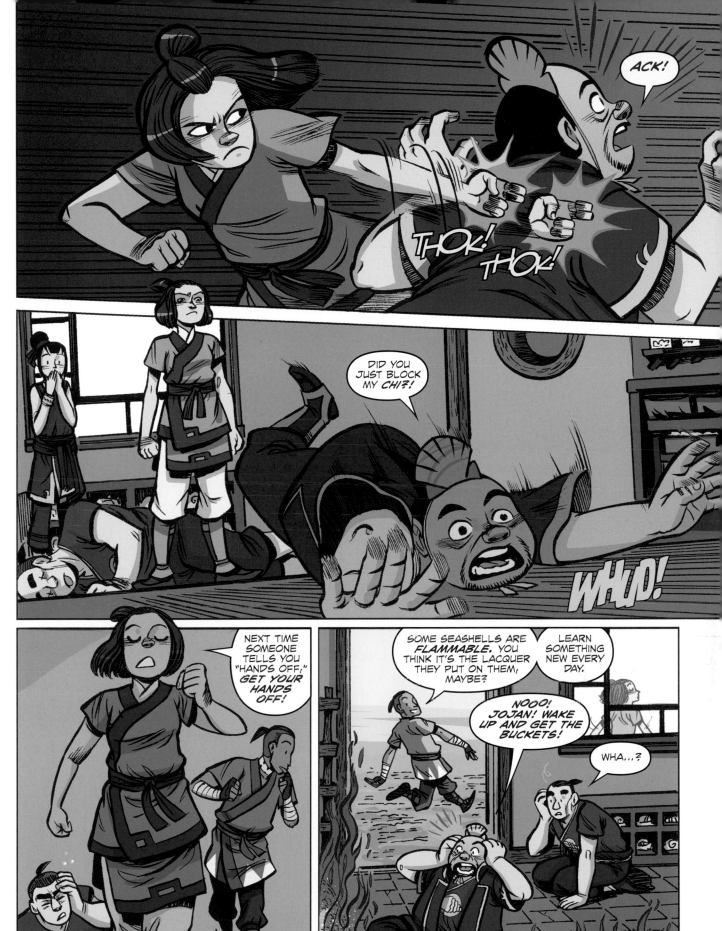
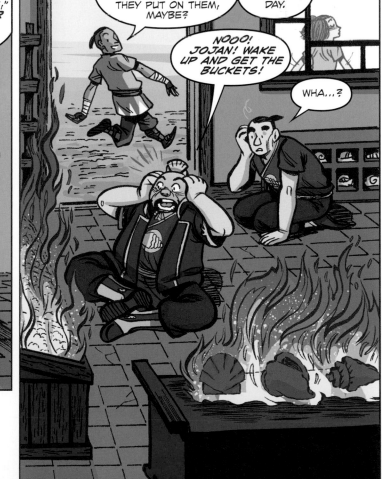

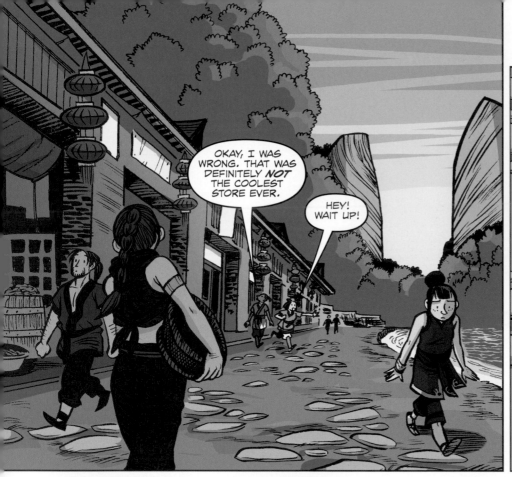

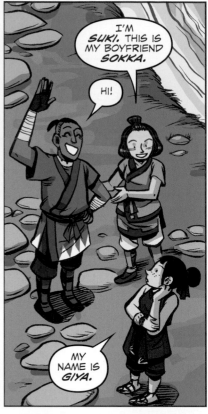

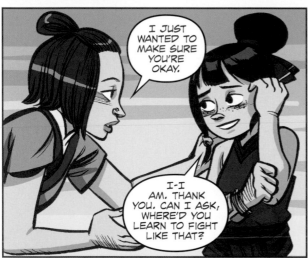

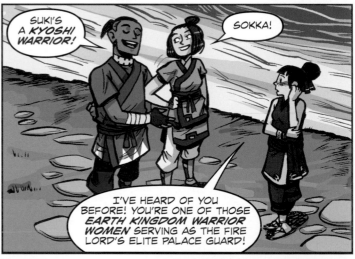

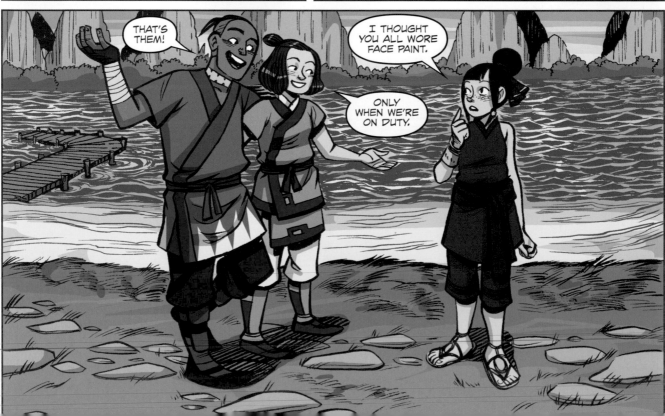

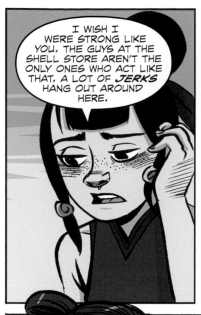

I WISH I WERE STRONG LIKE YOU. THE GUYS AT THE SHELL STORE AREN'T THE ONLY ONES WHO ACT LIKE THAT. A LOT OF *JERKS* HANG OUT AROUND HERE.

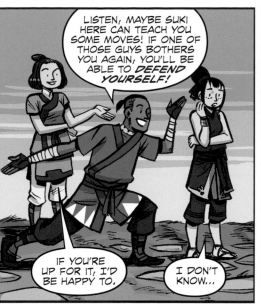

LISTEN, MAYBE SUKI HERE CAN TEACH YOU SOME MOVES! IF ONE OF THOSE GUYS BOTHERS YOU AGAIN, YOU'LL BE ABLE TO *DEFEND YOURSELF!*

IF YOU'RE UP FOR IT, I'D BE HAPPY TO.

I DON'T KNOW...

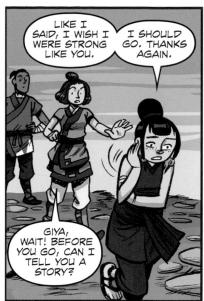

LIKE I SAID, I WISH I WERE STRONG LIKE YOU.

I SHOULD GO. THANKS AGAIN.

GIYA, WAIT! BEFORE YOU GO, CAN I TELL YOU A STORY?

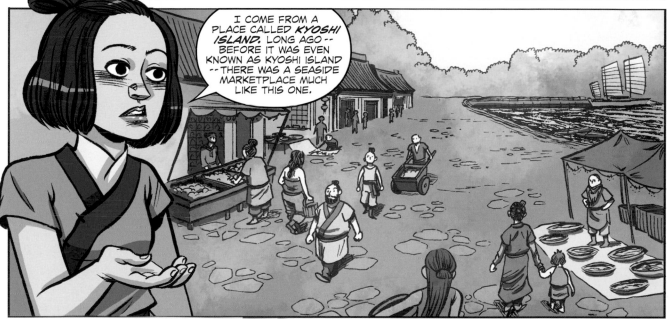

I COME FROM A PLACE CALLED *KYOSHI ISLAND.* LONG AGO -- BEFORE IT WAS EVEN KNOWN AS KYOSHI ISLAND -- THERE WAS A SEASIDE MARKETPLACE MUCH LIKE THIS ONE.

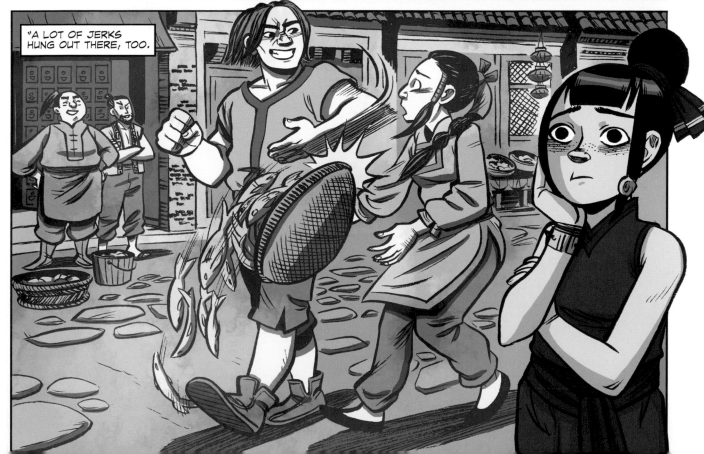

"A LOT OF JERKS HUNG OUT THERE, TOO.

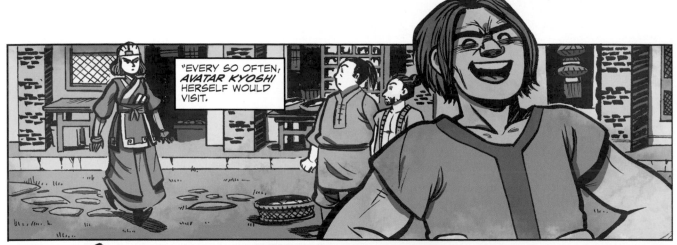

"EVERY SO OFTEN, *AVATAR KYOSHI* HERSELF WOULD VISIT.

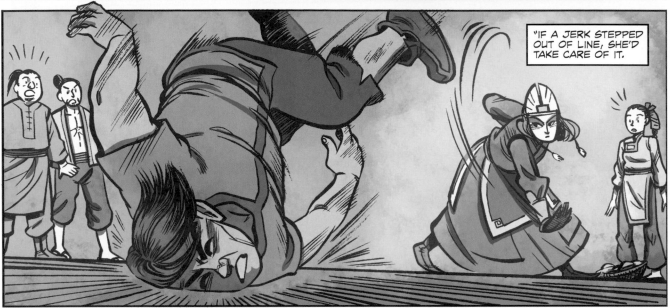

"IF A JERK STEPPED OUT OF LINE, SHE'D TAKE CARE OF IT.

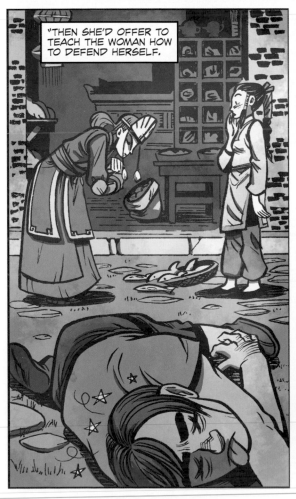

"THEN SHE'D OFFER TO TEACH THE WOMAN HOW TO DEFEND HERSELF.

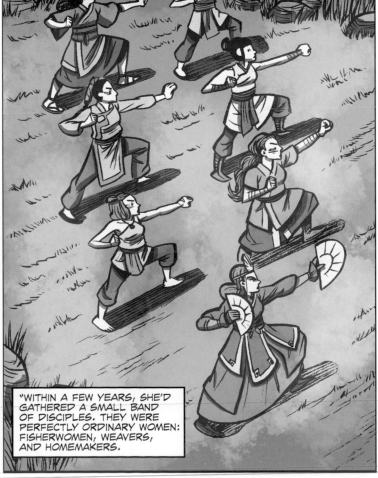

"WITHIN A FEW YEARS, SHE'D GATHERED A SMALL BAND OF DISCIPLES. THEY WERE PERFECTLY ORDINARY WOMEN: FISHERWOMEN, WEAVERS, AND HOMEMAKERS.

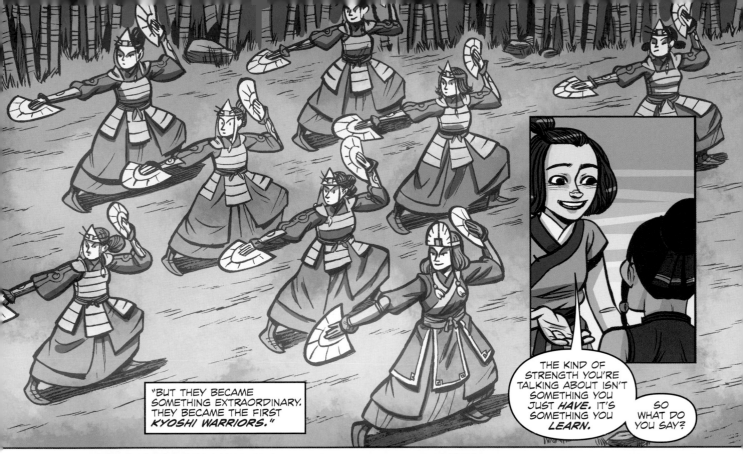

"BUT THEY BECAME SOMETHING EXTRAORDINARY. THEY BECAME THE FIRST *KYOSHI WARRIORS.*"

THE KIND OF STRENGTH YOU'RE TALKING ABOUT ISN'T SOMETHING YOU JUST *HAVE.* IT'S SOMETHING YOU *LEARN.*

SO WHAT DO YOU SAY?

OH, I --

I'M MUCH TOO SHY TO DO ANYTHING LIKE THAT --

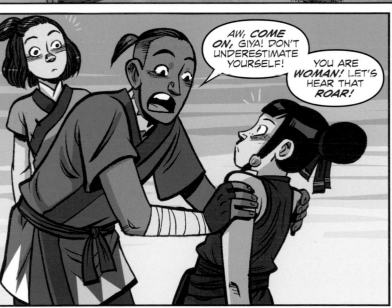

AW, *COME ON,* GIYA! DON'T UNDERESTIMATE YOURSELF!

YOU ARE *WOMAN!* LET'S HEAR THAT *ROAR!*

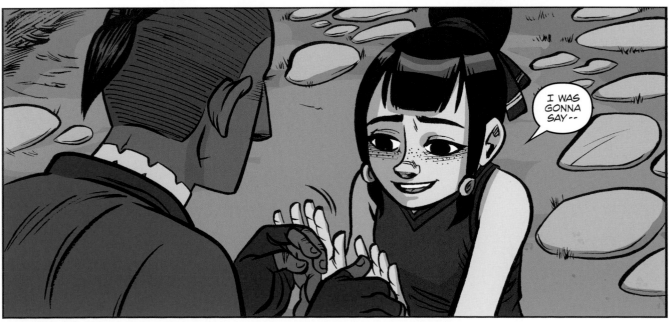

I WAS GONNA SAY --

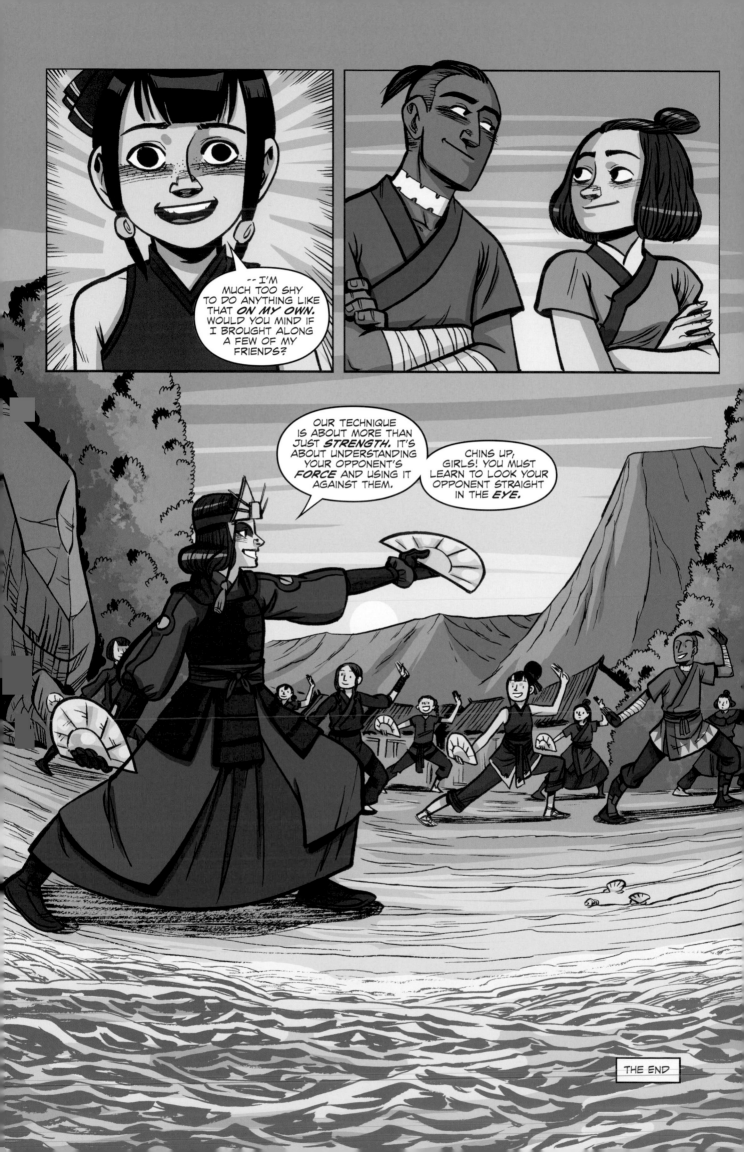

THE END

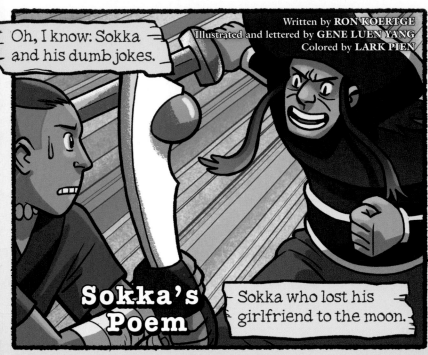

Oh, I know: Sokka and his dumb jokes.

Written by **RON KOERTGE**
Illustrated and lettered by **GENE LUEN YANG**
Colored by **LARK PIEN**

Sokka's Poem

Sokka who lost his girlfriend to the moon.

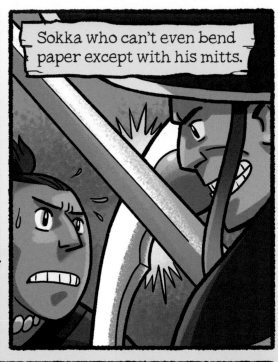

Sokka who can't even bend paper except with his mitts.

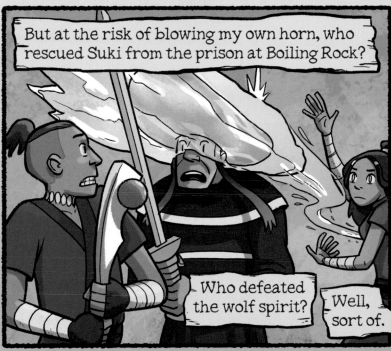

But at the risk of blowing my own horn, who rescued Suki from the prison at Boiling Rock?

Who defeated the wolf spirit?

Well, sort of.

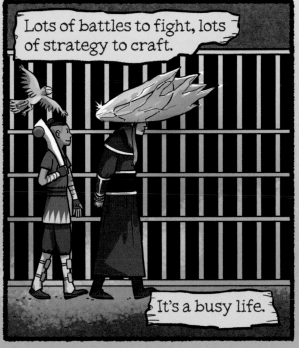

Lots of battles to fight, lots of strategy to craft.

It's a busy life.

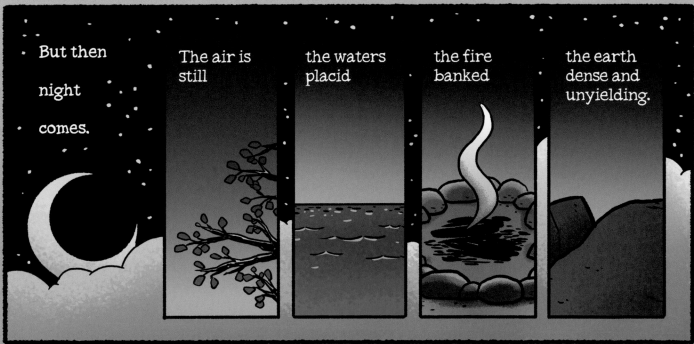

But then night comes.

The air is still

the waters placid

the fire banked

the earth dense and unyielding.

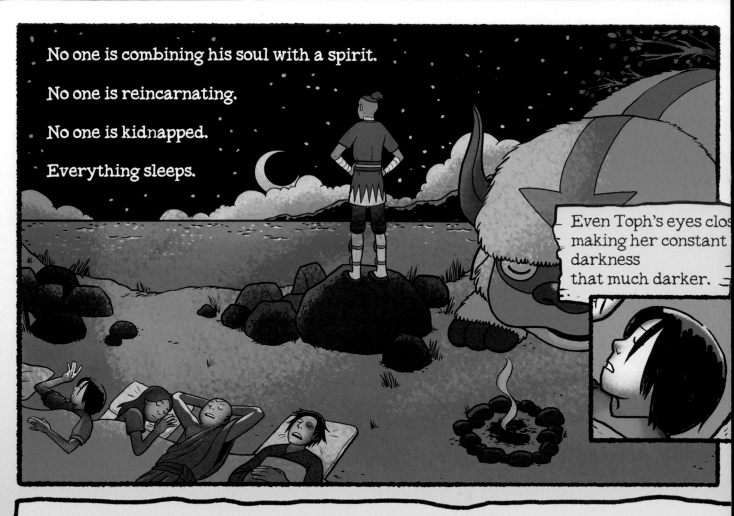

No one is combining his soul with a spirit.

No one is reincarnating.

No one is kidnapped.

Everything sleeps.

Even Toph's eyes clos[e] making her constant darkness that much darker.

Everyone vulnerable, barefoot and drowsy.

This is me at my best, when people I love or revere or both need me whether they know it or not.

I almost never sleep. There's too much to do and only I can do it!

THE END

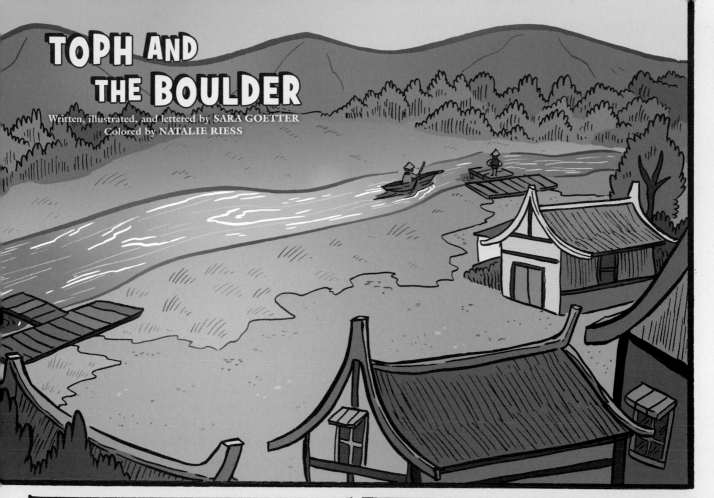

TOPH AND THE BOULDER

Written, illustrated, and lettered by SARA GOETTER
Colored by NATALIE RIESS

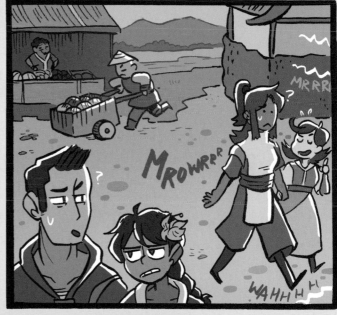

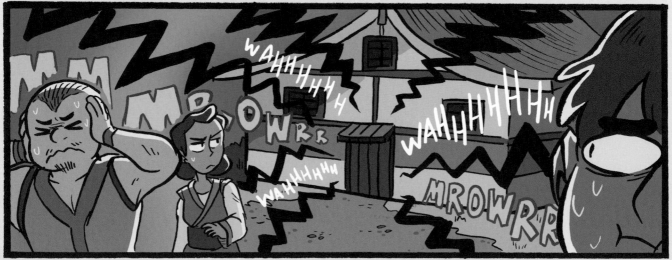

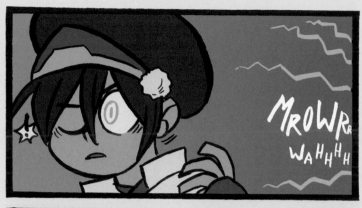

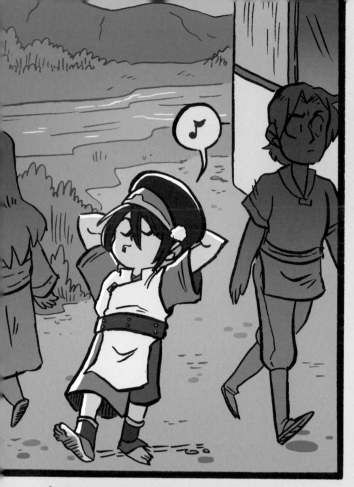

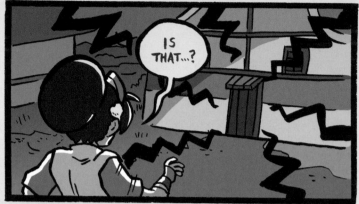

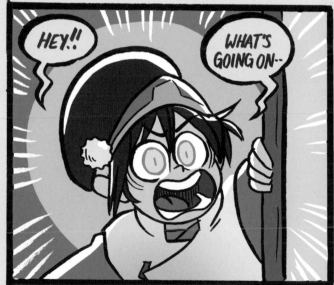

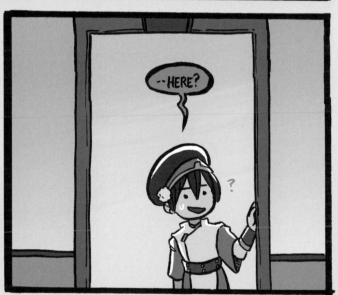

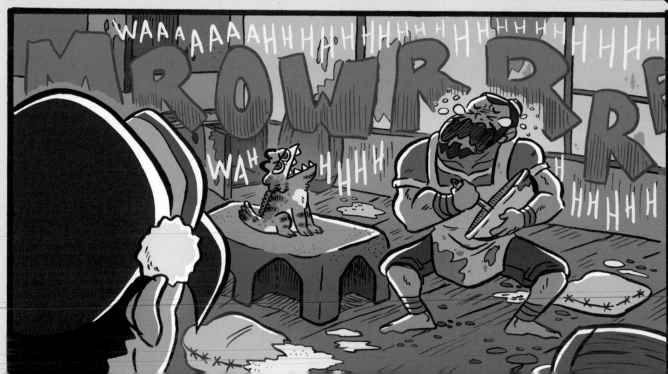

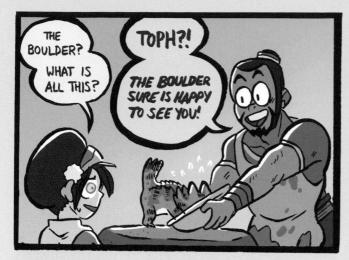
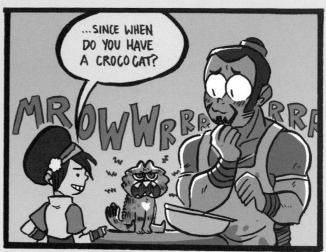
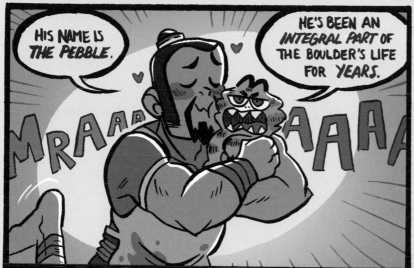
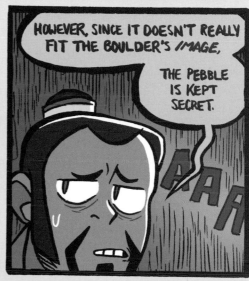
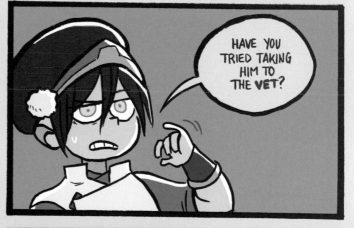
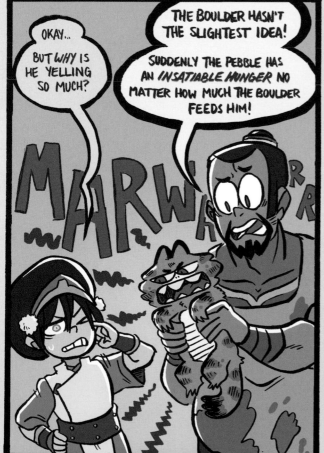
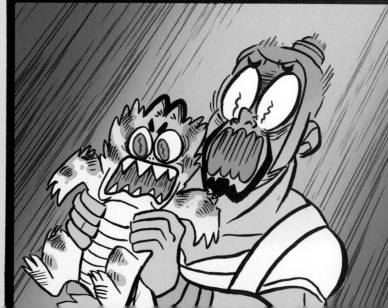

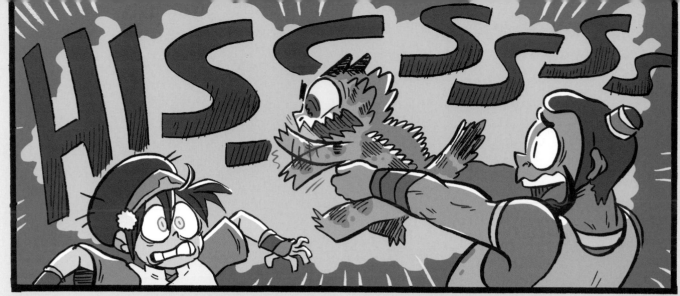

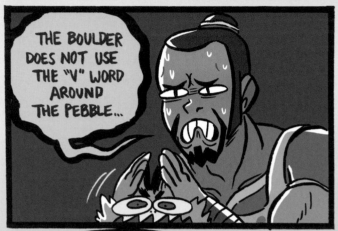

THE BOULDER DOES NOT USE THE "V" WORD AROUND THE PEBBLE...

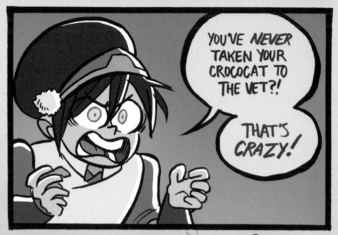

YOU'VE *NEVER* TAKEN YOUR CROCOCAT TO THE VET?!

THAT'S CRAZY!

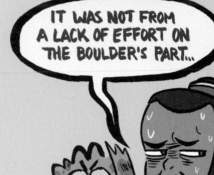

IT WAS NOT FROM A LACK OF EFFORT ON THE BOULDER'S PART...

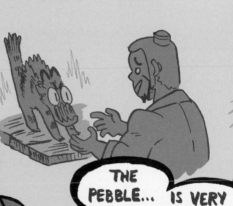

THE PEBBLE... IS VERY CONVINCING.

ALL RIGHT! FINE! NO VETS!

HISSS

DODGE!

WHAT DO WE DO THEN?

THE BOULDER HAS NO IDEA.

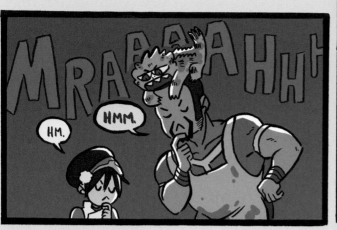

HM. HMM.

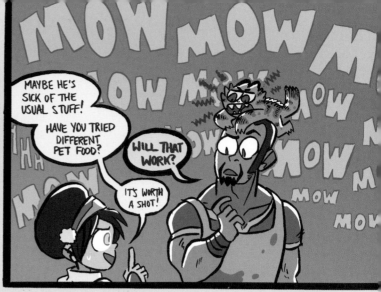

MAYBE HE'S SICK OF THE USUAL STUFF!

HAVE YOU TRIED DIFFERENT PET FOOD?

WILL THAT WORK?

IT'S WORTH A SHOT!

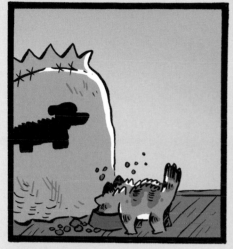

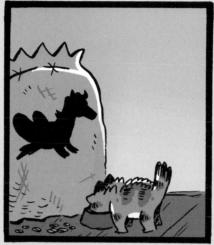

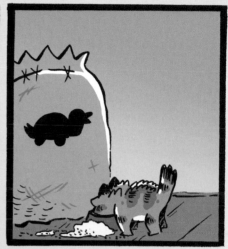

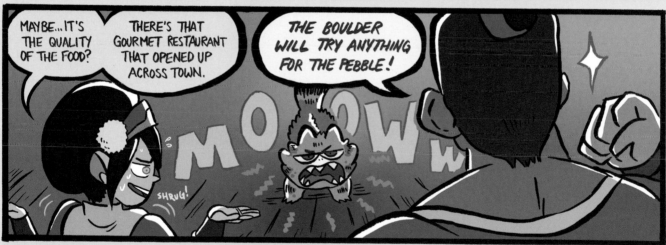

MAYBE...IT'S THE QUALITY OF THE FOOD?

THERE'S THAT GOURMET RESTAURANT THAT OPENED UP ACROSS TOWN.

THE BOULDER WILL TRY ANYTHING FOR THE PEBBLE!

SHRUG!

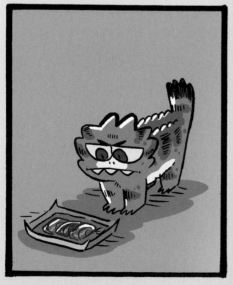

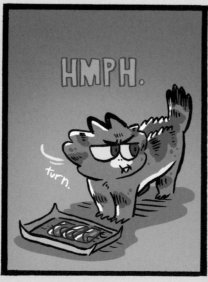

HMPH.

turn.

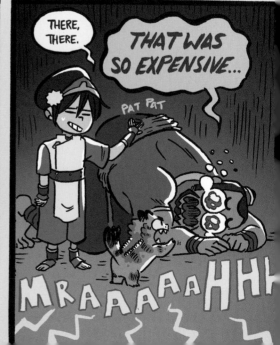

THERE, THERE.

THAT WAS SO EXPENSIVE...

PAT PAT

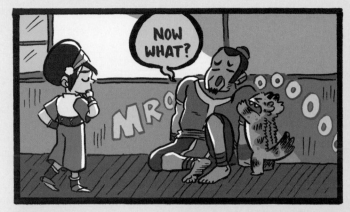

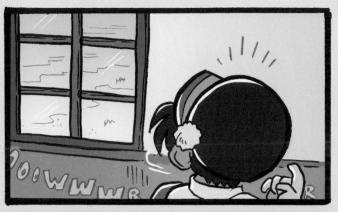

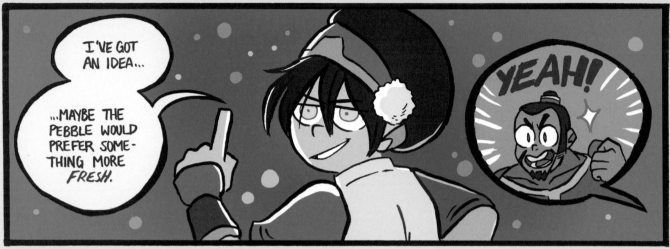

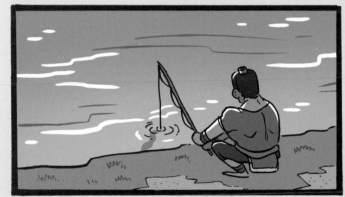

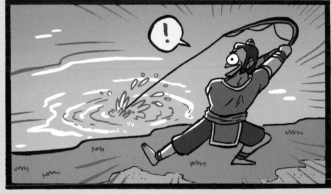

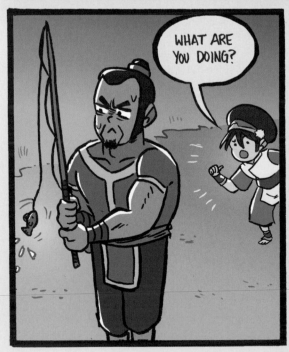

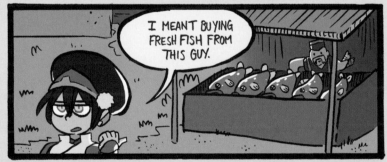

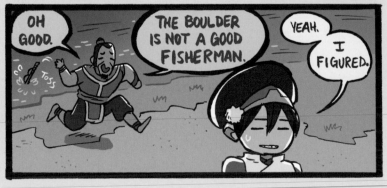

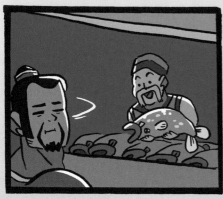
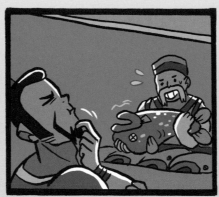
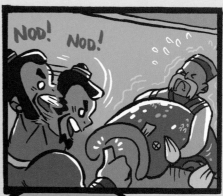
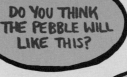
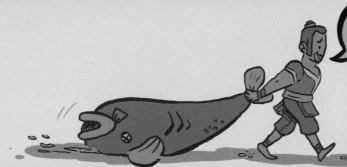
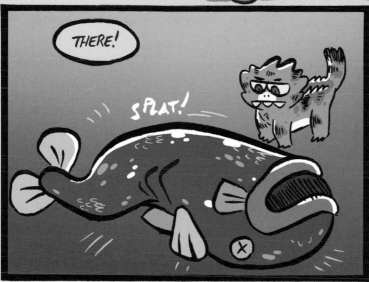

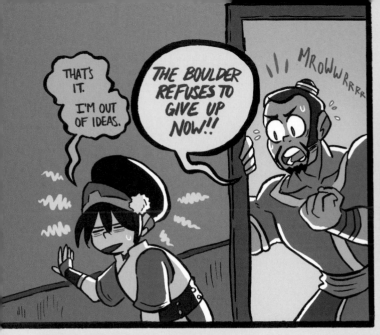

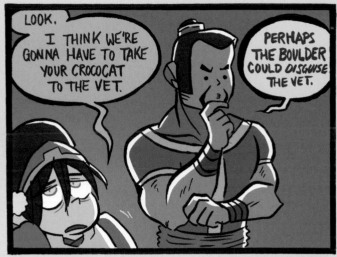

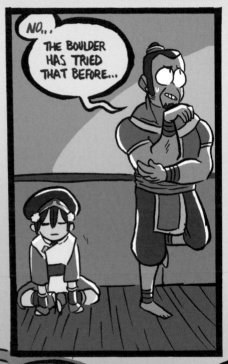

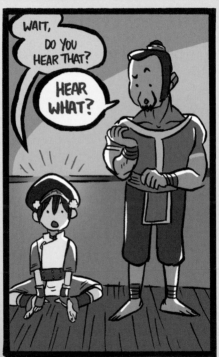

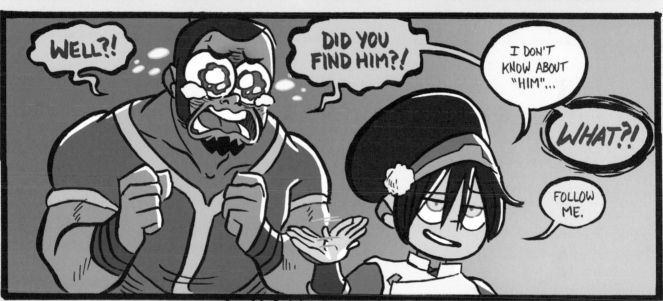

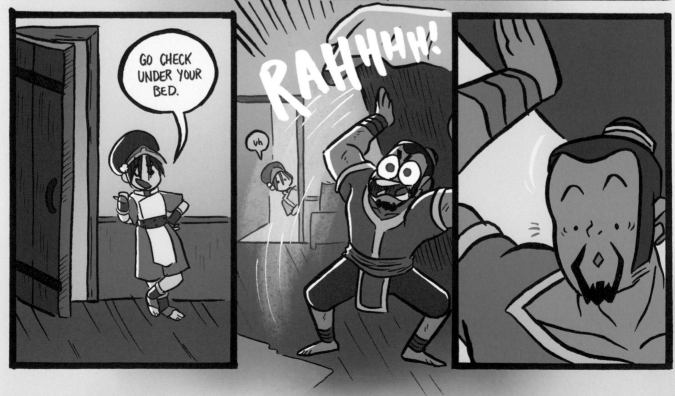

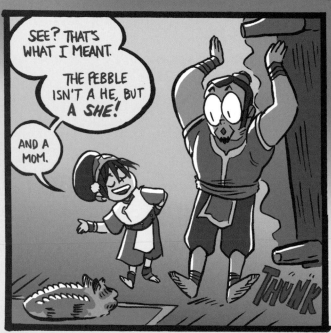

SEE? THAT'S WHAT I MEANT.

THE PEBBLE ISN'T A HE, BUT A *SHE!*

AND A MOM.

THUNK

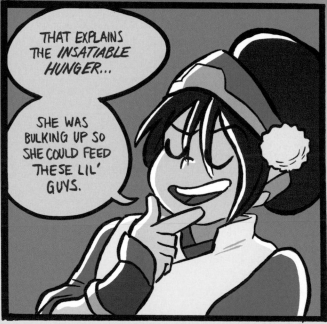

THAT EXPLAINS THE *INSATIABLE* HUNGER...

SHE WAS BULKING UP SO SHE COULD FEED THESE LIL' GUYS.

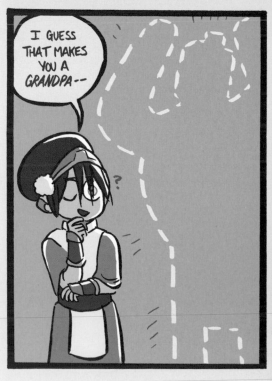

I GUESS THAT MAKES YOU A GRANDPA--

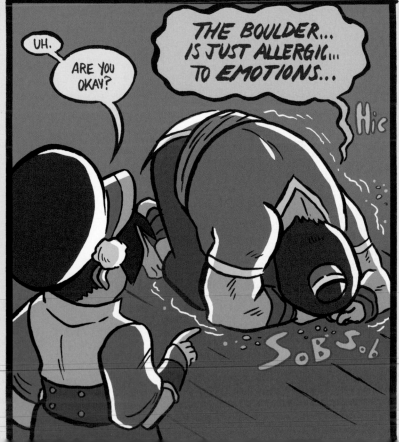

UH.

ARE YOU OKAY?

THE BOULDER... IS JUST ALLERGIC... TO *EMOTIONS...*

Hic

SOB SOB

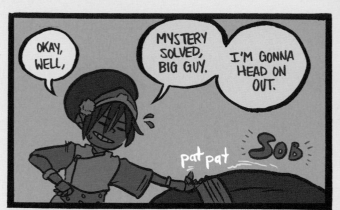

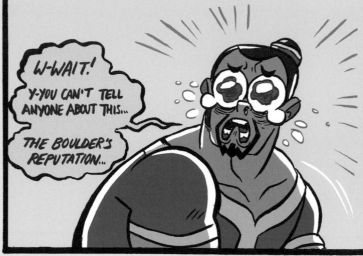

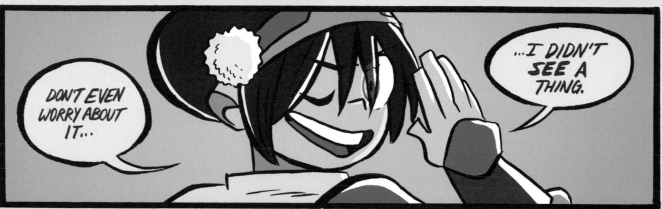

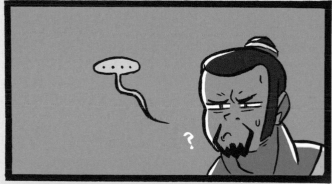

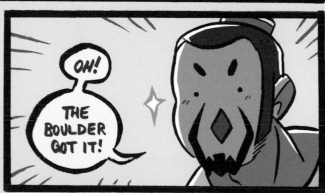

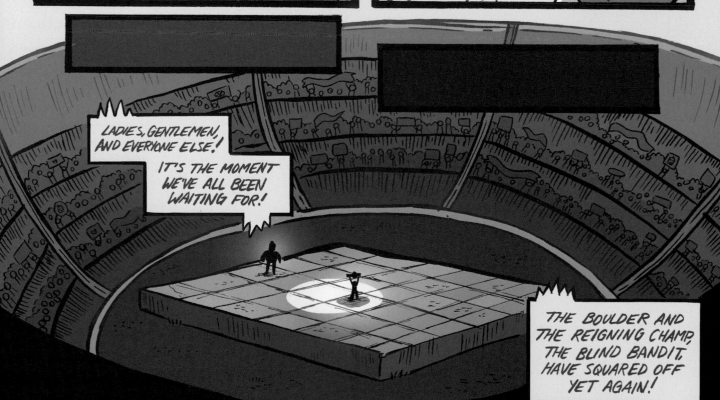

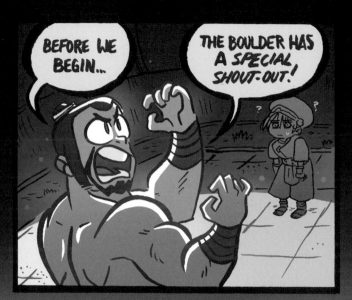

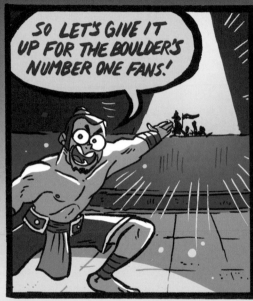
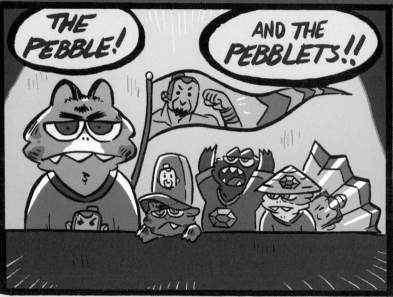
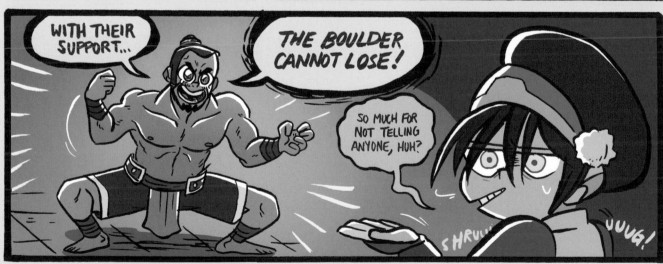
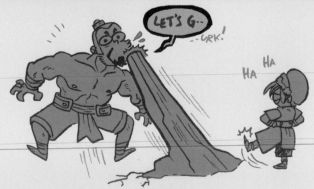

END.

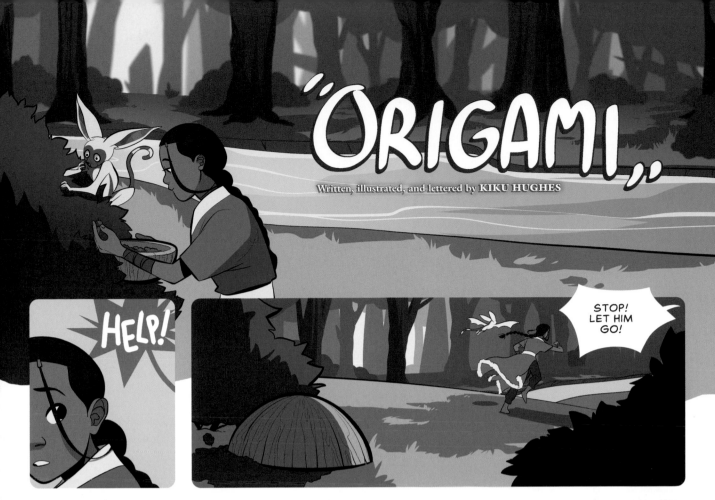

"ORIGAMI"

Written, illustrated, and lettered by **KIKU HUGHES**

HELP!

STOP! LET HIM GO!

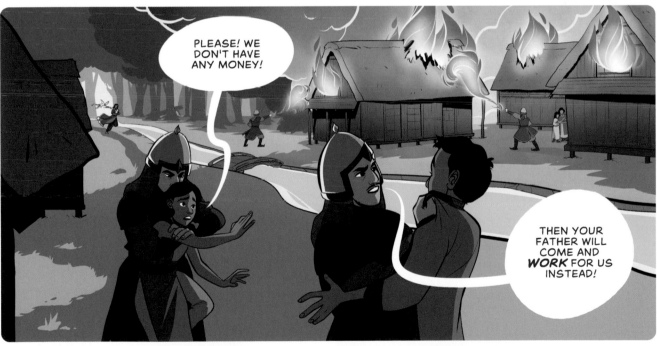

PLEASE! WE DON'T HAVE ANY MONEY!

THEN YOUR FATHER WILL COME AND **WORK** FOR US INSTEAD!

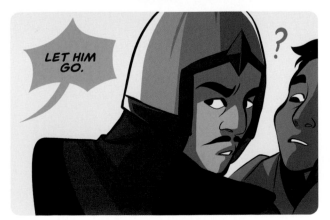

LET HIM GO.

?

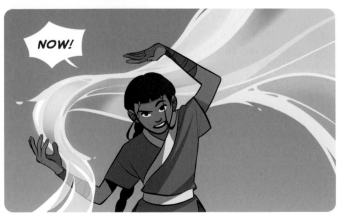

NOW!

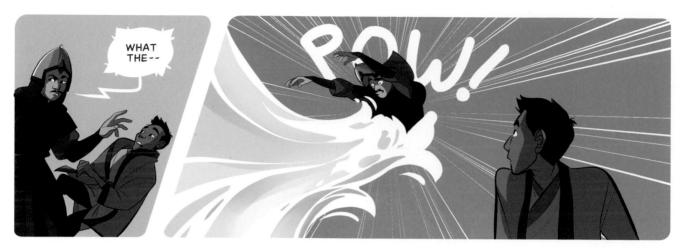

WHAT THE--

POW!

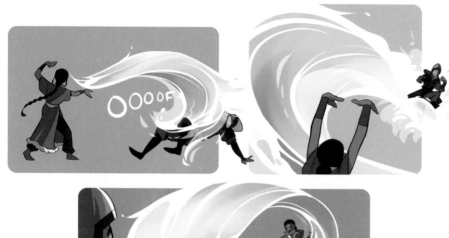

OOOOF

-AUGHHHH

BANG!

UH OH

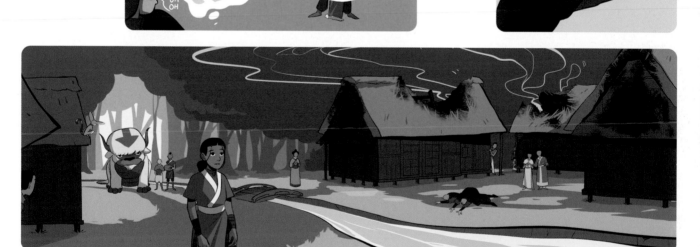

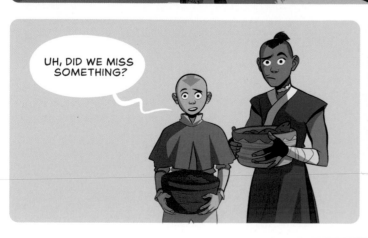

UH, DID WE MISS SOMETHING?

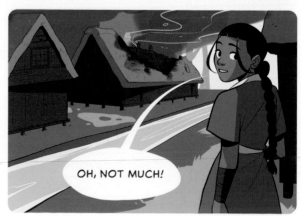

OH, NOT MUCH!

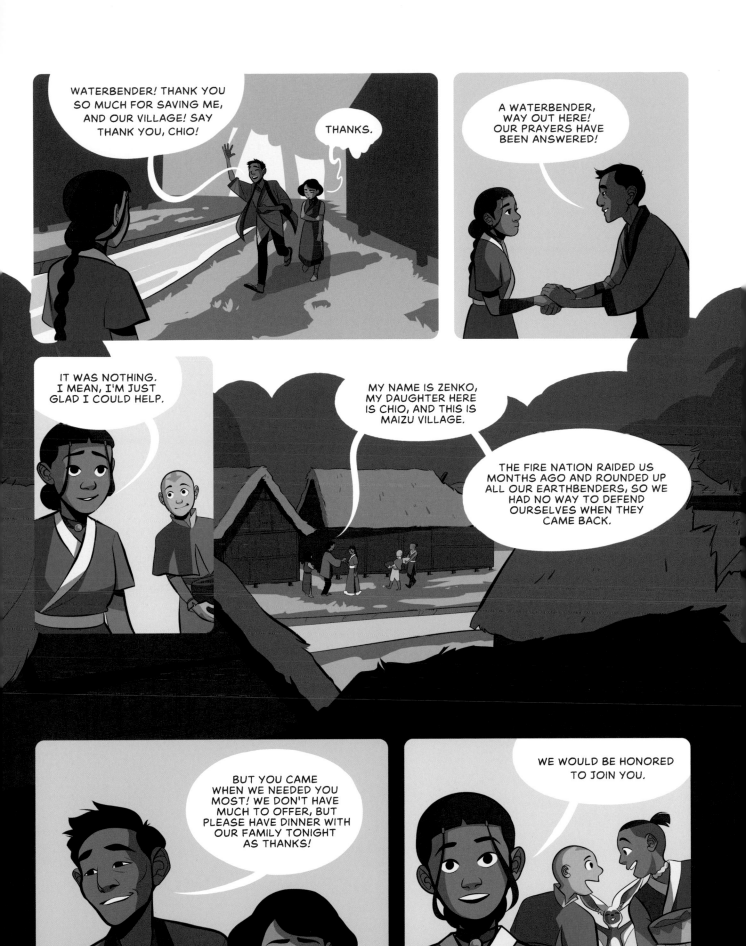

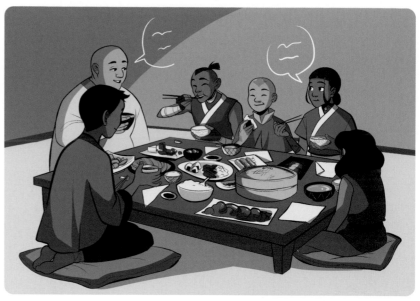

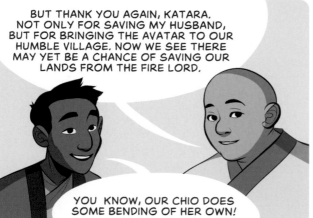

BUT THANK YOU AGAIN, KATARA. NOT ONLY FOR SAVING MY HUSBAND, BUT FOR BRINGING THE AVATAR TO OUR HUMBLE VILLAGE. NOW WE SEE THERE MAY YET BE A CHANCE OF SAVING OUR LANDS FROM THE FIRE LORD.

YOU KNOW, OUR CHIO DOES SOME BENDING OF HER OWN!

WHAT, REALLY? I THOUGHT ALL YOUR EARTH-BENDERS WERE—

DAD!

HE'S JOKING, IT'S NOT **REAL** BENDING. IT'S JUST...

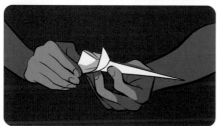

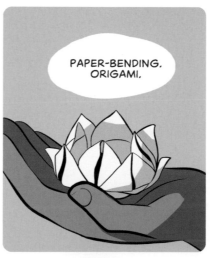

PAPER-BENDING. ORIGAMI.

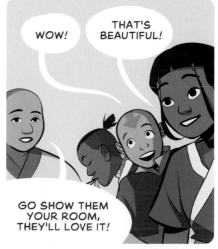

WOW!

THAT'S BEAUTIFUL!

GO SHOW THEM YOUR ROOM, THEY'LL LOVE IT!

PAPA, THEY HAVE BETTER THINGS TO DO THAN LOOK AT SOME DUMB PAPER. THEY'RE **HEROES** AFTER ALL.

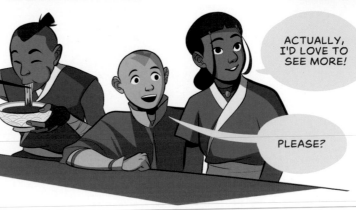

ACTUALLY, I'D LOVE TO SEE MORE!

PLEASE?

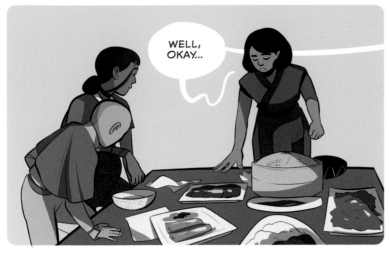

WELL, OKAY...

MY ROOM'S JUST DOWN THE HALL. YOU DON'T HAVE TO REALLY LOOK AT IT ALL.

ERK!

I KNOW YOU'RE USUALLY SAVING PEOPLE AND FIGHTING BAD GUYS AND ALL THAT, SO, YOU KNOW...

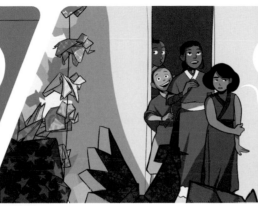

THIS ISN'T EXACTLY IMPRESSIVE.

CHIO, THESE ARE SO *COOL!*

THEY REALLY ARE!

BESIDES, IT'S NICE TO HAVE A NIGHT OFF FROM SAVING THE WORLD SOMETIMES.

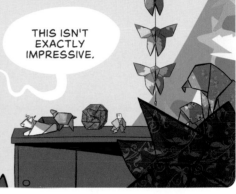

YOU'RE JUST BEING POLITE, I KNOW. YOU'VE DONE SO MUCH, YOU HELP PEOPLE ALL THE TIME. PEOPLE LIKE MY DAD. YOU DON'T HAVE TO JUST WAIT AROUND AND *HOPE* THAT THINGS GET BETTER.

ACTUALLY, I HAVE TO WAIT AND HOPE FOR THINGS TO GET BETTER ALL THE TIME. I'VE GOT TO STAY *OPTIMISTIC*, EVEN WHEN THINGS ARE SCARY AND SEEM IMPOSSIBLE.

YOU CAN'T WIN A WAR WITH FIGHTING ALONE. HOPE IS MORE POWERFUL THAN YOU MIGHT THINK.

HONESTLY, I WISH I HAD MORE OF IT SOMETIMES.

NO MATTER HOW EXHAUSTED I AM, NO MATTER WHAT I'M FEELING, I'M SUPPOSED TO HAVE *HOPE!* AANG NEEDS IT, THE PEOPLE WE MEET *ALL* NEED IT.

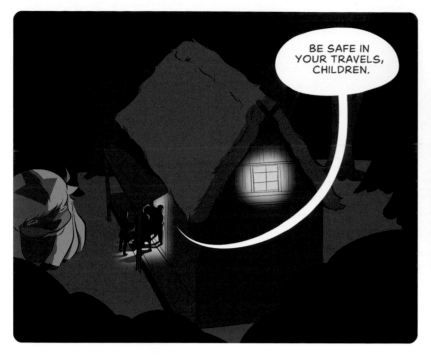

BE SAFE IN YOUR TRAVELS, CHILDREN.

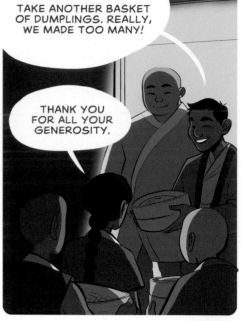

TAKE ANOTHER BASKET OF DUMPLINGS. REALLY, WE MADE TOO MANY!

THANK YOU FOR ALL YOUR GENEROSITY.

UM, KATARA?

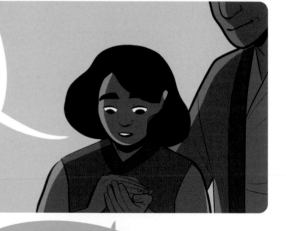

WHEN YOU CAME TO RESCUE US TODAY, I WISHED SO MUCH THAT I COULD FIGHT LIKE YOU. I WANT TO BE ABLE TO PROTECT MY DAD, AND MY PAPA, AND THE WHOLE VILLAGE. BUT YOU HELPED ME SEE THAT FIGHTING ISN'T THE ONLY WAY TO HELP PEOPLE.

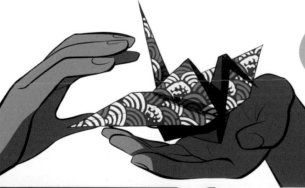

I MADE THIS FOR YOU TO TAKE ON YOUR JOURNEY. THE CRANE IS A SYMBOL OF LUCK AND PEACE.

AS YOU WORK FOR PEACE, MAY IT GIVE YOU PROTECTION, LUCK, AND MOST OF ALL, HOPE.

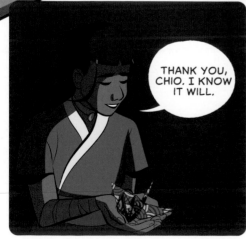

THANK YOU, CHIO. I KNOW IT WILL.

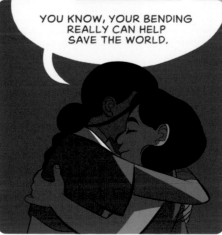

YOU KNOW, YOUR BENDING REALLY CAN HELP SAVE THE WORLD.

END!

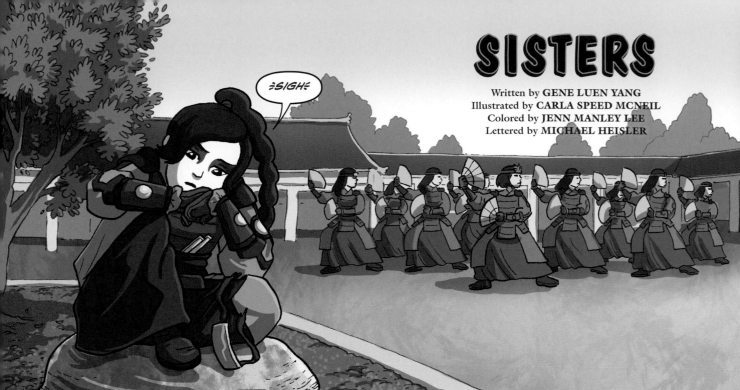

SISTERS

Written by **GENE LUEN YANG**
Illustrated by **CARLA SPEED MCNEIL**
Colored by **JENN MANLEY LEE**
Lettered by **MICHAEL HEISLER**

≈SIGH≈

BAP!

OW!

TOPH? WHAT'RE YOU DOING IN THE CAPITAL CITY?

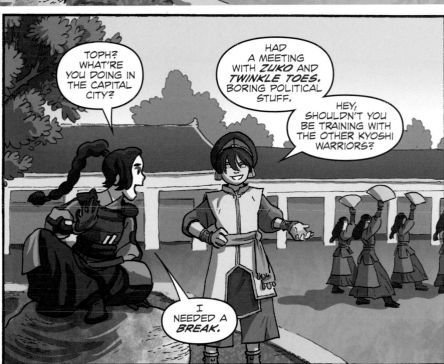

HAD A MEETING WITH *ZUKO* AND *TWINKLE TOES.* BORING POLITICAL STUFF.

HEY, SHOULDN'T YOU BE TRAINING WITH THE OTHER KYOSHI WARRIORS?

I NEEDED A *BREAK.*

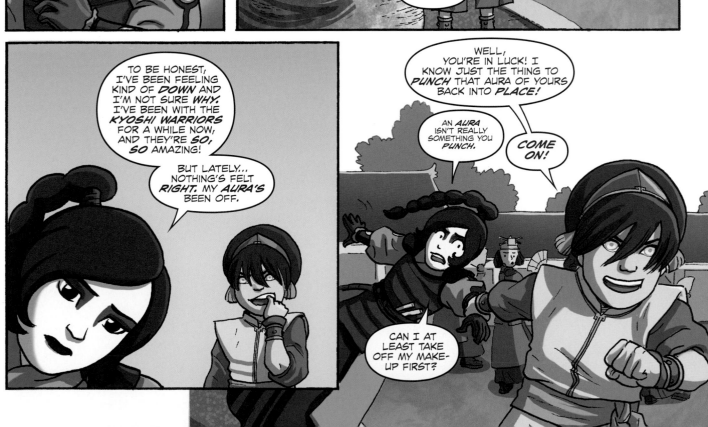

TO BE HONEST, I'VE BEEN FEELING KIND OF *DOWN* AND I'M NOT SURE *WHY.* I'VE BEEN WITH THE *KYOSHI WARRIORS* FOR A WHILE NOW, AND THEY'RE *SO, SO* AMAZING!

BUT LATELY... NOTHING'S FELT *RIGHT.* MY AURA'S BEEN OFF.

WELL, YOU'RE IN LUCK! I KNOW JUST THE THING TO *PUNCH* THAT AURA OF YOURS BACK INTO *PLACE!*

AN *AURA* ISN'T REALLY SOMETHING YOU *PUNCH.*

COME ON!

CAN I AT LEAST TAKE OFF MY MAKE-UP FIRST?

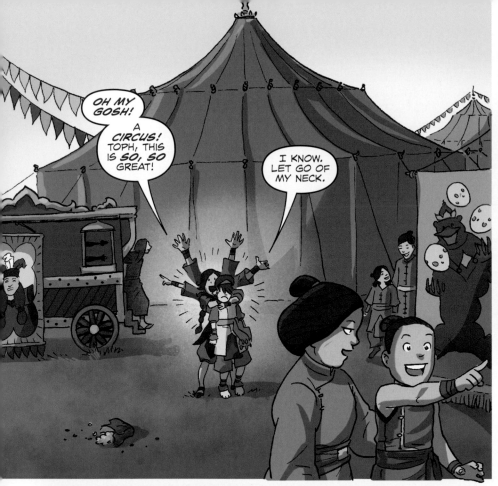

OH MY GOSH! A CIRCUS! TOPH, THIS IS SO, SO GREAT!

I KNOW. LET GO OF MY NECK.

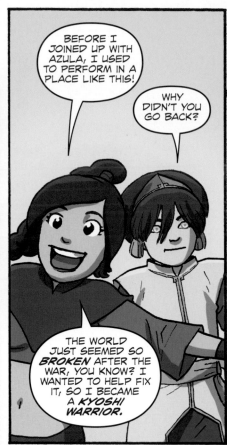

BEFORE I JOINED UP WITH AZULA, I USED TO PERFORM IN A PLACE LIKE THIS!

WHY DIDN'T YOU GO BACK?

THE WORLD JUST SEEMED SO BROKEN AFTER THE WAR, YOU KNOW? I WANTED TO HELP FIX IT, SO I BECAME A KYOSHI WARRIOR.

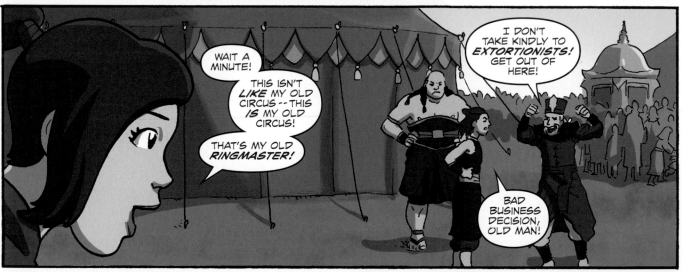

WAIT A MINUTE! THIS ISN'T LIKE MY OLD CIRCUS -- THIS IS MY OLD CIRCUS!

THAT'S MY OLD RINGMASTER!

I DON'T TAKE KINDLY TO EXTORTIONISTS! GET OUT OF HERE!

BAD BUSINESS DECISION, OLD MAN!

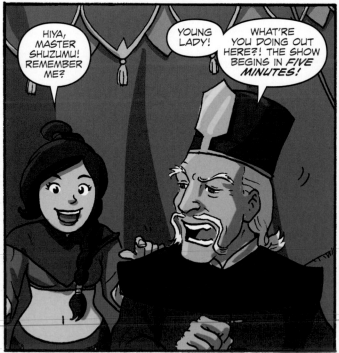

HIYA, MASTER SHUZUMU! REMEMBER ME?

YOUNG LADY! WHAT'RE YOU DOING OUT HERE?! THE SHOW BEGINS IN FIVE MINUTES!

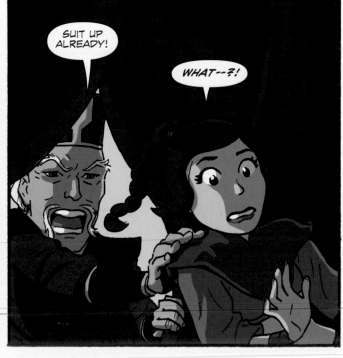

SUIT UP ALREADY!

WHAT--?!

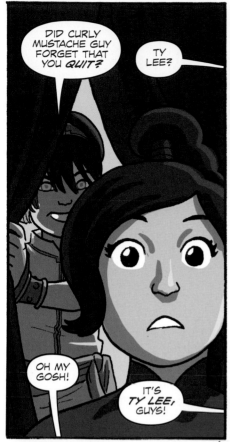

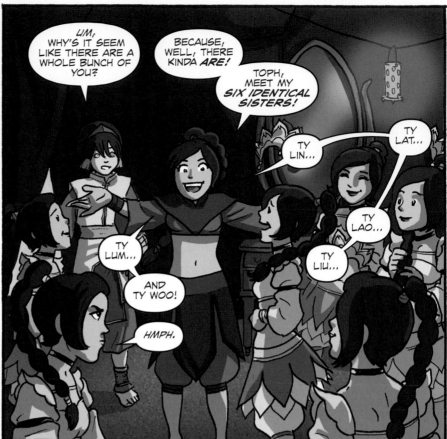

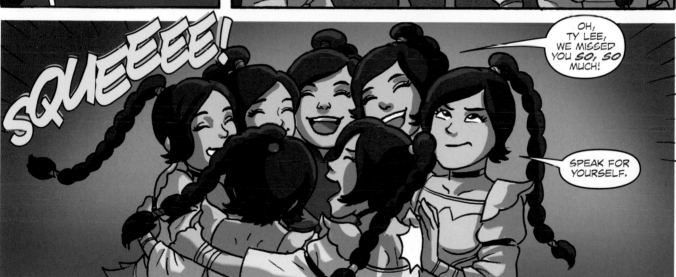

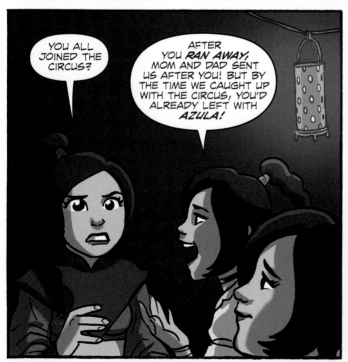

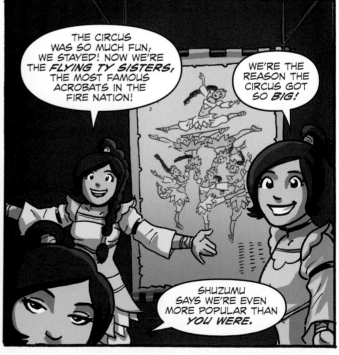

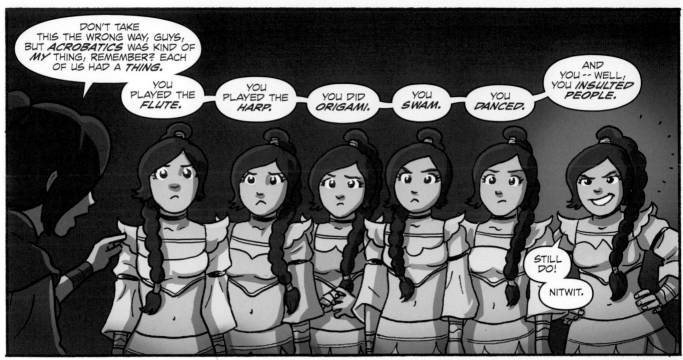

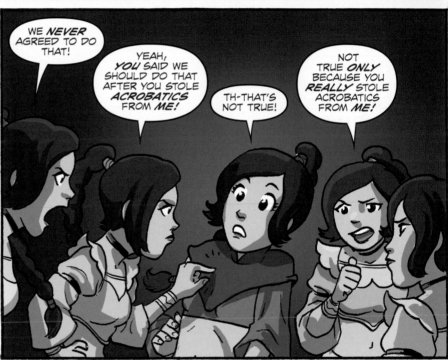

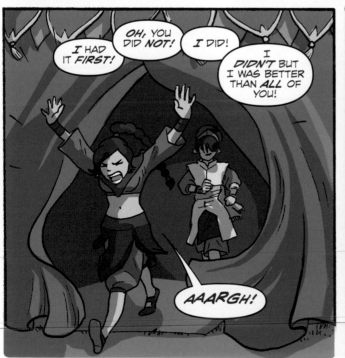

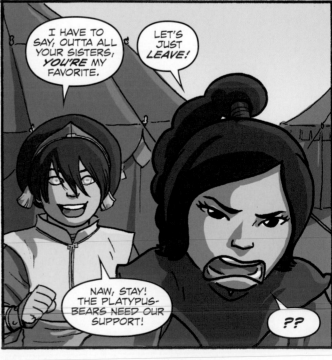

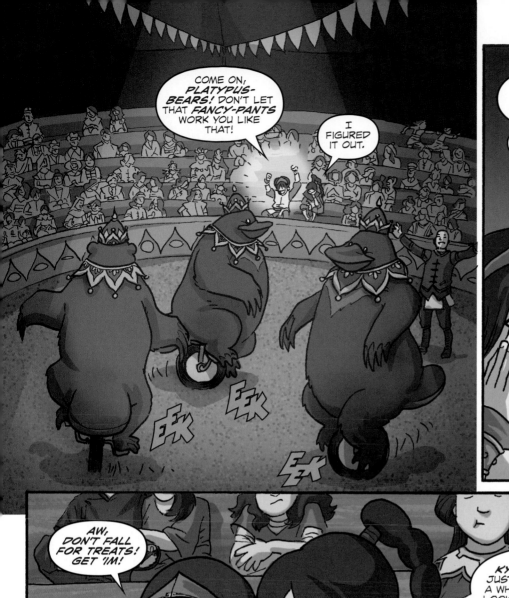
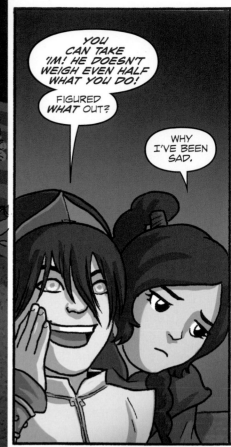
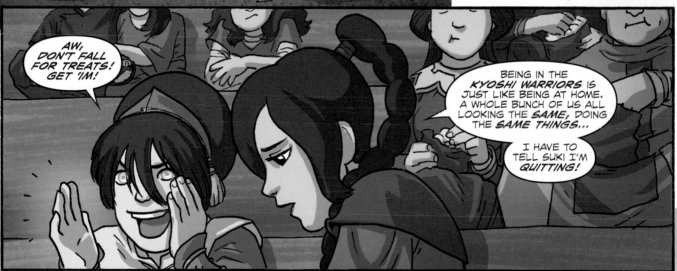
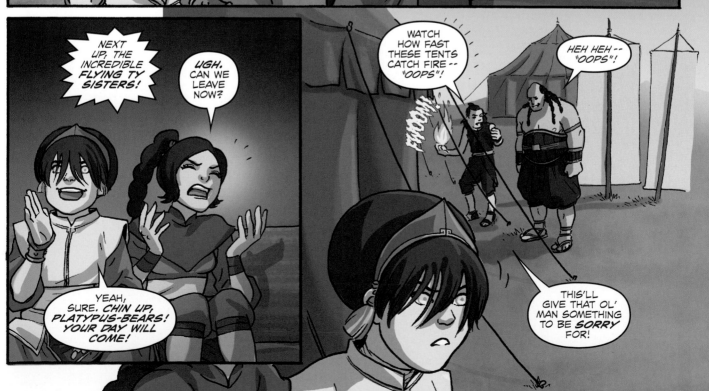

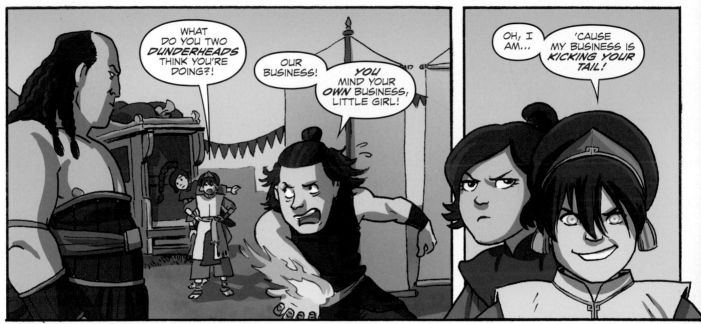

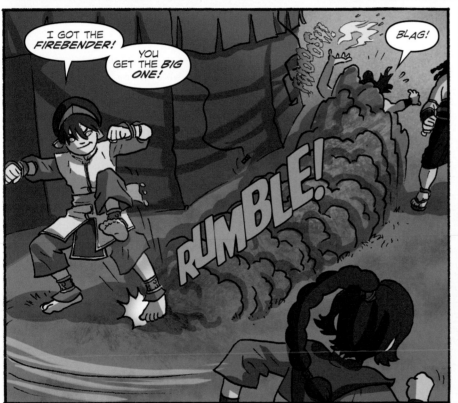

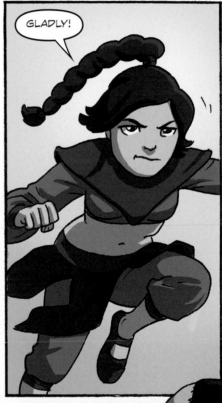

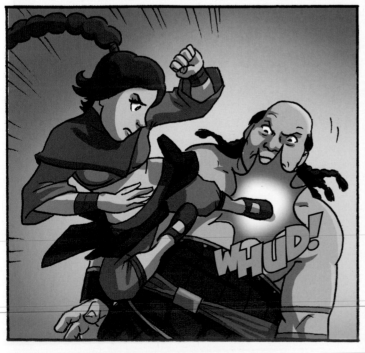

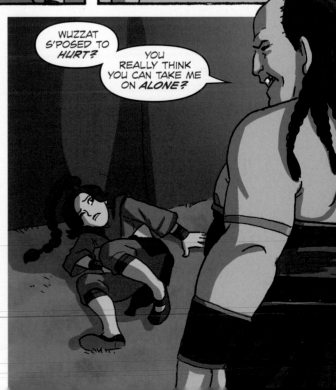

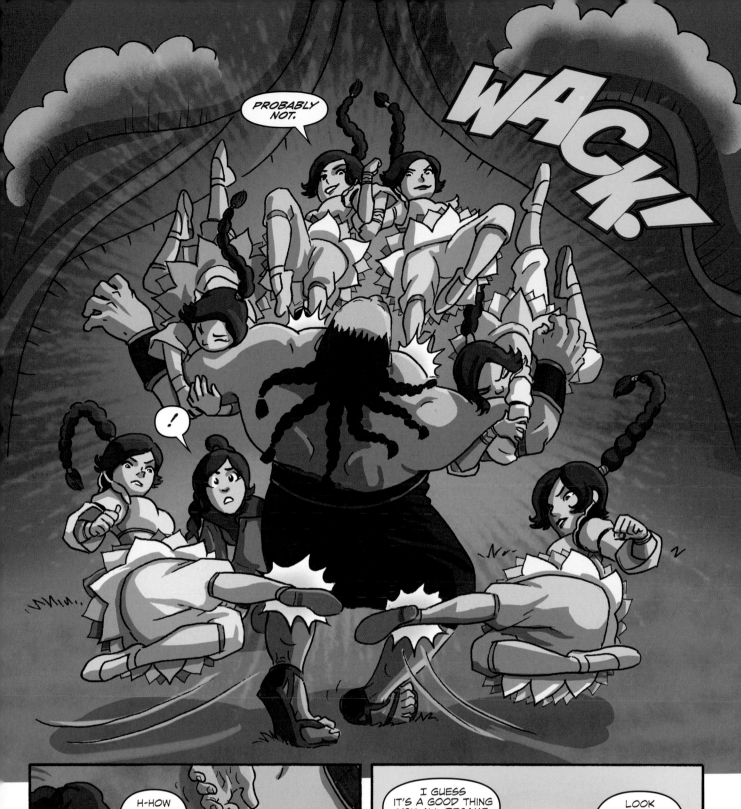
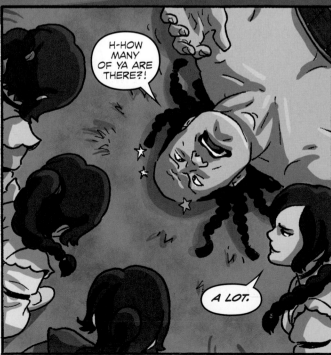
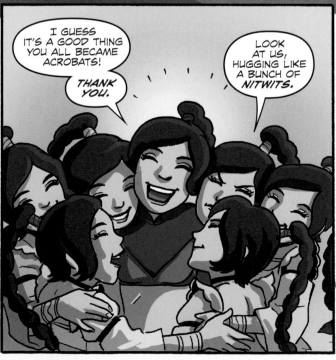

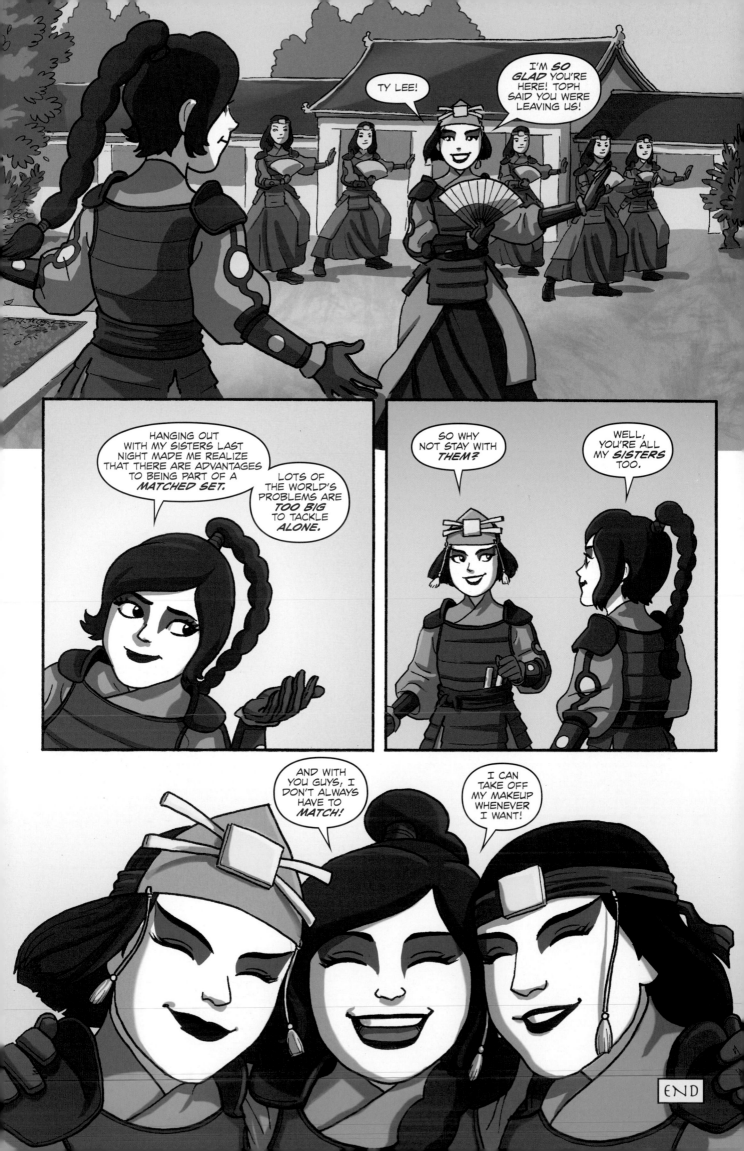

THE SCARECROW

Written by **DAVE SCHEIDT**
Illustrated and lettered by **CONI YOVANINIZ**

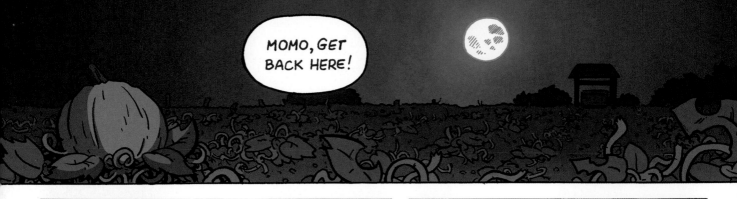

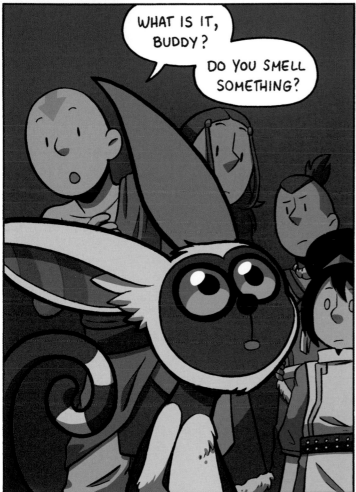

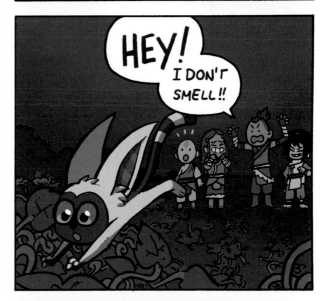

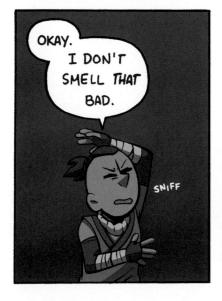

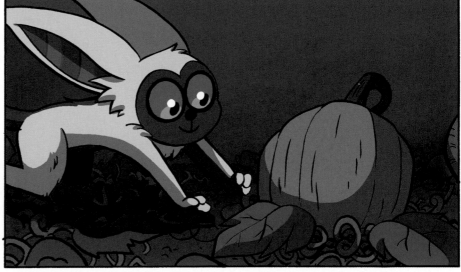

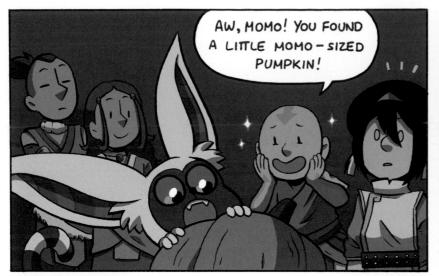

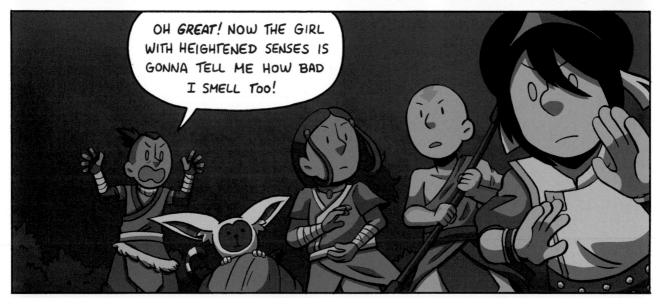

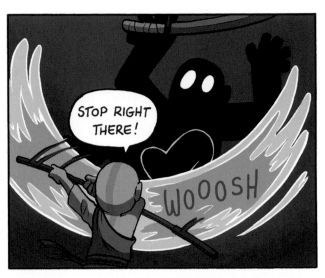

STOP RIGHT THERE!

WOOOSH

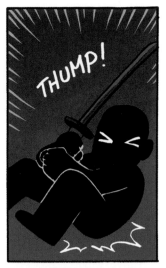

THUMP!

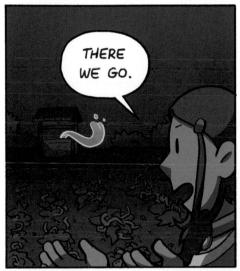

THERE WE GO.

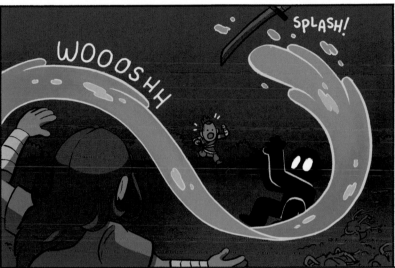

WOOOSHH

SPLASH!

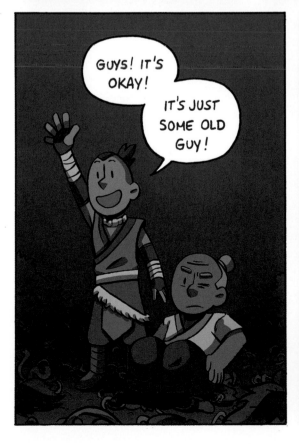

GUYS! IT'S OKAY!

IT'S JUST SOME OLD GUY!

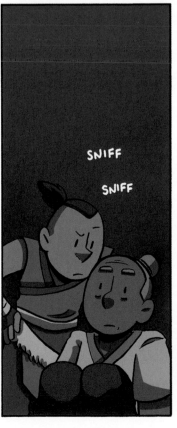

SNIFF

SNIFF

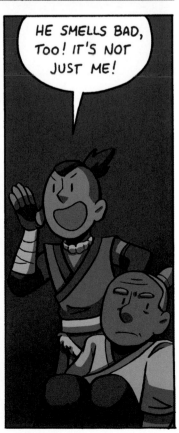

HE SMELLS BAD, TOO! IT'S NOT JUST ME!

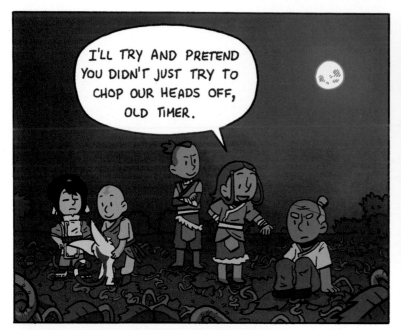

I'LL TRY AND PRETEND YOU DIDN'T JUST TRY TO CHOP OUR HEADS OFF, OLD TIMER.

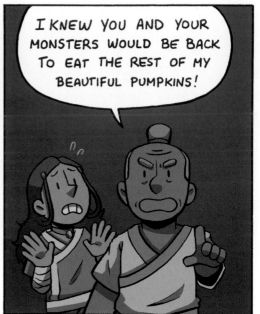

I KNEW YOU AND YOUR MONSTERS WOULD BE BACK TO EAT THE REST OF MY BEAUTIFUL PUMPKINS!

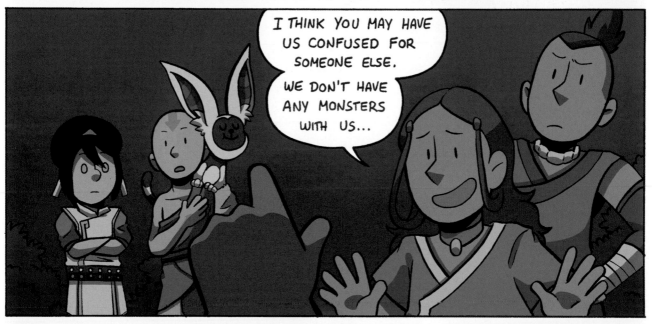

I THINK YOU MAY HAVE US CONFUSED FOR SOMEONE ELSE.

WE DON'T HAVE ANY MONSTERS WITH US...

BEELCH!!

WHAT DO YOU CALL THAT THING?!

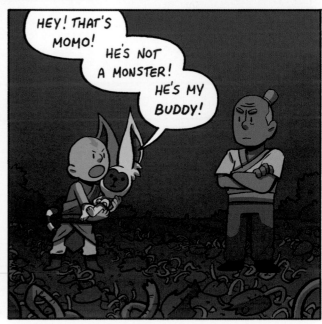

HEY! THAT'S MOMO!

HE'S NOT A MONSTER!

HE'S MY BUDDY!

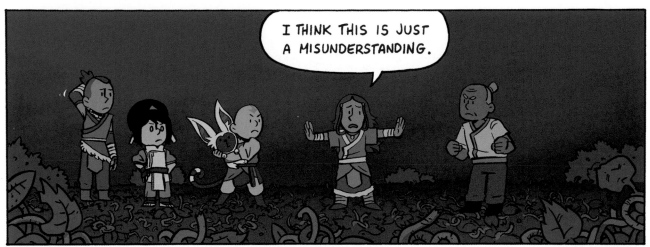

I THINK THIS IS JUST A MISUNDERSTANDING.

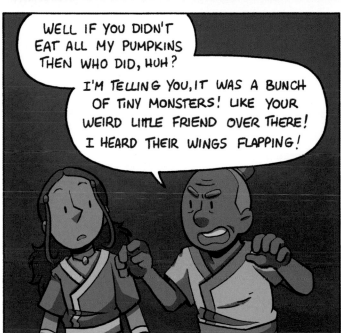

WELL IF YOU DIDN'T EAT ALL MY PUMPKINS THEN WHO DID, HUH?

I'M TELLING YOU, IT WAS A BUNCH OF TINY MONSTERS! LIKE YOUR WEIRD LITTLE FRIEND OVER THERE! I HEARD THEIR WINGS FLAPPING!

WE'LL GET TO THE BOTTOM OF THIS. IT'S KIND OF OUR THING.

RIGHT, GUYS?

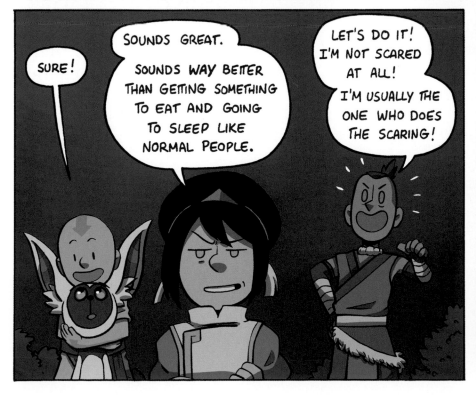

SURE!

SOUNDS GREAT.

SOUNDS WAY BETTER THAN GETTING SOMETHING TO EAT AND GOING TO SLEEP LIKE NORMAL PEOPLE.

LET'S DO IT! I'M NOT SCARED AT ALL! I'M USUALLY THE ONE WHO DOES THE SCARING!

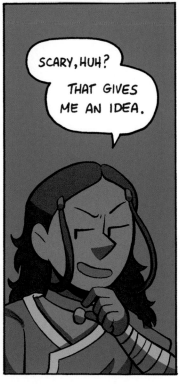

SCARY, HUH?

THAT GIVES ME AN IDEA.

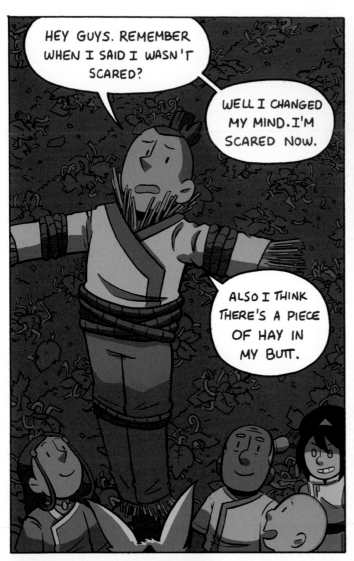

HEY GUYS. REMEMBER WHEN I SAID I WASN'T SCARED?

WELL I CHANGED MY MIND. I'M SCARED NOW.

ALSO I THINK THERE'S A PIECE OF HAY IN MY BUTT.

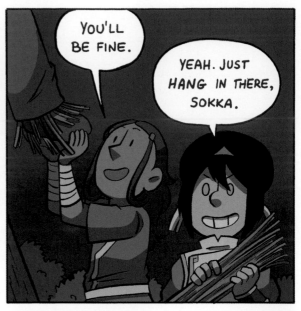

YOU'LL BE FINE.

YEAH. JUST HANG IN THERE, SOKKA.

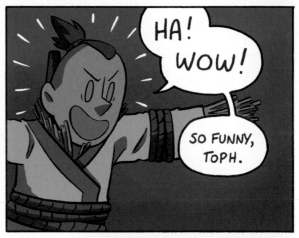

HA! WOW!

SO FUNNY, TOPH.

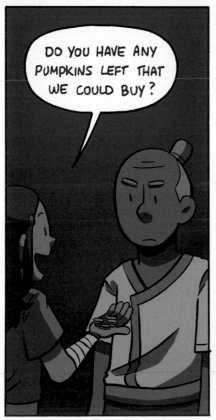

DO YOU HAVE ANY PUMPKINS LEFT THAT WE COULD BUY?

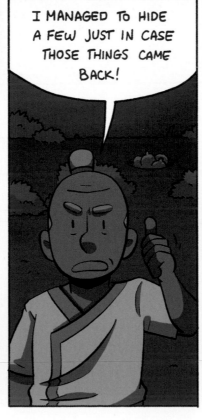

I MANAGED TO HIDE A FEW JUST IN CASE THOSE THINGS CAME BACK!

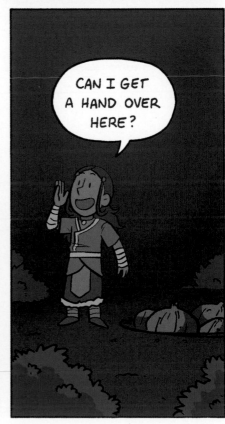

CAN I GET A HAND OVER HERE?

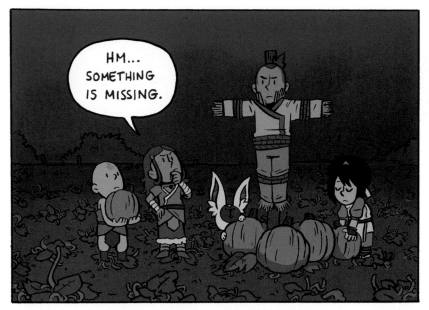

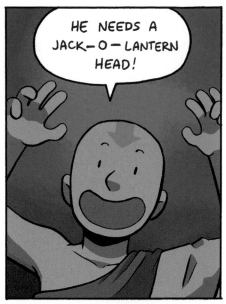

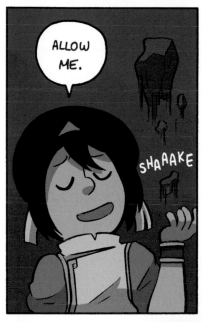

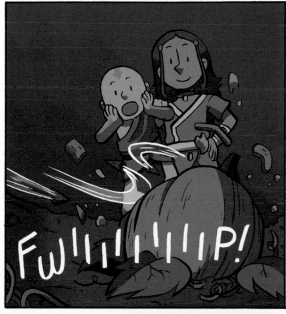

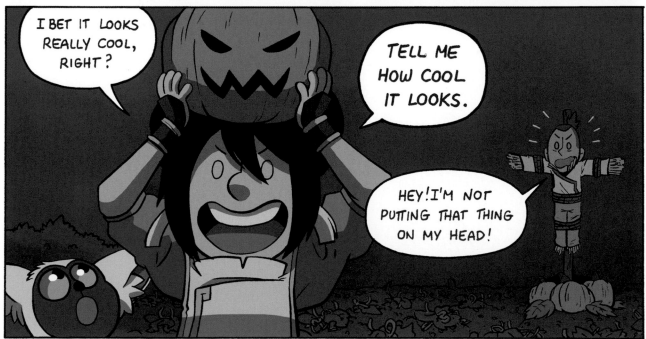

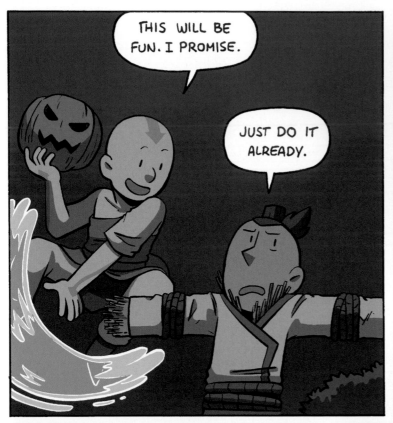

THIS WILL BE FUN. I PROMISE.

JUST DO IT ALREADY.

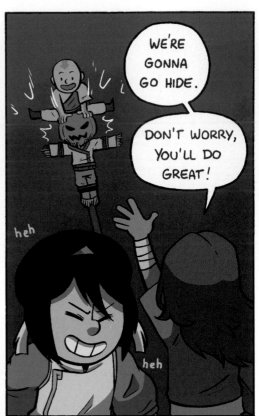

WE'RE GONNA GO HIDE.

DON'T WORRY, YOU'LL DO GREAT!

heh

heh

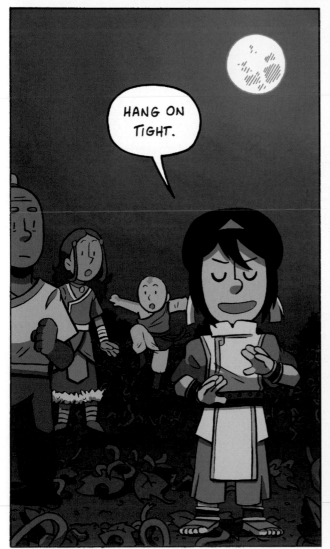

HANG ON TIGHT.

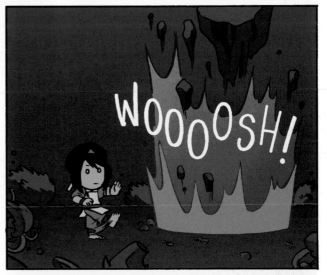

WOOOOSH!

SHALL WE?

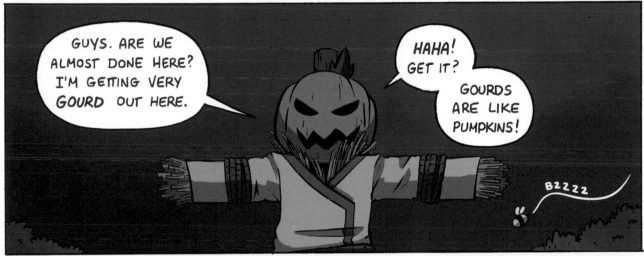

GUYS. ARE WE ALMOST DONE HERE? I'M GETTING VERY GOURD OUT HERE.

HAHA! GET IT?

GOURDS ARE LIKE PUMPKINS!

BZZZZ

CAW!

CAW!

CAW!

BZZZZZ

BZZZZZZZ

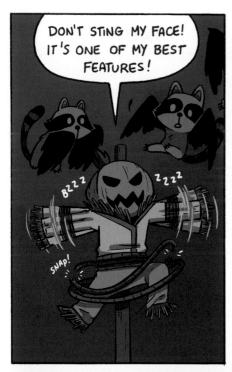

DON'T STING MY FACE! IT'S ONE OF MY BEST FEATURES!

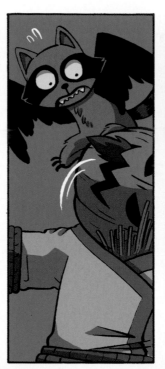

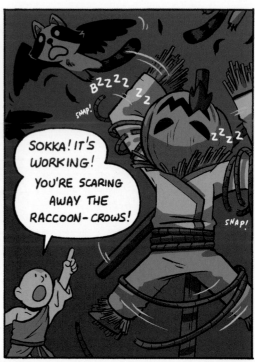

SOKKA! IT'S WORKING! YOU'RE SCARING AWAY THE RACCOON-CROWS!

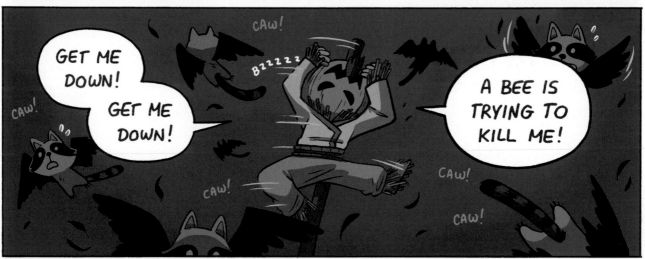

GET ME DOWN! GET ME DOWN!

A BEE IS TRYING TO KILL ME!

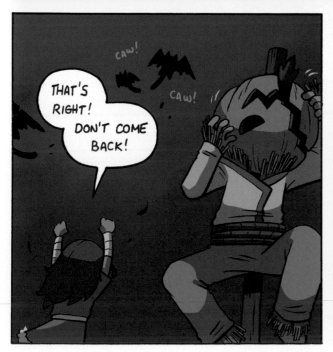

THAT'S RIGHT! DON'T COME BACK!

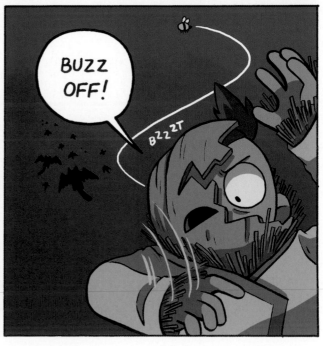

BUZZ OFF!

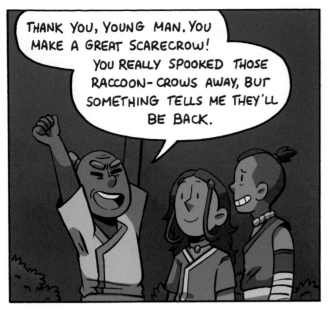

THANK YOU, YOUNG MAN. YOU MAKE A GREAT SCARECROW! YOU REALLY SPOOKED THOSE RACCOON-CROWS AWAY, BUT SOMETHING TELLS ME THEY'LL BE BACK.

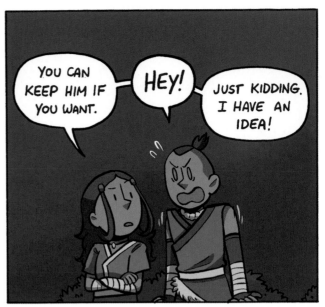

YOU CAN KEEP HIM IF YOU WANT.

HEY!

JUST KIDDING. I HAVE AN IDEA!

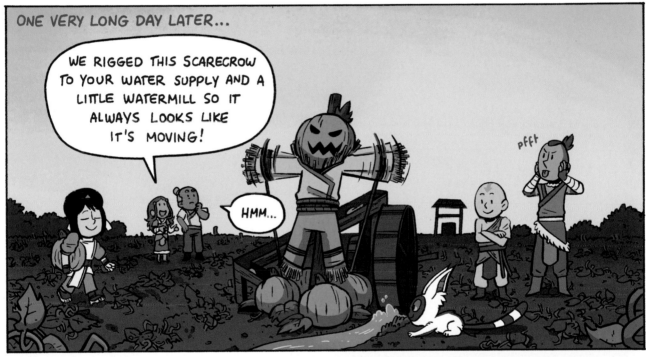

ONE VERY LONG DAY LATER...

WE RIGGED THIS SCARECROW TO YOUR WATER SUPPLY AND A LITTLE WATERMILL SO IT ALWAYS LOOKS LIKE IT'S MOVING!

HMM...

pfft

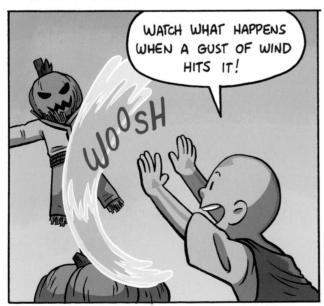

WATCH WHAT HAPPENS WHEN A GUST OF WIND HITS IT!

WOOSH

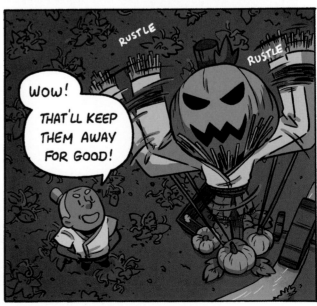

RUSTLE

RUSTLE

WOW! THAT'LL KEEP THEM AWAY FOR GOOD!

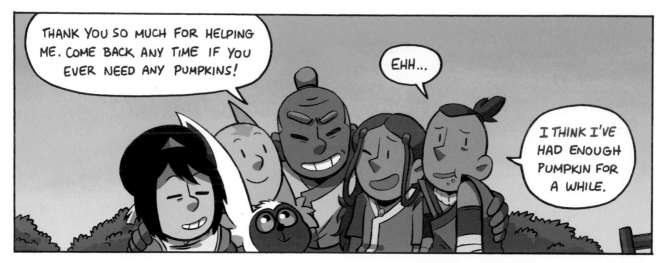

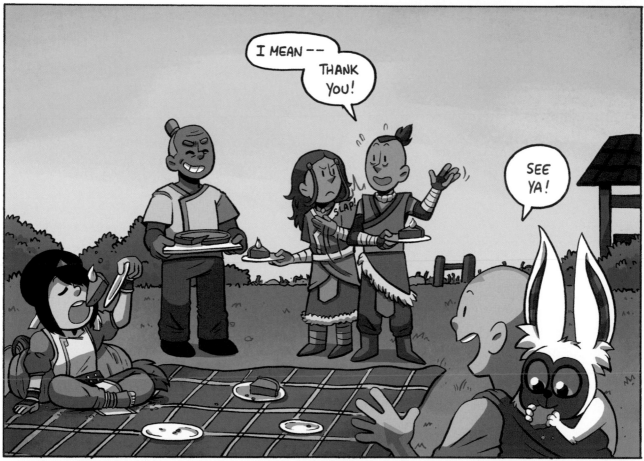

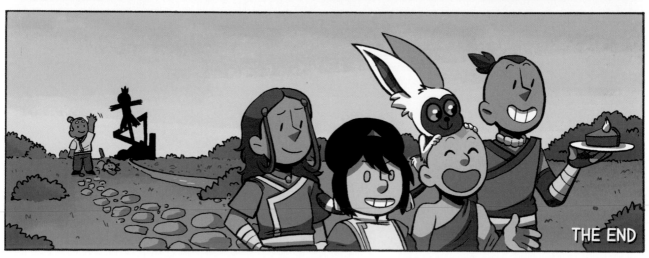

THE END

ABOUT THE
CREATORS

BRYAN KONIETZKO & MICHAEL DANTE DiMARTINO, the co-creators of *Avatar: The Last Airbender*, met at a Halloween party in 1995 and have been friends and creative partners ever since. They've worn many hats over the course of *Avatar*'s production, working not only as the show's executive producers but also as its writers, directors, story editors, and artists. And their hands-on approach to creating the series doesn't stop there—they've traveled the world taking reference photos for their artists, and have spent months in South Korea making sure their overseas animators are as involved in the creative process as the folks working out of their Los Angeles studio.

AARON EHASZ served as head writer and co-producer of many of *Avatar: The Last Airbender*'s most memorable episodes, including "Jet," "The Blind Bandit," "The Tales of Ba Sing Se," and the four-part series finale "Sozin's Comet." He's also written episodes of *Mission Hill*, *Ed*, and *Futurama*.

ALISON WILGUS co-wrote *Zuko's Story*, a graphic novel prequel to the *Last Airbender* feature film, and *The Last Airbender*, a manga-style adaptation of that same film, with writing partner Dave Roman. She's also written books for *Codename: Kids Next Door* and graphic novel duology *Chronin*.

One of the winners of Tokyopop's fourth Rising Stars of Manga competition, **AMY KIM GANTER**'s comics work includes an adaptation of the *Goosebumps* story "Deep Trouble," two stories for the acclaimed comics anthology *Flight*, and the graphic novel series *Sorcerers & Secretaries*.

BRIAN RALPH, the award-winning creator of the graphic novels *Cave-In* and *Climbing Out*, teaches at the Savannah College of Art and Design, which has one of the largest and best-known sequential art departments in the United States. His artwork has appeared in newspapers, magazines, and ad campaigns.

Richard Starkings' award-winning studio **COMICRAFT** has been providing the comics community with fine lettering since 1992. Best known for pioneering the use of computers in comic book lettering, Comicraft has not only lettered hundreds of comics, but has also designed some of the industry's most popular fonts!

CONI YOVANINIZ is a comic artist and Astronomy MSc based in Santiago, Chile. She spends her time making fun and wholesome comics, doing science outreach, and thinking about snacks. Previous work includes the webcomics *Postcards in Braille* and *Walking to Do*. You can check out her work at kurisquare.com

COREY LEWIS has created lots of great comics, but he's probably best known for *Sharknife*, the story of a busboy at a Chinese restaurant who transforms into a mighty warrior to battle the monsters that live in the restaurant's walls (providing no end of entertainment for their customers!).

CRIS (TIANE) PETER is a professional comic-book colorist of almost twenty years, and was nominated for the Eisner Award for best colorist in 2012. With almost 250 credited issues, she also works on personal projects in Brazil, teaches digital coloring, and is one of the people in charge of organizing panels about diversity during CCXP (the biggest entertainment convention in the world). You can find her on Instagram @coloristdiaries and Twitter @crispeter.

DAVE ROMAN, the award-winning author of *Astronaut Academy: Zero Gravity*, has had a long relationship with *Airbender*. As the comics editor of *Nickelodeon Magazine* for over ten years, he looked after the very first *Airbender* comics! More recently, he's been involved with *Airbender* as co-writer of the movie tie-in graphic novels *Zuko's Story* and *The Last Airbender*.

ELSA GARAGARZA is the concept artist and designer behind many of *Avatar: The Last Airbender*'s most exciting locations. She's also a storyboard artist, and has worked on projects like the *Penguins of Madagascar* TV series, *Green Lantern: First Flight*, and *Generator Rex*.

ETHAN SPAULDING directed twelve episodes of *Avatar: The Last Airbender*, and worked on many more as a storyboard artist, character designer, and background artist. He's also worked on *The Simpsons* and *Green Lantern: First Flight*, and *ThunderCats*.

FAITH ERIN HICKS is a writer and artist living in Vancouver, British Columbia. Her previously published works include *Friends with Boys*, *The Last of Us: American Dreams* (with Neil Druckmann), *The Adventures of Superhero Girl*, *Pumpkinheads* (with Rainbow Rowell), and *The Nameless City* trilogy. She has won two Eisner Awards, which look very nice sitting on a shelf next to her collection of *Fullmetal Alchemist* action figures. She can be found online at www.faitherinhicks.com.

FRANK PITTARESE has been writing and editing comics since the 1980s, working on titles like *The Flash*, *Superman*, and *X-Men*, and worked as a freelancer for *Nickelodeon Magazine*, where he edited and wrote articles, activities, and comics featuring almost all of their characters, from Rugrats to SpongeBob Squarepants.

GENE LUEN YANG writes, and sometimes draws, comic books and graphic novels. As the Library of Congress' fifth National Ambassador for Young People's Literature, he advocates for the importance of reading, especially reading diversely. *American Born Chinese*, his first graphic novel from First Second Books, was a National Book Award finalist, as well as the winner of the Printz Award and an Eisner Award. His two-volume graphic novel *Boxers & Saints* won the L.A. Times Book Prize and was a National Book Award Finalist. His other works include *Secret Coders* (with Mike Holmes), *The Shadow Hero* (with Sonny Liew), *Superman* from DC Comics (with various artists), and the *Avatar: The Last Airbender* series from Dark Horse Comics (with Gurihiru). In 2016, he was named a MacArthur Foundation Fellow. His most recent books are *Dragon Hoops* from First Second Books and *Superman Smashes the Klan* from DC Comics.

Teaming up under the name **GURIHIRU**, Japanese artists Sasaki and Kawano create artwork for comics, games, and animation studios. They've done a lot of work for Marvel, drawing and coloring *Thor and the Warriors Four*, *Power Pack*, *Tails of the Pet Avengers* and *World War Hulks: Wolverine & Captain America*, as well as for Disney.

HYE JUNG KIM worked on *Avatar: The Last Airbender* as a painter, artist, and color supervisor, using her talents to help create the show's rich settings and exotic environments. She's also worked her artistic magic on *Dora the Explorer*, *The Fairly OddParents*, and *Green Lantern: First Flight*.

Creator of the award-winning series *Alison Dare*, **J. TORRES** has also written *Batman: Legends of the Dark Knight*, *Wall-E*, *Teen Titans Go!*, and *Wonder Girl* comics. He's written for animation too, on series like *Hi Hi Puffy Ami Yumi*, *Edgar & Ellen*, and *League of Super Evil*. He's also written *Jinx* for Archie Comics.

JOAQUIM DOS SANTOS came to *Airbender* as a storyboard artist, but became a director on season three episodes like "The Beach" and "The Headband." He's since directed many other projects, including *G.I. Joe: Resolute*, and returned to *Airbender* as co-executive producer of its sequel series, *The Legend of Korra*. Joaquim has been nicknamed "Dr. Fight" because of his talent for choreographing dynamic action scenes.

Another veteran of the *Flight* comics anthology, **JOHANE MATTE** worked on *Avatar: The Last Airbender* as a storyboard artist. She's currently a storyboard artist at DreamWorks Animation, where she's worked on *The Penguins of Madagascar* and *How to Train Your Dragon*, for which she also helped write the "Legend of the Boneknapper Dragon" animated short.

JOHN O'BRYAN was a staff writer for *Avatar: The Last Airbender*, and wrote many episodes, including "The King of Omashu," "Avatar Day," and "Nightmares and Daydreams."

JOSHUA HAMILTON started on *Airbender* as a writers' assistant, but rose to become a full writer during the show's production, writing episodes like "The Painted Lady" and "The Runaway."

JUSTIN RIDGE worked as a storyboard artist on *Avatar: The Last Airbender*, and later worked as a storyboard artist for *G.I. Joe: Resolute* and as a director and storyboard artist on *Star Wars: The Clone Wars*. He's also worked as a guest director on *The Cleveland Show*. His comics work has appeared in *Zombies vs. Cheerleaders*, *Flight*, and *Shojo Beat*.

KATIE MATTILA started out as a production assistant on *Airbender*, but grew to become a production coordinator and ultimately a writers' assistant for the show, and wrote the episode "The Beach." She's currently working on the series *King Fu Panda: Legends of Awesomeness*.

KIKU HUGHES is a cartoonist and illustrator based in the Seattle area. She loves sci-fi, found family, and stories that uplift marginalized voices. Her debut graphic novel, Displacement, explores her family's time in Japanese American incarceration camps and the lasting effects of community trauma. You can follow her on Twitter @kikuhughes.

LARK PIEN is a cartoonist, children's book author, and pal to Gene Yang. Visit @larkpien on Instagram, Facebook, and Twitter for more comics and art.

LITTLE CORVUS is a transmasc Latinx comic artist and illustrator based in Seattle, Washington. A graduate of the School of Visual Arts with a BFA in Cartooning (2015), they are an Eisner- and Ignatz-nominated artist who has worked with Harper Collins, Dark Horse, Chronicle Books, and more. They love street fashion, diverse stories, and the color pink. Visit them at littlecorvusart.com, and on Twitter and Instagram @little_corvus.

As part of the Nickelodeon Writing Fellowship, **MAY CHAN** spent a lot of time in the writing room of the *Avatar: The Last Airbender* animated series, eventually writing part one of "The Boiling Rock." She also wrote for the Disney series *Phineas and Ferb*.

NATALIE RIESS is a cartoonist from Pennsylvania who loves to draw cats, food, and horrible monsters. She now lives in Austin, Texas, where she makes comics with her partner. Her previous titles include *Space Battle Lunchtime* and *Snarlbear*.

RAWLES LUMUMBA is a freelance writer and native of Baltimore, Maryland. In addition to comics, she is an author of fantasy and sci-fi young adult fiction. She also blogs about diversity in television, video games, and pop culture.

REAGAN LODGE got his start as a contributing artist on the acclaimed *Flight* anthology series, for which he created "Tea" and "The Dragon." He has also served in the U.S. Marine Corps as a Combat Photographer, but don't worry: he still draws too!

RON KOERTGE is the current poet laureate of South Pasadena, California. His latest book of poems is *Yellow Moving Van* from the University of Pittsburgh Press.

RYAN HILL never knows what to write in these so here's what the Postmates guy just said when asked to describe Ryan's work: "Wow, you worked on *Avatar* . . . man, that's cool, I just watched some of it with my niece on Netflix. Oh . . . describe the screen . . . what's onscreen? You did this? I mean, it looks nice. You seem like a nice dude. You're writing this down? . . ." Ryan has worked in comics for a while and is at https://www.secretclubhousestudio.com

SARA GOETTER is a Pennsylvania-born, Austin-based cartoonist. There she draws comics with her partner, such as *Dungeon Critters* (First Second). She's a big fan of drawing tough guys crying. Website: sgoetter.com Twitter: @sgoetter

SNO-CONE STUDIOS colored and lettered a wide variety of comic series, including *Star Wars*, *Teen Titans*, *Hawkman*, *Legion of Super-Heroes*, *Shrek*, and *Scooby-doo*. Though they've now closed up shop, their work is still enjoyed by comics fans to this day.

A writer for the *Avatar: The Last Airbender* animated series, **TIM HEDRICK** authored such episodes as "The Deserter," "Sokka's Master," and "The Puppetmaster."

TOM MCWEENEY has written, drawn, and lettered comics since the eighties. He co-created *Roachmill* and has contributed to a number of other titles, including *Teenage Mutant Ninja Turtles*, *Fantastic Four*, and *Gen13*.

WES DZIOBA has been coloring comics for over a decade, getting his start at comics-coloring studios but then moving on as an independent colorist on books like *Star Wars*, *G.I. Joe vs. Transformers: Black Horizon*, and *Aliens vs. Predator: Three World War*.

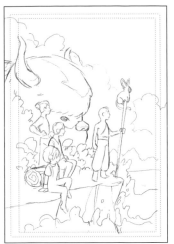
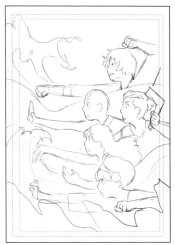
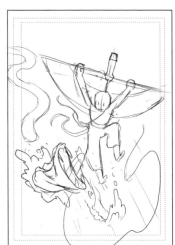
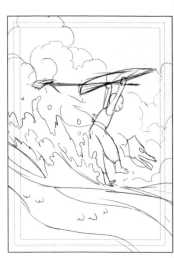

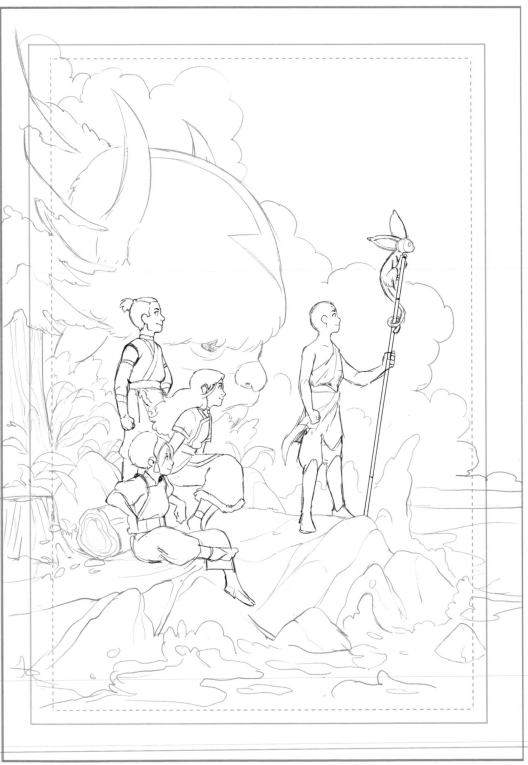

Chan Chau's process for the new cover can be seen here—thumbnails (*top*), pencils (*left*), and the first stage of colors (*right*). Because they paint their backgrounds, Chan blocked in approximate colors for the environment and Appa at this stage. This helped ensure the entire color palette came together. And it did, beautifully!

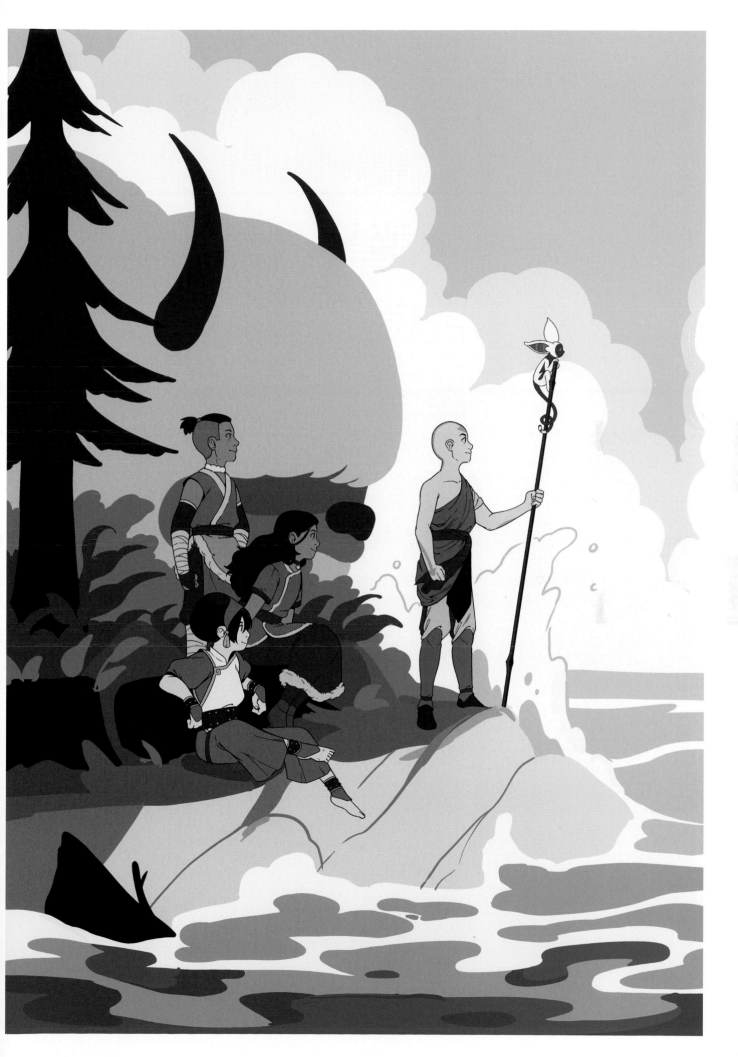

1

2

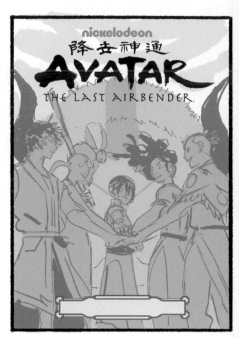

3

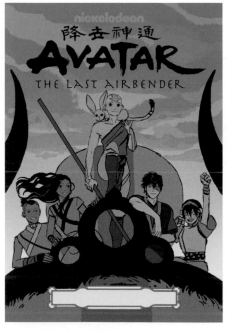

1

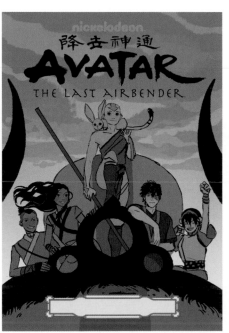

2

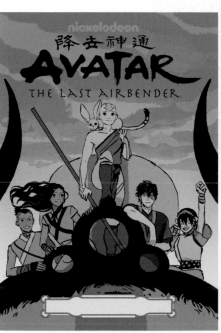

3

Sara Kipin's process for the original *Team Avatar Tales* cover art. After we chose a sketch to move forward with, Sara provided several color options before completing the final art. We felt that option one, the warmest palette of the three, felt inviting and hopeful . . . perfect for Team Avatar!

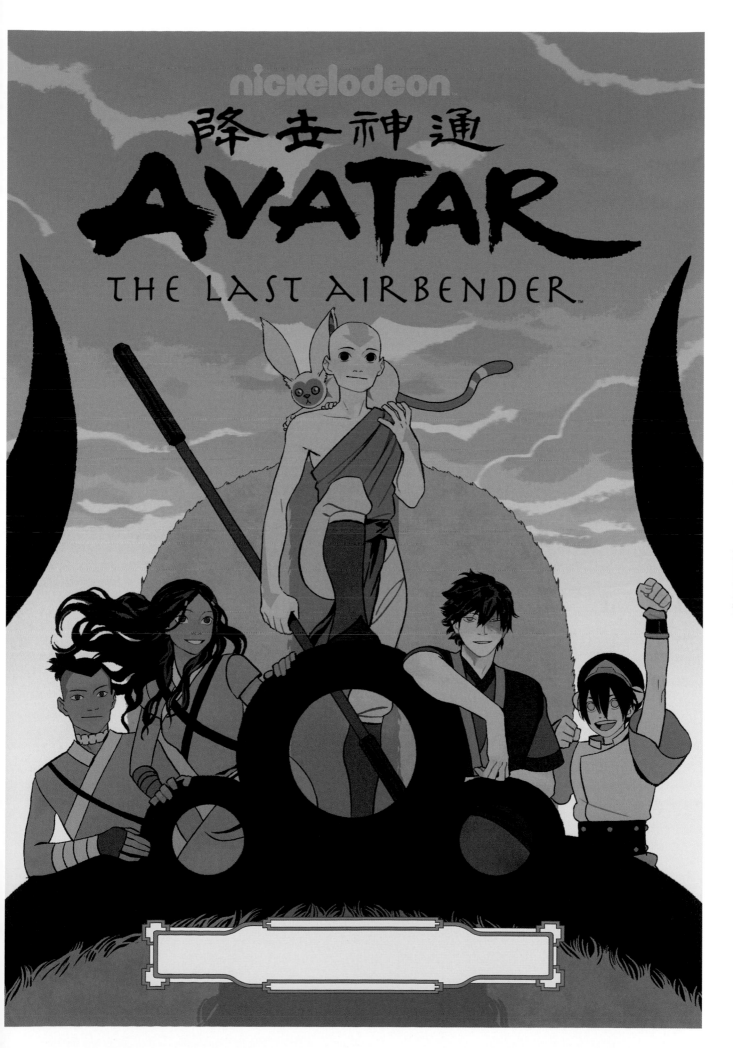

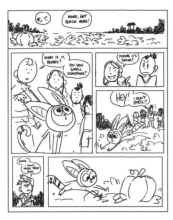

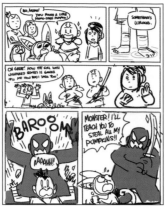

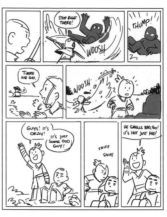

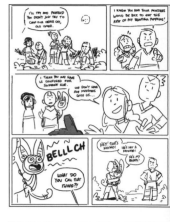

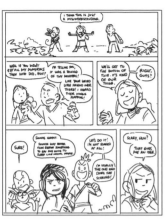

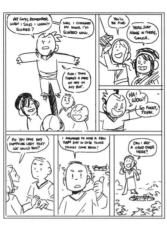

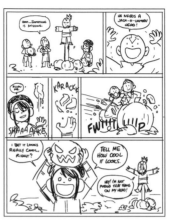

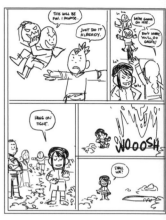

Throughout the next few spreads, you'll see layouts from multiple artists. It's always fascinating to see which processes work for different artists! Usually, the script and layouts are submitted separately and at different times; in the case of Sara Goetter's "Toph and the Boulder" short—which she both wrote and illustrated—the script and layouts arrived together. These two pieces of the comics puzzle generally inform one another, but in this case, they were practically hand-in-hand.

Sara Goetter also submitted some hilariously wholesome sketches along with her initial pitch for her story (*opposite*). Needless to say, all of us on the approvals team were completely smitten the moment we reviewed these.

Coni Yovaniniz's layouts for "The Scarecrow," written by Dave Scheidt, can be seen above, as an example of separate script and layouts stages. I love the way Coni draws Momo—too cute!

①

Panel 1: establishing shot of an earthbending village alongside a winding river.

Panel 2: slow zoom in on the river on the edge of town. Some people are fishing. There's some faint yelling in the distance.

Panel 3: shot of the people going about their business in town. Most look unfazed but some look concerned about the yelling in the background.

Panel 4: long shot of a house in the middle of town. It's the source of the screaming, but people around it look more annoyed than concerned.

Panel 1: Outside of the house, Toph is strolling down the street by herself, whistling.

Panel 2: Toph notices some screaming coming from somewhere.

Panel 3: Toph faces a house; the source of the yelling.
Toph: Is that...?

Panel 4: Toph enters the house, pops her head in the doorway.
Toph: Hey! What's going on—

Panel 5: Toph pauses
Toph: —here?

Panel 6: wide shot of The Boulder's kitchen, which is in great disarray, with a crococat on the table and a very stressed Boulder wearing an apron and whipping up something in a bowl. Both the crococat and The Boulder are yelling.

②

③

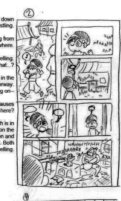

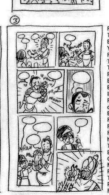

Panel 1: mid shot of Toph entering the kitchen, cautiously.
Toph: The Boulder? What is all this?
Boulder: TOPH?! THE BOULDER SURE IS HAPPY TO SEE YOU!
Panel 2: same shot, only the crococat sits between Toph and The Boulder and yells.
Toph: And since when do you have a crococat?
Panel 3: The Boulder picks up a very ornery crococat. The Boulder makes a ":3" face.
Boulder: HIS NAME IS THE PEBBLE AND HE HAS BEEN AN INTEGRAL PART OF THE BOULDER'S LIFE FOR YEARS...
Panel 4: zoom in on The Boulder's face, who looks more defeated.
Boulder: HOWEVER, SINCE HAVING A PET DOESN'T REALLY FIT THE BOULDER'S IMAGE, THE PEBBLE IS KEPT SECRET.
Panel 5: zoom out, The Boulder is still holding The Pebble but he's more discontent and yowls even more.
Toph: Okay...but why is he yowling so much?
Boulder: THE BOULDER HASN'T THE SLIGHTEST IDEA! ALL OF A SUDDEN THE PEBBLE HAS AN INSATIABLE HUNGER NO MATTER HOW MUCH THE BOULDER FEEDS HIM.
Panel 6: close up of Toph
Toph: Have you tried taking him to the vet?
Panel 7: close up of The Boulder holding The Pebble. The Pebble looks suddenly very angry, The Boulder looks shocked.

Panel 1: long shot of Toph and The Boulder thinking. The Pebble is on The Boulder's head, still hungry.
Toph: Hm.
Boulder: HMMM.
Panel 2: mid shot on Toph and The Boulder.
Toph: Maybe he's just sick of the usual stuff. Have you tried different pet food?
Boulder: DO YOU THINK THAT WILL WORK?
Toph: It's worth a shot!
Panels 3-5: The same mid shot of The Pebble devouring a number of different pet foods in the background (labeled with a silhouette on the bag): Gatordog food, froghorse oats, turtleduck seeds. (words will not be there it's just for clarity right now)
Panel 6: overhead shot of Toph and The Boulder thinking. The Pebble has eaten all the food and is resuming his demands.
Toph: Maybe it's the quality of the food? There's that gourmet restaurant that opened up across town.
Boulder: I'LL DO ANYTHING FOR THE PEBBLE.
Panels 7 & 8: A plate of incredibly fancy looking salmon is placed in front of The Pebble, who sniffs at it and then refuses to eat it.
Panel 9: The Boulder is on the ground, on all fours, pounding the floor. Toph pats while The Pebble yowls at him for more food (but not that food).
Toph: There, there.
Boulder: THAT WAS SO EXPENSIVE...

④

Panel 1: The Pebble starts thrashing and violently hissing. The Boulder is still holding him but farther away from his body.
Panel 2: The Boulder covers The Pebble's ears.
Boulder: THE BOULDER DOES NOT USE THE "V" WORD AROUND THE PEBBLE.
Panel 3: close up of Toph.
Toph: You've never taken your crococat to the vet?! That's crazy!
Panel 4: close up of The Boulder, slightly shuddering. In the background is a short montage of previous attempts to get The Pebble to the vet, each ending with The Boulder badly scratched up.
Boulder: IT WAS NOT FROM A LACK OF EFFORT ON THE BOULDER'S PART...THE PEBBLE IS VERY CONVINCING.
Panel 5: mid shot of The Pebble attempting to swipe at Toph, while still hissing violently.
Toph: All right! Fine! No vets!
Panel 6: zoom out, The Pebble stops hissing and yelling entirely. The Boulder is still holding him, both him and Toph pause to see if this means The Pebble has stopped.
Panel 7: same shot, The Pebble resumes yelling.
Toph: What do we do then?
Boulder: THE BOULDER HAS NO IDEA.

⑤

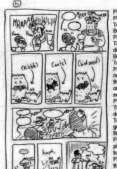

302

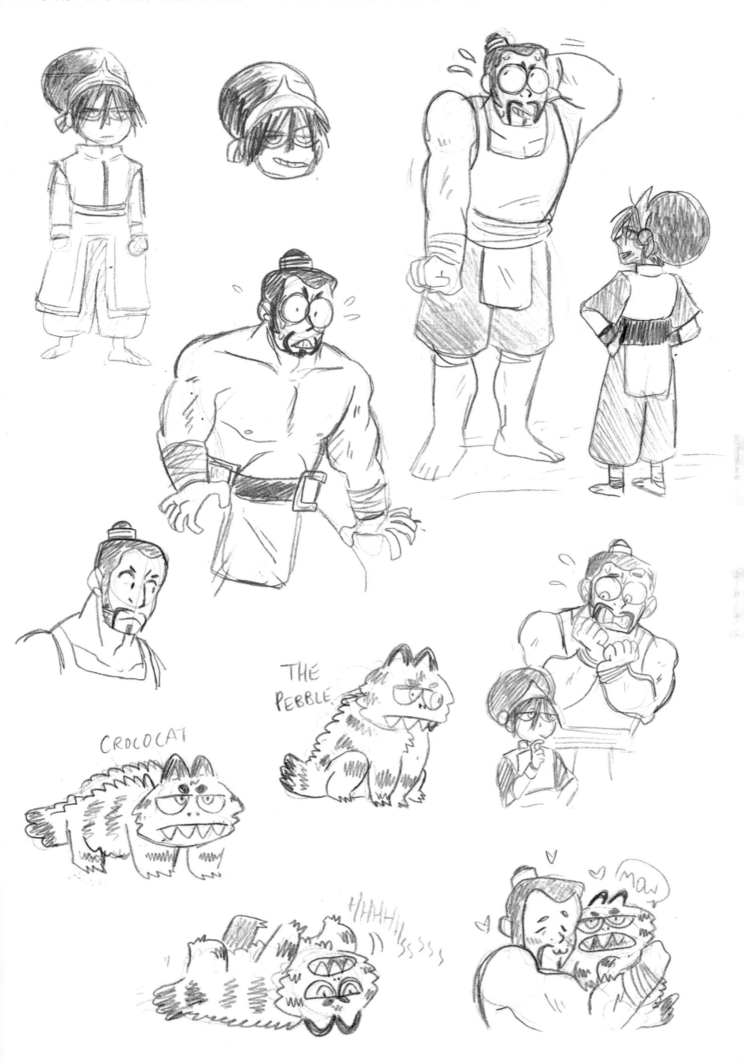

THE PEBBLE

CROCOCAT

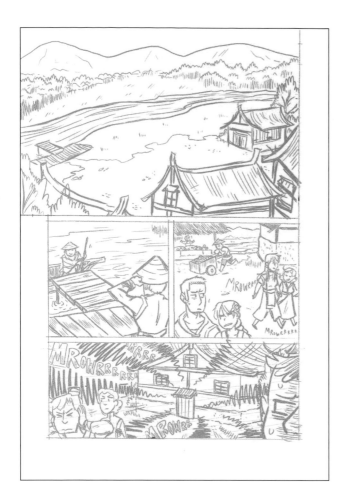

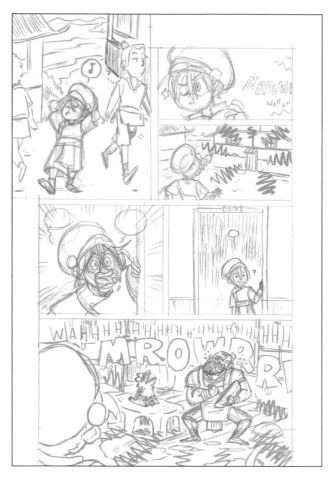

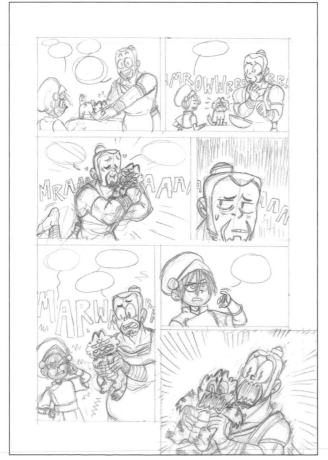

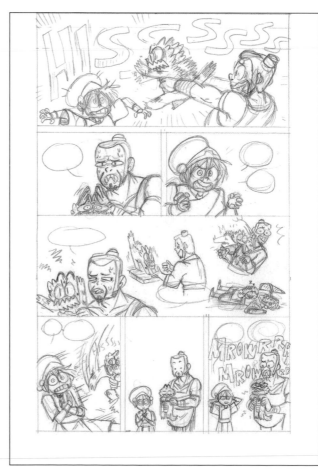

Sara Goetter's pencils for her "Toph and the Boulder" story. These were done in a mix of digital and traditional pencil. The blue hue is easier to scan and remove, especially when inking traditionally! Sara inked and lettered the story by hand, and then it was colored digitally by Natalie Riess.

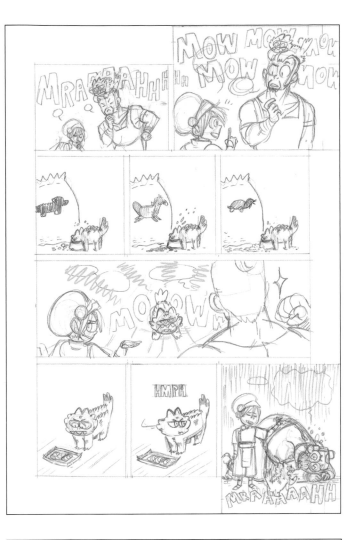

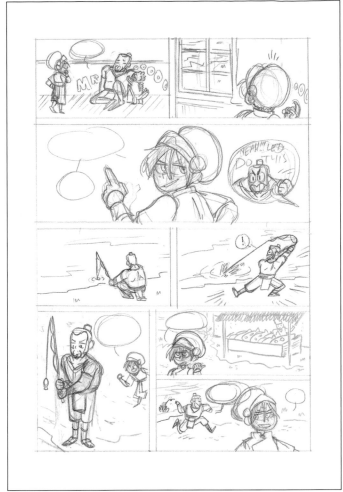

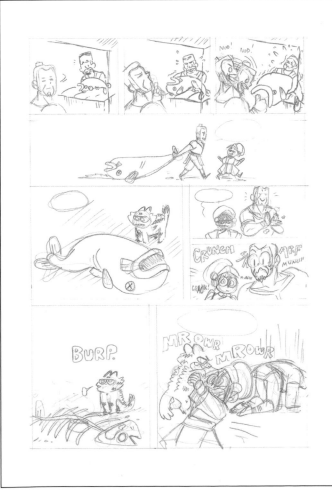

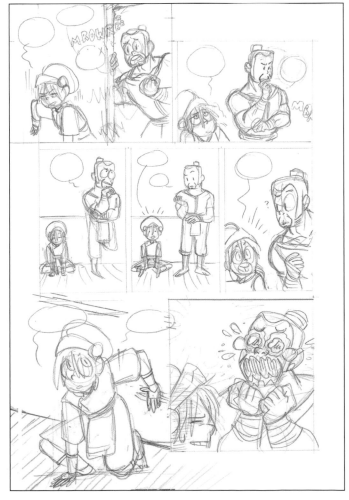

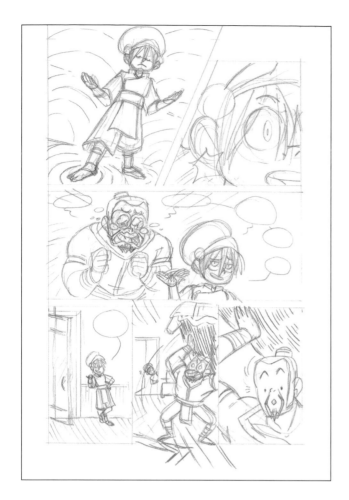

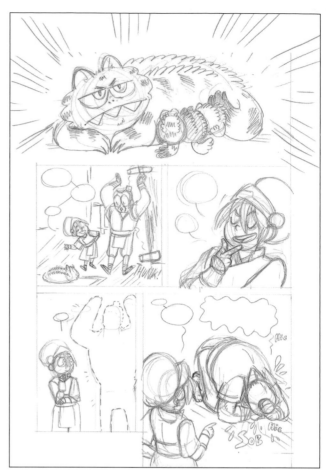

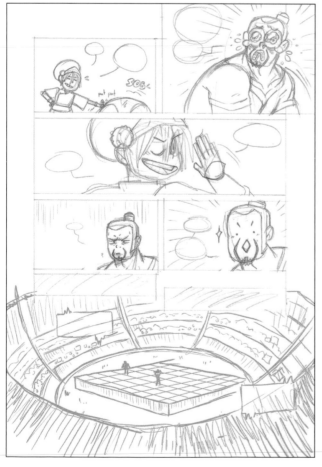

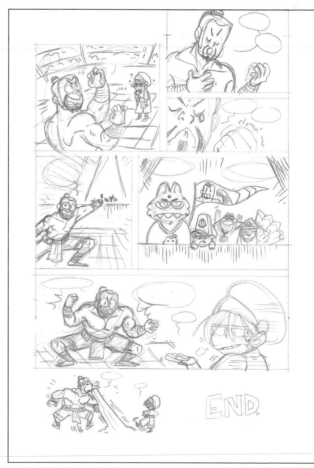

Ron Koertge and Gene Yang's script and layouts for "Sokka's Poem" (*right*). I adored Ron and Gene's team up—Captain Boomerang needs love too, and what better way than an illustrated poem! This also marked Gene's first time illustrating something for the Avatarverse, after years of writing it.

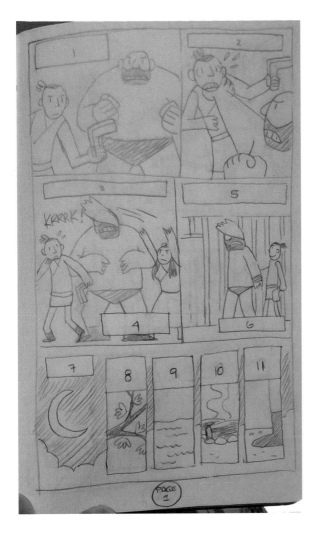

SOKKA
Word by Ron Koertge and Pictures by Gene Luen Yang

PAGE 1.

Panel 1. *Sokka vs. Big Brawny Bad Guy.*

CAPTION: [1]
Oh, I know: Sokka and his dumb jokes. Sokka who lost his girlfriend to the moon.

Panel 2. *Big Brawny Bag Guy grabs Sokka by the throat.*

CAPTION: [2]
Sokka who can't even bend paper except with his mitts.

Panel 3. *Katara to the rescue!*

CAPTION: [3]
But at the risk of blowing my own horn, who rescued Suki from the prison at Boiling Rock?

CAPTION: [4]
Who defeated the wolf spirit? Well, sort of.

Panel 4. *Sokka escorts Big Brawny Bad Guy to his jail cell.*

CAPTION: [5]
Lots of battles to fight, lots of strategy to craft.

CAPTION: [6]
It's a busy life.

Panel 5. *Long panel showing the moon; four inset panels showing the four elements.*

CAPTION: [7]
But then night comes.

CAPTION: [8]
The air is still

CAPTION: [9]
the waters placid

CAPTION: [10]
the fire banked

CAPTION: [11]
the earth dense and unyielding

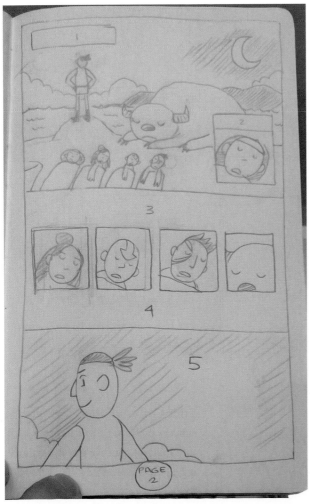

PAGE 2.

Panel 1. *Night. Sokka stands guard over his sleeping friends.*

CAPTION: [1]
No one is combining his soul with a spirit.

No one is reincarnating.

No one is kidnapped.

Everything sleeps.

Panel 2. *Inset panel showing Toph sleeping.*

CAPTION: [2]
Even Toph's eyes close, making her constant darkness
that much darker.

Panel 3. *Inset panels showing Sokka's sleeping friends.*

CAPTION: [3]
Everyone vulnerable, barefoot and drowsy.

CAPTION: [4]
This is me at my best, when people I love or revere or both
need me whether they know it or not.

Panel 4. *Sokka smiles over his shoulder.*

CAPTION: [5]
I almost never

sleep. There's too much to do and

only I can do it!

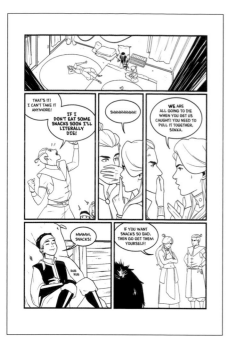

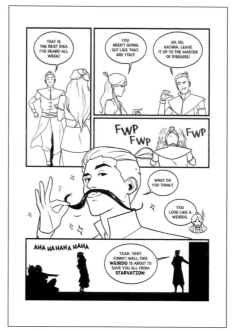

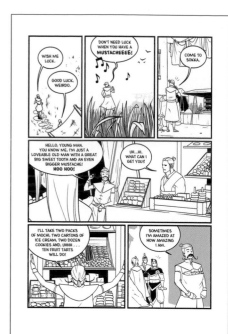

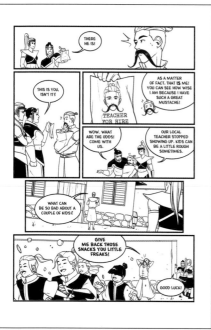

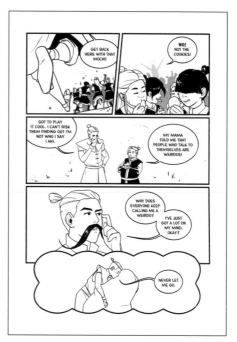

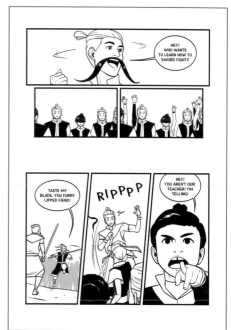

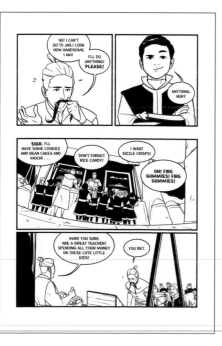

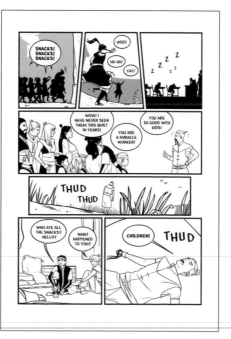

Little Corvus's inks for "The Substitute," written by Dave Scheidt. Their smooth and bold inking style and dynamic panel arrangements perfectly suited this silly Sokka story.

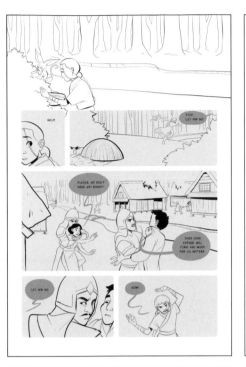

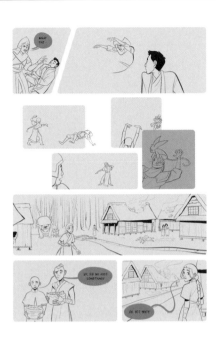

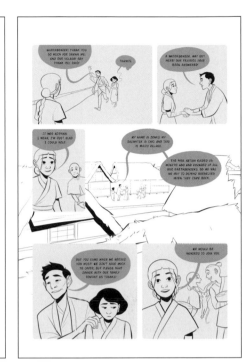

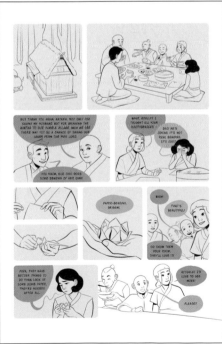

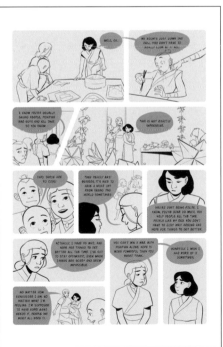

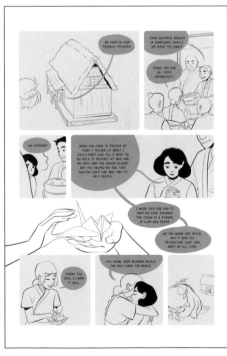

Kiku Hughes's line art for her story, "Origami." Katara's waterbending effects were added later in the colors stage, so in some panels here, art looks like it's missing. The lineless style of the waterbending added a graceful fluidity (pun intended?) to this heartwarming Katara story.

Avatar: The Last Airbender—
The Promise Library Edition
978-1-61655-074-5 $39.99

Avatar: The Last Airbender—
The Promise Part 1
978-1-59582-811-8 $12.99

Avatar: The Last Airbender—
The Promise Part 2
978-1-59582-875-0 $12.99

Avatar: The Last Airbender—
The Promise Part 3
978-1-59582-941-2 $12.99

Avatar: The Last Airbender—
The Search Library Edition
978-1-61655-226-8 $39.99

Avatar: The Last Airbender—
The Search Part 1
978-1-61655-054-7 $12.99

Avatar: The Last Airbender—
The Search Part 2
978-1-61655-190-2 $12.99

Avatar: The Last Airbender—
The Search Part 3
978-1-61655-184-1 $12.99

Avatar: The Last Airbender—
The Rift Library Edition
978-1-61655-550-4 $39.99

Avatar: The Last Airbender—
The Rift Part 1
978-1-61655-295-4 $12.99

Avatar: The Last Airbender—
The Rift Part 2
978-1-61655-296-1 $12.99

Avatar: The Last Airbender—
The Rift Part 3
978-1-61655-297-8 $10.99

Avatar: The Last Airbender—
Smoke and Shadow Library
Edition
978-1-50670-013-7 $39.99

Avatar: The Last Airbender—
Smoke and Shadow Part 1
978-1-61655-761-4 $12.99

Avatar: The Last Airbender—
Smoke and Shadow Part 2
978-1-61655-790-4 $12.99

Avatar: The Last Airbender—
Smoke and Shadow Part 3
978-1-61655-838-3 $12.99